Putting
Modernism
Together

Hopkins Studies in Modernism
Douglas Mao, *Series Editor*

Putting

Modernism

Together

Literature, Music,

and Painting, 1872-1927

Daniel Albright

Johns Hopkins University Press
Baltimore

Johns Hopkins University Press
2715 North Charles Street
Baltimore, Maryland 21218-4363
www.press.jhu.edu

Library of Congress Cataloging-in-Publication Data

Albright, Daniel, 1945–2015
 Putting modernism together : literature, music, and painting,
1872–1927 / Daniel Albright.
 pages cm. — (Hopkins studies in modernism)
 Includes bibliographical references.
 ISBN 978-1-4214-1643-4 (hardcover : acid-free paper) — ISBN
978-1-4214-1644-1 (pbk. : acid-free paper) — ISBN 978-1-4214-
1645-8 (electronic) — ISBN 1-4214-1643-3 (hardcover : acid-free
paper) — ISBN 1-4214-1644-1 (pbk. : acid-free paper) — ISBN
1-4214-1645-X (electronic) 1. Modernism (Literature) 2. Modernism
(Music) 3. Modernism (Art) 4. Music and literature. 5. Art and
music. I. Title.
 PN56.M54A48 2015
 809'.9112—dc23 2014027019

A catalog record for this book is available from the British Library.

*Special discounts are available for bulk purchases of this book. For more
information, please contact Special Sales at 410-516-6936 or
specialsales@press.jhu.edu.*

Johns Hopkins University Press uses environmentally friendly book
materials, including recycled text paper that is composed of at least
30 percent post-consumer waste, whenever possible.

To Marta

Contents

Illustrations

Putting
Modernism
Together

Introduction:
Modernist Transvaluation

Friedrich Nietzsche considered that the nineteenth century was in the midst of a transvaluation of all values, and it is possible to understand Modernism as a set of what might be called transvalues—that is, counterintuitive values. Modernist artists looked for value in all sorts of under- or ill-valued places, including evil (Baudelaire), dung heaps (Chekhov), noise (Russolo), obscenity (Lawrence), triviality (Satie). This steady expansion of the field of the estimable, however, had certain dangers: (1) if everything is valuable, nothing is valuable, since value exists only by virtue of a scale of comparison; or (2) these things newly found valuable achieve this state only by devaluing something previously considered worthy, such as elegance of diction, formal clarity, consonant harmony, lofty rhetoric, exactness of representation. (As Flaubert put it, Sancho Panza's belly has burst Venus's girdle.) In this tumult of revaluing, it became hard to judge the merit of an artistic work, since its congruence to ancient models of excellence was no longer enough to call it good. But judging merit became a sensitive, all-consuming issue the moment that it became difficult: one of the reasons that critical theory became a special area of interest for T. S. Eliot and many other Modernists was a desperate need to figure out how to evaluate artistic merit by inventing new notions of the function of art in the economy of human life.

Ezra Pound's famous tenets of Imagism will provide a useful example:

1. Direct treatment of the "thing," whether subjective or objective.
2. To use absolutely no word that does not contribute to the presentation.
3. As regarding rhythm: to compose in sequence of the musical phrase, not in sequence of the metronome.[1]

It doesn't occur to Pound to present an example from, say, Homer, partly because Homer's oral formulae (such as *rosy-fingered dawn*) don't always

contribute mightily to the "presentation," partly because Homer's rhythms, however musical, are also governed by the metronome, the rules of prosody that inform almost all pre-Whitman poetry in the languages of Europe. I mean that Pound invents (coinvents) the aesthetic of Imagism as a special response to the new conditions of the early twentieth century, an age of rapid flow that craved an art tersely liquid. In one of his later Cantos, Pound rewrites a two-centuries-old passage from Alexander Pope:

> Bear me, some god! oh, quickly bear me hence
> To wholesome solitude, the nurse of sense:
> Where Contemplation plumes her ruffled wings,
> And the free soul looks down to pity kings!

(Pope, "The Fourth Satire of Dr. John Donne, Dean of St. Paul's, Versifyed")

> Prayer: hands uplifted
> Solitude: a person, a NURSE
> plumes: is she angel or bird, is she a bird or an angel?
> ruffled, rumpled, rugged. . . . wings
> Looks down
> and pities those who wear a crown

(Pound, Canto 64/355, 1940)

Pound assimilates Pope's lines into the disrupted textures of twentieth-century poetry. Where Pope speaks of Contemplation's "ruffled wings," Pound starts to ask questions: do the wings belong to a bird or an angel? And is "ruffled" the best possible description? Might not the wings be better described as rumpled or rugged? This intimate examination of a figure of speech—a casual personification that Pope tosses out without any fuss—leads us into an age in which poetry performs all sorts of violence on the poems of the past. Pound has special fun with the second of Pope's couplets: after splitting open, cubifying, the first couplet, Pound rewrites Pope's second couplet in Pope's own language, but with a lot fewer syllables and altering the rhyme. It is as if Pound were saying, What the eighteenth century can do in a leisurely fashion, I can do much more quickly and efficiently, and toss in an allusion to Shakespeare as well: "Uneasy lies the head that wears a crown" (2 *Henry IV* 3.1.31).

This is what Pope looks like, transvalued. Pound's approach to the question of evaluation was twofold: sometimes he shows the special grain or

tenor of the Modernist era by rewriting the past; other times he simply tears out some small, hard, shiny thing from the past and quotes it directly. In one of his first significant essays, "I Gather the Limbs of Osiris" (1911-12), Pound compares himself to a man looking for diamonds by sifting the whole of South Africa: he has to ransack the whole, mostly vain literary effort of the human race in order to find a few things of value. Similarly, a twenty-first-century critic must go through the whole, partly vain effort of Pound's Cantos in order to find the passages that stand. Sometimes I may find it convenient to use the value criteria of Modernism to help me—and I may wish to scrutinize my own motor rhythms as a critic in order to see whether I have consistent principles of evaluation—but ultimately I must rely on Vladimir Nabokov's criterion of artistic excellence: does the work of art raise the small hairs on my back?

What is Modernism? In the older art of Europe, there is an easy way of determining excellence:

Value: Measure the success of your work by the lofty standards of antiquity.

Modern is one of those words that can make people uneasy, just as the word *modish* might mean something complimentary or might not. In the old days, it was definitely a negative kind of word: to Shakespeare *modern* could mean commonplace, almost trivial—as in the case of the justice in *As You Like It* 2.7, with his "wise saws and modern instances," that is, trite examples. In the eighteenth century, during the so-called Battle of the Books, the moderns were those who esteemed newfangled trash, while the ancients were those who looked to the Greek and Roman classics for models of excellence; in the twentieth century, the word *modern* generally meant something in the no-man's-land between hip and weird. The old scorn for the modern is easily explained, since in the Christian tradition, and to some extent in the Greco-Roman tradition as well, the descent of man is a long degradation: the further back in time you go, the better things get. Adam started out in the perfect image of God, and even after his fall he still managed to live 930 years; according to Genesis 6, "there were giants in those days," the days of the patriarchs. Human history is the story of the enfeeblement and diminishing of the human race. Jonathan Swift, the fiercest partisan in favor of the ancients against the modern, built the logic of degeneration into *Gulliver's Travels* (1726): "He approved of the tradition . . . that the two Yahoos said to be the first seen among them, had been driven thither over the sea; that coming to land, and being forsaken by their companions,

they retired to the mountains, and degenerating by degrees, became in pro-
cess of time, much more savage than those of their own species in the
country from whence these two originals came."[2] We imagined that man-
kind ascended to civilization from some life-form like the Yahoo, those hairy
subhumans who toss their excrement when they get excited, but instead
mankind is becoming ever more Yahooish with every passing century. In
fact, what is least flattering to Anglo-American prejudices, the Yahoos seem
to be British, according to a passage that appears close to the end of some
editions of *Gulliver's Travels*, at the moment when Gulliver is asking himself
whether he's the first European ever to visit the land of the angelic horses,
Houyhnhnmland: "A dispute may arise about the two yahoos, said to have
been seen many ages ago on a mountain in Houyhnhnmland, from whence
the opinion is, that the race of those brutes hath descended; and these, for
any thing I know, may have been English, which indeed I was apt to suspect
from the lineaments of their posterity's countenances, although very much
defaced."[3] You should even measure the shape of your nose by the standards
of antiquity—it's all been downhill since.

In the nineteenth century, the notion of measuring against antiquity was
still strong. The critic Matthew Arnold recommended that you test every-
thing you write against what he called a touchstone, that is, a short passage
memorized from Homer, Dante, Shakespeare, Milton:

> " . . . which cost Ceres all that pain
> To seek her through the world."
> [Milton, *Paradise Lost* 4.271-72]
>
> These few lines, if we have tact and can use them, are enough even of themselves
> to keep clear and sound our judgments about poetry, to save us from fallacious
> estimates of it, to conduct us to a real estimate.[4]

But this standard possibly works better in a nineteenth-century pretechno-
logical world: nobody wants to buy a computer built according to the tried-
and-true principles of last year, let alone one copied from the ENIACs of the
1950s. But, if we're far more suspicious of the values of antiquity than Swift
or Arnold was, why does the word *modern* still make us a bit uneasy?

The answer is simple: Modernist art tends to be confrontational, in-your-
face. All great art is to some extent unsettling—anything that moves us
deeply is an attack against the smooth operations of personality, the ploys
that allow us to glide through our lives without thinking or feeling too much.

But pre-Modernist art, such as certain passages of early Dickens, sometimes invites us to recline on a sofa of words, on which the author carefully seduces us into relaxing all our defenses, so that the (sometimes savage) critique of society will be assimilated without resistance—though elsewhere Dickens's words are less like a sofa than like a boat in bad water, as at the beginning of *Our Mutual Friend*.

Modernist art rarely hides its aggressions: you bleed when you handle the jagged edges of *The Waste Land*. But aggression can take many forms: it is possible to be not only aggressively lacerating but also aggressively modest—as when the composer Erik Satie performed, in the lobby during an intermission of a play, a piece called *Furniture Music*; when people gathered to pay attention, he yelled at them "Don't listen!" In other words, Muzak is also a Modernist invention.

Is there a definition of Modernism that might be adequate to all the contradictions and fault lines in this vast artistic movement, or heap of artistic movements? One possibility is this: Modernism is a *testing of the limits of aesthetic construction*. According to this perspective, the Modernists tried to find the ultimate bounds of certain artistic possibilities: volatility of emotion (Expressionism), stability and inexpressiveness (the New Objectivity), accuracy of representation (Hyperrealism), absence of representation (Abstractionism), purity of form (Neoclassicism), formless energy (Neobarbarism), cultivation of the technological present (Futurism), cultivation of the prehistoric past (the Mythic Method). These extremes, of course, have been arranged in pairs, because aesthetic heresies, like theological ones, come in binary sets: each limit point presupposes an opposite limit point, a counterextreme toward which the artist can push. Much of the strangeness, the stridency, the exhilaration of Modernist art can be explained by this strong thrust toward the verges of the aesthetic experience: after the nineteenth century had established a remarkably safe, intimate center where the artist and the audience could dwell, the Modernist age reaches out to the freakish circumferences of art. The extremes of the aesthetic experience tend to converge: in the Modernist movement, the most barbaric art tends to be the most up-to-date and sophisticated. This is, of course, an ahistorical definition, therefore allowing us to find Modernists in all sorts of distant times, such as the Venetian Baroque, or twelfth-century Germany, where the old Modernist Hildegard von Bingen, a German nun, invented an imaginary language to convey the truths of her private pentecost. But this book treats

only the historical Modernists, the technocrats of art who worked from the 1870s to the 1920s—a strange, arrogant, insecure age, framed by catastrophes (the Franco-Prussian War, the Great War, the Great Depression).

Counter to the old value statement about measuring your art against the standards of antiquity, modern art tended to measure itself against a criterion of originality:

Value: Do what has never been done before.

As Ezra Pound put it, *Make it new*. On the other hand, Pound discovered this slogan on a Chinese bathtub some 3600 years old, and there are everywhere strong counterpressures against making novelty an unequivocal virtue. We will often look at mythologies of progress, only to find various forms of recalcitrance to progress both inside and outside the progressive work. Every Modernist who tries to create a color never before seen, a sound never before heard, will also have a certain tendency to spoof this very desire; furthermore, another Modernist will raise his or her hand and say, in a sarcastic tone of voice, Wow.

I think that Modernist art will always appeal to those of us with an itch to explore. The trek to the South Pole, the quest for the source of the Nile, the search for birds of paradise in the interior of New Guinea, the climb up Mount Everest, the bathysphere descent into the Marianas Trench—Modernism provides something equivalent, in the domain of art. It matters, to those who want to peer inside the mind or to investigate the horizons of the human. You can hire a rocket to blast you into outer space—or, with less expense, but not necessarily less effort, you can watch Stanley Kubrik's *2001* (1968) or listen to Gustav Holst's *The Planets* (1918).

1 Two Originary Texts

1 Baudelaire and Symbolism

The writer who coined the term *modernity* was Charles Baudelaire, in *The Painter of Modern Life* (1864); the philosopher who did most to set the curriculum for Modernism was Friedrich Nietzsche, perhaps most notably in his first book, *The Birth of Tragedy* (1872). Both were fascinated by the music of Richard Wagner—in fact, *The Birth of Tragedy* can be read as a response to *Tristan und Isolde* (1857, 1865), in some sense the first Modernist work.

The first stirring, perhaps, of a modern attitude toward value in art can be found in Charles Baudelaire's *The Painter of Modern Life* (1864).

Value: Look not to the ancient, but to the casual, the ephemeral, the drifting.

The novelty of Baudelaire's argument was its elevation of status of urban junk: the city, with all its random motions of passersby and discarded wind-blown paper, was the most appropriate subject of contemporary art; and the idler, the *flâneur*, savoring the faceless drift of things, was, if not the ideal artist, at least a sort of precursor to the ideal artist:

> This solitary endowed with an active imagination, always voyaging across *the great desert of men* . . . is looking for this something we may be permitted to call *modernity*, since there is no better word to express the idea we mean. For him it is a question of disengaging from fashion [*mode*] whatever poetical that may be contained within the historical, of pulling out the eternal from the transitory. . . . Modernity is the transitory, the fugitive, the contingent, the half of art whose other half is the eternal and the immutable. . . . You have no right to scorn or to do without this transitory fugitive element, whose metamorphoses are so frequent. By suppressing it, you fall inevitably into the emptiness of an abstract and indefinable beauty.[1]

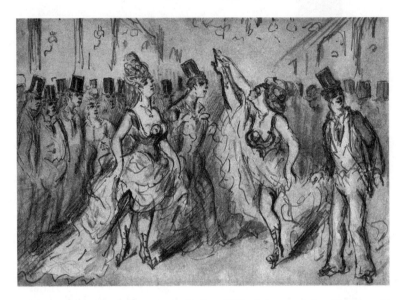

Constantin Guys, *Le chahut* Constantin Guys/Gift of George Cukor (M63.62.12)/
www.lacma.org

Baudelaire was particularly angered by painters (unlike Constantin Guys,
the "painter of modern life" and main subject of the essay) who dressed
their subjects in the garments of antiquity, instead of the clothes of contem-
porary life. Guys's eye was always looking for sexy novelties, such as the
new high-kicking dance called the cancan or *chahut*. Guys drew hastily, as
if he had only a few seconds to record the phenomenon before it passed
away—he embodied the ephemerality of the objects of his gaze in the al-
most careless speed of his drawing. He liked clothes, particularly fashionable
women's clothes that half conceal and half reveal zones of erotic interest—
low-cut gowns, petticoats opening to reveal more petticoats; if he had lived
in the 1940s, he might have been an illustrator for *Vogue*. Baudelaire claims
that Guys would have no interest in classical nudes; Guys instead delights
in "the muslins, the gauzes, the vast, iridescent clouds of stuff in which
[woman] develops herself, and which are as it were the attributes and the
pedestal of her divinity."

Baudelaire wanted to find the essences hidden in the fleeting junk of city
life, and the school of poetry that seeks immaterial essences, the phlogiston
inside common things, is called Symbolism.

Value: Seek meaning only in the occult essences hidden in external objects,
namely, symbols.

Baudelaire was one of the founders of this school, for his sonnet "Corre-
spondences" (1857) stated its means and hinted at its goals:

> Nature is a temple where living columns
> Reverberate at times with confusing words;
> There man walks across the symbol-woods
> And symbols with knowing glances look at him.
>
> As long-drawn far-off echoes themselves confound
> In a profound and tenebrous unity,
> Vast as night and vast as clarity,
> Perfumes, color, sounds, they all respond.
>
> There are perfumes fresh as children's flesh,
> Sweet as the sounds of oboes, green as prairies,
> —And others, corrupted, rich, triumphant, flush,
>
> Diffusing through space in an infinite series,
> Like amber and musk, benjamin and incense,
> Chanting the rapture of spirit and sense.[2]

A Symbolist artist is a detective hunting for treasure, living treasure; it is no
accident that Baudelaire was much inspired by Edgar Allan Poe, the inven-
tor of the detective story. The Symbolist finds most of existence to be a
desert, blank and boring; but somewhere there lurks meaning, if the artist
can respond fully enough to nature's subliminal urgencies. Baudelaire hoped
to find at the edges of nature certain faint sensations provocative of beauti-
ful feelings; hovering at the verge of things is the sensational Eden of which
the poet dreams, achieved by means of eerie combinations of sense data.

Realism tends to celebrate the world as it is. Symbolism, on the other
hand, concerns itself with the transcendental, the ideal; it dismissed the
physical world as meaningless, except for a few precious occluded objects—
symbols—phosphorescent with certain abstract potencies of meaning. As
Jean Moréas wrote in the Symbolist manifesto (1886),

> The enemy of "instruction, declamation, false sensibility, objective description,"
> symbolic poetry seeks: to clothe the Idea in a sensible form which would not be
> a goal in itself, but which, while always serving to express the Idea, would remain

subordinate to it. The Idea, in turn, must not let itself be seen deprived of the sumptuous robes of external analogy; for the essential character of symbolic art consists of never going so far as to conceive the Idea in itself. So, in this art, pictures from nature and human actions and all concrete phenomena are never allowed to be manifest in themselves: they are in the artwork as sensible appearances destined to represent their esoteric affinities with primordial Ideas. . . .

Sometimes mythical phantasms, from antique Demogorgon to Belial, from the Cabeiri to the Necromancers, appear luxuriously attired on Caliban's rock or in Titania's forest, to the mixolydian modes of barbitons and octachords.[3]

Symbolism treated not exact appearances, the heft of physical objects, but the far reaches of imagination.

How can art skim above the physical world, enter the azure realm of the ideal? One method is by naming obvious unrealities, such as unicorns; ordinary language is poorly equipped to describe the delicate delirium that Symbolist writers wish to present. Oscar Wilde's praise of lying in "The Decay of Lying" is precisely validated by this philosophy of art. A more arcane method is the language of *synesthesia* (that is, the crossing over from one sense to another): in Baudelaire's sonnet, perfumes are like oboes or the feel of a child's flesh. Synesthesia is a technique for reconstruing commonplace nature into something fresh, for indicating intuitions of some indwelling transsensuous beauty, a beauty that (since it is beyond the usual range of our sensory apparatus) expresses itself through an unusual, "wrong" sense organ.

The writer who did most to bring the French Symbolists—Baudelaire, Rimbaud, Mallarmé, and others—to the English-speaking world was Arthur Symons, in a book called *The Symbolist Movement in Literature* (1899). Symons dedicated his book to W. B. Yeats, whom he considered the great Symbolist poet in the English language.

Yeats regarded symbols as the basic vocabulary of poetry. Yeats was the son of a painter influenced by the Pre-Raphaelites, a sociable, highly intelligent, but not too successful man; his son William Butler seemed in his youth dreamy and unfocused, such a poor student that he couldn't think of attending Trinity College, the Protestant university in Ireland—he attended art school instead. He soon lost all interest in painting, but in beginning a career he was in the odd position of having a fairly good education in art history while having only a spotty and scattered knowledge of everything else. He had an acute mind and a retentive memory and was to learn a good

deal about philosophy, comparative religion, and occultism, but from youth on he conceived that the basic elements of poetry were imagistic, indeed pictographic—when Yeats speaks of symbols, he means visual designs, and in his poetry you can often watch him arraying little pictures into larger schemes of meaning. Sometimes it's as if Yeats wrote poems by arranging a tableau of fortune-telling cards, such as the tarot pack.

Yeats, under the influence of his studies with Madame Blavatsky and other Spiritualists and Rosicrucians, came to understand the business of the poet in a somewhat odd way. He considered that the human race had a single huge imagination, what he called the *anima mundi*, which was a treasure trove of all possible symbols; every poet was granted access to certain parts of the *anima mundi*, from which he or she gathered a private stock of symbols. Each poet claimed a different set. Shelley, Yeats explains, controlled such symbols as cave, tower, and star. Yeats himself was dealt a different hand, including tower, but not star; in addition to tower, Yeats controlled tree, hawk, well, moon, sun;[4] and perhaps I might add a few more to the list, such as sword, dome, dancing woman, and, most of all, rose.

In his essay "The Autumn of the Body" (1898), Yeats rejected the world of mainstream Victorian poetry, on the grounds that Tennyson and Browning tried to incorporate into poetry too much of the external world—politics, science, and so forth. Yeats, by contrast, was drawn to the Frenchified idea of *poésie pure*, a rarefied, immaterial sort of sensation cultivating:

> Man has wooed and won the world, and has fallen weary . . . with a weariness that will not end until the last autumn, when the stars shall be blown away like withered leaves. He grew weary when he said, "These things that I touch and see and hear are alone real," for he saw them without illusion at last, and found them but air and dust and moisture. . . . The arts are, I believe, about to take upon their shoulders the burdens that have fallen from the shoulders of priests, and to lead us back upon our journey by filling our thoughts with the essences of things, and not with things.[5]

Every symbol is the limit point of an essentializing process: a symbol is the residue of meaning that exists when all superfluous aspects of a thing are stripped away. Liberated from space and time and all other human constructs, a symbol truly exists only in the *anima mundi*, though you may find symbolic value embodied in actual physical objects, if those objects are significant enough to you. It's important here to distinguish a symbol from a sign: a sign has meaning only through an act of arbitrary labeling—we all

agree that a green traffic signal means go, not because there's anything about green that naturally excites forward motion, but because a convention has been established. A symbol, though, has its value transcendentally guaranteed: if lilies, honey, gold seem fringed with some aura of meaning, it's not our doing—the human race as a whole is responsible, or God. In fact, it's not easy to be a Symbolist and an atheist at the same time; Symbolism works most easily if you believe in a supernatural evaluator.

Symbolism always tends to be opposed to realistic representation. A simple example can be found in the third volume of *The Stones of Venice* (1853), by the Victorian art critic John Ruskin. Contemplating the Byzantine mosaic of olive trees in St. Mark's, Venice, Ruskin asks himself, how can an artist render an olive tree in such a way that it won't be mistaken for some other tree?

> Let it be granted that an idea of an olive-tree is indeed to be given us. . . . Now the main characteristics of an olive-tree are these. It has sharp and slender leaves of a greyish green, nearly grey on the under surface. . . . Its fruit, when ripe, is black and lustrous, but of course so small, that, unless in great quantity, it is not conspicuous upon the tree. Its trunk and branches are peculiarly fantastic in their twisting . . . and the trunk is often hollow, and even rent into many divisions like separate stems, but the extremities are exquisitely graceful . . . the notable and characteristic effect of the tree in the distance is of a rounded and soft mass or ball of downy foliage.
>
> Supposing a modern artist to address himself to the rendering of this tree with his best skill: he will probably draw accurately the twisting of the branches, but yet this will hardly distinguish the tree from an oak. . . . The fruit, and the peculiar grace of the leaves at the extremities . . . will all be too minute to be rendered . . . the main points of the olive-tree will all at last remain untold.
>
> Now observe, the old Byzantine mosaicist begins his work at an enormous disadvantage. It is to be some one hundred and fifty feet above the eye, in a dark cupola; executed not with free touches of the pencil, but with square pieces of glass . . . were he to draw the leaves of their natural size, they would be so small that their forms would be invisible. . . . So he arranges them in small clusters . . . elongated so as to give the idea of leafage upon a spray.[6]

In Ruskin's drawing of the mosaic olive tree, the mosaic is not a representation of an olive tree, but of olive-tree-ness, in which those salient points that separate an olive tree from every other type of tree find visual expression. To put it another way, the artist has presented the platonic form of the

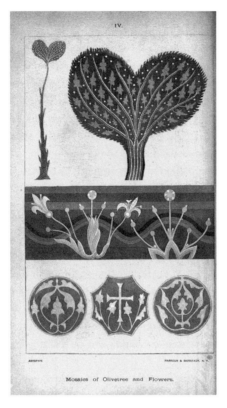

IV.

Mosaics of Olivetree and Flowers.

John Ruskin, drawing of olive tree mosaic in St. Mark's (1853) John Ruskin, *Stones of Venice*, vol. 3. New York: Wiley, 1880

olive tree, a schema of its ultimate growth pattern, not a picture of an individual specimen.

It is the liberation from accident, quirk, particularity that distinguishes a symbol from a normal object. In an early essay, "Symbolism in Painting" (1898), Yeats suggests that anything can be made symbolic simply by decontextualizing it, making it spaceless and timeless: "If you liberate a person or a landscape from the bonds of motives and their actions, causes and their effects . . . it will change under your eyes, and become a symbol of an infinite emotion, a perfected emotion, a part of the Divine Essence; for we love nothing but the perfect."[7] Symbols, then, interrupt the causal chain, frustrate the world, and populate a private domain of hyperentities.

The master symbol of Yeats's early poetry is the rose. The rose varies between two poles: the historical and particular, as when it refers to the love of Yeats's life, the beautiful revolutionary Maud Gonne, or when it refers to Ireland itself; and a state so ample and inclusive that it is almost a symbol of Symbolism itself—an allegation of the oneness of all beautiful objects, a hypothetical apex where all upward-striving things converge. On one hand, the rose is intimate with the immediate textures of our lives; on the other hand, it is fully transcendent. But what's strange about Yeats's poetic practice is his suspiciousness of the rose.

Often the contemplation of the rose leads the poet to an exhilarating but dangerous state of overwhelm: the rose seems to lead him to the brink of apocalypse, when the stars shall "be blown about the sky, / Like the sparks blown out of a smithy, and die."[8] Many of the poems that Yeats wrote near the end of the nineteenth century seem ready to terminate in the abyss: "The Valley of the Black Pig," for example, concerns the end of the world. The poem was a result of Yeats's researches into Irish folklore: a poor Irish woman told him of "the battle of the Black Pig, which seemed to her a battle between Ireland and England, but to me an Armageddon which shall quench all things in the Ancestral Darkness again."[9] Yeats sometimes thought of his poetry as a device to hasten the world's end, by realizing uncontrollable spiritual forces on earth.

But do we—does Yeats—really want the world to end? In one of his most famous poems, "To the Rose upon the Rood of Time"—that is, "To the Rose of Eternity Crucified on the Cross of Time"—Yeats prays ardently for the rose to descend to him, to inspire him; but in the middle of the poem, he stops beckoning the rose and stars thrusting her away:

> Come near, come near, come near—Ah, leave me still
> A little space for the rose-breath to fill!
> Lest I no more hear common things that crave;
> The weak worm hiding down in its small cave,
> The field-mouse running by me in the grass,
> And heavy mortal hopes that toil and pass;
> But seek alone to hear the strange things said
> By God to the bright hearts of those long dead,
> And learn to chaunt a tongue men do not know.[10]

Come near—but don't come *too* near. Most of the cherishable minute particulars of life seem to vanish if our eyes are blind to everything except Eter-

nal Beauty; and the poet himself may start to speak an unintelligible language under her influence, just as, at Pentecost, the Holy Ghost inspired a sort of hypersignificant babbling. In his middle age Yeats once said, "I have no speech but symbol, the pagan speech I made / Amid the dreams of youth";[11] but a speech that's *all* symbol may turn out to be no language at all. Perhaps poetry needs a certain degree of prose mixed in, a few stray worms and field mice, to keep it from becoming *précieux* and bizarre.

2 Nietzsche and the Dionysiac

In 1903 Yeats spent a great deal of time reading Friedrich Nietzsche, and Nietzsche's philosophy helped to lead him away from Symbolism to a harder, more forceful, more heroic sort of art. Nietzsche did a great deal to bring Modernism into being, so let us go back to the world of the 1860s and 1870s, to look at certain important intellectual and artistic events in Germany. But I want to approach Nietzsche in a somewhat roundabout way, through a French Symbolist painting by Gustave Moreau.

Gustave Moreau painted *Oedipus and the Sphinx* in 1864, eight years before *The Birth of Tragedy* appeared; for a number of reasons, it seems a good choice for an illustration to Nietzsche's thought. Moreau's sphinx is perhaps a little smaller than we thought—a woman whose body has been deleted until she consists entirely of erogenous zones. With her hind paws on Oedipus's crotch, she seems ready either to castrate him or to have sex with him, depending on how well he responds to her famous challenge—she killed everyone who could not answer her riddle about the human race. A little bouquet of shriveled body parts at the bottom of the canvas testifies to her power to dismember and devour her victims; herself a monster, she testifies to the monstrousness of the human, to our condition of having intellects and appetites that don't confine themselves within any bounds. Oedipus and the sphinx gaze into each other's eyes with a peculiar intimacy and familiarity, as if they've repeated this scenario many times—just as, in Nietzsche's philosophy, mankind and the abyss are all too familiar with one another. We know things about the depths of experience, about mutilation and chaos—things that we don't like to acknowledge; and all these things pertinent to riot, plague, incoherence of mind and body are overwhelmingly sexy.

At the beginning of *Beyond Good and Evil* (1886), Nietzsche contemplates

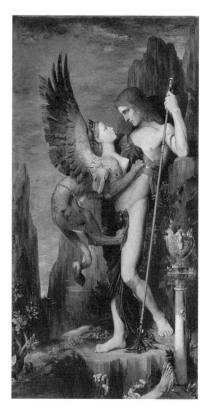

Gustave Moreau, *Oedipus and the Sphinx* (1864) The Metropolitan Museum of Art, Bequest of William H. Herriman, 1920 (21.134.10) Image © The Metropolitan Museum of Art

the large questions of philosophy and asks, "Who among us is Oedipus here? Who Sphinx? It is a rendezvous, it seems, of questions and question marks."[1] It seems that for Nietzsche questions and answers are all mixed up together. His philosophy is like a game of *Jeopardy!* in which the question is presented in the form of an answer and the answer in the form of a question.

The sphinx asked Oedipus, "What has four legs in the morning, two at noon, and three at night?" Oedipus answered "Man" and killed the sphinx. But if we present the answer as a question, "What is man?" perhaps the number of his legs isn't a sufficient response. The whole of *The Birth of Tragedy* can be considered an attempt to solve, or at least to frame, the riddle of

what it is that makes us human. Nietzsche locates this riddle in the world of Greek antiquity, not surprising since he was one of the most precocious classicists of his age—such a stupendous scholar of Greek and Latin that he was called to a professorship in classical philology at the University of Basel by the time he was twenty-five. Three years later he published his first book, *The Birth of Tragedy out of the Spirit of Music*, which was to have profound influence in modern art and thought. But at its core the book is a study not of the classical but of the human: Nietzsche uses old Greek history as a road into the prehistoric, into mankind in itself, before the perversions of civilization. In this he follows Jean-Jacques Rousseau, who spent a great deal of time in the 1750s imagining prerational human beings, what he called "noble savages."

The old answers to the question "What is man?" are generally along the lines of Blaise Pascal's "I am but a reed, but a reed that thinks." The capacity for logic, abstraction, step-by-step reasoning generally is the marker of the human. But Nietzsche defined the human differently: at the end of *The Birth of Tragedy* he says that *mankind is dissonance*, as if discord and contradiction were the markers of the human. In *Beyond Good and Evil* Nietzsche says, "Who struggles with monsters must see to it that he doesn't turn into a monster. And when you stare for a long time into an abyss, the abyss also stares into you."[2] The abyss is both Oedipus and the sphinx—it's hard to tell the questioner from the questioned. The ferociously quizzical gaze of Moreau's sphinx might do as an illustration for the abyss's stare—it promises strange delights as it seeks to tear you limb from limb. Early philosophers tended to see man as a well-defined thing, *bipes et implumis* (two-legged and featherless), but easily discriminated from a plucked chicken; Nietzsche sees man as blur, riddle, an intersection of question marks, highly questionable. Oedipus, unnatural, incestuous, a parricide, stands for the general knottiness and murk of the human condition: "With respect to the riddle-solving and mother-wooing Oedipus, what we immediately have to interpret is this: that there, where through prophetic and wizard powers the spell of the present and the future—the rigid law of individuation, even the actual magic of nature—is broken, a monstrous contrary-to-nature event must have happened earlier, as the cause."[3] The mind's categories of space and time, subject and object, must be annihilated if we're to understand what a man is.

Behind Nietzsche is the Romantic philosopher Arthur Schopenhauer, who anticipated Nietzsche's dismantling of the human subject. Indeed, Nietzsche's

phrase just quoted, "rigid law of individuation," is pure Schopenhauer—let me explain. In his great book *The World as Will and Representation* (1819), Schopenhauer begins by telling us that we live our foolish lives thinking ourselves private individuals, cherishing our uniqueness, our little body of private preferences—nobody else likes cinnamon and bitter chocolate and carpet slippers and grayish-green paint and wintry landscapes with rows of leafless poplar trees in quite the same way that I like those things. But to Schopenhauer individuality is a delusion: there is only one desiring agent in the universe—you desire, and I desire, and the hungry squirrel on the lawn desires, but these desires are only local expressions of a single great desire that gropes its way through you and me and lambs and tigers and amoebas and blades of grass that yearn for the sun. This master desire Schopenhauer calls the Will. In Thomas Mann's summary, the Will is arch-sinful, arch-stupid, a blind reaching out: "As the will's world-forming fulfills itself according to the principle of individuation, through its shattering into multiplicity, it forgets its original unity and, although in all its dismemberments it is one, it becomes a will a million times divided against itself, striving against itself . . . and so constantly drives its teeth into its own flesh, like that resident of Tartarus who greedily ate his own flesh."[4] Only through chaste intellection, through choosing a dispassionate life of ideas—what Schopenhauer calls Representation, *Vorstellung*—can we hope to save ourselves from Will; as Richard Wagner told Franz Liszt, Schopenhauer's "chief idea, the final negation of the desire of life, is terribly serious, but it shows the only salvation possible."[5] We think our way out of the horror of appetite—only thought is sufficient to kill desire.

Schopenhauer's theory of sexual love may indicate something of why desire has nothing to do with the individual—why it is a function of the great Will. Schopenhauer thought that sexual love functioned strictly through eugenic complements: if I have a weak chin and a large nose, I will necessarily lust after a woman with a large chin and a small nose, because I seek some repair for my defects—our children will have perfect chins and perfect noses. If Schopenhauer is right, I could go through a bunch of adults at a cocktail party and sort them all out into perfect pairs by studying closely their face shapes and body shapes—your own beliefs about your desires mean nothing, for your sexual appetites are determined by the huge urgency outside you, the Will. Love is involuntary, inhuman.

It's easy to see why Schopenhauer was attracted to Buddhism: the word *nirvana* simply means putting out a candle, and Schopenhauer and Buddha

alike advocated a snuffing of the candle of sensuous desire as the only form of salvation, I don't know if you find this philosophy attractive, but every so often in life you may feel the rightness of it. I myself once had a Schopenhauerian moment when I was in a small boat crossing rough seas around an island a few miles off the coast of Ireland, called Little Skellig, a pyramid of rock several hundred feet high, inhabited only by those enormous seagulls called gannets. Thousands of them swarmed around the boat, wheeling over my head, or skimming a few inches over the waves and diving for fish, while making raucous cries. I felt a kind of terror at the sheer monstrousness of appetite, as if I found myself in the midst of the Will itself.

Unlike Schopenhauer, Nietzsche embraces this horror and is profoundly suspicious of conceptual copies of experience. Schopenhauer tries to be outside the Will, looking in, keeping it at arm's length. *The Birth of Tragedy*, instead, is written from inside the will; it is a book trying *not* to turn itself into philosophy, but to keep itself loose and indeterminate—trying to remain a poem, full of vivid metaphor, preconceptual.

No previous philosopher was quite so skeptical of ideas, quite so ready to embrace *art* as the center of human life. The world justifies itself as an aesthetic phenomenon, he keeps repeating; Homer is a hero—the great villain, to Nietzsche, is Socrates, antimusical (until his final days), the murderer of the cosmos in that he gives full prestige only to rational understanding. Plato's forms eviscerate experience, leaving only a kind of empty shell. The Romantic poet William Blake, before Nietzsche, and the Modernist novelist D. H. Lawrence, after Nietzsche, completely concurred with this anti-Platonic sentiment; Nietzsche is Romantic in his intellectual anti-intellectualism, Modernist in his willingness to leave the human subject deconstructed, instead of substituting some sort of irrational unity—Nietzsche's vision of the human subject is spasmodic, lurching, incoherent, more like Frankenstein's monster or Moby Dick than like Frankenstein or Heathcliff or other Romantic heroes.

At the center of human culture Nietzsche places the story of the Silenus, who, asked what is best for man, says, "What is best of all is utterly beyond your reach: not to be born, not to *be*, to be *nothing*. But the second best for you is—to die soon."[6] "Not to be born is best for man" is exactly what Sophocles says in a chorus from *Oedipus at Colonus*—and this primordial state of complete erasure is promoted by Nietzsche into a strange sort of philosophy of indeterminacy. Here we can judge just how far Nietzsche has

come from previous art history. The greatest German art historian of the eighteenth century was Johann Joachim Winckelmann, who hoped to rescue the vile taste of the German Rococo for ornament, excrescence, curlicue by reinstating the values of classical Greek art, marked by *Allgemeinheit* (generality) and *Heiterkeit* (cheerfulness or serenity). For Nietzsche, Greece is at bottom not serene, not cheerful, not measured, not composed, not nothing-in-excess, not the golden mean, but close to a state of ecstatic existential despair.

Freud's first book was *The Interpretation of Dreams* (1900), and *The Birth of Tragedy* is also a dream book, a book about the unconscious, a book that tries to keep itself and the reader in some preconscious or semiconscious state. Only its villains, such as Socrates, are wide awake. Its rhythm is the rhythmic alternation of rapid-eye-movement sleep (the state of Apollo) and dreamless sleep (the state of Dionysus). Homer, Nietzsche tells us, is a "dream artist," dreaming the whole Apollonian culture of the Olympian gods into being; tragedy arises through the alternation of the Dionysiac chorus— reeling in the abyss, lost in a communal intuition of intolerable pleasure and terror—and the pretty Apollonian dream images incarnated in the actors on stage. We should remain as much as possible in these two states of reason's sleep.

Later we'll discuss the artistic movement most clearly devoted to states of sleep, Surrealism. Just as Nietzsche is a proto-Freud, describing the id, *das Es*, the inhuman core of human, under the name of Dionysus, so Nietzsche is a proto-Dalí or proto-André Breton, a Surrealist before the invention of Surrealism. Some of his images and metaphors are almost transcendentally weird, such as his concept of reverse afterimages: "When we exert ourselves to stare steadily at the sun, we turn away blinded, and we have dark-colored spots before our eyes, as a way of healing, so to speak: if we turn this backwards, the Sophoclean hero's apparitions of light—in short the mask in its Apollonian aspect—are the necessary productions of a gaze into inner terrors of nature, as if they were shining flecks that heal eyes damaged by the atrocious night."[7] The eye, ravaged by sheer blackness, attempts to repair itself through hallucinations of bright images. Similarly, when Nietzsche imagines how the spectator at a tragedy metamorphoses into a satyr—"the Dionysiac reveler sees himself as a satyr, *and as a satyr, in turn, he sees the god*"[8]—Nietzsche presents Greek tragedy as a movie like *The Matrix*, a dream of a heightened virtual reality more ravishing than real life; but unlike *The*

Matrix, The Birth of Tragedy suggests that we would be wise never to wake up. In tragedy we lose our human form, fall down the phylogenetic chain into goat and faun, turn into the mishmash, the shapeless thing we really are.

But I shouldn't exaggerate the irrationality of this book—Nietzsche wrote it as a sort of PhD dissertation, and it retains a few features of rational linear argument:

1. Greek tragedy grew out of choral hymns worshiping Dionysus—the god of drunkenness, riot, pain, ecstatic dismemberment, and the primal oneness of all things.

2. Human beings are too frail to accept the dark truths represented by Dionysus—we have to believe in the illusion that we are private individuals with private wills, and we have to screen ourselves from the abyss by inventing beautiful images, dreams of glory.

3. We call these beautiful images gods, and we identify Apollo in particular—the god of light, music, and clarity—with the principle of the saving illusion.

4. Therefore, instead of simply singing choral hymns to Dionysus, we intersperse these hymns with staged enactments (called tragedies) of the pretty stories that Apollo devises to distract us from the Dionysiac vertigo: we spend our lives suspended over a pit and ought never to have been born.

5. The ideal psychic functionality of Greek tragedy was destroyed by Socrates, who substituted abstract rational speculation for the immediate apprehension of the cosmos available only through artistic means—and the first symptoms of this corruption can be found in the decadent tragedies of Socrates's contemporary, Euripides.

6. When Greek tragedy was resurrected in the form of opera, around 1600, its inventors produced only a bloodless and vain parody of Greek tragedy, suited to the rationalistic temper of the times—instead of the Dionysiac satyr, opera provided only sexless shepherds, so insipid that they could hardly even sing, only speak in recitative (Nietzsche here grossly underestimates the excitement that could be generated from Monteverdian monody—though it's true that the shepherds and shepherdesses of seventeenth-century opera, endlessly carving their intertwined initials into the trunks of trees and mooning over absent lovers, can seem a bit infantile).

7. But the spirit of Greek tragedy has at last resurrected itself in the music

dramas of Richard Wagner, a composer intimate with both Dionysus and Apollo.

Toward the end of *The Birth of Tragedy* Nietzsche develops two final themes:

8. The necessity of the ugly, the dissonant, in the construction of the human subject; this is itself a romantic theme, from Victor Hugo, who wrote in 1827 that "the beautiful . . . is merely form considered in its simplest relation, in its most absolute symmetry, in the most intimate harmony. . . . It offers to us a finished ensemble, but circumscribed, as we ourselves are circumscribed. What we call the ugly, on the contrary, is a detail of a great ensemble that escapes our grasp, and which harmonizes itself, not with man, but with creation in its entirety. That is why it presents us ceaselessly with new aspects, but incomplete aspects."[9]

Beauty is narrow, exclusive, thin-lipped, thin-hipped, a little tedious, faintly repellent; ugliness is rich and diversified and evil and generous, life itself. Nietzsche is especially interested in musical ugliness, dissonance:

> The first requirement for explaining the tragic myth is just this, to seek its peculiar pleasure in the purely aesthetic sphere, without encroaching onto the region of pity, of terror, of the ethically sublime. How can the ugly and the discordant—the contents of the tragic myth—excite an aesthetic pleasure?
>
> Now here we need to whirl round with a bold advance into a metaphysics of art, while I repeat an earlier sentence [from section 5], that being and the world appear justified only as an aesthetic phenomenon: in this sense the tragic myth has to convince us that even the ugly and the discordant are an artistic game that the will, in the eternal fullness of its pleasure, plays with itself. But this difficult-to-grasp primal phenomenon of Dionysiac art will be instantly grasped only in the wonderful meaning of *musical dissonance*, since after all music alone, when set down beside the world, can give an idea of what is meant by the justification of the world as an aesthetic phenomenon. The pleasure that the tragic myth produces has the same country of origin as the pleasurable feeling of dissonance in music. The Dionysiac, with its primal pleasure felt even in pain, is the common womb of music and of the tragic myth. . . . A Dionysiac phenomenon . . . reveals to us ever anew the playful building-up and smashing-apart of the individual world as the outflow of a primal pleasure, as when Heraclitus the Obscure compared the power that shapes worlds to a child at play, who puts stones here and there and builds up and throws down heaps of sand. . . .

Music and tragic myth are in the same way expression of the Dionysiac capacity of a people and inseparable from one another. Both stem from a domain of art that lies beyond the Apollonian; both transfigure a region in whose pleasure-chords dissonance as well as the world's terrible image alluringly reverberate and vanish; both play with the thorn of displeasure, trusting their exceedingly powerful arts of magic; both justify through this game the very existence of this "worse world." Here the Dionysiac, measured against the Apollonian, shows itself as the eternal and primordial force of art that really calls into being the whole world of appearance, in whose midst a new halo [*Schein: appearance, illusion, glory, shine*] of transfiguration becomes necessary, in order to keep alive the bustling world of individuation. If we could think ourselves an incarnation of dissonance—and what else is man?—then this dissonance would need, in order to be able to live, a splendid illusion, to cover its own being with a veil of beauty. This is the true art-intention of Apollo: in whose name we comprise all these numberless illusions of beautiful appearance, illusions that after all make existence livable at every moment and press us to experience the next moment.[10]

Soon we'll be looking at the exact sort of dissonance—it turns out to be a half-diminished chord—that Nietzsche evidently found the most inspiring of all.

The oddest theme at the end of *The Birth of Tragedy*—the one that has inspired most distaste among readers—is German chauvinism:

9. Germany, the most pagan of countries, is the place where the art of tragedy will be reborn:

So in order to assess the Dionysiac capacity of a people, we have to consider not only its music, but just as necessarily its tragic myth as a second witness of its capacity. The close relation between music and myth makes us similarly suppose that the degrading and depraving of one will be connected to a shriveling of the other: if indeed in the weakening of the myth there is really manifest a diminishing of Dionysiac potential. But concerning both, a glance at the development of the German identity might leave us in no doubt: in our opera just as in the abstract character of our mythless existence, in our art with its debased amusements just as in our idea-ridden life, we see revealed the inartistic, life-withering nature of Socratic optimism. But to console us there are omens that despite everything the German spirit undestroyed rests and dreams in splendid health, depth, and Dionysiac strength, like a slumber-sunk knight in an inaccessible abyss: out of this abyss the Dionysiac song rises up to us, in order to make us understand

that this German knight even now is dreaming his primally-old Dionysiac myth in blessed-solemn visions. Let no one think that the German spirit may have lost forever its mythic home, when it still understands so distinctly the voices of the birds that tell of that home. Some day it will find itself awake in the morning freshness after a monstrous sleep: then it will kill dragons, wipe out the spiteful dwarfs, and awaken Brünnhilde—and Wotan's spear itself won't be able to block its way! [In *Ecce Homo* (1888), Nietzsche glosses the dwarfs of *The Birth of Tragedy* as "Christian priests"—at the beginning of his career, Nietzsche is circumspect about his opinion that Christianity is a religion fit for slaves. Nietzsche is also thinking here of Wagner's *Siegfried* (1869), in which Siegfried attains glory by forging a sword, killing the evil dwarf Mime, shattering his grandfather Wotan's spear (the source of divine authority), and plunging through flames to embrace the Valkyrie Brünnhilde.]

My friends, you who believe in Dionysiac music, you also know what tragedy means for us. In you we have, reborn out of music, the tragic myth—and in it you may hope for everything and forget what is most painful! But most painful for all of us—the long degradation, under which the German genius, estranged from house and home, lived in the service of spiteful dwarfs. You understand the word—as you will also, finally, understand my hopes.[11]

Among the many readers to be embarrassed by this passage was Nietzsche himself, who became extraordinarily suspicious of all virtues attributed to the German character: in *Beyond Good and Evil* he says that we should not speak of *das deutsche Volk* but of *das täusche-Volk* (*täuschen* means *deceive*).[12]

In the 1886 preface to a new edition of *The Birth of Tragedy* Nietzsche laughs at himself for predicting a rebirth of the German spirit at the exact moment when Germany was making "the pompous pretense of founding a *Reich* . . . a contrived moderation, democracy, and 'modern ideas'!"[13] It is a strange historical accident that during Nietzsche's long confinement and after his death his reputation was tended by his sister, an anti-Semitic, fiercely nationalistic woman who made Nietzsche's idea of the Will to Power one of the catchphrases of the German Far Right. In the same preface Nietzsche makes explicit the anti-Christian subtext of the book: "I baptized it, not without some liberty—for who would know the right name of the Antichrist?—in the name of a Greek god: I called it Dionysiac."[14] Dionysus, then, is conceived as the antidote to Christ.

Wagner

The role of Wagner is crucial in *The Birth of Tragedy*, for Wagner himself plays the role of Dionysus, inspiring us to tear limb from limb not the sacrificial goat, but our very selves. Or, more exactly, Wagner plays the role both of Apollo and of Dionysus. Wagner the composer is Dionysus, writing music that dissolves us into the immediate Will of Schopenhauer—for Schopenhauer, in a passage Nietzsche quotes at length, music is the one art that offers direct apprehension of the Will, not a mere copy of external phenomena. But Wagner the librettist is Apollo, rescuing us from the abyss by writing the text, the myth of Tristan and Isolde, a story that allows us to fasten our attention on recognizable human characters instead of chaos and black night riddled with flares.

The story is simple: The Cornish prince Tristan killed the Irish leader Morold but, deeply wounded himself, was nursed back to health by Morold's betrothed, Isolde, unaware of Tristan's identity. Tristan then abducted Isolde and took her to Cornwall to be married by force to Tristan's uncle King Marke. During the voyage across the Irish Sea, Isolde mocks and goads Tristan until they agree to commit suicide together, but Isolde's nurse Brangäne substitutes a love potion for the poison, and Tristan and Isolde, the mortal enemies, fall helplessly in love. Here Wagner's first act ends; the second act consists basically of one huge love duet, the musical equivalent of the most intense consummation of passion that Wagner could imagine. But Marke returns from the hunt and finds the lovers; one of his men fights Tristan and wounds him severely. The third act consists mostly of Tristan's desolation, as he writhes in pain on the coast of Brittany, waiting desperately for the ship that will bring him the one person who can cure him, Isolde. Isolde's ship does arrive, but too late, and she arrives at the moment when Tristan dies. She concludes the opera by singing the famous solo that Wagner called the *Verklärung* (Transfiguration) but that Liszt called, when he arranged the piece for piano in 1867, the *Liebestod* (Love-Death)—that was the name that stuck.

By one analysis, this is an ordinary tale of adultery; Nietzsche himself was eventually to say that all Wagner heroines, "as soon as they are stripped of their heroic skin, become almost indistinguishable from Madame Bovary!" (the stupid provincial adultress of Gustave Flaubert's 1856 novel).[15] But Wagner's music is extraordinary, even in the first two measures of the prelude. The key signature has no sharps or flats, suggesting that the key ought

to be either C major or A minor; and since the first three notes of the first measure are A-F-E, it seems that we're at home in A minor. Sure enough, at the end of the second measure, we get to a dominant chord in E major, confirming our suspicion that the key is A minor—such a progression from tonic to dominant is the natural movement of tonal music. It's the middle that's the problem, the chord in the second measure before we reach the E major chord: here we have the sphinx riddle of all Western music. This half-diminished chord (F-B-D♯-G♯) is impossible to account for in terms of traditional harmony: if the D♯ were a D, all would be an intelligible diminished seventh, but it's not, and analysts have gone to astonishing lengths to account for what it is, but it really doesn't make sense. Then again, it's *about* not making sense: it is an audible irrationality, which is why Nietzsche could make it into the Mark of Dionysus, so to speak. Wagner explained the method of *Tristan* in his 1870 essay on Beethoven, itself strongly indebted to Schopenhauer: after laying out Schopenhauer's distinctions between the waking consciousness and inward-turned experience of dreaming, Wagner goes on to posit that there are two worlds in every human subject, an eye-world (critical, captious, full of categories, time bound, space bound) and an ear-world: "Beside the world presenting itself visibly, in waking as in dream, there is a second world, only perceptible to hearing, making itself known through sound—therefore an actual soundworld beside the lightworld available to consciousness, of which we can say that it corresponds to the light-world as dream corresponds to waking: it is just as explicit as the other, though we must recognize it as completely different."[16] The ear-world, of course, is the domain of music, which blurs, smears, all the precisions of the eye's cognition of reality. So Wagner also is a kind of Surrealist-before-Surrealism, trading the cold comprehensible experience of waking life for the warm dissolutions of sleep. Few pieces of music are quite so intensely corporeal as the prelude to *Tristan und Isolde*: beneath the mind the body stirs, asserts its great rhythms of blood, tumescence, slumber. The main motive of the work is usually identified as the love potion motive, and that is all there is, except for echoes of the interechoing love words of Tristan and Isolde from the Act 2 duet—there is no opposing material at all, nothing that contrasts with the long development of the poison as it acts in Tristan's and Isolde's bodies. Kinesthetically speaking, the music is simple: it's a twelve-minute-long sexual act, with the moment of climax occurring exactly two-thirds of the way through.

In one of the most remarkable passages in *The Birth of Tragedy,* Nietzsche

treats *Tristan*'s interplay between music and text (text being equivalent to waking consciousness, whereas music belongs to the unconscious):

> The myth protects us against the music, just as on the other side the myth first gives to music the highest freedom. As a return gift music bestows on the tragic myth a penetrating and persuasive metaphysical significance, such as word and image could never attain without music's unique help; and in particular it is through music that the spectator of tragedy is seized by that sure premonition of a highest joy, a joy at the end of the road through ruin and negation, so that he thinks he hears the innermost abyss of things speaking audibly to him.
>
> . . . To true musicians I direct the question, if they can imagine a man capable of perceiving the third act of *Tristan und Isolde* with no help from word and image, purely as a monstrous symphonic movement, without expiring in a convulsion of the soul's wings, loosed from every restraint? A man like this, who has put his ear to the heart-chamber of the world-will, who feels the raging hunger for being as a thundering stream or as a brook dispersed to the sweetest mist, gushing from this source through all the world's veins—shouldn't he suddenly break to pieces?
> . . . Here the *Apollonian* power breaks forth, arising to restore the almost exploded individual with the healing balm of a delightful deception: suddenly we believe we're still seeing only Tristan, as, motionless and muffled, he asks himself: "The old tune; why does it wake me?" And what earlier seemed to us like a hollow sighing from the midpoint of being itself now wants only to say to us, "waste and empty the sea." And where breathless we imagined ourselves snuffed out in convulsive out-rackings of every feeling, and we felt only a little bit of a connection to our usual existence, now we see and hear the hero, wounded to death and yet not dying, with his despairing cry: "Yearning! Yearning!"[17]

The glimpse of the hero on stage brings us back to normal reality. But perhaps some of Wagner's text, as well as his music, is rhapsodic and world dismantling, ego dismantling, in the manner of Wagner's music. These are the last words that Isolde sings, during the Love-Death:

In dem wogenden Schwall,	In the pulsing surge,
in dem tönenden Schall,	in the sonorous roar,
in des Welt-Athems	in the world-breath's
wehendem All—	breathing All—
ertrinken—	to drown—
versinken—	to sink—
unbewusst—	unconscious—
höchste Lust!	highest bliss!

Wagner, even more explicitly than Nietzsche, here locates the liquidation of all idea, all representation, in the domain of the unconscious—the delirious text, with its shortening, intensifying lines, seems to be bringing us to a place where all words rhyme.

The influence of Wagner on early Nietzsche is quite overwhelming, and not only in the domain of philosophy. Nietzsche thought quite seriously about becoming a composer and wrote a good deal of music, some of it not bad. In a piece called *Manfred-Meditation*, written as he was writing *The Birth of Tragedy*, there is a figure almost embarrassingly close to the opening motive of *Tristan und Isolde*, but oddly truncated, thwarted, a kind of *musica interrupta*.

If mankind *is* dissonance, there must be ethical as well as musical ramifications. Just as Wagner's structures of delirium tended to undercut the concept of a tonic note out of which the music begins and into which it falls, so Nietzsche came to believe that philosophy ought to attack the notion of a solid undergirding to the universe—that is, to attack the concept of God.

Nietzsche, the son of a Lutheran minister, had a certain feel for the sacred, but his continual appeal to the word *abyss* may suggest that, for him, the sacred was most conspicuous in its absence. In *Fröhliche Wissenschaft* (1882) he tells the parable of the madman who cried at the market, "I seek God!" and was ridiculed by the passersby: "Has he got lost?" The madman replies,

> *We have killed him*—you and I. We are all his murderers. But how have we done this? How did we manage to drink up the sea? Who gave us the sponge to wipe away the whole horizon? . . . Is there still an up and a down? Are we not straying as through an endless nothing? . . . Are we still hearing nothing of the noise of gravediggers who are burying God? Are we still smelling nothing of God's decomposition? . . . Then what are these churches if they are not the tombs and burial vaults of God?[18]

In his most searching critique of Christianity, *Toward a Genealogy of Morals* (1887), Nietzsche tells how cruelty is the fundamental human urge—Roman banquets were not complete without a dwarf strolling among the tables for the feasters to kick. But, of course, civilization demands a certain restraint: we can't go around slapping one another whenever we feel like it. According to Nietzsche, the genius of Christianity lay in its discovery of a psychic mechanism that discharged the urge to inflict pain into a safe outlet: Christianity found that there's one person you can always be cruel to, namely,

yourself, and therefore erected a huge structure of guilt, a structure that permits us the satisfaction of punishing ourselves to our heart's content.

Nietzsche's anti-Christianity was also a factor in his break with Wagner, whose last opera *Parsifal* (1882) seemed to Nietzsche a sick-sentimental kissing of the cross. In his late book *The Case of Wagner* (1888)—which uses the Mediterranean clarity of Bizet's *Carmen* as a model of operatic virtue, as against the gargoyles of Wagner—Nietzsche writes,

> Wagner's art is sick. The problems he brings to the stage—purely problems of hysterics—the convulsive quality of his affect, his overstimulated sensibility, his taste that demanded ever stronger spices . . . together all this exhibits a picture of sickness, without any doubt. *Wagner est une névrose* [Wagner is a neurosis].[19]

> Wagner is . . . our greatest *miniaturist* of music, who packs into the smallest space an infinity of meaning and sweetness. His richness in colors, in half-shadows, in the secrecies of dying light spoils us so much that afterward almost all other composers appear too robust.[20]

> It is not his music by which Wagner conquered young people, it is the "idea"—it is the riddle-richness of his art, its playing hide-and-seek behind a hundred symbols, its polychromy of the ideal that leads and lures these young people to Wagner; it is Wagner's genius in shaping clouds.[21]

> There is nothing weary, nothing morbid, nothing life-dangerous and world-slandering . . . that his art would not secretly shelter. . . . He flatters every nihilistic (Buddhistic) instinct and clothes it in music; he flatters everything Christian, every religious expression-form of decadence. . . . All counterfeiting of transcendence and of the beyond, has in Wagner's art its most sublime advocate . . . through the persuasion of sensuousness . . . Music as Circe.[22]

Circe, of course, is the enchantress in the *Odyssey* who turns men into swine through her slippery-sexual magic art. I'm not sure that "Music as Circe" is really very far from Nietzsche's early opinion that Wagner's music was Dionysus: both reduce man to some less-than-human form, though pig grunting is less glamorous than the ecstatic abasement, loss of the *principium individuationis*, that Nietzsche found in the Greek choruses that turned the choristers into satyrs. Swooning before some irresistible and devastating erotic power—this was a fate that Nietzsche courted, feared, and mocked. There is even a photograph of Nietzsche in the act of succumbing (or pretending to succumb) to Circe: it shows Lou-Andrea Salome (Nietzsche's in-

tellectual companion) with whip in hand, with Nietzsche and his friend Paul Rée tethered to a horse cart. This joke is based on an old story that Aristotle was forced by his mistress Phyllis to take a bridle in his mouth.

Toward the end of the 1880s, Nietzsche's mind started to fail as syphilis invaded his brain, until he broke down completely in 1889, after becoming enraged by the sight of a man whipping a horse—the horse motif returning for the last time; he spent the last eleven years of his life in confinement, almost completely mute. Sometimes he suffered from the delusion that he *was* Richard Wagner—he once broke his silence to explain to his asylum keepers that he had been brought there by his wife Cosima. Nietzsche never married; Cosima was the name of Wagner's widow.

Thomas Mann, *Death in Venice* (1912)

The influence of Nietzsche on twentieth-century art is incalculable, but to suggest something of its power, I will discuss that Nietzsche-oversaturated novella *Death in Venice*.

If Nietzsche had written a novel, would it resemble *Death in Venice*? If penicillin had been discovered in the 1880s, Nietzsche would have turned sixty-seven years old in 1912 and might have tried his hand at fiction. All of Nietzsche's favorite themes are present here: the sense that something has gone desperately wrong with Western civilization, and German civilization in particular; the fascination with the East; the sense that Greek classicism, properly understood, is a form of liberation; the incipience of madness; and, of course, Dionysus and Apollo—if the novel had been called *The Revenge of Dionysus*, no one would have thought it strange. Dionysus and Apollo are the central instruments of Mann's dialectic; he uses Nietzsche to think with, so overwhelming is Nietzsche's influence.

Furthermore, the same strains of German Romanticism that deeply informed Nietzsche also informed Mann. Mann's first novel, *Buddenbrooks* (1901), is a meditation on Schopenhauer roughly in the way that *Death in Venice* is a meditation on Nietzsche. And Wagner's influence was crucial to Mann's art, just as it was to Nietzsche's. Two of Mann's best early stories, *Tristan* (1903) and *The Blood of the Wälsungs* (1905), attempt the odd feat of transposing plot lines from Wagner operas into modern bourgeois/Capitalist societies. *The Blood of the Wälsungs* is a hip version of *Die Walküre*, in which a twin brother and a sister, Siegmund and Sieglinde Aarenhold, offspring of a rich industrialist, are sexually infatuated with one another; in order to avoid the taboos against incest, they carefully map their life so that it looks

like the plot of Act 1 of *Die Walküre*, in which Siegmund and Sieglinde, brother and sister, drug Sieglinde's uncouth husband so that they can have sex and conceive the greatest of all heroes, Siegfried. That is, these smart-talking modern twins invent purely imaginary obstacles along Wagnerian lines so that they can see themselves as Wagnerian figures, thereby conjuring up an incestuous passion that feels like transfiguration, not like perversion. But their sexual embrace does indeed turn out badly, just as old-fashioned morality said that it would: they become infantile and compulsive, damned. Trying to become lead tenor and soprano of a Wagnerian opera, they become only a grotesque pip-squeak parody.

This also is a Nietzschean sort of plot—Nietzsche, we remember, considered Wagnerian heroes to be modern hysterics and neurotics in bearskins and winged helmets. This quality is even clearer in *Tristan*, a story that takes place in a tuberculosis sanatorium: a failed novelist and awkward aesthete named Spinell becomes enamored of Frau Klöterjahn, a stupid young matron of great delicacy and beauty. Spinell tries to persuade the woman to think of herself not as a proper businessman's wife, but as a figure from myth, a nymph wearing a golden crown. She falls so deeply into this fantasy that she asks Spinell if he really can see the golden crown he imagines on her head. When he finds the score of *Tristan und Isolde* and asks her to play the love duet on the piano, she starts to fall into the role of Isolde. Because she looks more beautiful the more she wastes away, she seems deliberately to let herself become more and more diseased, turning a light case into a fatal one. Spinell seems to hope for a Love-Death in which he and she will be united in a rapturous death; but he's the kind of lover who suffers a lot from tooth decay, and she's the kind of lover who is fond of recalling recipes for potato pancakes, so that it's unlikely that any great swells of deliriously modulating orchestral music will well up at the end of their lives. Like Nietzsche, Mann understood Wagner as a kind of disease, though a most fascinating sort of pathology. A caricature by George Grosz, *In Memory of Richard Wagner* (1921), gives something of the feel of Mann's Wagnerian stories. Both Nietzsche and Mann felt Wagner's immense power and had to summon up great reserves of resistance to fight it.

Death in Venice does not allegorize a particular Wagner opera but is nevertheless strongly shaped by music. The most famous nineteenth-century artist who died in Venice was, of course, Richard Wagner himself: so Mann's title prepares us as much for a novel about Wagner as for anything else. The book's hero, Gustav Aschenbach, is an extraordinarily ambitious and suc-

George Grosz, *In Memory of Richard Wagner* (1921) bpk, Berlin/Art Resource, NY. Art
© Estate of George Grosz/Licensed by VAGA, New York, NY

cessful artist, whose works, we're told, are already part of the canon of
German literature; but far from being Wagner-like, he seems to be the anti-
Wagner, a somewhat prissy artist who detests sprawl and ungainliness of
every sort. The great Greek play about resistance to Dionysus—which, for
Nietzsche, means resistance to Wagner—is Euripides's *The Bacchae*, discussed
at some length in *The Birth of Tragedy*; and I think it's fair to say that in the
implicit version of *The Bacchae* lurking behind Mann's novel, Aschenbach
plays the role of Pentheus.

In Euripides's play, Dionysus is an incognito god, returning to Thebes,
the land of his birth, from the Far East:

> Overland I went,
> across the steppes of Persia where the sun strikes hotly

down, through Bactrian fastness and the grim waste
of Media. Thence to rich Arabia I came;
and so, along all Asia's swarming littoral . . .
I taught my dances to the feet of living men,
establishing my mysteries and rites.[23]

In Thebes he depraves the women, driving them to orgiastic frenzies in
which they tear living animals limb from limb, in order to punish the city for
denying his divinity, as he prepares to manifest himself as a god. King Pen-
theus soon learns that a "charlatan" magician has come to town, "with long
yellow curls smelling of perfumes" (lines 234-35), an "effeminate stranger
. . . who infects our women / with this strange disease and pollutes our
beds" (lines 352-53), a man who claims to be a god; Pentheus will arrest this
man and put him to death. Pentheus's men seize Dionysus; Pentheus ac-
cuses him, shears away the god's curls (line 494), confiscates his thyrsus (his
magic wand), and orders him bound and locked in a stable (line 509), while
Dionysus darkly warns him against sacrilege. Dionysus commands an earth-
quake and a bolt of lightning; Pentheus's palace is destroyed, and the god
escapes. Pentheus hears of miracles: the Bacchantes can make the ground
spurt fountains of wine, or honey, or milk; Pentheus would like to see these
marvels, and Dionysus tells him a way: "you must dress yourself in women's
clothes" (line 822); "In a *woman*'s dress, / you mean? I would die of shame";
"On your head / I shall set a wig with long curls." Pentheus reluctantly con-
sents; he hides in a fir tree to watch the orgy, but the Bacchantes see him,
pull down the tree, and his own mother, Agave, rips the flesh off his bones.
She comes home boasting that she has killed a lion with her bare hands (line
1239)—but she holds in her hands the head not of a lion, but of her own son
Pentheus, as her father Cadmus gently forces her to see.

In adapting this fable to modern circumstances, Mann was perhaps most
brilliant in his treatment of the Dionysus figure. There is no one character
who represents Dionysus, but a whole crowd of minor actors, so similar to
one another that Aschenbach seems to have entered a fun house where the
same face leers at him from many different tunnels. This pluralizing of the
god is faithful both to Euripides—where the disguised Dionysus adopts dif-
ferent roles—and to Nietzsche, whose Dionysus represents the destruction
of the *principium individuationis*, and is therefore properly represented not
by an individual but by a whole heap of shadowy reddish presences that
menace and entice. The first of these Dionysi is the backpacking traveler

whom Aschenbach sees as he exits the mortuary chapel in Byzantine style, guarded by two apocalyptic beasts, in the Munich cemetery:

> Moderately tall, thin, beardless, strikingly snubnosed, he belonged to the red-haired type and possessed its milky and freckled skin. Obviously he was not Bavarian; at any rate the broad and straight-brimmed bast hat that covered his head lent to his appearance the stamp of something foreign and faraway . . . his Adam's apple protruded stark and naked, he glanced with colorless, red-lashed eyes, between which two vertical, resolute furrows stood . . . either because he grimaced, blinded by the setting sun, or because of some permanent facial deformity, his lips seemed too short, they were completely drawn back from his teeth, leaving his gums exposed.[24]

The sight of this "pilgrim" leads Aschenbach to a remarkable fantasy of a "primal wilderness-world" where "curiously unshaped trees, whose roots grew out of their trunks and sank through the air into the earth and the water, formed tangled forests. On the stagnant water mirroring green shadows there swam milk-white flowers. . . . Among the knotty reed-trunks of a bamboo thicket he thought he saw for a moment the phosphorescing eyes of a tiger flashing." With his snub nose and bared teeth, the pilgrim resembles any number of old pictures of Silenus, satyr, or goatish man; and he so enchants Aschenbach's imagination that the whole landscape seems to decompose into some sinister Oriental puddle. Dionysus's spell has already started to act; Aschenbach is already infected with a sort of cholera of the mind, long before the real cholera makes its way from some Asiatic swamp to Venice. Dionysus's power to deform, to twist every created thing out of shape and thrust the abyss into the foreground, is already in play.

The novel has a careful five-part design. The first chapter takes place in the Munich cemetery and ends as Aschenbach decides to go East—not all the way to the tigers, he says to himself, but only to Venice. The second chapter is a review of Aschenbach's career. The catalogue of his works is worth close attention for several reasons: (1) It presents a picture of an obsessively Apollonian artist—his novel *The Wretch*, for example, is a product of his "disgust with the psychologism of his age . . . [he] announces the turning-away from all moral ambiguity, of any sympathy with the abyss—announces the rejection of the laxity of the pitiful maxim that to understand all is to forgive all; what came into being here . . . was that 'miracle of reborn impartiality' . . . one observed an almost excessive strengthening of his sense of beauty, that noble purity and simplicity." Nothing Dionysiac here—

Aschenbach is the exact opposite of an Expressionist: his classicizing art ostentatiously manifests its own discipline, and the heroes of his fiction are such disciplined souls as Frederick the Great. (2) Most of the literary projects here described are projects that Mann himself had considered writing. (3) Homosexuality is whispered everywhere: Frederick the Great was homosexual; Saint Sebastian, his body penetrated by arrows, has always been an icon of sexual deviance. Aschenbach's marriage dwells in the compass of a single curt sentence, but hints of forbidden desire infect Aschenbach's whole mental life, and not just in the catalogue of his works in chapter 2. As Aschenbach's ship approaches Venice in chapter 3, "he thought of the melancholy and susceptible poet who had once seen the towers and turrets of his dreams rise out of these waves": this poet was August Graf von Platen, who was as close to being openly homosexual as a nineteenth-century nobleman could be. Of course, when Tadzio appears, homosexuality is no longer whispered but shouted aloud, in a refined literary sort of way: Aschenbach compares Tadzio to Critobulus, who kissed the son of Alcibiades—Socrates said that Critobulus's kiss was like a tarantula's bite. Aschenbach also compares Tadzio to Hyacinthus, the Spartan boy whom both Apollo and Zephyr loved—when Apollo threw a discus, the jealous Zephyr blew the discus into Hyacinthus's head and killed him. Dionysus seems to be pushing Aschenbach not only inexorably eastward but boyward, toward some vision of sexual behavior that partly represents the total destruction of all Aschenbach's careful self-discipline and partly represents the culmination of his lofty classicizing—this is the paradox that so bemuses Aschenbach at the end of the novel, the discovery, so to speak, that Apollo himself is gay.

The first Dionysus figure whom Aschenbach encounters in chapter 3 (the trip to Venice) is a loud fellow: "A bright yellow, too-fashionably-cut summer suit, a red cravat and a boldly tilted Panama hat, outdid the others with his screeching voice. . . . Aschenbach noticed with a kind of horror that the 'youth' was a fake. He was old, no one could doubt it. Wrinkles surrounded his eyes and mouth. [There was] dull carmine on his cheeks." This is almost a Cubist reconstruction of the pilgrim of chapter 1, his straw hat turned panama, his red hair turned into a red cravat, his freckles transposed into the facial blemishes of aging. The pilgrim seemed a liminal creature between man and animal; the old dandy seems a liminal creature between youth and age. All the Dionysus characters resist the normal categories of time and space; indeed, the sight of the dandy makes Aschenbach nauseated, dizzy. An ugly sort of lasciviousness clings about the dandy, "his tongue

kept repulsively licking the corner of his mouth," for all the threshold conditions of the Dionysus figures pertain finally to the threshold between male and female, to regions of sexual taboo. After he sings a little pimpish song to Aschenbach, the dandy adds, " 'Our compliments to the darling, the dearest prettiest darling. . . .' And suddenly his upper plate fell from his jaw onto his lower lip." Under Dionysus's influence, the human body itself seems about to collapse, amid the general collapse of all form.

The next Dionysus is the oarsman of the gondola, who lacks the usual red badge but has most of the other attributes: "an unpleasant, even brutish face, with . . . a shapeless straw hut. . . . The shape of his face, his blond curling moustache under the short upturned nose, made him appear to be of non-Italian stock. . . . The strain of rowing pulled back his lips and bared his white teeth." Like the pilgrim, he seems ready to bite into living flesh. He insists on rowing Aschenbach in the wrong direction and has distinct suggestions both of Charon, the ferryman across the River Styx, and of the psychopomp Hermes, the shepherd of dead souls; his threshold, his limbo, is between the rest of the world and Venice, if not between life and death. The whole description of Venice depicts it as a threshold region, an indeterminate place, half water and half land, half real and half unreal, with its architectural glories continually sinking into slime, into the abyss.

The second half of chapter 3 is devoted to Aschenbach's falling in love with Tadzio, the fourteen-year-old Polish boy: "His face—pale and gracefully reticent, ringed with honey-colored hair, with a straight-falling nose, and a lovely mouth, and an expression of delicate and divine seriousness—recalled Greek sculpture during its most noble age." It's a Winckelmann-like description—Winckelmann was still another homosexual—of a Greek sculpture come to life, all *Heiterkeit* (serenity) and *Allgemeinheit* (generality). But soon this image of boyish beauty starts to become less serene in all sorts of ways: first the sculpture becomes not just any Greek god but "the head of Eros" in particular; then it becomes a living erotic object, as Jaschiu gives Tadzio a kiss, while a wolf's howl starts up gently in the background, "two melodious syllables, like 'Adgio,' or still more often 'Adjiu,' with a sustained *u* calling out at the end. . . . The name . . . dominated the beach." As Tadzio falls from Apollonian to Dionysiac, imperfections start to manifest themselves: "Tadzio's teeth were . . . jagged and lusterless, without the glaze of health. . . He is tender, he is sickly, thought Aschenbach. He will probably never become old. He gave up any reckoning of the satisfaction or peacefulness that accompanied this thought." Aschenbach starts to manifest signs

not only of homosexual desire but of sadism: Jaschiu's later cruelty to Tadzio seems a projection of Aschenbach's own wish to despoil Hyacinthus, to blow the discus into his head. Not only is Aschenbach charmed by the thought that Tadzio will die young, but he likes to caress the mental image of Hyacinthus's "broken body, and the flower that sprang up from his sweet blood and bore the inscription of his endless lament." Pentheus cut off Dionysus's effeminate locks and tried to capture him; Aschenbach tries to capture Tadzio as an image in his mind, even (later) writing a "page and a half of exquisite prose" that magically preserves his likeness. And in a strange way Aschenbach is excited by Tadzio's desecration, which operates in this tale as a surrogate for rape. Chapter 3 may be said to concern loosening: the loosening of Tadzio himself, as he enters an erotic and social world, a world of tooth decay; the loosening of Aschenbach's resolve, as he chooses to remain in Venice; and finally the loosening of Aschenbach's very muscles. In chapter 2 a "keen observer" says that Aschenbach " 'has so far only lived like this'—and the speaker closed the fingers of his left hand into a hard fist— 'never like this'—and he let his open hand hang comfortably on the back of his chair"; at the end of chapter 3 Aschenbach lets his hands hang "slack over the back of his chair" and then made "a slow, sustained, and lifting motion, turning his palms forward . . . a welcoming gesture, calm and accepting."

Chapter 4 opens with a tremendous rhetorical flourish:

> Now day after day the naked god with burning cheeks drove his chariot, drawn by four fire-breathing horses, through the spaces of heaven, and his yellow locks fluttered in the gales of the east wind. A white-silky glister lay over the far expanses of the lazy surges of Pontos. . . . Then it seemed to him as if he had been rapt away to Elysium, at the far borders of the earth, where the lightest life is bestowed on men, where snow is not, and winter, nor storms and streaming rain, but Oceanus ever wafts his gently cooling breath, and in blessed idleness the days run on, without fatigue, without struggle, completely dedicated to the sun and the feasts of the sun.

After all the loosening of chapter 3, the novel seems to be making a last-ditch attempt to get a grip on itself. Mann seems to be aping Aschenbach in his most ultrarefined, classicizing mode—not only is the style of writing Apollonian, but Apollo himself, the sun god in his chariot, is the subject of the first sentence. But there's something slightly fake, self-conscious, in this reassertion of formal mastery, in the lofty paraphrases of Pindar's ode on

Elysium: Aschenbach isn't living in Elysium, but only a brittle image of Elysium superimposed on seedy, morbid Venice.

The novel is extraordinary in its undercutting of its own literariness. In the scene where Aschenbach finds himself too cowardly actually to speak to Tadzio, he works up a little fable about Eros in order to hide from himself the truth about his own feelings and conduct: "He made jokes at his own expense over his comico-sacral anxiety. 'Dismayed,' he thought, 'dismayed like a game-cock that anxiously lets his wings hang down in the battle. That is truly the god that breaks our courage and casts our proud mind to the ground at the sight of the one we love . . .' He played, he waxed lyrical, and was too arrogant to fear his own feeling." This passage suggests that all the highfalutin effusions about Narcissus, Hyacinthus, Apollo, Phaeax, Phaedrus, Eros, and so forth, are complicated prevarications to disguise the deep desire that an aging author wants to sleep with a beautiful boy. In Nietzsche, Apollo is the inspiration of lovely dreams, gauzy gorgeous unrealities that save us from darknesses we can neither face nor fathom. By creating a crumbling, self-dispelling classical fantasia, Mann turns Nietzsche's dialectic into a novel. The interdependence of Apollo and Dionysus, the rhythm of passage from black choral hymn to pretty enactments of stories about the gods, finds a clever substantiation in the figure of Tadzio, at once beautiful in the best detached Apollonian manner and a Dionysiac curly-haired provocateur, goading Aschenbach to intolerable desires. Mann's mythologizing sometimes approaches self-conscious kitsch: "infant clouds, transfigured, lit from behind, hovered like attendant amoretti in the rosy, bluish haze"; this Disneyesque version of classical heaven is so artificial that it scarcely hides for a moment the huge wooden phallus that pops up in Aschenbach's (later) dream of Euripides's snake-cinctured revelers. Aschenbach's attempt to compose himself, to get a grasp on himself, fails utterly: at the end of chapter 4, "overpowered . . . he whispered the usual formula longing—impossible here, absurd, worthy of condemnation, ridiculous and yet sacred, and worthy of honour even here: 'I love you!'"

Chapter 4, like chapter 2, concerns literature, style, personality and doesn't advance the plot much. Chapter 5, like chapter 3, illustrates the loosening of Aschenbach's ligatures, the teasing apart of the tendons of his being. Now the cholera epidemic appears, and Aschenbach silently rejoices, for "passion is like crime . . . it must welcome the world's every confusion and infestation, because there it can hope to find its advantage." In the sick

city the sick Aschenbach stalks Tadzio and his family, as if he were a bacillus waiting to infect. At an entertainment at his hotel Aschenbach encounters the most striking of all the novel's Dionysus avatars, a

> Buffo baritone, with almost no voice, but a gifted mime with remarkable comic energy. . . . Slim in build, with a thin, haggard face, he stood . . . with his shabby felt hat on his neck, so that a great shock of red hair shot out under the brim. . . . He did not seem to be of Venetian stock, much more of the race of Neapolitan comics, half pimp, half comedian, brutal and rakish, dangerous and entertaining. His song, only silly if you listened to the words, managed in his mouth to mean something ambiguous and vaguely nasty, by means of the play of his features, the movements of his body, his way of winking suggestively and making raunchy play with his tongue at the corner of his mouth. . . . a strikingly large and naked Adam's apple grew out of his gaunt neck. His pale, snub-nosed face—his beard-less features made it hard to determine his age—seemed to be ploughed through with grimaces and vice . . . two furrows stood defiant, overbearing, almost wild between his red brows.

This singer is a composite of all the various badges that have accumulated around the various satyr figures that the novel has proposed: like the pilgrim of chapter 1, he's red-haired and snub-nosed, with prominent furrows and larynx; like the elderly dandy, he is raucous, coarse, and ribald and likes to stick out his tongue; like the gondolier, he's brutal and bullying. In *The Bacchae* Pentheus accuses Dionysus of being a charlatan magician, and in the figure of this baritone buffo Mann arrives at just such an image of Dionysus, as we see in the laughing song: "He bent his knees, he struck his thigh, he held his sides, he wanted to burst, he laughed no more, he shrieked; he pointed his finger up as if there could be nothing so comic as the audience laughing above, and at last everyone laughed in hotel, terrace, and garden, even the waiters and lift-boys and servants." This whole scene of nightmare derision seems to transpose the scene in Euripides where the Bacchantes in the course of their revels discover Pentheus in the tree and pull it down, though, of course, the only Aschenbach who's being dismembered here is the noble disciplined austere image of Aschenbach in Aschenbach's mind.

In Euripides, Pentheus first has to dress up as a woman before entering the domain of the Bacchantes; but Mann places the feminizing scene a bit after the clown's laughing song and after the dream of the Bacchantes laughing and howling, thrusting "sharpened sticks into one another's flesh and lick[ing] the blood from their limbs. But the dreamer was now with them,

in them, caught up by the stranger god. Yes, they were himself, as tearing and biting they threw themselves on the beasts and swallowed steaming shreds of flesh. . . . And his soul tasted the degeneration and frenzy of his fall." As Mann tells the tale, the sequel to this dream is a visit to the barber, who acts as the last, mildest, most insinuating of the Dionysus figures—he is amazed by his own face in the mirror: "where the skin had been brownish-leathery he saw a delicate carmine waking, his bloodless lips swelling with the color of raspberries . . . with his heart beating hard he gazed at a young man. . . . 'Now the gentlemen can fall in love without any trouble.' The spell-bound man went off, dream-happy, confused, afraid. His neck-tie was red, his broad-brimmed straw hat circled with a many-colored ribbon." Now the badges of the Dionysus figures have been affixed to Aschenbach himself: the elderly dandy's carmine rouge and red necktie, the pilgrim's straw hat; and the berry color of the lipstick becomes in the context a smear of cholera on his face—Aschenbach will contract the disease from eating overripe strawberries.

But, of course, Aschenbach makes a poor orgiast: timid, inept, held back by scruples and neuroses of every sort, he's a far less potent figure than the elderly dandy, let alone the baritone buffo. In his summary of his ruin, Aschenbach thinks, "Form and detachment lead to intoxication and desire, lead perhaps the noblest to atrocious outrages of feeling, which his own beautiful severity condemns as disgraceful—lead to the abyss, even they lead to the abyss." This sentence, taken out of context, looks like good Nietzsche: Apollo's formal beauties aren't self-sufficient, but rise out of and fall back into Dionysus's abyss. On the other hand, what kind of abyss does Mann propose here? It seems to me a fairly shallow abyss, a caricature of an abyss, just as the Dionysus figures throughout the book are simply caricatures of the god. The world's foundations don't totter because a man timidly falls in love with a boy.

I suspect that Nietzsche would have disliked *Death in Venice*, just as he disliked Euripides's *The Bacchae*. Dionysus is trivialized: the utter night that underlies all human constructs of reality is here reduced to a study of sexual pathology, a quasi-Freudian case history of the failure of certain strategies of repression and sublimation of desire. The moral neatness of the ending—Aschenbach is punished for his sins and dies—suggests that Mann is closer to Socrates (Nietzsche's great villain) than to either Dionysus or Apollo. A certain rationalizing self-consciousness never deserts Aschenbach, even at the limit of his not-very-depraved depravity: he is perfectly capable of judg-

ing and condemning himself up until the moment of his death; the light of his clear intelligence is occasionally muddled but never extinguished. One of Mann's most telling visual details in the death scene is a camera left behind on the beach: "A camera stood on its tripod by the edge of the sea, looking abandoned, and a black cloth spread over it fluttered and snapped in the wind that grew colder." This camera functions as a visible sign of the omniscient narrator, a visible sign of Aschenbach's own still detached, still fully operative self-scrutiny. A Dionysiac novel, if such a thing could exist, would have to surrender control at some point; but Mann never abandons his grip on the proceedings for even a moment. I don't object to this; I only mean to say that this novel doesn't represent a triumph of the Dionysiac in art.

The last theme I want to treat here is the theme of music. Italian popular music forms a continual undercurrent, from the elderly dandy's ditty to the convulsions of the laughing song. But the world of serious German music is also present, in somewhat disguised form. A 1921 letter that Mann wrote to an illustrator who had drawn a picture of Aschenbach that happened to look a lot like the composer Gustav Mahler will show what I mean:

> The conception of my story, which occurred in the early summer of 1911, was influenced by news of the death of Gustav Mahler, whose acquaintance I had been privileged to make in Munich. . . . I was on the island of Brioni at the time of his passing and followed the story of his last hours in the Viennese press. . . . Later, these shocks fused with the impressions and ideas from which novella sprang. So that when I conceived my hero who succumbs to lascivious dissolution, I not only gave him the great musician's Christian name, but also in describing his appearance conferred Mahler's mask upon him.[25]

For a number of reasons Mann found it convenient to make his hero a writer and not a composer, but perhaps it's easier to understand Aschenbach through Mahler's music than through any German writer. The Third Symphony (1896) in particular is a profoundly Nietzschean work: the fourth movement sets a poem that Nietzsche published in *Also Sprach Zarathustra*, and Alma Mahler's account of the composition of the first movement puts us in the world of *The Birth of Tragedy* and *Death in Venice*: "One day in the summer he came running down from his hut in a perspiration and scarcely able to breathe. At last he came out with it: it was the heat, the stillness, the Panic horror. He was often overcome by this feeling of the goat-god's frightful and ebullient eye upon him."[26] It wasn't until thirty years after *Death in*

Venice that Mann felt comfortable enough with the world of music to write a novel about a composer, in *Dr. Faustus* (1947), where the protagonist is based on a bizarre conflation of Arnold Schoenberg and Friedrich Nietzsche; but to some extent the notion of a Nietzsche-like composer is buried in the premise of *Death in Venice* as well.

II Isms

Impressionism

The story of Modernism is also a story about the Darwinian struggles of a host of lesser isms, all of which feared (in Peter Viereck's joke) that, if they didn't prosper, they might be relegated to wasms. We've already had occasion to discuss Symbolism; now we'll discuss in turn some of the other important components of the Modernist movement.

Our sermon today begins with a text by the Jesuit poet G. M. Hopkins:

> Glory be to God for dappled things—
> For skies of couple-colour as a brinded cow;
> For rose-moles all in stipple upon trout that swim;
> Fresh-firecoal chestnut-falls; finches' wings;
> Landscape plotted and pieced—fold, fallow and plow
> And all trades, their gear and tackle and trim.
> All things counter, original, spare, strange;
> Whatever is fickle, freckled (who knows how?)
> With swift, slow; sweet, sour; adazzle, dim;
> He fathers-forth whose beauty is past change:
> Praise him.[1]

This is what Hopkins called a curtal sonnet; it retains the usual sonnet ratio of eight lines to six lines, but in shortened form: it consists of six lines plus four-and-a-half lines; the final "Praise him" is an *amen* read so slowly that it takes up half a line to pronounce it. The poem celebrates the particularity of experience: it depicts a landscape without generalities, a world of uniquenesses. This is close to the Nietzschean ideal, in which the mind is sensitive to particular dapples and freckles and irregularities, not to concepts that blur distinctions. Of course, the Roman Catholic priest Hopkins, unlike Nietzsche, attributed all these distinctions to the particularizing paintbrush of

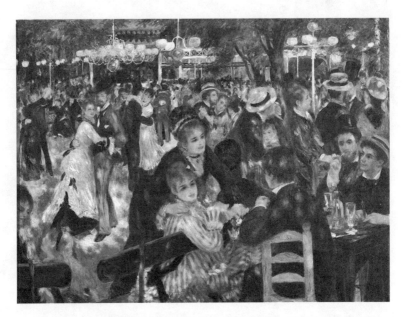

August Renoir, *La Moulin de la Galette* (1876) Erich Lessing/ Art Resource, NY

God; in fact, Hopkins found his doctrine not in advanced German philosophy but in the medieval scholastics: whereas Thomas Aquinas looked toward the *quidditas* (the "whatness") of things, Hopkins's hero Duns Scotus looked toward the *haecceitas* (the "thisness") of things, the precious unlikenesses of individual objects. Dapple is king; and the world of French Impressionist painting is, of course, near the limit of the idea of dapple.

The pattern of the leaf shadows seems so imprinted on the dresses, the whole scene, that we scarcely believe that it would go away if the women stepped into the plain light: freaks of lighting don't seem to be something added onto preexisting solid objects, but instead seem to be coextensive, inextricable with the objects. Without the dapple there would be no women, no landscape at all. The objects are ephemeralities generated by the power of light and would cease to exist, at least in their present form, if the intensity or the color of the light were to alter.

Impression became the truth of a generation of anticonventional French painters. What is visual truth? For many previous artists, the truth lay in the presentation of an articulate space occupied by a poised collection of lucid objects. Since the Renaissance, painters have sought to make credible im-

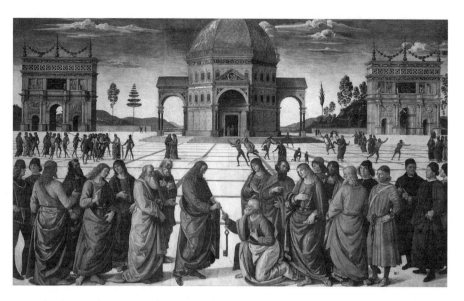

Perugino, *Christ Giving the Keys of Heaven and Hell to St. Peter* (1482) Wikimedia Commons

ages by following the rule of perspective: that is, by depicting parallel lines as toed in, converging at an infinitely distant point on the horizon opposite the viewing eye. This method is indeed faithful to the eye's apprehension of receding grids and creates a methodical space in which the relative size of distant objects can be judged. (Recent research has even suggested that those blind from birth can follow the spatial logic of perspective reliefs.) But it can be said to tell the truth about nature only if we identify nature with space: the rule of perspective tends to make space more fascinating than the objects that inhabit that space. So in many Renaissance paintings we find an abnormal prevalence of open public squares with cross-hatched paving. If railroad yards had existed in the Renaissance, there might have been a whole subgenre of the Madonna of the railroad yard.

Every artistic rule based on truth telling tends to cherish one aspect of truth at the expense of others. Even such a simple rule as the outline has its disquieting aspects: in the real world, an object does not have an outline but an edge, a "flowing contour where the body suddenly leaves off, upon the atmosphere" (as D. H. Lawrence put it). An outline is a convention that we use to make objects easier to recognize; to draw with outlines is to promote

an idea that nature consists of a heap of finite objects. But nature is not a thing dump; nature is not an empty space parceled out into narrowing boxes; nature is . . . what? Whatever it is, it is beyond the power of art to do more than to suggest that it is *there*, more *there* than we can possibly imagine.

In the second half of the nineteenth century, a number of painters decided that the old rules for visual representation had become a hindrance, not a help, in the attempt to seize nature as it really is: "I can do nothing without Nature. I do not know how to make things up. As long as I have tried to paint something in accordance with the lessons I have been taught, I have never produced anything worthwhile. If my work has any real value today, it is because of the exact interpretation and truthful analysis."[2] The speaker was Éduard Manet, and the reporter was Zola, whose portrait Manet was painting; the great naturalist was highly intrigued by recent developments in painting and indeed was to write a novel about an advanced painter, *L'Oeuvre* (1886). But the question arises: how can an artist interpret nature exactly, and analyze it truthfully, without an established lesson plan? Perhaps nature is a shimmer of fleeting percepts—as Claude Monet said, his goal was "to paint directly from nature, striving to render my impression in the face of the most fugitive effect."[3] If Nietzsche claimed that truth, far from being a stable idea of the external world, was nothing more than a stutter of sensations through our nerve endings, then the French Impressionists tried to convey a visual representation of these nerve stimuli not yet fully mapped into a coherent world. Traditional painting had addressed itself to the mind, had done everything it could to facilitate the sense of *recognition*—this young boy has a slingshot, so he must be David, about to kill Goliath. But Impressionist painting addressed itself to the eye and did everything it could to facilitate the sense of *shock* prior to recognition: Monet told an American painter that he tried "to see the world as a pattern of nameless colour patches—as it might to a man born blind who has suddenly regained his sight."[4]

Traditional painting tended to do homage to nature by presenting it in a familiar and generalized form: a willow tree tended to possess every single trait characteristic of willows, so that the mood associated with willowness—pensive, brooding—could be potently embodied. But Impressionist painting tended to do homage to nature by presenting it in its most specific, temporally acute manifestations: not *the* willow but *this* willow. One Impressionist, Auguste Renoir, even denied that generalities had anything to do with

art; he proposed to found a Society of Irregularists, devoted to the proposition that "nature abhors regularity":

> Observers have noted in fact that, despite the apparent laws which preside over their formation, the works of nature from the most important to the most insignificant are infinitely varied, no matter what type or species they belong to. The two eyes of even the most beautiful face are never exactly alike; no nose is ever situated immediately above the middle of the mouth; the segments of an orange, the leaves of a tree, the petals of a flower, are never exactly identical. It would seem that every type of beauty derives its charm from its diversity.[5]

It is remarkable how closely this project of 1884-85 echoes Nietzsche's then-unpublished essay on truth and falsehood in the extramoral sense:

> Every concept originates through equating the unequal. Certainly one leaf is never exactly like another, and so the concept leaf is formed through an arbitrary abandonment of these individual differences, through forgetting the disparities, and it awakens the idea—as if there existed in nature, in addition to leaves, the "leaf," a sort of primal form [*Urform*] after which all leaves were woven, marked, precisely measured, colored, curled, painted, but by unskilled hands, so that no exemplar turned out correctly and reliably as a faithful image of the primal form.[6]

Here Nietzsche mocks Plato's notion of transcendent form (which affirms that only the concept "leaf" is real, and that any mere leaf that you pluck from a tree is but a shadow). For centuries, painters had been painting the concept "leaf"; but the Impressionists were much less interested in the idea of the leaf than in the impinging of the leaf's light on the sensory network. Instead of the ruled truth of perspective, they sought unruled, immediate truth.

Hence, an impression looks like an antidote to rule—since impressions seem too vagrant to solidify into rules. But this was not quite the case: indeed, in the domain of the arts, every method of transgressing against the old rule quickly stiffens into a rule of its own, a codifiable procedure. The Impressionists, far from escaping from law, had simply traded the laws that govern the spatial placement of solid objects for the laws that govern impalpable forces: if they were no longer under Newton's thumb, they were still bound by the rules of the physiology of sensation, the rules of electromagnetism itself. The painter Camille Pissarro closely studied the contemporary physics of Hermann Helmholtz and James Clerk Maxwell (who taught that

electromagnetic lines of force could be understood through analogy with the motion of liquids, and who created the color photograph by understanding that the eye has three kinds of color receptors), but the great scientific hero of the Impressionists was Eugène Chevreul, a chemist who worked for the Gobelin tapestry factory by investigating the optics of dyestuffs. He discovered that nearby colors influenced one another—this had been known at least since Leonardo's time, but Chevreul gave precision to this idea, by making a color wheel in which the complement of every color was 180 degrees away.

A spot of any pigment swims in a little halo of its own complementary color—a drop of red discolors the surrounding field with blue-green. As Pissarro wrote, the work of advanced painters was "to seek a modern synthesis of methods based on science, that is, based on M. Chevreul's theory of colour and on the experiments of Maxwell . . . to substitute optical mixture [juxtaposed dabs of unmixed colors] for mixture of pigments."[7] When Walter Pater wrote that the art of the nineteenth century tried to show subtle fields of magnetic force, he might have been talking about the paintings shown in Paris the year after *The Renaissance* was published.

But this image of the painter as a researcher in ophthalmic neurology is not easy to reconcile with the image of the painter as pure wild heroic eye, confronting reality without preconditions, without rule. Impressionism was, alas, from its very origin a method—a new and powerful method, to be sure, but not the simple truth of things. Truth is always someone's truth, and to reject the truths learned in art school—from the Canon of Polyclitus (concerning the ratio of limb length to body length in a statue) to the law of perspective—means that the artist must seek truths from other fields of inquiry. A grainstack might be better, or at least more intriguingly, conveyed by reconstructing on canvas the firing processes of the rods and cones of the retina than by quoting a traditional image of a grainstack; but Monet was just as dependent on a method as the Old Master was. The aesthetic law that governs artistic rules in every medium is this: *the rule created to persuade us that the artist is telling the truth will, if followed slavishly, erode the sense of truthfulness that it tries to enhance.*

Now that we've looked at some of the ideas that Impressionists used to justify their amental art, let's return to Renoir's *Moulin de la Galette* to examine the relation of theory to practice. Does this painting offer a truly Irregularist vision of reality? There are plenty of irregularly shaped objects, some of which are so irregular that they might be called mere blobs; but I think

that the objects are so little credible, so little tenable, so easily absorbed into fields of light and shadow, that you don't feel that you're transported into a picky world of sharp edgy things, but that you're transported into a liquifying, dissolute, swimmy world, in which only the familiarity and essential agreeableness of the scenery prevent you from drowning. The dark suits of the male dancers pressed tightly against the light dresses of the women are only a larger version of the dabs of dark and light created by the shadows of the leaves. It is Nietzschean less in the sense of the essay on truth and lies than in the sense of the Dionysiac: nothing has solid imagistic presence, but instead there is a breakdown of category—between light and illuminated object, between atmosphere and thing, between nature and man, as the stippling turns everyone and everything indifferently into dryads. Of course, in any painting, there is a certain unifying tendency, because everything in the painted field is made of paint; in previous centuries painters tried many tricks to differentiate human flesh and clothes from the background (by heaping the paint more thickly, or drawing with more detail, for example), but the Impressionists made sure that sky and face and rock all looked like various modalities of the same stuff. If older painters painted space, the Impressionists painted air—a sort of matrix that enfolds, encloses, half reveals, all the objects within it. Monet even went so far as to announce, "I want to paint the air which surrounds the bridge, the house, the boat: the beauty of the air."[8] They liked fog, haze, railway steam, smoke, whatever calls attention to the medium through which light passes before it reaches the eye—they were (to judge from pictures of them) mostly heavy smokers, as if they carried their own little cloud around with them. This search for smoke, for thickened air, for special effects of atmosphere, led the Impressionists both to the countryside and to the city.

Impressionism is often thought of as an outdoorsy sort of movement—after the invention of pigment contained in metal tubes, it became a great deal easier to set up your easel in the countryside and paint directly from nature, instead of the old way of sketching outdoors and then painting in a studio. Indeed, among the very first paintings of the new Impressionist school we find studies of haze, a blurriness in which it's very hard to pick out particular objects. The spectators found the first Impressionist exhibition (1874) of this smearing out of basic categorical distinctions—as in, for example, Monet's *Impression: Sunrise*—disturbing.

Monet himself wasn't quite sure how to describe what this painting was, since it so little resembled previous landscape paintings; as one contempo-

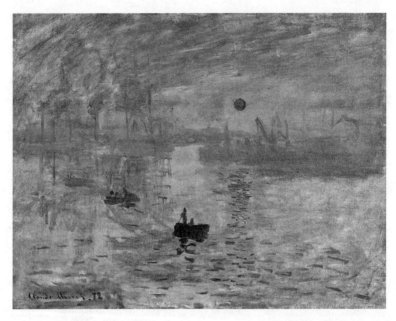

Claude Monet, *Impression: Sunrise* (1874) Album / Art Resource, NY

rary writer noted, "Monet later explained that he had selected for the exhibition a painting done in Le Havre from his window: the sun appearing in damp vapors, in the foreground a few shipmasts pointing. 'I was asked to give a title for the catalogue; I couldn't very well call it a view of Le Havre. So I said: "Put *Impression*." Indeed, the painting was catalogued as "Impression, Sunrise." ' "[9] This painting struck its first viewers as less a painting than a hasty unfinished sketch for some painting that never got painted. The seeming speed of its composition becomes a metaphor for instantaneity of perception: only a painting that looks slapped together in a few minutes can hope to show the undoneness of the world, the world before the mind sorts it into solid objects. One of the reviewers of the first Impressionist exhibition was starting to understand:

> The common view that brings these artists together in a group and makes of them a collective force within our disintegrating age is their determination not to aim for perfection, but to be satisfied with a certain general aspect. Once the impression is captured, they declare their role finished. . . . If one wishes to char-

acterize and explain them with a single word, then one would have to coin the word impressionists. They are impressionists in that they do not render a landscape, but the sensation produced by the landscape. The word itself has passed into their language: in the catalogue the Sunrise by Monet is called not landscape, but impression.[10]

It's clear that Castagnary was struggling to find an adequate vocabulary for this revolutionary art—revolutionary in both its aesthetic and its commercial aspect, since this exhibition had been organized by the painters themselves, a quite novel strategy in a country where exhibitions of painting had been controlled by the state; even such a counter-Salon as the Salon des Refusés of 1863 (Manet, Monet, Whistler) was itself a state-mandated exception to the state's authority, since it was set up by Napoléon III himself. Castagnary was remarkably sensitive to the strangeness of these newfangled paintings: when he spoke of the painters as "impressionist in that they do not render a landscape, but the sensation produced by the landscape," he understood the aesthetic with remarkable clarity.

Not all the spectators were as pleased as Castagnary; in a newspaper review that appeared the day before Castagnary's, Louis Leroy published a little dialogue between himself and an art student:

> I glanced at Bertin's pupil; his countenance was turning a deep red. A catastrophe seemed to me imminent, and it was reserved for M. Monet to contribute the last straw.
>
> "Ah, there he is, there he is!" he cried, in front of No. 98. "I recognize him. . . . What does that canvas depict? Look at the catalogue. 'Impression, Sunrise.'"
>
> "Impression—I was certain of it. I was just telling myself that, since I was impressed, there had to be some impression in it . . . and what freedom, what ease of workmanship! Wallpaper in its embryonic state is more finished than that seascape."[11]

Leroy saw only something drippy and incomplete—as if the canvas weren't a painting, but something preparatory to a painting. But that, of course, was the point: Monet was trying to approximate an act of preliminary seeing, what seeing is like before the mind has figured out what it is that the eye is looking at.

The extreme priority of the ocular over the cognitive is especially prominent in the paintings of Berthe Morisot, such as *Lady at Her Toilette*. The woman is staring into the mirror on the left, but the wallpaper also seems

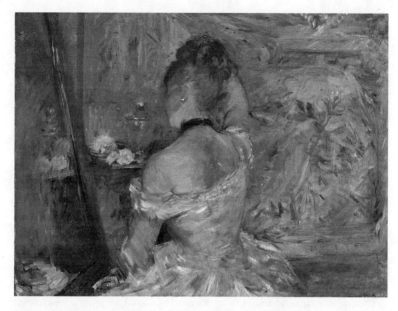

Berthe Morisot, *Woman at Her Toilette*, 1875/80, oil on canvas, 23 3/4 × 31 5/8 in.
(60.3 × 80.4 cm), Stickney Fund, 1924.127, The Art Institute of Chicago Photography
© The Art Institute of Chicago

to reflect her blurry dress in a still more blurred fashion. It is as if the wall
were the painter's palette, out of which the woman's image tentatively takes
distinct shape. Both the lady and the painter stare into a glass, darkly. This
woman seems an artifact of her own mirror: she's a flimsy creature, dwelling
in a purely ocular, specular reality. The Impressionist emphasis on the purely
visual tends to dematerialize the whole field of vision: it's hard to know
where Morisot's lady ends and the mirror or the wallpaper begins. Perhaps
Leroy was secretly right in thinking that Impressionist art is just wallpaper:
the whole canvas becomes background, for all finite figuration seems in dan-
ger of losing itself in a dapple or a whiteout.

There is a considerable tension between Morisot's advanced methods
and her prosaic subject matter. But if you want to devise a new representa-
tional method, you don't paint bizarre unrecognizable things, but the most
familiar stuff you can find. The weather in Impressionist paintings is usually
not too violent; the scenery, with the exception of Étretat (a coastal area full
of striking rock formations), not too dramatic; the narrative content, low;

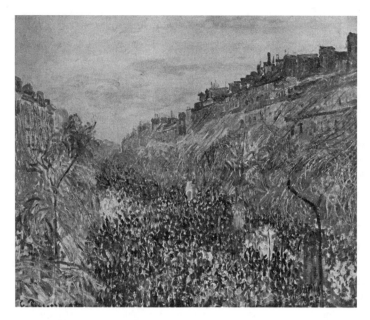

Camille Pissarro, *Mardi Gras on the Boulevards* Wikimedia Commons

the activities, mildly festive (racetrack, roller-skating, boating); the emotional content, somewhat restrained—scenes of wild weeping or laughter are rare, and bemusement and idle strolling common.

But, as I've said, it's important to regard the city as well as the countryside when considering these painters. Impressionism was the first artistic movement to concern itself with city life for its own sake—not for the sake of satire, or as background for a portrait or some religious theme, but just because cities are interesting. In the eighteenth century, painters such as William Hogarth spent a lot of life painting cityscapes, but usually to illustrate the moral degradation of the inhabitants, the squalor, the bad hygiene. But the Impressionist city tends to be recreational (as in *Moulin de la Galette*) or exhilarating. Maybe the Impressionist painting that gives the strongest sense, through purely pictorial means, of the gaiety and breathless excitement of city life is Pissarro's *Mardi Gras on the Boulevards*. The festive crowd is so small that you can't see what's going on, but the buildings themselves are full of a kind of elation. The streamers of confetti are depicted as curved streaks that dissolve the hard façades—the buildings whoop it up along with

the revelers. This is a painting that strongly confirm Baudelaire's thesis that Modernism is about cities.

Walter Pater

Part of the forward-looking, futuristic aspect of Impressionism is its preoccupation with contemporary science. As we've seen, the Impressionist painters looked to Chevreul and Maxwell for help in working out their refigurations of the visual field; literary Impressionists also took note of scientific discoveries to sharpen their sense of craft. The first major writer for whom the word *impression* was central to his understanding of art was the critic and Oxford don Walter Pater: he begins his 1873 book *The Renaissance* by quoting a famous definition of criticism and then subtly subverting it: " 'To see the object as in itself it really is,' has been justly said [in Matthew Arnold's "On Translating Homer," 1862, and "The Function of Criticism," 1864] to be the aim of all true criticism whatever; and in aesthetic criticism the first step towards seeing one's object as it really is, is to know one's own impression as it really is, to discriminate it, to realise it distinctly."[12] The distinction between object and impression-of-object may not seem important, but in practice this leads to an almost complete suppression or dissolution of the object, as well as a monstrous growth of sensuous tendrils, tentacles, from the space where the object used to be into the nervous system of the critic.

Pater thought that the older art criticism, and the older art itself, dealt with objects: it was governed by an Aristotelian/Newtonian physics in which the universe is understood as a collection of objects arrayed in space. But Pater's heroes were the new scientists, such as Michael Faraday and Hans Christian Oersted, who developed the principles of electromagnetism; along similar lines, Pater demoted the status of the object in favor of the field.

Pater liked to contrast his Impressionistic art criticism with that of the great eighteenth-century German art critic Johann Joachim Winckelmann. Winckelmann was fascinated by the art of classical Greece, which (as I've noted before) he described as *allgemein* (general) and *heiter* (serene). Pater agreed completely with this description, but, unlike Winckelmann, Pater thought that Greek art was somewhat inadequate because of its very generality and serenity:

Pheidias and his pupils [sought] the type in the individual, to abstract and express only what is structural and permanent, to purge from the individual all that be-

longs only to him, the accidents, the feelings and actions of the special mo-
ment. . . . In this way their work came to be like some subtle extract and essence,
or almost like pure thoughts or ideas. . . . But it involved to a certain degree the
sacrifice of what we call *expression*. . . . The beauty of the Greek statues was a
sexless beauty; the statues of the gods had the least traces of sex.[13]

But the modern world, Pater felt, needed a different sort of art, and a differ-
ent sort of criticism: Winckelmann's "conception of art excludes that bolder
type of it which deals . . . with life, conflict, evil. Living in a world of exqui-
site but abstract and colourless form, he could hardly have conceived of the
subtle and penetrative, yet somewhat grotesque art of the modern world."[14]
Despite the endless stream of glorious male bodies in Greek art, Pater found
it slightly eunuchoid; the Renaissance of Michelangelo or Luca della Robbia
anticipated the subtlety and penetrativeness—in other words, the sexiness—
of modern art. Pater juxtaposed Winckelmann's idea of Greek sculpture—
blithe, generalized, impersonal, monumental—to the fluent subtleties of
Luca della Robbia, who found the exact plastic equivalent for "the passing
of a smile over the face of a child, the ripple of the air on a still day over the
curtain of a window ajar," or to the finesse of Browning's poetry: "what a
cobweb of allusions, what double and treble reflexions of the mind upon
itself, what an artificial light is constructed and broken over the chosen situ-
ation."[15] If Greek sculptors based their work on strict numerical calculation,
della Robbia and Browning based their work on psychological vibrations in
the ether—Pater borrowed metaphors from electromagnetics to describe
the effect of modern art: "For us, necessity is not, as of old, a sort of mytho-
logical personage without us, with whom we can do warfare. It is rather a
magic web woven through and through us, like that magnetic system of
which modern science speaks, penetrating us with a network, subtler than
our subtlest nerves, yet bearing in it the central forces of the world."[16]

 As Pater puts in the famous passage at the beginning of the conclusion
to *The Renaissance*,

> To regard all things and principles of things as inconstant modes or fashions has
> more and more become the tendency of modern thought. Let us begin with that
> which is without—our physical life. Fix upon it in one of its more exquisite inter-
> vals, the moment, for instance, of delicious recoil from the flood of water in
> summer heat. [In other words, Pater has gone swimming.] What is the whole
> physical life in that moment but a combination of natural elements to which sci-
> ence gives their names? . . . Our physical life is a perpetual motion of them—the

passage of the blood, the waste and repairing of the lenses of the eye, the modi-
fication of the tissues of the brain under every ray of light and sound—processes
which science reduces to simpler and more elementary forces. Like the elements
of which we are composed, the action of these forces extends beyond us: it rusts
iron and ripens corn. . . . That clear, perpetual outline of face and limb is but an
image of ours, under which we group them—a design in a web, the actual threads
of which pass out beyond it.[17]

The human image all but vanishes in the network of forces that transpierce
it. Not only has the object fallen asunder into a heap of impressions, but the
subject that regards it has diffused into a loose shimmery nexus in the hectic
scamper of radiation through the universe. In Yeats's phrase, the swimmer
has turned into the waves.

Ford Madox Ford

Impressionism is a method well adapted to fiction and music as well as
painting. The best-known essay on this theme is Ford Madox Ford's "On
Impressionism" (1913), a chatty, diffuse, but nevertheless important piece
written by a distinguished novelist (best known for *The Good Soldier*, 1915).
Instead of defining Impressionism, Ford muses on it—the essay is itself too
Impressionistic to offer a solid statement of what Impressionism is. But it is
possible to tease out of it a coherent account:[18]

1. "Impressionism is a thing altogether momentary." Impressionist prose is
 temporally shallow: the writer does not pause to reflect in order to offer
 a nuanced, gradated picture of the object to be treated, but instead deliv-
 ers the thing as sense organs relay it at a given instant. Ford illustrates his
 point as follows:

 Sings Tennyson:
 "And bats went round in fragrant skies,
 And wheeled or lit the filmy shapes
 That haunt the dusk, with ermine capes
 And woolly breasts and beady eyes."[19]

 Now that is no doubt very good natural history, but it is certainly not Impression-
 ism, since no one watching a bat at dusk could see the ermine, the wool, or the
 beadiness of the eyes. These things you might read about in books or observe in
 the museum or at the zoological gardens. Or you might pick up a dead bat on the

road. But to import into the record of observations of one moment the observations of a moment altogether different is not Impressionism.

2. "Impressionism is a frank expressionism of personality." The method prizes idiosyncrasy, quirkiness, distortion, exaggeration: there is never any attempt to erode private truths into noncontroversial statements of fact.

3. Impressionism is polyphonic. Many different processes of thinking and perceiving are whirling around in the Impressionist's head at the same time, and the writer's task is to make these simultaneous mental operations co-present in the text:

It is . . . perfectly possible that a piece of Impressionism should give a sense of two, of three, of as many as you will, places, persons, emotions, all going on simultaneously in the emotions of the writer. It is, I mean, perfectly possible for a sensitised person, be he poet or prose writer, to have the sense, when he is in one room, that he is in another, or when he is speaking to one person he may be so intensely haunted by the memory or desire for another person that he may be absent-minded or distraught. And there is nothing in the canons of Impressionism, as I know it, to stop the attempt to render those superimposed emotions. Indeed, I suppose that Impressionism exists to render those queer effects of real life that are like so many views seen through bright glass—through glass so bright that whilst you perceive through it a landscape or a backyard, you are aware that, on its surface, it reflects a face of a person behind you. For the whole of life is really like that; we are almost always in one place with our minds somewhere quite other.

4. Impressionism is collage. Because the method stresses the momentary, literary Impressionism has a certain spatial and visual aspect: a given scene in an Impressionist text is to be apprehended all at once, as the eye apprehends a picture. Ford says that the Impressionist writer would like to

attain the sort of odd vibration that scenes in real life really have; you would give your reader the impression that he was witnessing something real, that he was passing through an experience. You will observe also that you will have produced something that is very like a Futurist picture—not a Cubist picture, but one of those canvases that show you in one corner a pair of stays, in another a bit of the foyer of a music hall, in another a fragment of early morning landscape, and in the middle a pair of eyes, the whole bearing the title of "A Night Out." And, indeed,

those Futurists are only trying to render on canvas what Impressionists *tel que moi* [such as I] have been trying to render for many years.

Because Ford is writing as late as 1913, he can derive his visual metaphors for literary Impressionism from art well beyond the ken of the Impressionist painters of the 1870s and 1880s. Cubism was about six years old, and Futurism was about four years old. For Ford, literary Impressionism is a forward-looking moment, not something indebted to Monet (still painting water lilies at Giverny at the time when Ford was writing).

Joseph Conrad

Ford Madox Ford's friend and sometime collaborator Joseph Conrad (and, by Ford's account, an Impressionist) also considered that his artistic method was informed by contemporary science. In 1898 he and some friends watched a demonstration of the newfangled apparatus the X-ray machine, invented by Wilhelm Röntgen three years earlier:

All day with the shipowners and in the evening dinner, phonograph, X rays, talk about *the* secret of the universe and the nonexistence of, so called, matter. The secret of the universe is in the existence of horizontal waves whose varied vibrations are at the bottom of all states of consciousness. If the waves were vertical the universe would be different. This is a truism. But, don't you see, there is nothing in the world to prevent the simultaneous existence of vertical waves, of waves at any angles; in fact there are mathematical reasons for believing that such waves do exist. Therefore it follows that two universes may exist in the same place and in the same time—and not only two universes but an infinity of different universes—if by universe we mean a set of states of consciousness; and note, all (the universes) composed of the same matter, *all matter* being only that thing of inconceivable tenuity through which the various vibrations of waves (electricity, heat, sound, light etc.) are propagated, thus giving birth to our sensations— then—emotions then thought. Is that so?

These things I said to the Dr while Neil Munro stood in front of a Röntgen machine and on the screen behind we contemplated his backbone and his ribs. The rest of that promising youth was too diaphanous to be visible. It was so—said the Doctor—and there is no space, no time, matter, mind as vulgarly understood, there is only the eternal something that waves and an eternal force that causes the waves.[20]

Like Ford, Conrad makes much of the word *vibration*: the human consciousness is a kind of tingling, and the purpose to art is to transmit that tingle as

accurately as possible to the reader. And like Ford, Conrad has a polyphonic understanding of the mind's operation; in fact, he goes much farther than Ford by speculating that reality is a polyphony of multiple and interpenetrating universes. (In 1901 Conrad and Ford cowrote a novel, *The Inheritors*, in which emotionless "Fourth Dimensionists" try to overrun the earth—a theme that, in later years, H. P. Lovecraft would find especially attractive.) In his fiction Conrad tries repeatedly to show the essential tenuousness and undularity of the physical world.

One year after he saw the bones of his own hand in the Röntgen machine, Conrad published *Heart of Darkness*, a book that dismantles many of the familiar structures of reality: when the universe turns fully diaphanous, you see through into its far side, a sort of inflected darkness. Of course, it isn't easy for a novelist to break down objects into pure vibration, primary sense data, in the way that Monet did—streaks and specks, a pattern of firing of the rods and cones of the retina. But it is possible, in prose, to record raw impressions of shape, color, glints and gleams of light, roarings and distant murmurs of sound. The Africa of *Heart of Darkness* is exceedingly deficient in recognizable objects, but exceedingly full of sense data, perceptions that blast or tease the spectator. The Impressionistic method allows Conrad to appeal to his readers with great sensuous immediacy but leaves the reader uncertain about how to constitute all these data into a definite world.

Conrad's landscapes are Impressionist in that they often struggle to present the eye's whole infinite field of vision, unimpeded by particularities. This effect can be seen even on the novel's first page:

> The sea-reach of the Thames stretched before us like the beginning of an interminable waterway. In the offing the sea and the sky were welded together without a joint, and in the luminous space the tanned sails of the barges drifting up with the tide seemed to stand still in red clusters of canvas sharply peaked, with gleams of varnished sprits. A haze rested on the low shores that ran to sea in vanishing flatness. The air was dark about Gravesend, and farther back still seemed condensed into a mournful gloom, brooding motionless over the biggest, and the greatest, town on earth.[21]

It is all very painterly: one can almost see the swirling brushstrokes in this panorama of sea and sky, and indeed expressions such as "luminous space," "red clusters of canvas," "gleams of varnished sprits," "haze," and "vanishing flatness" almost sound like cues to the painter. I imagine that Conrad was

thinking of the style of J. M. W. Turner, but the methods of Monet's *Impression: Sunrise* aren't far from the implied methods of this word-painting. Except for a few red triangles, the oceanscape has been swept bare of things; it is the perfect introduction to this objectless novel, this book that deconstructs, dematerializes the world into a few vehement expressive gestures.

Conrad's most Impressionistic device is his peculiar habit of refusing to name something until after he's described it—it's his way of imitating processes of cognition, where first you have raw sense data, and then you grasp at some idea that regularizes and classifies the sense data as a finite object. Consider, for example, the attack on the steamship: "Sticks, little sticks, were flying about—thick: they were whizzing before my nose, dropping below me, striking behind me against my pilot-house. All this time the river, the shore, the woods, were very quiet—perfectly quiet. . . . We cleared the snag clumsily. Arrows, by Jove! We were being shot at!"[22] The sticks stick around in Marlow's brain for a few sentences, until at last the long thin cylinders get recognized for what they are: arrows. For Marlow, for anyone, the passage from *stick* to *arrow* would take much less than a second; but in the distorted, elongated time frame of the attack, in which adrenaline stops the heart, stops time itself, the instant of recognition is agonizingly prolonged. We seem caught in a sort of epistemological caesura, in which the transformation of impression into knowledge seems indefinitely suspended. Monet spoke of trying to "see the world as a pattern of nameless colour patches—as it might to a man born blind who has suddenly regained his sight." In this sense, *Heart of Darkness* is a blind man's novel, a novel of color patches slowly acquiring names.

To offer one more example of this sort of deferred noun: Marlow raises his binoculars to study Kurtz's ruined compound in the jungle: "I made a brusque movement, and one of the remaining posts of that vanished fence leaped up in the field of my glass. . . . Its result was to make me throw my head back as if before a blow. . . . These round knobs were not ornamental but symbolic. . . . I had expected to see a knob of wood, you know. . . . There it was, black, dried, sunken, with closed eyelids—a head that seemed to sleep at the top of that pole."[23] Here Marlow/Conrad is consciously teasing us by deferring the noun, *shrunken head*, until we've reached a decent tingle of anticipation of the horror. Conrad is a master of suspense on every level: on the level of plot, he suspends the sight of Kurtz, the horrified and horrifying European who has enslaved the local populace, until we've stared

at a huge question mark for many pages; on the level of the sentence, he suspends the subject until we've traversed a lot of disturbing predicates.

Claude Debussy

Both Monet and Conrad emptied their work of content in the usual sense—ideas, recognizable objects, stories, characters—in order to fill their work with enigmas, with strangeness: fields of percepts that tease the mind without quite solidifying into the recognizable. A spatter of blurs and dots that resolve into a picture only as the spectator steps away from the picture; loose or torn-apart sentences that reconstitute themselves only with diffi-culty into the normal syntax of things—such are some of the methods for replacing the cooked, even predigested experience of most art with some-thing more raw, more ambiguous. Now we'll look at similar sorts of spatters, dots, loosenings, and rippings in the domain of music. Just as Monet's paint-ings sometimes constitute a sort of threshold space between intelligible form and a chaos of paint, so Debussy's music sometimes seems to take place in some liminal region between theme and clusters of notes that re-fuse to organize themselves into a theme.

Like the Impressionists, Claude Debussy was self-consciously progres-sive, avant-garde, and faced his share of uncomprehending reviewers. He was impatient with all the constraints and legalisms of textbook music and looked far afield to find new sonorities, new harmonies, new shadings of melody. Debussy liked to create soft umbras of seventh and ninth and elev-enth chords—harmony that functioned less as structural undergirding than as chiaroscuro. Such chords, with lots of notes distributed in thirds, tend to confuse the ear: if you play a C^{11} chord—that is, the notes C-E-G-B♭-D-F (you usually flatten the seventh to avoid a dissonance)—you've got a major triad in C, a minor triad in G, and a major triad in B♭ all stacked on top of one another, comfortably but unintelligibly coexisting. You don't know where it's going, because there's no natural way to resolve it; Debussy made a specialty of devising strategies of aimlessness, instead of the clear forward thrust esteemed in most previous music. If you harmonize a familiar tune with seventh and ninth chords, not to mention secondary melodies, it starts to sound vagrant, exotic, thickened, uncertain. The beginning of Debussy's comical piano piece *Hommage à S. Pickwick, Esq* (*Préludes* 2.9, 1913), for ex-ample, starts out as a resolute statement of *God Save the King*, but it quickly loses its way, turning into an image of good-hearted British blithering.

In his youth Debussy had visited Russia with Mme von Meck (Tchai-kovsky's patron) and found in Russian music some of the emancipation he sought: the songs of Modest Musorgsky, in particular, seemed to have no "established, one might say official, form," but consisted of "successive minute touches mysteriously linked together by mean of an instinctive clair-voyance." Debussy looked wherever he could to find an alternative to fixed, perhaps dead procedures of Western music. In 1889, Debussy heard a trav-eling Javanese gamelan (mostly percussive) orchestra and later evoked it on the piano in *Pagodes* (1903)—it's remarkable how uncanny, alien, it sounds.

His chief new resource, however, was not the exotic East but nature it-self. The chief procedure for incorporating nature into musical compositions is imitation of nature sounds, as when Beethoven imitates a nightingale, a cuckoo, and a quail at the end of the *Scene at the Brook* in his sixth sym-phony. But this has often seemed a cheap effect, rather than real music—Beethoven was embarrassed enough that he specified "more expression of feeling than painting," and Schopenhauer, who regarded music as the one art that could give a faithful account of Will, the single desiring subject in the universe that works through all living creatures, thought nature imitation the most meretricious sort of representation: "The music does not express the inner nature of the will itself, but merely gives an inadequate imitation of its phenomenon. All specially imitative music does this; for example, 'The Seasons,' by Haydn . . . also all battle-pieces. Such music is entirely to be rejected."[24] Nietzsche was sufficiently impressed by Schopenhauer's writ-ings on music that he quoted them at great length in *The Birth of Tragedy*.

But Debussy didn't look for truth in the actual sounds of birds and other nature phenomena; instead, he tried to use nature's constitutive processes to replace the rule book of old texts of harmony. One of Ezra Pound's he-roes, the American scholar of Chinese poetry Ernest Fenollosa, wrote that nature has no grammar, no parts of speech: "A true noun, an isolated thing, does not exist in nature. Things are only the terminal points, or rather the meeting-places, of actions, cross-sections cut through actions. . . . And though we may string ever so many clauses into a single compound sen-tence, motion leaks everywhere, like electricity from an exposed wire. All processes in nature are interrelated; and thus there could be no complete sentences (according to this definition) save one which it would take all time to pronounce."[25] Debussy in effect asked himself what music would sound like if it weren't articulated with cadences, half cadences, and other sorts of punctuation, but instead had the rhythmic sinuous dynamism of nature

itself. Debussy is sometimes called a composer of musical prose (indeed, he wrote in 1895 a song sequence called *Proses lyriques*), and the term is exact: if poetry is an imposed artifice, Debussy's music often aspires to a perfect ease of flow, in which recurrent elements are neither predictable nor startling.

Starting in 1901, the same year as the première of the *Nocturnes* as a complete sequence, Debussy started to work as a music critic for a little-read yet influential journal; here he tries to suggest obliquely what he wants as a composer. He ascribes his wisdom to one M. Croche—a name that suggests a certain crotchetiness, and which might be translated as Mr. Crooked or Mr. Eighth-note: it seems that through him music itself speaks. He hates the technical vocabulary of music, however; he speaks mostly through pictorial metaphors, for to Debussy a painting and a musical composition seem to be two aspects of the same project, the apprehension of the natural world.

M. Croche appears at the beginning as a kind of Buddha or oracle, and he immediately starts to indulge in musical pictorialism:

> Monsieur Croche was a spare, wizened man and his gestures were obviously suited to the conduct of metaphysical discussions. . . . He spoke almost in a whisper and never laughed, occasionally enforcing his remarks with a quiet smile which, beginning at his nose, wrinkled his whole face, like a pebble flung into still waters, and lasted for an intolerably long time.
>
> He aroused my curiosity at once by his peculiar views on music. He spoke of an orchestral score as if it were a picture. He seldom used technical words, but the dimmed and slightly worn elegance of his rather unusual vocabulary seemed to ring like old coins. I remember a parallel he drew between Beethoven's orchestration—which he visualized as a black-and-white formula resulting in an exquisite gradation of greys—and that of Wagner, a sort of many-colored "make-up" spread almost uniformly, in which, he said, he could no longer distinguish the tone of a violin from that of a trombone.[26]

The notion of Beethoven's exquisite gradation of grays is intriguing, since Debussy's earliest idea for the *Nocturnes* of 1899 (my principal example of musical Impressionism), way back in 1894, was for a set of pieces for solo violin and orchestra in which he divided the orchestra into separate sections, in order to find "the different combinations possible inside a single colour, as a painter might make a study in grey." Now, "study in grey" is a very Whistlerian sort of title—the famous painting at the Louvre we usually call *Whistler's Mother* is titled *Arrangement in Grey and Black* (1871)—and in

fact *Nocturne* is a very Whistlerian sort of title too: if Chopin wrote nocturnes for piano, Whistler liked to paint shadowy, vague, highly evocative night scenes, often with a restricted palette, just one or two colors.

The American expatriate painter J. M. Whistler was not exactly an Impressionist—he wasn't interested, as far as I know, in dots of pigment thought through in terms of complementary colors—but he did exhibit at the 1863 Salon des Refusés along with some of the painters that history would clearly label as Impressionists. If it may seem far-fetched to associate Whistler and Debussy, it is nevertheless exactly what Debussy's contemporaries did: after the successful première of *Nocturnes*, the composer Alfred Bruneau wrote, "Themes there are none in the ordinary sense of the word, but the harmonies and rhythms adequately transmit the composer's thought and that in the most original and striking manner. . . . They recall the strange, delicate, vibrating 'Nocturnes' of Whistler, and like the canvases of the great American painter, they are full of a deep and poignant poetry."[27] Neither Whistler nor Debussy gives much in the way of recognizable form; indeed, Debussy's themelessness seemed exactly correlative to Whistler's nearly empty fields of dim paint.

What does Debussy provide, if he doesn't provide themes, doesn't provide recognizable formal structures, such as sonata or rondo? The opening of *Sirènes*, the third nocturne, is a case in point: I know of no piece of music at once so languid and so urgent. At the beginning the horns seem to make great bird cries of desire (the sirens of antiquity weren't mermaids, but women on top and birds on the bottom), but it is an endless, insatiable desire—Odysseus's ship is never going to come to their rock. The music seems to have no particular sense of beginning or end: it doesn't drive toward a cadence; it simply elaborates the big waves with little waves, underpulses, in the way that the surge of surf on a beach falls into long rhythms of tide and medium rhythms of regular wave fall and short rhythms of little splashes at the end of the regular wave fall. It's hypnotic in that it's at once monotonous and infinitely varied. Part of Debussy's secret is that the piece is organized around the interval of the major second, an interval that has no particular harmonic tension, since it doesn't tend to fall into a triadic chord. A theme or pseudotheme composed of a single major second (and *Sirènes* is the apotheosis of the major second) has little melodic content (hence Bruneau's sense of themelessness); so Debussy makes elaborate fantasies of rhythm, subdividing his skips into oddly ligatured combinations of eighth notes and triplets—the rhythm, at once ambiguous and strong, can't be con-

strued as either a beat in threes or a beat in twos. In his program note De-
bussy says that this piece "depicts the sea and its countless rhythms"—and
in a sense the music is about countlessless.[28] In addition to these major-
second themes, we also hear, a little later, an oriental-sounding slither of
minor seconds. This snake-charmer theme is one of Debussy's sexier themes:
the conventions of harem-girl-music aren't always far away here. The sirens
are sirens not only in the Homeric sense but in the vaudeville sense.

The delicacy, the ravishment, the sense of a thousand minute touches of
light—Debussy's program specifies that *Sirènes* shows "the waves silvered
by moonlight"—all suggest Impressionist painting. And the first audience
heard exactly that: one reviewer (Jean d'Udine) called the *Nocturnes* a "de-
lightful impressionist symphony. It does not trace the sinuous outlines of
definite melodic curves, but its treatment of timbres and chords—its har-
mony, as the painters would say—maintains nevertheless a certain strict
homogeneity which replaces the beauty of line by the equally plastic beauty
of a sonority skilfully distributed."[29] On the other hand, the sense of re-
moteness in *Sirènes* is distinctly contrary to the aesthetic of the Impres-
sionist painters: the women's chorus sounds far-off; the music itself sounds
echoey, because of the superimposing of little pieces of the major-second
theme; and the classical subject matter is distant too—the Impressionist
painters didn't usually paint scenes from Homer or Apollodorus. If Impres-
sionism is about immediacy of impressions, *Sirènes* isn't very Impressionist
at all.

If there is a nocturne that has any sort of direct pictorial immediacy, it is
Fêtes, the second one, which begins loud and rhythmically intense. But it
may not be quite so immediate as it first seems, as Debussy's program may
indicate: "*Fêtes* gives us the vibrating dancing rhythm of the atmosphere
with sudden flashes of light. There is also the episode of the procession (a
dazzling fantastic vision) which makes its way through the festive scenes
and becomes merged with it. But the background remains persistently the
same; the festival with its blending of music and luminous dust participat-
ing in the cosmic rhythm."[30] Debussy told Paul Poujaud that *Fêtes* was a
reminiscence of old-time merrymaking in the Bois de Boulogne, with happy
crowds; the drum-and-bugle band of the Garde Nationale enters, beating a
tattoo, and vanishes. Debussy told Paul Dukas that the music of *Fêtes* was
based "on distant memories of a festival in the Bois de Boulogne; the 'ghostly
procession' [*cortège chimérique*] was . . . made of cuirassiers [heavily armed
cavalry]!"[31] There are two separate planes in this music painting: the festival

and the procession. The first plane, the festival, has certain elements of festivals as we know them: the tarantella-like rhythm of the opening theme is the sort of thing that strolling musicians might perform at a carnival, and the "sudden flashes of light" might evoke fireworks. There is a painting by Whistler, *Nocturne in Black and Gold: The Falling Rocket* (1875), full of "sudden flashes of light" and "luminous dust," exactly like Debussy's Nocturnes. This is the painting that led the art critic John Ruskin to accuse Whistler of "flinging a pot of paint in the public's face"; Whistler sued him for libel. Some listeners found Debussy as hard to understand as Ruskin found Whistler.

But Whistler's anti-Impressionistic character—a certain self-conscious artiness, artificiality—is present in the painting, as well as, I think, in the music of Debussy. When we come to Debussy's second plane, the procession, the feeling of aestheticizing distance becomes overwhelming. Note the uncanny throb of a low harp at the beginning—one of Debussy's most famous touches of imaginative orchestration. Debussy called this a "ghostly procession" based on distant memories, and the first critics strongly concurred: Pierre Bréville spoke of the "phantom-like impressions" he felt throughout the Nocturnes; d'Udine wrote, concerning *Fêtes*, of "fairy-like effects the light produces as it plays through the furbelows of the cirrus clouds"; Bruneau heard "the transient impressions of a dream."[32]

The Nocturnes may *allude* to music that you recognize, but they render such music dreamlike, phantasmagorical. No military band ever played anything like the processional march here: it modulates madly from A♭ minor to the very remote key of B minor. To understand more precisely just how dreamy Debussy's music is, we might compare it to a similar evocation of bands heard long ago, in Charles Ives's *Fourth of July* (1912)—Ives gives the effect of different brass bands playing different patriotic tunes simultaneously. Ives suggests that you're right *there* in the midst of cacophony; Debussy suggests that you're remembering or fantasizing a scene. In Ives all is (roughly speaking) in the foreground, whereas Debussy carefully separates foreground from background: the "cosmic rhythm" undergirds the procession. Debussy is pictorial; Ives is acoustic. To d'Udine, *Fêtes* seemed to evoke "dainty gavottes and rigaudons . . . the French taste of a century ago . . . the rustling dresses of [Watteau's] 'Embarquement pour Cythère'"—an old-fashioned world, as opposed to the contemporary evocation of Ives.[33] The *Nocturnes* are exercises in figuration from memory: as the despairing Debussy wrote to his friend Pierre Louys, "The three *Nocturnes* have shown the bad influence of my private life, first full of hope, then full of despair,

and then full of nothing! Besides, I've never been able to do what ought to be done while something has been happening in my life; I believe that's what makes memory such a superior faculty: you can pull out of it useful emotions—but those folks who weep while writing their masterpieces are implacable liars."[34] If Debussy isn't quite an Impressionist, still less is he an Expressionist; he works at a great distance from greatly stylized material. He wants real waves, real processions, but purified and made salient through imagination.

4 Expressionism

Value: Cut to the interior—human truth lies in the electroencephalogram.

The Origins of Expressionism

Expressionism entered the vocabulary of art criticism in 1910 by a Czech art historian, Antonin Matějček, who saw the movement as the opposite of Impressionism: "An Expressionist wishes, above all, to express himself. . . . [He rejects] immediate perception and builds on more complex psychic structures. . . . Impressions and mental images pass through his soul as through a filter which rids them of all substantial accretions to produce their clear essence . . . [and] are assimilated and condense into more general forms, into types, which he transcribes through simple short-hand formulae and symbols."[1] Expressionism, then, is distilled and internalized Impressionism: raw sense data concentrated into hieroglyphs, terse equivalents of psychic states. (And these hieroglyphs are symbols, though not quite in the Symbolist's sense, since they were original and improvised, not quoted from a dictionary of visual emblems.) Many Expressionist painters agreed with this definition. The first Expressionist school was called *Die Brücke* (The Bridge), soon followed by the *Neue Sezession* in Berlin and *Der blaue Reiter* (The Blue Rider) in Munich. *Die Brücke* derived its name from Nietzsche's prologue to *Thus Spoke Zarathustra*: "Man is a rope tied between beast and Overman—a rope across an abyss. . . . What is great in man is that he is a bridge."[2]

Die Brücke arose in 1905 at a *Jugendstil* (Art Nouveau) art school in Dresden led by Hermann Obrist; Obrist taught that the purpose of art was to give "a deepened expression and intensification of the essence, instead of a hasty impression." Ernst Ludwig Kirchner, one of its leading painters, spoke of his designs as "hieroglyphs in that sense that they represent natural forms

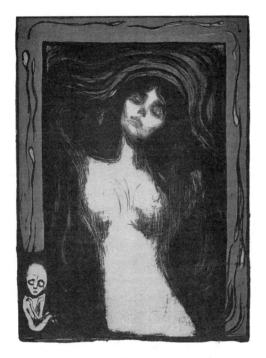

Edvard Munch, *Madonna* (1893-94) Digital Image © The Museum of Modern Art/Licensed by SCALA/Art Resource, NY. © 2015 The Munch Museum/The Munch-Ellingsen Group/Artists Rights Society (ARS), NY

in simplified, two-dimensional forms and suggest their meaning to the on-looker."[3] Instead of providing news of the look of the outer world, Expressionist pictures provide glimpses of the inner workings of the mind. Part of the character of Expressionist art can be understood from another aphorism of Nietzsche's: "Who struggles with monsters must see to it that he doesn't turn into a monster. And when you stare for a long time into an abyss, the abyss also stares into you."[4] Expressionist art depicts the patient gaze of the abyss into the deformed gibbering thing at the core of your being, the ape within.

The Expressionists, especially the artists of *Die Brücke*, sought their quintessences and intensities in the domain of the raw, abrupt, sickening. The outer world required some powerful dismantling. The idea of a progenerative fury, a sexual fury, that deforms or shatters all physical objects in order to produce images of its own intensity is strong in Expressionist art. The role

of sex is hard to exaggerate. Sometimes this is a flagrant show of a harsh, disturbing eroticism—an outthrust of vehement breasts and erect penises. We can see this in some proto-Expressionist works by the great inspiration of the Brücke artists, the Norwegian Edvard Munch, such as his *Madonna*. This painting's title leads us to expect, of course, the Virgin Mary and the Christ Child. But if this is Mary, she doesn't look virginal: she looks strung out, blasé, hollow eyed, sick; instead of a Christ Child, Munch gives us a withered fetus in the left-hand corner of the frame, with a comical little frowny face—how sad I am that my prostitute mother has aborted me. And around the painted frame there swim spermatozoa, suggesting just how maculate a conception this was. This is a deliberate act of destruction not just of the outer world but of the history of art: an act of blasphemy against Raphael, Bellini, Fra Angelico. The sacred image decomposes into reproductive physiology, into a spew of ejaculate.

Art, according to the Expressionists, should be about cutting to the core of the human—which might mean looking to African or Polynesian tribes, or might mean cutting the body open to see what's inside. The Expressionists found a number of tools for tracing the contours of the hidden feelings deep within us. The painful elongations and cavings-in of the painted figure—as if the human subject had been smashed in, or pulled apart on a rack—become a measure of psychic authenticity, visible signs of the internal stresses that bent it out of shape. A certain ghoulish pleasure in depicting skeletons or other oversimplified human forms is often manifest: Oskar Kokoschka used anorexic models "because you can see their joints, sinew and muscles so clearly, and because the effect of each movement is modeled more emphatically with them"; Kokoschka evidently considered the painter's gaze as something like an X-ray, as if naked feeling was best depicted through images of flayed flesh and bone.[5] Röntgen's invention of the X-ray created a certain anxiety; in Thomas Mann's novel *The Magic Mountain* (1924), set in a tuberculosis sanatorium, the young hero sees an X-ray of his hand and shivers—he is staring into his own grave.

The Expressionist everywhere promoted the idea of anatomy lesson, the idea of the knife. Sometimes the knife, as in a Kokoschka drawing we will see in a little while, appears as a theme; other times it appears as a technique—the Expressionists liked woodcuts because, as Ludwig Kirchner said, the sheer effort needed to cut the design into the block brought out energies in the artist not needed in the unstrenuous crafts of drawing and painting. You, the spectator, *feel* the strain of knife against wood: the im-

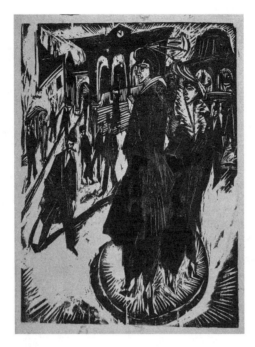

Ludwig Kirchner, *Women at Postdamer Platz* (1914) bpk Berlin/Staatliche Museen, Berlin, Germany/Joerg P. Anders/Art Resource, NY

plicit muscular effort is part of the aesthetic effort, a visible reminder of the sort of wound that the artwork seeks to inflict on the mind of the spectator. Few woodcuts stress the gash of the artist's knife quite as strongly as Kirchner's *Women at Postdamer Platz*, in which the women move like blades, seem to cut the city into chunks.

Sometimes Kirchner turns the knife against himself, as in *Self-Portrait as Soldier*. This was painted near the beginning of the Great War; Kirchner had enlisted in the 75th Artillery Regiment. On the painting's left there is a tilted canvas; on the painting's right is a standing nude—evidently suggesting that the contents of the soldier's thoughts are art and sex. The most striking thing, of course, is the amputation of the soldier's right hand, evidently just performed, since the stump is still raw. Kirchner's face is dead, expressionless, for expression seems to be a property not of the human countenance but of the whole environment: his blood seems to have seeped into the background, reddened it, made it ghastly with the dreams of sexual and

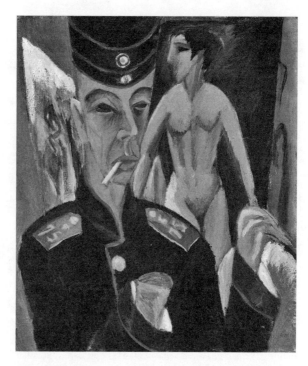

Ludwig Kirchner, *Self-Portrait as Soldier* (1915) Allen Memorial Art Museum, Oberlin College, Ohio, USA / Charles F. Olney Fund / Bridgeman Images

artistic conquest that this mutilated, even castrated being will never be able to perform. Ultimately Kirchner was a suicide: after his paintings were shown in a 1937 Nazi exhibition of degenerate art, he shot himself.

Sharp edges are everywhere in Expressionist art. Consider, for example, Erich Heckel's *Glassy Day*. The nude seems precariously posed in a bright but edgy landscape consisting entirely of shards of glass. The critic Donald E. Gordon has compared this picture to a passage by the philosopher of abstraction Wilhelm Worringer, who taught that abstraction and empathy are opposite tendencies—abstract is essentially life denying:

> Thus all transcendental art sets out with the aim of de-organicizing the organic, i.e. of translating the mutable and conditional into values of unconditional necessity. But such a necessity man is able to feel only in the great world beyond the living, in the world of the inorganic. This led him to rigid lines, to inert crystalline form. He translated everything living into the language of these imperishable and

Erich Heckel, *Glassy Day* (1913) bpk, Berlin / Art Resource, NY. © 2015 Artists Rights Society (ARS), New York / VG Bild-Kunst, Bonn

unconditional values. For these abstract forms, liberated from all finiteness, are the only ones, and the highest, in which man can find rest from the confusion of the world picture.[6]

The Expressionist is the friend of death in many ways: here Heckel seems to provide an ecstatic passage into human life remade into quartz.

Sometimes the Expressionist artist can seem to be a sort of hothouse simulation of a psychotic, flailing with knife or brush against the lies of bourgeois existence. One of the great heroes of the Expressionist movement is the London mass murderer Jack the Ripper, whose way of carving up his victims appealed to the movement's surgical quality. Frank Wedekind's play *Lulu* (1913, but assembled from two earlier plays of 1895 and 1902) tells the story of an irresistible seductress who descends from wealth into street prostitution and is finally murdered by Jack; a Berlin revival, in fact, led to George Grosz's painting *Jack the Ripper*. (Jack would eventually

George Grosz, *Jack the Ripper* (1918) bpk, Berlin / Hamburger Kunsthalle, Hamburg, Germany / Elke Walford / Art Resource, NY. Art © Estate of George Grosz / Licensed by VAGA, New York, NY

find lasting homes in G. W. Pabst's 1929 film *Pandora's Box* and in Alban Berg's 1935 opera *Lulu*.) Here Jack comically scuttles away, through an urban space full of bad angles, from a body as luscious and sexually inviting as a nearly decapitated and disarmed woman can be. Grosz tended to identify himself with even the most repulsive characters in his art; and in the same year, 1918, he photographed himself dressed up as Jack the Ripper with his model Eva Peter (soon to be his wife) as the victim.

Expressionism in Music

Alban Berg, whose operas *Wozzeck* and *Lulu* both concern knife murderers, was a pupil of the great Expressionist composer Arnold Schoenberg. To introduce Schoenberg, I'd like to digress for a moment to the Schoenberg of science, Albert Einstein.

The period from about 1905 to 1913—just before the Great War—was probably as productive in the development of the arts and sciences as any decade in history. In physics, Einstein published his paper on special relativity in June 1905, showing that luminiferous ether is a completely unnecessary hypothesis, and that the speed of light is always the same, no matter what the inertial frame; in September 1905 he published a very short paper noting that $E = mc^2$. Now many historians of science think that the special theory of relativity was no great breakthrough, in that Lorentz and Poincaré had already figured out most of the equations and most of the ideas—Einstein put together something that was already there. On the other hand, the theory of general relativity was, and still remains, a matter of general astonishment, since it reassembled the universe in a new way. Its first inklings came to Einstein in 1907, when he hit upon what he called the happiest thought of his life, the idea that if you fall from a roof you don't experience gravity, at least not until you hit the ground. This led him to formulate the equivalence principle: "we shall therefore assume the complete physical equivalence of a gravitational field and the corresponding acceleration of the reference frame."[7] From this followed many things, such as the fact that light should be bent by gravity. However, Einstein couldn't think of a way to measure this infinitesimal bending until 1911, when it occurred to him that astronomers ought to be able to measure something too small to observe on earth; it wasn't until 1915 that Einstein figured out that an old puzzle concerning unexpected deviations in the orbit of Mercury suddenly made sense according to his theory of gravitation. In the end, Einstein left space itself looking vastly altered: instead of the gleaming emptiness of Newtonian space, through which stars and planets moved unimpeded and silent, there was a new kind of space, elastic, tattered, full of bulges and distensions of all sorts. The sun operates as a big funnel in space into which the solar system tries to fall.

Is there anyone of Einstein's weight in the field of the prewar arts? A few candidates propose themselves from this period: Picasso as the developer of Cubism; Stravinsky as the composer of *The Rite of Spring* ("I am the vessel through which *Le Sacre* passed," Stravinsky once wrote, as if the ballet were less written than transubstantiated inside him); Proust as the author of *Swann's Way*, which appeared, like *The Rite of Spring*, in 1913 (Proust seemed capable of making finer dissections of the fabric of conscious thought than any previous novelist). But to my mind the one artist who made a breakthrough as radical as Einstein's was Arnold Schoenberg. Eventually some-

one would have written potent concert music that lacked a tonic, but I'm pretty sure that Schoenberg vastly accelerated this process. In some ways Schoenberg's reconstitution of musical space was just the opposite of what Einstein did in physical space: Einstein showed that everything in the universe was relative to the speed of light, as if he were promoting the speed of light into the universe's general tonic, its middle C, in both the physicist's and the musician's sense of c; Schoenberg removed any principle of orientation and left musical space oddly indifferent to the notes that occupy it. Instead of finding a principle of gravitation, Schoenberg removed one—a change every bit as radical as what Einstein did in physics.

Schoenberg was also like Einstein in that he transgressed into taboo regions. Einstein never won a Nobel Prize for relativity: he received the prize in 1921 for his work on the photoelectric effect. He couldn't even persuade Hendrik Lorentz that there was no such thing as ether and no such thing as universal simultaneity—and Lorentz was the man who had worked out the equations that describe the changes in length and mass as a body approaches the speed of light! If there's anything you want to defend, it's your idea of what space and time are: nobody wants to live in a universe where clocks necessarily tell different times, and you get a little thinner and a little heavier every time you get up from your desk and start to walk. Similarly, not many musicians greeted with pleasure the notion that, in the world of music, everything was permitted. Musicians since the beginning of time have been confronted with an almost endless list of *thou shalt not*s, a list that became so elaborate that, around 1702, some fifty-seven musicians contributed to an anxious discussion because a Spanish composer named Francisco Valls had used an unprepared ninth in a setting of the Catholic mass. But then Schoenberg comes along, and instead of saying *Thou shalt not*, he says *Do it*. Debussy's M. Croche urged composers to get rid of all the book rules, and Debussy did indeed violate many rules. But there were many rules that Debussy consciously or unconsciously followed, including the prime directive of music, that a composition should have a tonic.

Schoenberg's music, however, reached such a pitch of anarchy between 1907 and 1913 that musicologists are still trying to puzzle out how he went about doing what he did. Later in life Schoenberg wrote an opera about Moses, reasonably enough, if we remember that Moses not only received the table of *Thou shalt not*s on Mount Sinai but also smashed them when he came down. This shattering of stone tablets is the climax of Schoenberg's 1930-32 opera. The taboo against nontonal music didn't make itself explicit

until after Wagner's *Tristan und Isolde*, which permitted listeners a glimpse at a post-tonal world; before that, no one needed to defend tonality, any more than a fish needs to defend the virtues of water. Wagner's father-in-law, Franz Liszt, wrote near the end of his life a *Bagatelle without Tonality* (1885), but this piece sounds nothing like Schoenberg's music, mostly because the chord formations themselves are fairly normal, even though they leap about spasmodically from key to key—you feel caught on a sinister whirligig that spins you round and starts and stops abruptly. It's good to note that the original title of this piece was *Mephisto Waltz No. 4*—so we see that when you lose a clear tonal center you have put yourself in the arms of the Devil. Schoenberg was a profoundly religious man—though he was first a Jew, then a Protestant, then (when Hitler seized power) a Jew again—and he conceived his novel way of writing music as an expression of the divine. It was his odd role as a composer to adapt the musical tropes associated with the Devil—dissonance, rupture, inconsequence—to the depiction of God.

There is every reason to think that Schoenberg developed his atonal (he preferred the word *pantonal*) style in order to find a music appropriate to mystical (Swedenborgian, theosophical) visions of the divine. One of his first forays into atonality occurs in his second string quartet (1907-8), an unusual quartet in that the third and fourth movements contain a part for soprano; the fourth movement sets a Symbolist poem by Stefan George, *Entrückung* (Rapture). In Schoenberg's words, it "begins with an introduction, depicting the departure from earth to another planet. . . . Becoming relieved from gravitation—passing through clouds into thinner and thinner air, forgetting all the troubles of life on earth—that is attempted to be illustrated in this introduction."[8] We hear the whole medium of music detaching itself from the gravitational field of the tonic and entering the new planet, the planet without inertia—when the soprano enters, she first sings, "I feel air from other planets." The poem ends with the poet's absorption into God: "I am only a spark of the holy fire."

But the new style was well adapted not only for imaging heaven but for imaging that other new planet, the Freudian unconscious. These themes perhaps first appear in Schoenberg's paintings—Schoenberg's work as a painter was much admired by Wassily Kandinsky, and he enjoyed close relations with Kandinsky's Blue Rider school. His paintings were often obsessive self-portraits, sometimes literal depictions, sometimes what he called inner visions, as in *The Red Gaze* (1910). Here the eyes are pools of blood—perhaps

Arnold Schoenberg, *The Red Gaze* (1910) © 2015 Belmont Music Publisher, Los
Angeles/ARS, New York/Bildrecht, Vienna

the face of a man who has looked into the abyss, perhaps the face of the
abyss itself. This painting seems to be a scream made pictorial—in fact, it
may have been influenced by Edvard Munch's famous *The Scream of Nature*
(1893).

Schoenberg's nontonal musical compositions also seemed to find musi-
cal equivalents for Symbolist transcendence or for registers of feeling never
before reached: the sound keys that induced the listener to convulsions of
the brain. As the musicologist Theodor Adorno brilliantly put it,

> The passions are no longer feigned, but are registered in the medium of music as
> undissimulated, incarnate impulses of the unconscious, without calculation. . . .
> The first atonal works are session-notes in the sense of a psychoanalyst's session-
> notes on a patient's dreams. In the first book published on Schoenberg, Kandin-

sky called Schoenberg's paintings brain-acts [*Gehirnakte*]. The scars of that revolution of expression, however, are the blots which have fixed themselves, in the music as well as on the paintings, as the messengers of the id against the composer's will—blots that disturb the surface and can no more be wiped away by subsequent correction than the traces of blood in the fairy tale.[9]

Adorno was particularly struck by Schoenberg's *Erwartung* ("Expectation," 1909), an opera for one singer, the Woman: haunted by the moon, haunted by the memory of her faithless lover, she strolls alone in a forest close to an inhabited street; she comes upon a corpse, perhaps the corpse of her lover, and utters a long, psychiatrically detailed complaint; but the audience never knows whether she mistakes a log for a corpse, or she really finds a corpse, or she killed her lover and has forgotten she did it, or the whole monodrama is stark hallucination. Adorno felt that the disturbances in the woman's brain—the electrical stimulations that produce slow dread, quick horror, epileptic fury—found an exact embodiment in the music: the music was not an image of feeling, but feeling itself, made audible. (There's a faint echo here of Schopenhauer's notion that music shouldn't try to copy things, since music is a direct embodiment of the Will itself.) The absence of a tonic corresponded to the absence of conscious mental control; the forbidden intervals in the chords and melodies corresponded to the naked confrontation with taboo; the emancipation of dissonance corresponded to a filling out of the full spectrum of human emotion.

The title *Erwartung* seems ironic: the German word means "expectation," but, since the music provides the listener with no predictive structure, expectation becomes a free-floating anxiety. The text—by an Austrian medical student, Marie Pappenheim—was evidently a rough draft that Schoenberg decided to set without further polishing; its rawness, its unevenness, its lack of syntactical control may have seemed the literary equivalent of the encephalographically lurching music that he wanted to write.

The text's shattered, splintery sort of diction helped him investigate form at a level of improvisation almost unprecedented in the history of the arts. Schoenberg chose a text so maimed that it seems already the victim of some ghastly avant-garde surgery, too debilitated to offer any resistance to the music. If, as Nietzsche thought, the text belongs to the realm of Apollo and music to the realm of Dionysus, then Dionysus has almost completely overcome Apollo. The text of *Erwartung* is all ellipsis; and the music of *Erwartung* is even more elliptical, in that it omits all the transitions that might

soften or condone the strange successions of chords full of major sevenths, or the melodic spikes that seem to represent pathological contractions of the heart through pathological contractions of the larynx.

Marie Pappenheim was a relative of Berthe Pappenheim, the woman known to history as "Anna O.," the hysteric whom Freud described in a famous case history. She was the patient not of Freud but of his collaborator Joseph Breuer; Freud's account of her hysteria, in "Five Lectures on Psychoanalysis," includes the following description:

> She fell into a waking dream and saw a black snake coming towards the sick man [her dying father] from the wall to bite him. (It is most likely that there were in fact snakes in the field behind the house and that these had previously given the girl a fright; they would thus have provided the material for her hallucination.) She tried to keep the snake off, but it was as though she was paralysed. Her right arm, over the back of the chair, had gone to sleep, and had become anaesthetic and paretic; and when she looked at it the fingers turned into little snakes with death's heads (the nails).[10]

Similarly the Woman in *Erwartung* keeps feeling, especially in scene 2, that some unknown thing from the forest is dangling down or crawling up to touch her:

> (*bends down, feels with her hand*) Is this still the path? It's level here.
> (*crying out*) What's that? Let go!
> (*trembling, trying to look at her hand*) Am I caught? No, something crawled . . .
> (*wild, grabs her face*) And here as well . . . Who is touching me?

Hysteria comes from the Greek word for *womb*, and hysteria was considered a uterine disease—even by Freud, in a sense, in that repressed sexual urges, leaking out in fantastical surrogates of sexual acts, were considered its cause. (In fact, Breuer discontinued his treatment of Anna O. when he found her on the floor pantomiming the act of giving birth; she told Breuer that he was the father of her imaginary child.) Marie Pappenheim may have conceived the Woman of *Erwartung* as a sort of talking womb, a naked quivering organ, infinitely sensitive without much in the way of sensory apparatus except the sense of touch. Everything around her is vague and dripping and wants to violate her. Lost in the body's depths, time means nothing to the Woman: the past and the present, the real and the fantastic, all coexist inextricably. The music should also give this impression: Schoenberg remarked that *Er-*

wartung represents "in *slow motion* everything that occurs during a single second of maximum spiritual excitement, stretching it out to half an hour."[11] It is a study of time expansion in the domain of Schoenbergian relativity. The whole thing is one short scream made interminable.

In his "Beethoven" essay, Wagner wrote that the scream was the basis of every musical act: "We consider the scream, in all the attenuations of its vehemence, down to the tenderest lament of longing, to be the fundamental element of every human declaration to the ear . . . the will's most immediate utterance of all."[12] Wagner's essay is the basis of Expressionism as movement in music, since, for Wagner, expressions of rage, of misery, even of tender love were all merely weakenings of the scream. The *Tristan* chord, then, is just a soft scream alluding to a hard scream. It was Schoenberg's gift to present the primal scream in unusually pure form.

The history of the scream is one of the good stories of Modernist music. One fine example occurs at the climax of the adagio of Mahler's Tenth Symphony (left unfinished at his death in 1911): a huge lacerating chord in which appear nine of the twelve notes of the chromatic scale. (It is a powerful stimulus to fantasy: in Ken Russell's film *Mahler* this chord illustrates the bursting into flames of the little hut in which Mahler wrote his music.) Schoenberg also evidently conceived of expressivity as being intense to the degree that it approximated the fullness of the chord in which all notes are sounded. Not every musicologist agrees with Charles Rosen, who argues, following Adorno, that the "atonal" Schoenberg redefined consonance as *chromatic saturation*, so that the chords of *Erwartung* tend to succeed one another complementarily—a sequence of chords will contain all twelve notes of the chromatic scale. It is true, however, that if you look at successive chords in *Erwartung*, the notes in one chord tend to be (sometimes) exactly those that are missing from the previous chord, so that the sequence of chords seems to be struggling to add up to the big chord that has all the notes at once. Adorno thought that this sort of complementary harmony provided an analogue to the tension and release of traditional harmony: each note, each chord, strives to lose itself in the total aggregate smash of sound. Adorno, furthermore, thought that this principle destroyed any sense of forward movement in time; so it makes sense that the whole opera is a single amplified second, since it isn't built on the sort of musical structure that allows for leisurely and articulate discourse. It's music that tries to abolish its own temporality.

Perhaps we can see this by looking at two passages, at the beginning and the end of this monodramatic opera:

(*hesitantly*) In here? You can't see the path . . .

How silvery the trunks shimmer . . . like birches

(*looking intently at the ground*) Oh, our garden. The flowers for him are surely withered . . . The night is so warm.

(*suddenly anxious*) I'm afraid . . .

(*listens to the forest, oppressed*) How heavy the air that's coming . . . Like a storm, standing still . . .

(*wrings her hands, looks behind her*) So horribly calm and empty . . . But here at least it's bright . . .

(*looks up*) Earlier the moon was so bright . . .

(*crouches, listens, looks in front of her*) Oh, always the cricket, with its lovesong . . . Don't speak . . . it's so sweet beside you . . . The moon's twilight . . .

(*irritated. turns toward the forest. hesitating, then violently*) You are a coward, don't you want to search?

The quick changes between the lyrical and the angry are part of the proto-col of madness music, going as far back as the sixteenth century: a mad-woman doesn't inhabit a single inertial frame, one might say, but is going in several directions at the same time. But it's not just that the music is scarily quick to respond to changes of mood, instantly responding when she ac-cuses the moon, or herself, of cowardice; it's also that *Erwartung* can be understood as a prolonged teasing out of music's id, the huge shifting sound blot that lurks under all the rules and regulations that govern polite dis-course. The music takes us into a realm of distorted sound images lurking beneath what we actually hear: among what Adorno calls actual notations of symptoms of unconscious forces, shocks, and traumata, you can her feathery pulse, the ringing in her ear, the eccentric trilling of something loose and about to fall, the chirps of crickety things, the low gurgling of blood from an artery in her brain.

The end is the most remarkable thing in the score. There are no chords in *Erwartung* that actually contain all twelve notes of the chromatic scale, though such a chord does appear in Schoenberg's next opera, *Die glückliche Hand*; nevertheless, *Erwartung*'s ending goes far to prove Adorno's and Rosen's idea that this sort of atonal music is always moving toward chro-matic saturation:

> Your kiss like a fiery sign in my night . . . My lips burn and shine . . . toward
> you . . .
> (*crying out in rapture*) Oh, are you there . . .
> (*toward something*) I searched . . .

There is nothing I know more astonishing than that final bar, in which the
runs of notes up the chromatic scale keep getting faster and faster and qui-
eter and quieter, until they shiver away in a whisper—an effect that corre-
sponds to the twelve-note smash chord as absence corresponds to presence.
With its upward inflection, it's the apotheosis of the question mark—as if
the whole system of expressive devices in music were calling itself into
question. In seventeenth-century Roman oratorio there was a minor musi-
cal genre called the *vanitas*, in which the text and the music urged the lis-
tener to regard everything we value in the physical world as emptiness—
vanitas vanitatum, as the book of Ecclesiastes has it. In one such piece, the
composer Giacomo Carissimi inserted odd silences, as if the vanishing of
the music corresponded to a more general vanishing; Schoenberg's strange
ending suggests a sudden reversion to psychic emptiness, the bursting of
the mind's bubble, a general loss of function at the end of this half-hour-long
instant of time.

Erwartung rested in Schoenberg's drawer for fifteen years—nobody
heard the music until 1924. In 1930 Schoenberg wrote a letter to the super-
intendent of the opera with his thoughts about the stage set appropriate to
Erwartung:

> It is essential for the woman to be seen always *in the forest*, so that people realise
> that she is *afraid of it*!! For the whole drama *can* be understood as a nightmare.
> But for that very reason it must be a *real* forest and not merely a "conventional"
> one, for one may loathe the latter, but one can't be afraid of it. . . . I have no liking
> for what is called 'stylised' decorations (what style?) and always want to see a set
> done by the good old experienced hand of a painter who can draw a straight line
> straight and not model his work on children's drawings or the art of primitive
> people.[13]

Schoenberg wanted *Erwartung* to be shown not as a witty adaptation of a
dream but as an actual induction into nightmare. (The modern computer
simulation of "virtual reality," which blocks out external stimuli and fully
engages the eyes and ears in fictitious experiences, might have been much
to Schoenberg's taste.) The trees should look like trees. Take, for example,

Arnold Schoenberg, *Erwartung*, scene 3 Used by permission of Belmont Music Pub-
lishers. © 2015 Belmont Music Publisher, Los Angeles / ARS, New York / Bildrecht,
Vienna

Schoenberg's designs for scene 3: the Woman seems to project a spectral
emanation floating between the light and the dark, perhaps the conscious
and the unconscious.

Expressionism in Literature

Expressionism made its strongest play in painting, music, and cinema (as
in Robert Wiene's 1920 film *The Cabinet of Dr. Caligari*, in which the camera
sees a paranoid world in which shadows keep encroaching on walls that jut
out at bad angles), but there is some significant Expressionist literature as
well, such as Oskar Kokoschka's *Murderer, Hope of Women* (1907), by some
accounts the first Expressionist play, a black fable in which murder seems
the only way in which males can rid themselves of the power that women
exert over them.

Kokoschka's play seems influenced by the misogynistic philosophy of
Otto Weininger's *Sex and Character* (1903). Weininger was perhaps the most
precocious scholar since Nietzsche, widely read in biology, philosophy, and
the literature of several languages; he was also an anti-Semite of Jewish ori-

gin who, at the age of twenty-three, in 1903, staged his suicide at the house where Beethoven died. Perhaps Weininger's book might be called Expressionistic philosophy: it argues that maleness is essentially spiritual, antimaterialistic, pure, but that maleness suffered a fall when it was tempted by sensuality. This fallen manhood created woman, to embody and express its evil, to revel in it. Femaleness is therefore a contingency and an inauthenticity; a virtuous man will have nothing to do with women and will certainly never stoop to procreation. Women are fundamentally filthy creatures, who have no interest in anything except phallus worship and sexual intercourse. Weininger concludes his book with a recommendation of universal chastity, in the hope that the biological extinction of the human race will lead to its reunion with the spiritual One, lost so long ago when we descended to coarse material existence. The whole book, garish and overtechnical, suggests what Expressionist nausea would look like, translated into the world of intellectual debate.

There are two points in *Sex and Character* which touch closely on Kokoschka's play. The first lies in Weininger's sense of the deep ferocity of sex: "All sexual urge is related to cruelty. The 'association' has a deep foundation. Everything born of a woman must die. Birth and death stand in an indissoluble relation. In the presence of untimely death the sex drive awakens most violently in every being, as the need to propagate itself. And so coitus, not only psychologically as an act, but also from an ethical and scientific viewpoint, is related to murder: . . . Love is murder."[14] The second lies in Weininger's conclusion concerning the ultimate formlessness and nonentity of women. For Weininger, women aren't even evil, since they lack any sort of decisive interior lives: "Women have no existence and no essence, they *are* not, they are *nothing*. . . . Woman has no relation to idea, she neither affirms it nor denies it: she is neither moral nor anti-moral . . . neither good nor evil, neither angel nor devil. . . . Woman is a lie."[15]

Kokoschka's play is an allegory of coition, from a Weininger-like point of view. Sex is an act in which the Man tries to brand the Woman with a hot iron, thereby establishing ownership (this branding occurs onstage); it is also an act in which the Woman tries to kill the Man, drink his blood, incorporate his force. Sex is also a game of mutual imprisonment, torture, and general cramp of being: at one point the Woman locks the Man behind the lattice gate of a tower, and she seems to triumph over him, but in fact it is she who grows weaker and weaker, until the Man tears the gate open and kills everyone like flies. In sexual intercourse a man confronts the formless

horror of biological existence; the murderer is the only hope of women, and the only hope of men too, for the Woman must be destroyed if the Man is to achieve freedom and purity of being. A man can hope to escape; a woman, being nothing to begin with, can only hope to be annihilated.

Kokoschka regarded human sexual relations as a raw wound; his play attempts not to heal it but to tear it open further, by using every resource of various arts—painting, speech, and bodily movement—in order to maximize sensation. The intended dramatic effect may be seen in a drawing Kokoschka made for the play: a man stands on a fallen woman, his foot half covered by her fat breast, his hand clenching a dagger; the woman's hand, more lobster claw than hand, seems to be groping for the man's groin. Both large figures, as well as the scrawny dog behind them, are drawn with vehement cross-hatchings, as if the musculature and nerve structure were popping through the skin. It seems that men and women come together for the sake of flaying one another. Those interested in further investigation of Expressionist music might enjoy hearing the short opera that Paul Hindemith wrote in 1919, setting the revised text of *Mörder, Hoffnung der Frauen* to music, full of bitonal chords and fanfares of pain.

Franz Kafka, though in no way eager to affiliate himself with the Expressionists, was in some ways the greatest of the Expressionist writers. He belongs to the world of Expressionism in its preoccupation with histrionic displays of extreme states of feeling—Kafka's art is a sort of theater of dissonance. It may seem odd to speak of the theater in connection with a fiction writer, but in fact the theater was an ongoing preoccupation of Kafka's: though he was born into the well-to-do, mercantile, German-speaking, secular Jewish circle of Prague, Kafka was fascinated by the Yiddish theater and made a serious, though finally unsuccessful, effort to write plays. His fiction is so visually intense and so full of *coups de théâtre*—a father who sentences his son to drowning, a man who wakes up as an insect, a machine that cuts messages into the human body—that it seems like drama translated into novella. Kafka's themes may also remind us of Expressionism: mutilation, loss of self-control, concentration on the general ickiness of things (rotten apples, oozing brown slime, life in the garbage bin).

On the other hand, Kafka doesn't accept the central premise of Expressionism, that extreme states of feeling constitute a value in their own right—extreme states of feeling are the site of authenticity of being. Kafka is profoundly skeptical about the value of extreme states of feeling, just as he is profoundly skeptical about the value of every aspect of the physical world.

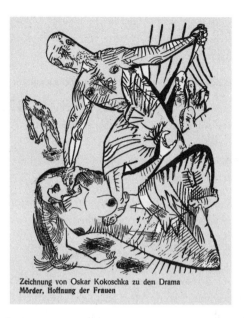

Zeichnung von Oskar Kokoschka zu dem Drama
Mörder, Hoffnung der Frauen

Oskar Kokoschka, design for *Murderer, Hope of Women* akg-images. © 2015 Fonda-
tion Oskar Kokoschka / Artists Rights Society (ARS), New York / ProLitteris, Zürich

Kafka was attracted to Gnosticism, that old belief that the physical world
is hopelessly corrupt, made by an ignorant and incompetent creator, and
that the only hope for us is to sift out those few sparks of spiritual light that
lie buried in the heavy, wretched material world. The abstractionist Kandin-
sky (as we'll see in a while) thought that nonrepresentational forms could
realize this spiritual light precisely because, not being representational, they
weren't contaminated by matter. But Kafka knows no such simple solution
for threshing out the spiritual from the material. Some of Kafka's maxims
reveal the almost complete hopelessness of finding anything genuine in the
opaque and deceptive world in which we live:

> There is nothing but a spiritual world; what we call the world of the senses is
> the evil in the spiritual one. . . . In the strongest light one can see the world
> dissolve.

> The whole visible world is perhaps nothing more than a motive-hunting of a man
> seeking peace for a moment.

For all things outside the world of the senses language can be used only sugges-tively, but never as even an approximate term of comparison, since like the physi-cal world itself it only concerns possession.

There is a goal, but no way; what we call the way is a hesitating.

It would be conceivable that Alexander the Great, despite his early success in war, despite the excellent army that he had trained, despite the world-transforming strength that he felt within him, would have remained standing at the Hellespont and never crossed it, not out of fear, not out of indecisiveness, not out of weak-ness of will, but out of the weight of the earth.

What is called suffering in this world is, without undergoing any change, except that it is freed from its opposite, bliss in another world.[16]

The entire universe available to your senses is false, unreal, corruptive; and there is no escape. This exitlessness explains why Kafka's stories often take place in small rooms or even cages in a zoo: the protagonist has to find some means of enlightenment, some "strongest light" in which the cage will de-construct itself, manifest its essential unbeing. Kafka felt that language is compromised by its referential, materialistic character—at best language could shadow forth some glimpse at the corner of vision of what is beyond the physical world. Thus, Kafka continually provides his readers with theat-rical spectacles in which the stage—the whole world of the fiction—tries to dematerialize itself, manifest its rickety, flimsy, two-dimensional, purely artificial quality.

Perhaps Kafka's closest approximation to Expressionism is *In the Penal Colony* (1914). This is one of Kafka's most abstract stories; it is a schematic representation, spiritual, at once a model of our dwelling place and a proof of its unreality. The world of experience has dwindled to a diabolical ma-chine, a device for executing condemned criminals by engraving, in a florid and embellished script, the broken commandment on their skins with vi-brating needles. It is a simple two-part fable. In the first part, the presiding officer describes to an explorer—who is a bourgeois liberal, horrified by inhumane punishment—how the machine operates, how it has operated in the past; the criminal's death is reached at a moment of terminal enlighten-ment: "Comprehension comes to the stupidest. It begins around the eyes. From there it spreads out. A moment that could tempt one to lie under the Harrow oneself. Nothing further happens, the man merely begins to deci-pher the writing, he purses his lips as if he were listening. You have seen it

is not easy to decipher the script with your eyes; our man deciphers it with his wounds."[17] In former times executions were great public festivals in which men, women, and children alike rejoiced at the spectacle of the "expression of transfiguration on the sufferer's face." But now the institution has fallen into public disfavor, and the new Commandant—the old Commandant was the builder of the machine, at once "soldier, judge, constructer, chemist and designer," in short, God—is clearly abolishing the custom, letting the machine fall into disrepair. In the second part of the story, the officer, the last true believer in the machine, has failed to persuade the explorer to plead on the machine's behalf; he then decides to undergo the enlightening torture himself, to execute himself on his own machine. He sets the controls to write "*Sei gerecht!*" ("Be Just!") on his body, but the machine goes haywire, spews out its cogwheels in all directions, jabs him to death without writing anything—"no torture of the sort the officer wished to attain, it was just sheer murder."

The first part is a kind of stylization of the system of justice as we might wish it to be, a smooth, easy transition from divine commandment to our comprehension of it in our wounds. It is the ideal justice of the Old Testament, in which the least sin is punishable by a measured death, in which the condemned man grows wise in a bloody clarification of his guilt. The radiance of the condemned man seems to prove that suffering is bliss, but it is, in reality, not as simple as the officer wishes it to be. The second part is the collapse, the abolition of the first part. Justice does not operate as theory suggests it should; the commandment, already embellished into near illegibility in the first part, grows so complicated and random that it ceases to be any sort of sentence at all. As the Designer, the box that contains the encoded commandments, and the Harrow, the apparatus of needles, fall apart, the links between spirit and nature are severed, and the manifestations of justice reduce to freakish whorls and arbitrary punctures, neither signs nor symbols.

The pretty letters of the alphabet are elaborated into unmeaning; this is the real enlightenment, not the sham radiance of the officer's indulgent memory, but the confrontation with "murder," stark, unmitigated by the Word. The pattern of jabs that ought to have read "Be Just!" is instead a symbol denoting a lack of symbols, a visible unintelligibility, a rift design traced by its failure of meaning. The hope of justice is to convert the sinner into a text, a kind of illuminated manuscript in which he is a signal denunciation of his own sin; and even at the end of the story the sinner is a text—

what the Harrow does to the officer is still a kind of writing—but it is a lapsed text, a verbal absurdity. Kafka once wrote a famous little fable called "An Imperial Message," a Gnostic parable about the infinite distance between the spiritual and the material: the emperor has whispered a message intended for you and you only, but the messenger can't even get out of the inner courtyard, let alone to the outer courtyard, let alone to the second palace surrounding the first, let alone to the open fields, let alone to your doorstep. Similarly, the commandant's machine—a kind of typewriter for the damned—can't hope properly to transmit and engrave the revelation in your flesh.

I think of *In the Penal Colony* as (among other things) a critique of Expressionist art: the Expressionist artist is always trying to sear the message into your body and brain, but the whole system of art, necessarily predicated on illusion, is likely to collapse under the strain. Just as the machine falls apart into cogwheels bouncing over the landscape, so art itself may explode if it is asked to do too much, to serve immodest goals. The twentieth century has been intrigued by machines like Jean Tinguely's *Homage to New York*, which are built solely for the purpose of shaking themselves to pieces. On 17 March 1960, in the garden of the Museum of Modern Art in New York, Tinguely pushed the switch that made this thirty-foot-high sculpture self-destruct noisily. This remarkable machine was made from eighty bicycle, tricycle, and baby carriage wheels, as well as objects such as a bathtub, a piano, a bell, a car horn, playing cards, scraps of the American flag, many bottles, fire extinguishers, a meteorological sounding balloon, a radio, an oil canister, a hammer, a saw, and so on, and was powered by fifteen engines. In a diary notation Kafka once spoke of the "self-canceling-out of art";[18] and like Tinguely's machine, Kafka's fictions undo themselves, point to the basic nonentity of art and of the whole external world.

Kafka's story is also a self-destroying mechanism, a theater in which the stage machinery is designed to annihilate the sole actor in the process of its own collapse, a drama ended by the exit of the sole spectator, as if nothing had ever happened at all: " 'But then he turned back to his work as if nothing had happened.' That is a remark that seems commonly used in a vague abundance of old stories, although it perhaps occurs in none."[19] It would be the proper last line of *In the Penal Colony*, perhaps of all of Kafka's tales. Not only must we learn to read "bliss" for "suffering," "white" for "black," but we must learn to unread the whole fictive world erected for our contemplation.

In the Penal Colony is a verbal approximation to reality achieved by an act

of self-contradiction, by a dismantling of the artifice of itself. It is one of Kafka's favorite techniques; at the end of *Letter to His Father*, written five years later (a long document in which Kafka records how his father might have been a good father to some child, but not to him), Kafka imagines a long rebuttal his father might make against the whole of the *Letter*: "Naturally things in reality can't fit together like the evidence in my letter; life is more than a puzzle; but with the correction offered in this rebuttal—a correction that I neither can nor will elaborate in detail—something has been reached that in my opinion is so very near the truth that it might calm us both a little and make our living and dying easier."[20] Words can approach reality only by including denials of themselves. It is a lawyerly aspect of Kafka's mind, this notion that the sifting of competing claims and denials is the best method for attaining truth; but what is not good legal practice is Kafka's habit of being both prosecutor and defendant at once. In the *Letter* Kafka does not invite his father to present his case; and this was sometimes, in fact, Kafka's practice as a lawyer, for Janouch tells us that Kafka occasionally hired and briefed in secret a defense attorney for old pitiable laborers whose accident claims Kafka was required to dispute, thereby transforming a court of law into a theater of competing Kafkas.[21] Similarly, the officer of *In the Penal Colony* is a hangman who of his own will becomes the victim, who expels the ignorant condemned man from the bed of execution as if he could not bear another actor to intrude in the solitary drama in which all roles are played by one man.

Kafka thought that each of us consisted of a myriad of different selves, put into a complicated play with one another. Kafka's stories typically have one character, who struggles to make sense of his various spiritual and physical lives, who struggles to overcome various obstacles to enlightenment. But enlightenment is difficult to distinguish from mutilation, from terror, in the backward world of Kafka's fiction.

Futurism

Value: The art that is coming into being is better than the art that already exists.

In the nineteenth century, most of the official isms were constructed not by artists but by critics—as we've seen in the case of Impressionism. But by the beginning of the twentieth century the artists themselves were starting to name their movements and take responsibility for their success. It wasn't enough for the individual artworks or even the individual artist to gain fame; the ism had to share in the glory.

This created a different sort of artistic community. Some of the Impressionist painters were friends, and they were all deeply interested in one another's work. But they didn't understand themselves as intimately bound together, part of a common artistic cause: if you insulted Renoir, Cézanne wouldn't necessarily take personal offense. But some of the twentieth-century isms were extraordinarily communitarian: an ism could become something between a monastic order and a college fraternity of the *Animal House* variety. If one of your brothers (or, in rare cases, sisters) fell down, it was your responsibility to pick him up; but if he deviated too far from the principles of the tribe, the leader would formally expel him. Among the Impressionists, nobody would have had the authority to kick out (say) Degas for being insufficiently Impressionistic; indeed, no one thought that the word *Impressionism* denoted anything that a painter had an obligation to conform to. Expressionism was slightly more cohesive but still a loose confederation of artistic tribes, not an organized society. But later in the twentieth century, André Breton felt that it was his duty to excommunicate Salvador Dalí from the merry band of the Surrealists, and isms tended to become organized cadres—by one of history's little ironies, the more the ism demanded

total artistic freedom, the more restrictive its internal discipline was likely to become.

The first of these brigades of Modernist shock troops announced its existence with a bang: on 20 February 1909, Filippo Tommaso Marinetti published, on the front page of the distinguished Parisian newspaper *Le Figaro*, a manifesto of a previously unknown artistic movement, Futurism. This article attracted a lot of attention. Marinetti, the "caffeine of Europe," was a histrionic man who hated lethargy and rules of conduct and adored speed and power. He exulted in war and indeed wrote a pamphlet called *War—the World's Only Hygiene* (1915); he wrote odes in praise of his signora the machine gun and hoped for destruction—without destruction there would be no room to build new things. Marinetti's article was not the first manifesto of a Modernist ism: back in 1886, for example, the poet Jean Moréas wrote a Symbolist manifesto. But by 1886 Symbolism had been in existence for thirty years or so, ever since Baudelaire published his famous poem *Correspondances*—the movement was in no sense fresh news, and in any case Moréas's manifesto wasn't especially insightful or revelatory. But the Futurist manifesto jolted its readers. It still makes for exciting reading.

In some sense the manifesto takes its place as part of an old European debate, between the ancients and the moderns. At the beginning of this book I mentioned Jonathan Swift's participation in this so-called Battle of the Books, from the early eighteenth century: Swift was a fierce defender of the values of antiquity against the trashy novelties of his age. In the nineteenth century, Baudelaire found a sort of loveliness in the ephemeral dreck of city life. But no one before Marinetti ever suggested burning libraries and flooding museums with such passionate nonchalance. His rejection of the past is all but complete: he does suggest that an annual visit to a museum might not be a bad thing, but basically he wants Italy swept clean of Michelangelos and Berninis and all those glories of the past, works whose sheer supreme excellence inhibits production in the present. The nicest touch in the whole *Figaro* article is his recognition that in ten years he and his friends will themselves have become *passé*, and it will be time for a new generation of artists to cleanse Italy from Futurism: "When we are forty, other younger and stronger men will probably throw us in the wastebasket like useless manuscripts—we want it to happen!"[1]

One striking feature of this manifesto is that Marinetti can scarcely open his mouth, his very big mouth, without falling into contradiction. Consider this passage, from the beginning of the article: "'Let's go!' I said. 'Friends,

away! Let's go! Mythology and the Mystic Ideal are defeated at last. We're about to see the Centaur's birth . . . ' We went up to the three snorting beasts, to lay amorous hands on their torrid breasts. I stretched out on my car like a corpse on its bier, but revived at once under the steering wheel, a guillotine blade that threatened my stomach."[2] Marinetti says that he has defeated Mythology—and indeed a rejection of old fables and hazy dreams is a strong part of his embrace of a new, spiffy, explicit, clean-lined, dynamic sort of art. But in the very next sentence after his triumph over Mythology, he starts to speak of the birth of centaurs—has Marinetti defeated Mythology, or has Mythology defeated Marinetti? Soon he gets into his motorcar, which he immediately mythologizes as a snorting beast, a snorting beast with a guillotine blade, an odd hybrid of a horse and a murder device. Marinetti's rejection of the past is so uncompromising that he even rejects his own sentences as soon as he speaks them. The anecdote about the joyride ends when Marinetti swerves to avoid a cyclist and the car tumbles into a ditch: a nice parable for Marinetti's whole creative effort, for he continually pushes his rhetoric too far and has to find ways of digging himself out. He was a great public performer—the artist as transcendentally gifted public relations man—and like other comedians of genius, he managed to offend almost everyone.

In the 1909 Paris article Marinetti sets off on a mad ride in his automobile; three years later, in the "Technical Manifesto of Futurist Literature," he embarks on a still wilder ride, on an airplane. His imagination was moving at such speed that he was in danger of accelerating completely out of reach of the human race. Dehumanization is indeed the main theme of the technical manifesto.

His first concern is to rid language of its warm, humane, complacent, meditative elements. How can you make a sentence move like bullet, or like a torpedo? His solution is to eliminate most parts of speech, which, to his mind, simply clog up the sentence, inhibit its speed: "One must destroy syntax and scatter one's nouns at random . . . the noun should be followed, with no conjunction, by the noun to which it is related by analogue. Example: man-torpedo-boat, woman-gulf, crowd-surf, piazza-funnel, door-faucet. . . . Abolish even the punctuation. . . . To accentuate certain movements and indicate their directions, mathematical symbols will be used: $+ - \times : =$ and the musical symbols."[3] If a sentence can be turned into a mathematical equation, then it will have the gleaming precision and efficiency of a motor engine; indeed, if you try to imagine a dialogue in which

you and your friends are talking with one another in Marinetti-speak, I think that you would find yourselves doing robot shtick of various sorts—moving your arms with jerky motions, or walking without bending your knees. Machine-stumble-affectlessness-hoho; spectator-eyeball-bellylaugh-eighth-note-quarter-note.

Marinetti likes strings of nouns, but he particularly loves verbs, as long as they're infinitives: "One should use infinitives, because they adapt themselves elastically to nouns and don't subordinate them to the writer's *I* that observes or images. Alone, the infinitive can provide a sense of the continuity of life and the elasticity of the intuition that perceives it."[4] It's easy to see why: a finite verb implies a person, an *I* or *we* or a *you* or a *he* or a *she* or a *they*—especially in Italian, in which pronouns are omitted far more often than in English. To dehumanize language, you must get rid of these inconvenient people who keep trying to squeeze their way into sentences, contaminating them with private egos.

Marinetti insisted that language must be purged not only of human presence but of what we usually call the animate universe: "Destroy the *I* in literature, that is, all psychology. The man sidetracked by the library and the museum, subjected to a logic and wisdom of fear, is of no interest. . . . To substitute for human psychology, now exhausted, the lyric obsession with matter. . . . The warmth of a piece of iron or wood is in our opinion more impassioned than the smile or tears of a woman."[5] This is why Marinetti keeps using devices of mythological personification when he speaks of dead things such as motorcars, even though he disapproves of such devices: he knows of no other way to show that the world of iron and wood is more alive than the world of people. Metallic heat has a vibratory intensity beyond anything known to mere men and women.

Marinetti's sense that inert matter has its own dynamism, its own intuitive physiology, had remarkable consequences for his art. The notion that the whole cosmos is profoundly alive is itself nothing new: there are words—*hylozoism*, or *panpsychism*—that refer to the old doctrines that all things are animate, that every object has its own soul. What is new is Marinetti's sense that iron and wood are more vital, more worthy of attention, than human beings. To imagine the sensations of a Bessemer converter belching liquid steel, or of a piston in an internal combustion engine, was to some degree the goal of Futurism. This is one reason that Marinetti was so dazzled by the war: yes, it caused human suffering on an unthinkably wide range, but it also gave unprecedented scope to the delirious fun of the inanimate universe—

gunpowder could indulge itself in wonderful explosions, tracer bullets could draw burning parabolas across the whole sky.

In 1914 Marinetti published a sound poem, *Zang Tumb Tumb*, an eyewitness account of the Bulgarian siege of Adrianopolis during the Balkan War. I speak of an eyewitness account, and Marinetti did in fact see the events described, but he does his best to eliminate his presence as a witness and let the war speak for itself. It is the apotheosis of onomatopoeia:

> *breath eyes ears nostrils open! watching! straining! what joy to see hear smell everything everything taratatata of the machine guns frantically screaming amid bites blows traak-traak whipcracks pic-pac pum-tumb strange goings-on leaps height 200 meters of the infantry Down down at the bottom of the orchestra stirring up pools oxen buffaloes goats wagons pluff plaff rearing of horses flic flac tzing tzing shaak hilarious neighing iiiiii stamping clanking 3 Bulgarian battalions on the march croooc-craaac* (lento) *Shumi Maritza or Karvavena* TZANG-TUMB-TUUUMB *toctoctoctoc* (rapidissimo) *crooc-craac* (lento) *officers' yells resounding like sheets of brass bang here crack there* BOOM *ching chak* (Presto) *chachacha-cha-chak up down back forth all around above look out for your head chak good shot!*[6]

Marinetti simply opens his sense organs as wide as possible and registers the speech of machine guns and the rest of the noise of battle. It is especially noteworthy that he hears it as music, decorating his prose with tempo markings (lento, rapidissimo, presto), as if he were writing a score for a piece of music, especially notable for the percussion part—BOOM! This refiguring of war as music is one strategy for objectification, for eliminating all psychology.

Futurism was a peculiarly invasive movement, with little respect for the basic categories by which we organize experience, such as *inside* or *outside*. A radio wave, even a loud sound wave, goes right through your body: you can feel rock music agitating not only your eardrums but also your diaphragm. Marinetti likes fast cars, fast boats, fast airplanes, but finally even the fastest machine is way too slow for his dreams: only radiant energy is fast enough. In his 1916 essay "The New Religion-Morality of Speed," Marinetti mocks the torpor of natural rhythms: nature is lazy and tortuous, streams and roads move in indolent curving paths, whereas "speed finally gives to human life one of the characteristics of divinity: *the straight line*."[7] He goes on to construct a kind of theology of speed: "Our male saints are the numberless corpuscles [that is, meteors] that penetrate our atmosphere

at an average velocity of 42,000 meters a second. Our female saints are the light and electromagnetic waves at 3×10^{10} meters a second."[8] Albert Einstein once said that he made his great breakthrough on the theory of relativity by imagining what it would be like to ride on a beam of light; Marinetti also seems to crave to live at light speed.

Marinetti considered that it might be possible to totalize Futurism: you could lead an entirely Futurist life, in which you saw only Futurist art, traveled in only Futurist contraptions, communicated not in Italian or English but Futuristic.

The "Technical Manifesto of Futurist Literature" of 1912 was only one of at least ten Futurist manifestos and polemical essays published between 1910 and 1914: there were two manifestos on painting, two on music, one on sculpture, one on abstract cinema, and one on architecture—not to mention a curious piece from 1913 written by one of the few women associated with Futurism, Valentine de Saint-Point, called "Futurist Manifesto of Lust." Ms. de Saint-Point thinks that social interactions ought to move a lot faster—courtship, like everything else, should be conducted at light speed:

> We must get rid of all the ill-omened debris of romanticism, counting daisy petals, moonlight duets, heavy endearments, false hypocritical modesty. When beings are drawn together by a physical attraction, let them—instead of talking only of the fragility of their hearts—dare to express their desires, the inclinations of their bodies, and to anticipate the possibilities of joy and disappointment in their future carnal union. . . . We must face up to lust in full consciousness. We must make of it what a sophisticated and intelligent being makes of himself and of his life; we must make lust into a work of art.[9]

It's odd to read a Futurist manifesto that sounds like Hugh Hefner's *Playboy Advisor* circa 1960, but Futurism was a totalitarian movement, a movement that sought to integrate every aspect of human life—perhaps it's little wonder that Marinetti and some of the other Futurists were strongly drawn to Benito Mussolini's totalitarian politics.

Like all movements that embrace many different artistic media, Futurism had mixed success. In literature it had real strength, mostly owing to the wit of Marinetti himself; in music it was pretty weak—it's telling that most of the significant musical work was done by Luigi Russolo, a man who was not a professional musician (though the son of an organist). But the painting! The Futurist painters were hair-raisingly gifted. Indeed, the constellation

of Umberto Boccioni, Giacomo Balla, Fortunato Depero, Gino Severini, and Luigi Russolo, to mention only five names, ranks as one of the most significant groups in the history of art.

Like Marinetti himself, the Futurist painters adored speed. But depicting speed on a flat canvas is not easy. You can show a running man or horse as if caught in a freeze frame, as Renaissance painters did. But this was not the Futurist way, as we can see from the "Technical Manifesto of Futurist Painting" (1912), signed by Umberto Boccioni, Carlo Carrà, Luigi Russolo, Giacomo Balla, and Gino Severini:

> The gesture which we would reproduce on canvas shall no longer be a fixed *moment* in universal dynamism. It shall simply be the *dynamic sensation* itself.
>
> Indeed, all things move, all things run, all things are rapidly changing. A profile is never motionless before our eyes, but it constantly appears and disappears. On account of the persistency of an image upon the retina, moving objects constantly multiply themselves; their form changes like rapid vibrations, in their mad career. Thus a running horse has not four legs, but twenty, and their movements are triangular.[10]

The Futurists wanted to paint not an instant of dynamic action, but dynamism itself.

How can a painter manage to do this? For one thing, if a running animal has twenty legs and not four, you can paint all twenty, as in Giacomo Balla's *Dynamism of a Dog on a Leash*. The retina's retained images are superimposed: we are watching at least three seconds of dachshund, not a freeze-frame. This sort of thing is now familiar to us from comic strips and any number of other sources, but it was a radical device at the time.

In the same year (1912) that Balla painted his dog, Marcel Duchamp (not an official member of the Futurist movement) painted a still more famous superposition exercise, *Nude Descending a Staircase, No. 2*. Duchamp admitted that he was influenced by the photographic experiments of Étienne-Jules Marey, in which still images of (for example) a man running toward a chair and leaping over it are superimposed to give a clear analysis of the act of running. (In America, Eadward Muybridge, partly inspired by Marey's work, made similar experiments.)

But the chief wonder of Futurist painting comes not from its prizing of the machine, not from its blurs and multiplied forms, but from its destruction of space. As we've seen, the Renaissance perspectivists expended enormous labor to create a secure, credible vision of space. Futurist painters were

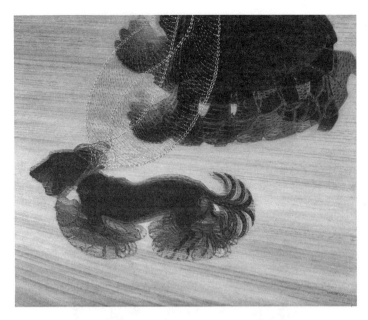

Giacomo Balla: *Dynamism of a Dog on a Leash* (1912) Albright-Knox Art Gallery/Art Resource, NY. © 2015 Artists Rights Society (ARS), New York/SIAE, Rome

willing to go far to abolish and discredit space, as the "Technical Manifesto" explains:

> Space no longer exists: the street pavement, soaked by rain beneath the glare of electric lamps, becomes immensely deep and gapes to the very center of the earth. Thousands of miles divide us from the sun; yet the house in front of us fits into the solar disk.
>
> Who can still believe in the opacity of bodies, since our sharpened and multiplied sensitiveness has already penetrated the obscure manifestations of the medium? Why should we forget in our creations the doubled power of our sight, capable of giving results analogous to those of the X-rays?
>
> It will be sufficient to cite a few examples, chosen amongst thousands, to prove the truth of our arguments.
>
> The sixteen people around you in a rolling motor bus are in turn and at the same time one, ten, four, three; they are motionless and they change places; they come and go, bound into the street, are suddenly swallowed up by the sunshine, then come back and sit before you, like persistent symbols of universal vibration.

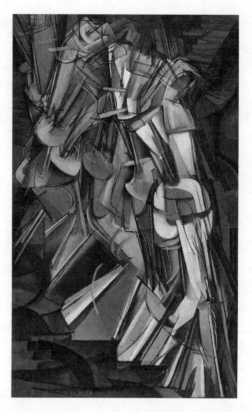

Marcel Duchamp, *Nude Descending a Staircase, No. 2* (1912) The Philadelphia Museum of Art/Art Resource, NY. © Succession Marcel Duchamp/ADAGP, Paris/Artists Rights Society (ARS), New York 2015

How often have we not seen upon the cheek of the person with whom we are talking the horse which passes at the end of the street.

Our bodies penetrate the sofas upon which we sit, and the sofas penetrate our bodies. The motor bus rushes into the houses which it passes, and in their turn the houses throw themselves upon the motor bus and are blended with it.[11]

This is a remarkable passage: the authors of the manifesto claim that the universe in its entirety can be found glinting off or reflected in every finite particular—your toenail, your pencil, a piece of your navel lint, each thing is a microcosm. A stray cheek is imprinted with the form of a horse, as if cheeks contain horses. There is no opacity anywhere: each object in the

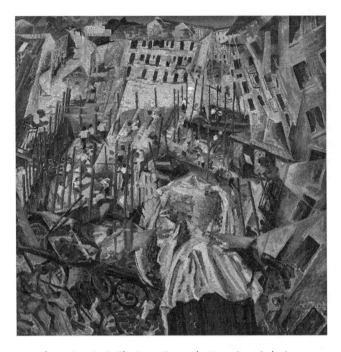

Umberto Boccioni, *The Street Enters the House* (1911) akg-images

universe is only a kind of provisional thickening of glass, and every other object is visible behind it. All vision is X-ray vision and beholds not a settled landscape but a world of shooting stars, forms madly penetrating one another.

This whole passage sounds like a gloss on one of Boccioni's greatest paintings, *The Street Enters the House*. The painter's point of view is behind the woman, presumably from within the room from which the balcony protrudes. If Perugino were painting this according to the good conventions of perspective, we would see only a rather narrow slice of the street. But Boccioni gives us a 360-degree view, as if he were leaning out of the balcony much further than the woman herself, and his eyeball were a sort of panoramic or swiveling camera, seeing in all directions at once. His eye is behaving like an ear, picking up omnidirectional signals.

The images don't seem to be literally transparent, but they're all mixed up with one another. The houses seem in a general state of squash, as if they're all falling into the center of the square. The folks in the street all

seem engaged in frantic building activity, as if the cityscape were a stage set being furiously dismantled and reconstructed—a world is being improvised into existence as we watch. The "Technical Manifesto" speaks of the motor bus that "rushes into the houses which it passes, and in their turn the houses throw themselves upon the motor bus." If we substitute *horse* for *motor bus*, this is literally true of Boccioni's painting: if you look at the woman's right buttock, you can see that one of the horses in the street has thrown its front legs around it, as if it were literally inside the house. The categories of inside and outside no longer have meaning: Boccioni has destroyed space.

This is a disturbing image, partly because of the vertigo of its implied space, partly because the component images are so garish, swarming, over-stimulated—everyone seems to have had a lot of coffee this morning. Even the houses look hyper. The "Technical Manifesto" speaks of "persistent symbols of universal vibration," and the whole street seems trembling, deeply shaken. Some Futurist painting dispensed almost completely with physical objects in order to paint pure vibration or radiation or acceleration. Consider Giacomo Balla's *The Streetlight*. Once you see the title *Streetlight*, you can understand that there's a vague representational aspect to the painting, but if the title were, say, *Perseus's Mystic Shield Slays the Gorgon*, you might not think of streetlights at all. The image is pure immanence of dazzle: like all painting, it can only reflect light, not emit it, but Boccioni gives the impression of a light so intense that it hurts your eyes to look at it. It is an unusually persistent symbol of universal vibration.

Just as physicists were learning how to understand matter itself as a special case of a wave, the Futurist painters were learning how to understand the physical world in terms of vibrations and undulations. A case in point is Luigi Russolo, perhaps the most versatile of the Futurists—that's saying something, because they were a versatile lot. He was, as we'll see, a composer and music theoretician as well as a painter—his "The Art of Noises" (1913) is the best of the Futurist manifestos on music. He inspected music from many different angles: he even painted it, as can be seen in his *Music*. Here the comet masks—grinning, or pensive, or astonished, or resigned, or goofy, or quietly amused—give some account of music's expressive potentialities; but what chiefly interests Russolo is the shape of energy. As it happens, waves come in two basic types: transverse (in which the displacement of the medium is perpendicular to the direction of propagation, as in the sine waves made by a shaken string) and longitudinal (in which the displacement of the medium is the same as the direction of propagation, as in a

Giacomo Balla, *The Streetlight* Digital Image © The Museum of Moden Art/Licensed by SCALA/Art Resource, NY. © 2015 Artists Rights Society (ARS), New York/SIAE, Rome

sound wave). A note struck on a piano makes the air bulge and recede, in an out-pulsing of concentric shells. This is exactly what Russolo depicts here; but through the shells of the longitudinal wave Russolo has threaded a transverse wave, a blue snake. The two sets of waves, along with the facial vectors pointing inward at the pianist's head, constitute a remarkably effective image of directed energies.

As I mentioned, the Futurists, rich in writers and painters, were poor in musicians. Russolo, therefore, decided to fill this almost empty ecological niche: he devised a series of noisemakers called *intonarumori*, each enclosed in a black box, so that a concert of them would resemble a Cubist painting. These noisemakers had noisy names—*Ululatori, Rombatori, Crepitatori, Gor-*

Luigi Russolo, *Music* (1911) © DeA Picture Library / Art Resource, NY

gogliatori, and *Sibilatori* (howlers, rumblers, cracklers, gurglers, hissers)—and
Russolo devised concert pieces for them, such as the 1913 *Risveglio* [or *Veg-
lio*] *di una città* (*Awakening of a City*), the score to which is a fine piece of
Futurist graphic, with its normal bars, clefs, time signatures, and staves, all
decorated with thick black lines, holding steadily horizontal, or ascending
up and down in slow glides, or proceeding in fast jerks from one flat line to
the next.

In "The Art of Noises," Russolo's argument is based on a simple analysis
of the history of music: in ancient and medieval music, he says,

> the *chord* did not exist: the flow of the individual parts was never subordinated
> to the agreeable effect produced at any given moment by the ensemble of those

parts. In a word, the medieval conception of music was horizontal, not vertical. An interest in the simultaneous union of different sounds, that is, in the chord as a complex sound, developed gradually, passing from the perfect consonance, with a few incidental dissonances, to the complex and persistent dissonances which characterize the music of today.

The art of music at first sought and achieved purity and sweetness of sound; later, it blended diverse sounds, but always with intent to caress the ear with suave harmonies. Today, growing ever more complicated, it seeks those combinations of sounds that fall most dissonantly, strangely, and harshly upon the ear. We thus approach nearer and nearer to the MUSIC OF NOISE.

This musical evolution parallels the growing multiplicity of machines, which everywhere are assisting mankind. Not only amid the clamor of great cities but even in the countryside, which until yesterday was ordinarily quiet, the machine today has created so many varieties and combinations of noise that pure musical sound—with its poverty and its monotony—no longer awakens any emotion in the hearer.[12]

Machines are noisy, and the sounds they make from the stress of their operation seemed the right music for the twentieth century—in fact, a few years after Russolo wrote these lines, the new Soviet Union would organize a concert of factory whistles. But Russolo's argument depends less on the appropriateness of the mechanical than on a new aesthetic of music. A single pure flute or violin tone seems thin, lax, not much of anything at all; you can enrich it with overtones by playing it on (say) an oboe, but it's still sort of boring. Music has been straitjacketed by its reliance on specific tones: as soon as we enter the world of the unpitched—the world of noise—suddenly we find ourselves in the full universe of sound, dense, dizzying, full of howls and chirps and rattles and little humming whirligigs. We had been only skating on the surfaces of the acoustic; now we dive into the ocean. Russolo's *intonarumori* were about the best that could be done in the days of the First World War—it was not until the invention of the tape recorder, during the Second World War, that the art of noise could reach its full development, in such pieces as Pierre Henry's *Variations for a Door and a Sigh* (1963), a fairly long composition generated mostly through modifications of the sound of a squeaking door.

Most of Marinetti's significant work was already in place by 1912, but during the 1920s—when he predicted, to some extent correctly, that his work would be outmoded—he published a few more important essays. In a

1924 piece called "Tactilism," Marinetti imagined an art for the skin to complement and perhaps replace the arts of the eye and ear (painting, sculpture, music, literature): you would make poems for the fingertips, by juxtaposing (say) sponges, sandpaper, wool, pig's bristle, and wire bristle:

TOWARD THE DISCOVERY OF NEW SENSES

Imagine the Sun leaving its orbit and forgetting the Earth! Darkness. Men stumbling around. Terror. Then the birth of a vague sense of security and adjustment. . . . A visual sense is born in the fingertips.

X-ray vision develops, and some people can already see inside their bodies. Others dimly explore the inside of their neighbors' bodies. . . . The epigastrium sees. The knees see. The elbows see. . . . Perhaps there is more thought in the fingertips and the iron than in the brain that prides itself on observing the phenomenon.[13]

All you have to do is to turn out all the lights, and the rest of your body lights up with eyes: your glands, your joints, your bones become sense organs, receptive to subtle pressures of gravity and radiation. There is a sort of cosmic dance of force going on all around you, and you can tune into it if you can make your whole body a sensorium. You should think with your stomach, your liver, your intestines, not just your brain.

Ultimately, Marinetti wanted an art that was not confined to a particular material body—an art dissipated into the whole radiant spectrum, to be perceived by an equally nonlocalized spectator. Radio increasingly haunted him—he had amazing visions of the radiophonic future. In 1933 Marinetti and Pino Masnata published "La radia"—in Italian there is no such word as *radia*, but Marinetti made it up because it sounds like radio, radiation, and the verb *radiare*, which means "to strike off or cancel"; Marinetti meant it as a ferocious sort of word, doing away with the old barriers, boldly going where no art has gone before. The essay declares that radio must abolish every vestige of the old theater, including character, theatrical space, unity of action, and instead concentrate on the transmission of radiation itself, pingings in the ether transfigured as they pass from one medium into another:

LA RADIA ABOLISHES

1 the space and stage necessary to theater . . .
2 time
3 unity of action

4 dramatic character

5 the audience as self-appointed judging mass systematically hostile and servile always against the new always retrograde

LA RADIA SHALL BE

1 Freedom from all point of contact with literary and artistic tradition Any attempt to link la radia with tradition is grotesque

2 A new art that begins where theater cinema and narrative end

3 The immensification of space No longer visible and framable the stage become universal and cosmic

4 The reception amplification and transfiguration of vibrations emitted by living beings living or dead spirits dramas of wordless noise-states

5 The reception amplification and transfiguration of vibrations emitted by matter Just as today we listen to the song of the forest and the sea so tomorrow shall we be seduced by the vibrations of a diamond or a flower.[14]

What would pure radio look like—radio in which the medium was itself the message? Marinetti wrote a script for a *Dramma di distanze* consisting of eleven-second snippets from seven remote places: "a military march in Rome, a tango from Santos (Brazil), Japanese religious music played in Tokyo, country dance music from Varese (northern Italy), sounds of a boxing match in New York, street sounds from Milan, and a Neapolitan song performed in Rio de Janeiro."[15] This is an exercise in teleportation: at the speed of light, Marinetti-Mephistopheles skips the listener from point to point across the surface of the globe, a breathtaking circumnavigation within a minute and a half. Where life flares up with special fire, there you are. You have been a beam of light, like the one that Einstein imagined riding on.

Cinema

Futurism was the most technologically intensive species of Modernism, but technology was changing all art and bringing new artistic media into being, such as the radio drama and the cinema. Many of the early efforts in these new media stressed the technical necessities of the chosen medium. The very first radio play, Richard Hughes's *A Comedy of Danger* (1924), was set inside a coal mine, as if absence of pictures were not only the technical precondition of radio but also its best theme. Since the hearer was necessarily blind, blindness became a popular subject of the radio play, and the tapping of a blind man's cane became a staple sound effect—even Samuel Beckett's radio play *All That Fall* (1957) makes (parodic) use of this cliché.

Cinema, on the other hand, was originally silent. And in some sense the ideal protagonist of a silent movie is mute or nearly mute—someone whose expressive power lies in gestural intensity, such as Quasimodo, played by Lon Chaney in *The Hunchback of Notre Dame* (1923), or the somnambulist killer Cesare in *The Cabinet of Dr. Caligari* (1920). After sound did come to movies, in 1927, nonspeaking characters were often still prominent, as if a certain sense persisted that cinema was, at its core, silent or halting in speech: for example, the monster played by Boris Karloff in *Frankenstein* (1931), the ape in *King Kong* (1933), or Harpo in any of the Marx Brothers films. Most of these characters I've mentioned are figures of horror, as if the cinematic sublime, its core astonishment, arises from the inability of the pure image to make articulate sound: the language of cinema is most fluently spoken by pictures, only pictures. In one of the first important movies, the Lumière brothers' *The Arrival of a Train at La Ciotat Station* (1896) caused panic in the audience, according to a reporter for *Der Spiegel* magazine, as the train seemed about to run from the screen into the theater: an overwhelm by purely visual means.

I think that the director most sensitive to the difference of cinema dialect between silent and talking movies was Charlie Chaplin. In his *Modern Times* (1936), there is a soundtrack, with the usual quantity of background music. But the role of speech is odd: the factory boss can bark orders through a kind of loudspeaker, a gramophone can utter a sales pitch, but neither Chaplin himself nor the female lead, the gamine (played by Paulette Godard), ever says a word (Chaplin does sing a song, but the lyrics are gibberish). The dialogue between the lovers is handled by the old silent-movie device of intertitles, although often it's easy to read their lips: it's as if cinematic intimacy requires silence, and speech is a kind of harsh technological intrusion. In the film's most famous scene, Chaplin is sucked into the gears of a huge machine, and only his slithery grace prevents him from being chopped into hamburger. To Chaplin, speech in movies feels invasive, abrasive, a threat to the dance of light and shadow.

If sound is alien to the classical language of cinema, what is its proper vocabulary? For Sergei Eisenstein, it is montage—a collage in time, instead of space. Eisenstein was impressed by a famous experiment in reaction shots: the director Lev Kuleshov prepared a series of montages based on archival footage of a close-up of the expressionless face of the actor Ivan Mozhukhin: first Mozhukhin's face was followed by a bowl of soup on a table; then by an old woman's corpse in a coffin; then by a child playing with

a teddy bear. The audience, it is said, was impressed by Mozhukhin's skill as an actor: how hungrily he stared at the soup, how mournfully he regarded the corpse, how delicately he smiled at the girl. Nonreactivity, then, is retrospectively interpreted as reaction. Kuleshov was trying to make a point about emotional leakage from one element of a montage into another: a montage makes an aesthetic whole not entirely predictable from its parts in isolation. If a snippet of film is considered a word in cinema language, then it has little meaning in itself: just as in spoken language, a cinema word acquires meaning from the context in which it appears. One of Eisenstein's most famous examples of what he called "intellectual montage" occurs in his first full-length movie, *Strike*: an attack on striking workers and the slaughter of a bull are spliced together.

Before the era of digitalization, movies were filmed, and projected, by winding a filmstrip from one reel onto another; so to think filmically was always to think in terms of spinning circles. Some of the earliest movies were just loops of action, just as the old optical toys, like the zoetrope, gave the spectator the visual impression of, say, a horse endlessly jumping over a fence. Some silent movies found ways of embodying the rotary motion of the medium into the film's theme: for example, *Ballet mécanique* (1923-24), by the painter Fernand Léger and the cameraman Dudley Murphy, is a plotless exercise in motion repetition, both human and mechanical. The film discovers (or imposes) such uniform rhythms in the world of machines and the world of human beings that it tends to flatten any distinction between them. Attractive women and piston engines seem two species of the same genus—or, as Marinetti put it, the heat of iron is just as interesting as the smile of a woman. Both machines and persons seem equally urbane, compelling, witty. The film's first episode shows a happy young woman on a swing; later episodes show various clock pendulums, and swinging balls, and an older woman climbing up the same few stone steps over and over, and locomotive-like pistons, and other sorts of back-and-forth and in-and-out. The young woman on the swing is perhaps the key episode, in that it contains both a human being and a (very simple) machine, cohabiting quite amiably. In cinema language, it's easy to say the same thing over and over again.

The cinema not only developed its own language but quickly started altering the languages of other media as well. In his *U.S.A.* trilogy (1930-36), John Dos Passos interspersed his narrative with sections called *Newsreels*, containing not only newspaper headlines and snippets of articles from (for

example) the *Chicago Tribune* but also song lyrics, as if the novel were try-
ing to provide a soundtrack for itself. Some novelists not only incorporated
cinematic techniques but became filmmakers themselves, notably Samuel
Beckett, whose *Film* (1965) starred the silent movie comedian Buster Keaton—
Beckett seemed to be trying to show that the cinema is just as vain, dis-
turbed, and disturbing as novels or dramas.

6 Cubism

Cubism came to the attention of the general public around 1910, though Georges Braque had exhibited some paintings in the style as early as 1908. The poet Apollinaire saw the 1910 show of the *Salon des Indépendants* and said, "We would say without hesitation—and with great pleasure—that it means the rout of Impressionism." And at the *Salon d'Automne* in the same year, Roger Allard noted (of Gleizes), "I had the very definite impression of a sobering up after an Impressionist debauch."[1] It's easy to see why Impressionism looks like a binge and Cubism like a hangover: Impressionism is sloshy, full of too-bright colors, while Cubism is mostly muted tans and hard lines—hush, no loud noises while I recover from my headache; let me hold onto this ladder of lines while I try to haul myself upright. On the other hand, as we'll see, it may be that Cubist coffee leads to even more vertigo than Impressionist alcohol.

In several ways Cubism really is a kind of anti-Impressionism. We've seen that Impressionism is an ocular, anti-mental sort of art—the idea of the willow means little; the impinging of light glancing off leaves onto the retina means much. Cubism by contrast is an extraordinarily mental, anti-ocular sort of art: Picasso said explicitly, "I paint objects as I think them, not as I see them."[2] Now, most of us don't think of, say, a spectator at a bullfight as a scattered pile of papers figured with letters and curlicues suggestive of musical instruments, fight programs, pieces of clothing, and the occasional hunk of face or limb; we *think* the spectator as a coherent human body decorated with various insignia.

And yet, the coherent human body we outline in our heads is an artifact generated through our experience with various conventions of visual representation. Picasso plays games with these conventions, dismembers them. There's the face, recognized by schematics of lips, eyes, nose, but most of

Pablo Picasso, *L'Aficionado* (1912) Erich Lessing/Art Resource, NY. © 2015 Estate of
Pablo Picasso/Artists Rights Society (ARS), New York

all the mustache, which is asked to bear most of the aficionado's whole
identity system; in this Mr. Potato Head version of a human being, the mus-
tache looms over the other features. There's the picador's dart, which, along
with a few other signs, gives us the context of a bullfight. And there are
words, such as *torero*, which simultaneously provides a title-like caption in-
side the picture surface and suggests a program for the match—every sports
fan needs a program; how can you tell one bull from another without one?

 For comparison with the little schema of a front-facing body we all know
so well, let's turn to another way of *thinking* a human body. In ancient Egyp-
tian murals, a man is often depicted in a way that looks hopelessly twisted—
the shoulders and torso in full face, the head and legs in profile—*but* it gives

much more information about what a man looks like than a perspective representation. A full frontal foot or nose is a lame, unrecognizable thing, while a profile foot or nose is telling and characteristic; shoulders in profile have no definition, while full-face shoulders look strong and able. Go further than this: put a frontal eye on a profile face, and you're well on your way to Cubism, which is, among other things, a technique for giving maximum information. For the monocular fixed point of view of traditional perspective and Impressionism alike, the Cubists substituted a compound eye, not like a spider's compound eye, but like the visual system of a science-fictional snail with twenty eyes at the end of stalks, wrapping around the object, studying it from twenty perspectives at the same time. The painter's monstrous array of eyes converts the subject of the painting into a kind of monster. The Cubist painter has, in effect, *reasoned* himself or herself into this sort of vision of the human.

This method is cerebral in many ways. At about this time, Bertrand Russell was trying to eliminate subjectivity from philosophy by hypothesizing phantom perceivers that fill the gaps between real perceivers, so that if I look at a table from six feet away, and you look at the same table from twelve feet away and a bit to my left, Russell tried to guarantee the ontological validity of the table by imagining an infinite series of perceivers between six and twelve feet away, not to mention less than six and greater than twelve, and spread out left and right and up and down in all directions. The point was to try to isolate the table *an sich*, the ultimately there table independent of any mind that happened to behold it; this turned out to be part of the Cubist program as well.

To some, Cubism looked like a means for chasing down a visual representation of the thing purged from all accidents, the thing in all its luminous significance, in its purest state of being—something not far from the Platonic form of the thing so strongly repudiated by Nietzsche and Renoir (another anti-Impressionist aspect). The Cubist painters themselves were, to some extent, intellectuals: Juan Gris, for example, made an intent study of Poincaré and Einstein. And the spectators who first felt the shock of Cubist art considered it to be an overwhelmingly mathematical method: André Salmon gazed at *Les demoiselles d'Avignon* and saw not ghastly images of naked women but mathematical formulae expounded by a professor: "These are stark problems, white equations on a black-board. This is the first appearance of painting as algebra."[3]

If you look at the fourth woman, the squatting one, in *Les demoiselles*

Pablo Picasso, *Les demoiselles d'Avignon* (1907) Digital Image © The Museum of Modern Art/Licensed by SCALA/Art Resource, NY. © 2015 Estate of Pablo Picasso/ Artists Rights Society (ARS), New York

d'Avignon, you see a kind of mathematical composite: she's obviously seen from the rear, and yet her face is frontal, as if her neck, like an owl's, could swivel 180 degrees; furthermore, she crooks her right arm—though it's hard to be positive it's her right arm and not her left—as if facing front. Braque spoke of trying to paint an Absolute Woman, seen like a house blueprint "in plan, elevation, and section";[4] and Picasso's women are often synthetic in a similar manner. Behind the third figure, Picasso chops up pieces of sky—I think you can even see a fragment of sun—in forms that rhyme with the figure's elbow joint, nose, and breast cone: again, the air behind the figures repeats the instructions for cutting out and folding the paper dolls. Picasso evidently thought of entitling the painting *Le bordel philosophique*, and there is a strong sense that this is Plato's bordello, not *a* brothel but *the* brothel, the brothel translated into some sort of perfect arithmetic of sex. Picasso hoped that the spectator would feel able "to cut up" the canvas and put it

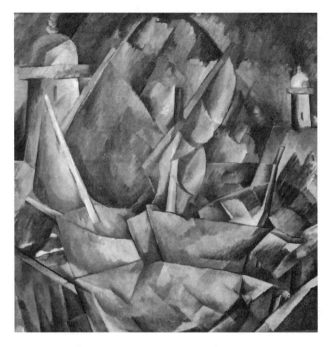

Georges Braque, *Harbor* (1909) © 2015 Artists Rights Society (ARS), New York/ ADAGP, Paris

back together again "according to the color indications . . . [and] find one-self confronted with a sculpture."[5] The excitement that Picasso and Braque felt at discovering a new way of representing volume is still contagious after a hundred years: Braque said that he felt that he and Picasso were "rather like two mountaineers roped together," and Picasso used to address Braque as "mon cher Vilbure," as if they were Wilbur and Orville Wright, the first painters who had learned how to fly.[6]

 Braque was unlike Picasso, though, in that he went farther in abolishing the distinction between figure and ground. Indeed, Braque understood him-self as a sort of researcher into the feel of space: "There is in nature a tactile space, I might almost say a manual space. . . . This is the kind of space that fascinated me so much, because that is what early Cubist painting was, a research into space."[7] In his *Harbor*, the sky is divided into checks exactly like the rocks on the bottom; indeed, one rock on the right is colored the same blue as the sky. The whole painting crinkles and bulges, as if the can-

vas had been crumpled and then smoothed out, but retained folds that stick out a bit, folds that your hand could feel if you rubbed the surface. Cubism is, so to speak, painting for the blind, painting in braille; it appeals to the mind's finger to generate its sense of depth. And it is here that we begin to find the Dionysiac character of this seemingly Apollonian, or even Socratic, art movement: (1) by dissolving the boundary between figure and ground, it tends to emphasize the primal oneness of experience—no *principium indi-viduationis* obtains (this Cubism has in common with Impressionism); and (2) by muting the visual, by appealing to a virtual sense of touch, by creating eerie facsimiles of whole-body experience, Cubism engages the depths of the human (this Cubism does not have in common with Impressionism).

Dionysus peeks from behind the cerebral games in many ways—sometimes quite explicitly, as in *Les demoiselles d'Avignon*, where the brothel seems a gaze into the abyss, into some prehuman australopithecine version of the self. In an early sketch for the painting, there was a seated male, intended to be a sailor, and a male to the left, intended to be a medical student with book and skull—as Robert Hughes has said, even without the medical student the painting looks like an allegory of venereal disease; and photos (printed by Francis Frascina in his study of Cubism) of faces so eaten away by syphilis that they became severe stylizations, noseless, akin to African or Iberian figures, only reinforce this feeling. The most radical face looks more concave than convex, as if it were a negative image of a face, a minus face, more an abyss than a human countenance. There are actual African masks, some of which Picasso may have known, that have a similar look.

For a basically cerebral sort of paint play, Cubism was saturated in magic from the beginning. Picasso called *Les demoiselles d'Avignon* an "exorcism" picture: "For me the masks were not simply sculptures, they were magical objects. . . . They were weapons—to keep people from being ruled by spirits, to help free themselves."[8] If this is indeed the first Cubist painting, the movement begins with demonic possession.

The very notion of using painting to seize some transcendental version or Platonic form of a thing—Absolute Woman, as Braque put it, Woman in all her dimensions at once—is magical, a transgression of the limits of the medium, a weird violation of taboo. The Cubists were to develop many ways of increasing the ontological intensity of painting, of hauling a painted image from a mere semblance to something equal in dignity with a physical object. Picasso went so far as to glue an actual object onto the canvas, in

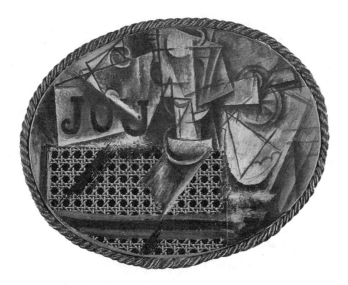

Pablo Picasso, *Still Life with Chair-Caning* (1912) © RMN-Grand Palais / Art Resource, NY. © 2015 Estate of Pablo Picasso / Artists Rights Society (ARS), New York

Still Life with Chair-Caning. The object is a bit of cloth printed to simulate chair-caning—in other words, a real object that fakes another real object, introduced onto a canvas in such a way that it's hard to tell if it's real or itself a painted fake, leading to a sort of delirium that abolishes the distinction between artificial and real, genuine and hoax. But it was Braque who did most with introducing a sort of materialism into Cubist painting. Sometimes he mixed sand or sawdust or some other substance into his pigments, so that the painting's texture had something of the physical world's grit in it. (Braque was the son of a housepainter and knew many tricks, such as raking a painted surface with a comb, common in the domain of the useful arts but little known in the world of the fine arts.) The idea that painting could improve its status from imitation to a kind of dignity of being-in-its-own-right was strong in Braque: as Braque's first important critic, Waldemar Georges, put it, "Anxious almost to excess to render not the ephemeral effect produced by colour, but its very essence, Braque introduced into his paintings extrapictorial substances. He thus produces ingenious compositions, in which the parts . . . don't represent reality but embody it and become confounded with it."[9]

All these introductions of the extrapictorial pertain not to analytic Cubism but to another kind of Cubism, often called synthetic Cubism (already in 1910 D. H. Kahnweiler was talking about ways in which Picasso sometimes synthesized information onto a canvas instead of making an "analytical description"; in a 1929 article Carl Einstein described Cubism's evolution from analysis to synthesis).[10] This distinction is fragile, but analytic Cubism deals with the breaking down of a single image (nude woman, for example) into a heap of semicoordinated spatial systems, whereas synthetic Cubism deals with the creation of hovering object complexes by means of juxtaposed pieces of objects, sometimes including actual things as well as pigment. It is a sort of painting that is both disturbingly illusionistic and disturbingly anti-illusionistic.

Cubist Literature

Cubism often transgressed media boundaries. Just as Symbolism has its synesthetic character, so Cubism—a late derivation of Symbolist magic, so to speak—deals in wrong sense organs. Braque's idea of manual space suggests that the canvas addresses itself to the sense of touch, and the frequent incorporation of sheet music, clef signs, erotic outlines of guitars into synthetic Cubist paintings suggests that you're supposed to hear the painting as well as see it—as in Picasso's *Guitar and Wine Glass* (1912). And, of course, you're supposed to read the painting as well, if scraps of newsprint or stencils are incorporated into it.

From here it isn't far to the idea that a poem might become a Cubist painting—an idea realized by Apollinaire in a book first called *Me, I'm a Painter, Too*, and then called *Calligrams*. One calligram, *Mandolin, Carnation, and Bamboo*, strongly refers to the visual vocabulary of Cubism, since stringed instruments, flowers, and pipes occur commonly in Picasso's work:

> May this carnation tell you the not-yet-promulgated law of smells that will come one day
> to reign over our brains truly precise and subtle as the sounds that guide us
> I prefer your nose to all your organs o my girlfriend
> It is the throne of future wisdom
>
> like the bullet through the body the sound runs through truth for reason that's your art woman
> o battles the earth trembles like a delirious thing

O nose of the pipe the smells-center O pipe-bowl they forge there the chains
O universe the chains infinitely disconnected that O connect the caves formal
reasons O

[Note: Apollinaire spells *raison* (reason) as *rai son* (ray sound).]

Le mandolin l'oeillet et le bambou is a hymn to the liberating powers of certain
odors, such as opium and perfume, an attempt to shape words into the sinu-
osity of fragrance. Apollinaire substitutes a syntax of contiguity for a syntax
of grammar: note how the curve of the mandolin that cradles the simile
"like the bullet through the body" operates as a sort of parsing diagram,
folding the phrase into its referent, "the sound." Apollinaire attempts to
heighten the referentiality of language by forcing the text into the form of
the thing spoken of. Its liveliness is so intense that one might compare Apol-
linaire to Debussy: with both there is an absence of conventional punctua-
tion, an attempt to force artifice to behave like nature. In a sense the Word
is made Absolute in this calligram: the Carnation is present in several differ-
ent modes of extension of itself, as the sentence ramifies like a growing
thing. The Cubist dream of giving volume to flat canvas here changes into
the hope that a kind of volume, tactile heft, can be given to words, as they
present themselves in manual space.

The other great Cubist poet was Gertrude Stein. As a Modernist, she was
at once startling, uncompromising, and good-humored, a rare combination.
She spent much of her childhood in Oakland, California (the place of which
she famously said, "There's no there there"), but as an adult she lived in Paris
and was for many years Picasso's closest friend. Her apartment was, for a
time, the best museum of modern art in Paris, though open by invitation
only; she had an acute eye for painting, and indeed her writing was itself a
kind of visual art, insofar as she claimed that it was addressed not to the ear
but to the eye. Picasso painted her portrait, and Stein "painted" Picasso
back, in a word portrait called "If I Told Him": "Would he like it would Na-
poleon would Napoleon would would he like it. . . . Shutters shut and open
so do queens. Shutters shut and shutters and so shutters shut and shutters
and so and so shutters and so and so shutters shut."[11] To compare Picasso
to Napoleon (imperially short) has its own aptness, but the shutters are the
principle matter of interest. I think that the shutters that seem to shut so
much more frequently than they open have something to do with the fac-
eted surfaces of Cubist painting, imaged as a network of closed windows at

Guillaume Apollinaire, *Mandoline, Carnation, and Bamboo* Wikimedia Commons

once hiding and bodying forth the subject—just as Stein's portrait at once hides and bodies forth Picasso. It is also possible that the compulsive sentence structure verbalizes the obsessive rhythm of Picasso's work habits, or the rhythm of Picasso's brush on canvas.

Sometimes Stein ventured into the verbal equivalent of pure pictorial abstraction, as in *An Elucidation* (1923):

> I know the difference between white marble and black marble. White and black marble make a checker board and I never mention either.

> Either of them you know very well that I may have said no.

> Now to explain.

> Did I say explanations mean across and across and carry. Carry me across.

> Another Example.

>> I think I won't
>> I think I will
>> I think I will

I think I won't.
I think I won't
I think I will
I think I will
I think I won't.
I think I won't
I think I will
I think I will
I think I won't
I think I will
I think I won't
I think I will
I think I won't.
I think I will
I think I won't
I think I won't
I think I won't
I think I won't
I think I will
I think I won't
Of course[12]

This is a game of making a text that embodies various checkerboard designs: if you think of *I think I won't* as a black square and *I think I will* as a white square, Stein presents you with

Stein printed on her stationery her famous sentence (from *Sacred Emily*, 1913) "Rose is a rose is a rose" arranged in a circle, and in many places you can see her writing struggling to assume visual shape.

Abstractionism

Gertrude Stein's "logographs" (as Samuel Beckett called them) can be understood as abstract art, and already in this book we've seen a number of ideas and images that move strongly toward abstraction, such as Wilhelm Worringer's argument that primitive cultures that prize geometrical designs do so out of a certain disdain for the organic world, as well as certain designs by Picasso difficult or impossible to construe as representations. Picasso did not believe that nonrepresentation was itself an important artistic goal, but elsewhere in Europe artists were entertaining that conviction.

In 1911 Wassily Kandinsky, a Russian painter settled in Munich and one of the founders of the school called *Der blaue Reiter*, argued that a nonrepresentational style was an advance in the art of painting, in that it liberated art from its dependence on the coarse and corrupt external world and sensitized its medium to spiritual vibrations in the ether: "The more abstract the form, the more clear and direct is its appeal. In any composition the material side may be more or less omitted in proportion as the forms used are more or less material, and for them substituted pure abstractions, or largely dematerialized objects. The more an artist uses these abstracted forms, the deeper and more confidently will he advance into the kingdom of the abstract."[1] Kandinsky, born in 1866, was part of the older generation of Modernists, but, trained as a lawyer, he came late to painting. *On the Spiritual in Art* is a kind of brief (1) for an antirepresentational mode of painting and (2) for erasing the boundaries that separate the various media. Behind both arguments there is a certain Gnostic sense that the material world is fallen, evil: the world apparent to our senses is a botched world created by an ignorant demiurge, and only by attuning ourselves to transcendental vibrations can we hope to attain salvation; as Schoenberg (also attracted to this sort of mysticism) once wrote in his *Kol Nidre*, "Myriads of sparks are

Wassily Kandinsky, *Improvisation "Klamm"* (1914) akg-images/© 2015 Artists Rights Society (ARS), New York/ADAGP, Paris

hidden in the world, but not all of us behold them." To obey the rule of representation is to compromise oneself with corruption.

On the other hand, not every sort of abstraction is good, either: Kandinsky had a certain mild contempt for the sort of designs suitable for "neckties or carpets"—the merely decorative.[2] What he wanted was an abstraction that has a certain creative power, a living abstraction. One way—not the only way—that an abstraction could show its essential strength was to hover on the brink of representation, as if it were a depiction of the force that brought a physical form into being, instead of the physical form itself. In Kandinsky's painting of a ravine, *Improvisation "Klamm,"* we can see how this works. At the bottom of the canvas you can (maybe) make out two human beings, and a boat landing, and a waterfall, but they're almost lost in the swirl of colors—as if Kandinsky were painting the geological energy that tore apart the ravine.

In other paintings, such as *Sketch for Deluge I*, the force seems as much destructive as creative, as if the material world were simply falling asunder. Here you can (maybe) see on the center left a horseman blowing a horn, as

Wassily Kandinsky, *Sketch for Deluge I* (1912) Norton Simon Museum, Museum Purchase with funds acquired from the Galka E. Scheyer Estate, for the Blue Four Galka Scheyer Collection. © 2015 Artists Rights Society (ARS), New York/ADAGP, Paris

if to announce the end of the world, as the mountains themselves seem swept away in the deluge—a bit of boat on the far right may indicate Noah's Ark. As Kandinsky wrote, "Technically, every work of art comes into being in the same way as the cosmos—by means of catastrophes, which ultimately create out of the cacophony of the various instruments that symphony we call the music of the spheres. The creation of the work of art is the creation of the world."[3] Every act of destruction in the physical world seems to be an act of creation in the spiritual world. Interestingly, Kandinsky used the vocabulary of modern science to describe the deconstruction of the physical world which he felt happening around him: as Kandinsky noted in 1911, "We find professional intellectuals who . . . finally cast doubt upon matter itself, which yesterday was the basis of everything, and upon which the whole universe was supported. The electron theory—i.e. the theory of moving electricity, which is supposed completely to replace matter, has found lately many keen proponents."[4] Rutherford's picture of the atom seemed as dematerializing as anything that could be found in the works of Madame

Blavatsky. In this way Kandinsky continues Pater's habit of looking to the physical sciences to approve counterintuitive outrages against the solidity of our surrounding world—the floor, the walls, the ceiling resolve themselves into a vibration, a shimmer.

In Kandinsky's very first full abstractions—by some accounts the first abstract paintings in Western art, though there are other candidates—a certain creative strength is felt. All of Kandinsky's early abstractions are watercolors, and they depict swimming blobs like paramecia and amoebas and diatoms—not the primitive organisms of the physical world, but the ones of the spirit.

As Kandinsky moved further into the kingdom of the abstract, he started to perceive vitality not in the biomorphs of the first abstract watercolors but in the intrinsic motility of paint itself. He thought that pigment doesn't just lie flat on the canvas, but blue tends to burrow in, and yellow tends to bulge out; pigment even tends to determine form: "keen colours are well suited by sharp forms (*e.g.*, a yellow triangle), and soft, deep colours by round forms (*e.g.*, a blue circle)." Furthermore, Kandinsky insists on the three-dimensionality of the picture plane: "The thinness or thickness of a line, the placing of the form on the surface, the overlaying of one form on another may be quoted as examples of artistic means that may be employed [to make a three-dimensional effect]."[5] Every Kandinsky abstraction is a virtual equivalent of an animated cartoon, in which lines swerve, swoop, tangle themselves ecstatically—the painting is a kind of aerial ballet of geometry. This is how to paint energy, instead of representational forms.

As to the second large point of Kandinsky's brief, the melting away of the boundaries that separate one artistic medium from another, this also is the result of an antimaterialist perspective. If matter means nothing, then it doesn't matter whether you're a painter or a composer or a poet—what counts is the artistic impulse behind the medium, not the material medium itself. A♭ and the color green and the word *love* are all just vibrations—vibrations in air, vibrations in ether. This is one reason for Kandinsky's fondness for Schoenberg: Kandinsky thought that Schoenberg's abandonment of tonality wasn't just an analogy for his own abandonment of representation, but the exact same thing, one expressed in music, the other in painting. And, of course, Schoenberg wasn't just a musician, but a painter himself; and Kandinsky wasn't just a painter, but a playwright—the artist is not at all bounded by the medium of his first mastery. A sample of Kandinsky's play *Der gelbe Klang* (1912) will show how a play and a painting can be almost the

same thing: it is a play almost without dialogue, consisting of stage direc-
tions: "The music is shrill and tempestuous, with oft-repeated *a* and *b* and *b*
and *a-flat* . . . the brilliant white light becomes progressively grayer. On the
left side of the hill a big yellow flower suddenly becomes visible. It bears a
distant resemblance to a large, bent cucumber, and its color becomes more
and more intense. . . . Later, in *complete silence*, the flower begins to sway
very slowly from right to left."[6] It is about as abstract as stage action can be,
a vague flower-cucumber that suddenly appears and starts, for no reason,
to move. In the introduction to the play, Kandinsky states his theory of the
equivalence of the artistic media as clearly as possible:

> The means belonging to the different arts are externally quite different. Sound,
> color, words!
>
> *In the last essentials*, these means are wholly alike: the final goal extinguishes
> the external dissimilarities and reveals the inner identity.
>
> This *final goal* (knowledge) is attained by the human soul through finer vibra-
> tions of the same. These finer vibrations, however, which are identical in their final
> goal, have in themselves different inner motions and are thereby distinguished
> from one another. . . .
>
> A certain complex of vibrations—the goal of a work of art.[7]

However, some sorts of transgressions between artistic media displeased
Kandinsky. He disliked paintings with narrative content—paintings based
on stories or fairy tales: "the literary element of 'story-telling' or 'anecdote'
must be abandoned as useless."[8] Now, Kandinsky's earlier work is full of
anecdotes and fairy tales, but he came to believe that a painting mustn't
be subservient to literature, mustn't be allegorical or illustrative, because
that would compromise its dignity. But if Kandinsky was uneasy about
paintings that transposed stories, he rejoiced in paintings that transposed
music. He used musical metaphors in describing the effect of abstract art—
understandably enough, since music has always been considered the most
abstract of the arts: "Color is the keyboard, the eyes are the hammers, the
soul is the piano with many strings. The artist is the hand which plays,
touching one key or another, to cause vibrations in the soul. . . . Scriabin . . .
has paralleled sounds and colours. . . . In 'Prometheus' he has given con-
vincing proof of his theories."[9] Kandinsky saw his painting as a keyboard
that struck chords in the emotional/spiritual centers of the brain, compa-
rable to the light-keyboard that the composer Alexander Scriabin, one of
the great synesthetes in Western art, used in *Prometheus* (1910) to accom-

pany his mystic chords—though the color organ went haywire at the first performance.

Although Kandinsky delighted in the avant-garde music of Schoenberg and Scriabin, it was Wagner who helped inspire him to be a painter—and Wagner's notion of the *Gesamtkunstwerk* (total artwork—in which poetry, music, and painting all work together toward a unified effect) helped inspire Kandinsky's theory of the oneness of the arts. Here is Kandinsky's account of how he became a painter:

> I experienced two events that stamped my whole life and shook me to the depths of my being. These were an exhibition of the French Impressionists in Moscow—first and foremost, *The Haystack*, by Claude Monet—and a performance of Wagner at the Court Theatre—*Lohengrin*.
>
> Previously, I had known only realistic art. . . . And suddenly, for the first time, I saw a *picture*. That it was a haystack, the catalogue informed me. I didn't recognize it. I found this nonrecognition painful, and thought that the painter had no right to paint so indistinctly. I had a dull feeling that the object was lacking in this picture. And I noticed with surprise and confusion that the picture not only gripped me, but impressed itself ineradicably upon my memory, always hovering quite unexpectedly before my eyes, down to the last detail. It was all unclear to me, and I was not able to draw the simple conclusions from this experience. What was, however, quite clear to me was the unsuspected power of the palette, previously concealed from me, which exceeded all my dreams. Painting took on a fairy-tale power and splendor. And, albeit unconsciously, objects were discredited as an essential element with in the picture. . . .
>
> [In] *Lohengrin* . . . I saw all my colors in my mind; they stood before my eyes. Wild, almost crazy lines were sketched in front of me. . . . It became . . . quite clear to me that art in general was far more powerful than I had thought, and on the other hand, that painting could develop just such powers as music possesses.[10]

But Kandinsky, of course, did not want to paint stage sets for Wagner operas; he wanted to make paintings that were themselves complete *Gesamtkunstwerke*, paintings that trembled on the verge of becoming music, paintings that were poems of the apocalypse.

8 Primitivism

The desire to capture the body leads to a fascination with Primitivism, on the theory, perhaps not completely obvious, that in prehistoric times people lived more intensely corporeal lives than we desiccated civilized folks live today. Insofar as Cubism began with *Les demoiselles d'Avignon*, with its famous right-hand nude whose head is an African mask, Cubism has a strong Primitivist impulse: you reduce visual phenomenon to cube, cylinder, cone, the elementary forms of perception, as if savages saw stark rudiments instead of the surfaces of things. Indeed, Picasso helped create a vogue for African art, as we can see in a passage from Lawrence's novel *Women in Love* (1920), in which the hero remembers an African statuette that he saw in the living room of a London painter with advanced taste:

> It was a woman, with hair dressed high, a tall, slim, elegant figure from West Africa, in dark wood, glossy and suave. It was a woman, with hair dressed high, like a melon-shaped dome. He remembered her vividly: she was one of his soul's intimates. Her body was long and elegant, her faced was crushed tiny like a beetle's, she had rows of round heavy collars, like a column of quoits, on her neck. He remembered her: her astonishing cultured elegance, her diminished, beetle face, the astounding long elegant body, on short, ugly legs, with such protuberant buttocks, so weighty and unexpected below her slim long loins. She knew what he himself did not know. She had thousands of years of purely sensual, purely unspiritual knowledge behind her . . . knowledge such as the beetles have, which live purely within the world of corruption and cold dissolution. This was why her face looked like a beetle's: this was why the Egyptians worship the ball-rolling scarab.[1]

Modernist Primitivism tends to be just such a mixture of fascination, disgust, and something like terror: the statuette is, for Lawrence, an image of

a knowing body, a body that Western civilization has lost through the bleaching, attenuating effect of cerebral thought—a body that is the source of wonder, and yet is intimate with dung and pus. The copresence of sexual desire and sexual anxiety, the eerie intimacy of love and death—these are the motivating forces of Primitivism, from Gauguin's Tahiti to Picasso and onward.

Primitivism in music tends to differ from Primitivism in literature and painting, in that the darker side is sometimes minimized. When folk song researchers carried their recording equipment to out-of-the-way places, they reported their experiences in an almost completely positive manner: here, in Transylvania or Lincolnshire, was something unspoiled and precious. One such researcher was the Australian-born Percy Grainger, who spoke of the primitive in the most ebullient manner conceivable: Grainger considered "the root emotion of my life: the love of savagery, the belief that savages are sweeter and more peaceable and artistic than civilized people, the belief that primitiveness is purity and civilization filthy corruption, the agony of seeing civilization advance and pass its blighting hand over the world."[2]

But musical Primitivism wasn't a matter of pure research; it also involved the application of the fruits of research into sophisticated new contexts. And when folklore-collecting composers wrote pieces that evoked the archaic instead of directly transcribing, the pieces often had something of the frightening quality that Lawrence found in African statuettes. When the Hungarian composer Béla Bartók transcribed real folk dances from Romania, he wrote music that was exciting, catchy, cheerful. But when Bartók wrote a Primitivist piece of his own, as in his *Allegro barbaro*, the effect is different. This piece uses some of the rhythmic tricks that Bartók found in his folk research, but there's a frenzy, a savagery to it not found in the originals: this is music for Neanderthals as imagined by one of the most sophisticated musical intelligences of the twentieth century. Indeed, it's possible that it's a sort of parody of the barbaric: at this level of advancement it's hard to tell Bartók's intention. The piece might evoke barbarians, or it might invoke a modern factory or the boiler room of a steamship. Modernism is a movement in which extremes converge: for example, the up-to-date and the prehistoric often become one and the same, and the whole urgent complex of attraction and revulsion is clearly on display.

Value: The law of parity: every value system presupposes a countervalue exactly equal.

Bartók's stage pieces, such as *Duke Bluebeard's Castle* (1911, 1918) and *The Miraculous Mandarin* (1918-19, 1926), depict not cheerful peasants clapping their hands in a round dance, but Symbolist spectacles full of sadism and angst—such as a murdered Mandarin, stabbed repeatedly, dripping blood, who refuses to die until he embraces a prostitute. Even in Bartók's music, the ritualistic aspect of Primitivism is sometimes transposed into expressions of terror, terror before archaic sexual intensities that are beyond our power to comprehend.

Similarly, in the most famous of all Primitivist experiments, *The Rite of Spring*, the chief rite of spring is the mass execution of a virgin. The defining moment of Modernism—not just in music, but in all the arts—took place on a hot day in Paris, 29 May 1913, at the première of Stravinsky's ballet. This established the gold standard for twentieth-century artistic scandals: from that day on, young composers such as George Antheil clung to the hope that they, too, could achieve a comparable riot. At *The Rite of Spring*, a rite of spring occurred in the auditorium as well as on stage.

The ballet had a rich cast of characters. The organizer of the Ballets Russes was Serge Diaghilev (Sergei Dyagilev), a man of sensitive taste in the field of the astonishing. The importance of his work as an impresario cannot be overstated. He promoted many different kinds of musical stagecraft, but his initial notoriety grew out of his presentations of flamboyant, sexually charged, sensorily overloaded exoticism—the advanced art of Russia, often of an orientalizing tendency, was little known in the West. He changed forever the notion of ballet.

There is nothing odder about the careers of Diaghilev and of Stravinsky himself than the fact that they chose to make their reputations in the field of ballet. Ballet at the turn of the century was a threadbare, somewhat disreputable genre. With the exception of Tchaikovsky's three masterpieces and a few works by Adam and Delibes, the music of repertory ballets tended to be perfunctory if not actively awful. Degas's endless paintings of ballet dancers usually show not dancers taking wing in ecstatic leaps, but somewhat put-upon, garish, even seedy girls going through mechanical exercises. Sometimes toward one side there stands a man with a stick, presumably to beat time, but also perfectly capable of beating the girls; Degas's ballet pictures, like many of his pictures of women, have a deliberately contorted, somewhat unpleasant quality, as if he were investigating the aesthetics of painful twists and extensions of the body. A Degas dancer tends to be a woman twisting herself in order to please a man; and in Degas's day, the

Lev Bakst, *Nijinsky as Faun* Wadsworth Atheneum Museum of Art / Art Resource, NY

ballet had the reputation of a venue where wealthy men inspected the sup-
ple charms of young women with an eye toward finding mistresses.

Diaghilev changed all that. His lead dancer and chief sex object at the
time was male: Vaslav Nijinsky, a short, somewhat stocky man capable of
inhumanly high leaps—one critic called him a "celestial insect." Nijinsky
wasn't entirely drawn to men, but he was willing to become Diaghilev's
lover. Some critics charge Diaghilev with single-handedly homoeroticizing
the whole art of ballet. Nijinsky appeared on stage in a variety of roles, from
blue god to slave sex toy—these roles were often Dionysiac in character,
but highly mannered, as portrayed in Lev Bakst's *Nijinsky as Faun*. Here is
Nijinsky as the faun in the famous ballet of Debussy's *Prélude à l'après-midi
d'un faune*, choreographed by Nijinsky himself. Nijinsky did little work as
a choreographer, but his work in that field was astonishingly original: he
conceived the faun ballet as a Greek frieze, in which the dancers appeared

almost exclusively in profile. The end of the ballet caused a great scandal: Nijinsky as the faun grabbed the scarf of the nymph as she danced out of his grasp, and he proceeded to masturbate with the scarf as the curtain came down. But this scandal was nothing compared to the scandal of another ballet he choreographed, *The Rite of Spring*.

The painter mainly responsible for the ritzy, glitzy riot of oriental color was Bakst, but the painter of the stage sets for *The Rite of Spring*, as well as the ballet's scenarist and chief instigator, was Nicholas Roerich (Nikolay Ryorikh), painter, archeologist, and folklorist, specializing in pagan Russia. Roerich's scenario for the ballet described the ceremonies and ritual games preparatory to the sacrifice of a virgin, the Elect, the chief female character, to the pagan sun god Yarilo. The nineteenth-century folklorist Alexander Afanasyev, whose monumental works Roerich read carefully, described Yarilo as follows: "The significance of Yarilo is wholly explained by his name ["ardent god"] and in the surviving traditions associated with him. The root yar' combines within itself the ideas: (a) of vernal light and warmth, (b) of youthful, impetuous, violently awakening forces, (c) of erotic passion, lasciviousness, and fecundation: ideas inseparable from the manifestations of spring and its terrifying phenomena."[3] Yarilo, then, is the god of the spring thaw; and Stravinsky sometimes claimed that his music was inspired by memories of the "violent Russian spring that seemed to begin in an hour and was like the whole earth cracking."[4]

The Yarilo of Afanasyev and Roerich is one of a number of European attempts to understand a savage, preconscious, archaic seizure of feeling. In the eighteenth century, Giambattista Vico and Johann Gottfried Herder tried to understand the savage mind as a sort of continuous fantasia of divine presence; as Herder put it, the "savage saw the tall tree with its mighty crown and sensed the wonder of it: the crown rustled! There the godhead moves and stirs! The savage falls down in adoration! . . . Everywhere gods, goddesses, acting beings of evil or of good. The howling storm and the sweet zephyr, the clear source and the mighty ocean."[5] Indeed, Nietzsche's Dionysus can be understood as an attempt to ground the truth of the civilized human condition in old ideas of the prehistoric condition.

The sources of the music's uncanny power have been the object of speculation ever since the first performance. As the result of the work of Richard Taruskin and others, it is now clear that Stravinsky's music was built up out of fragments of folk tunes, as if Stravinsky were trying to approach the prehistoric by consulting the research of folklorists: in distant corners of Russia

Nicholas Roerich, *The Great Sacrifice* (1910) Wikimedia Commons

were some specimens of archaic music that might be dug up, like frozen mammoths, out of the tundra. The melody in the first bars of the prelude, played by a bassoon in a bizarrely high register, is itself taken from an anthology of folk tunes that Stravinsky consulted. The sonority is supposed to evoke the sound of the dudki, a pagan Russian wind instrument. But Stravinsky's archaism isn't the result simply of quoting folk songs: he also keeps alluding to a sort of implied kinesthesia of neolithic existence. What would you feel like if you were a barbarian? Well, I think that Stravinsky answered that question as follows: barbaric life consists of bouts of lethargy interrupted by spasms of grotesque excitement. In other words, you would be living the life of a bear, hibernating much of the time, but sometimes rousing yourself to chase and tear apart your quarry.

I suspect that Stravinsky made much use of Roerich's bearskins in trying to imagine the music. Stravinsky liked bears: in his previous ballet, *Petrushka* (1911), a dancing bear appears at the carnival, and in fact a sort of ursine torpor is an important part of *Petrushka*'s musical dialectics, since Petrushka's rival, the Moor, is assigned galumphing, stompy music, much like that of the bear. In *The Rite of Spring*, too, heaviness-in-music is present in many places, as if Stravinsky were thinking of winter sloth that resists the energizing of Yarilo. In the second act (as Roerich specified) the bear, in fact a whole group

Valentine Hugo, watercolor of rehearsal for *The Rite of Spring* © 2015 Artists Rights Society (ARS), New York/ADAGP, Paris/Victoria and Albert Museum, London

of bears, or at least were-bears, will circle around the Elect—in fact, one of the earliest signs of the impulse that led to *The Rite of Spring* can be seen in a 1910 picture by Roerich, *The Great Sacrifice*, though here the ritualists are not were-bears but were-moose.

Heaviness is significant in the choreography too. The movements of classical ballet are expansive, poised, pigeon-toed, turned out; the movements of the dancers in *The Rite of Spring* were huddled, hunched, knee-buckled, turned in. Classical dancers seem on the brink of escaping the pull of gravity; Nijinsky's dancers seemed to live on a planet like Jupiter—they stooped under the weight of their own bodies. Valentine Hugo's watercolor from the initial rehearsals shows that the dancers, far from flying, are crouching. At the original performances, the dancers complained that they found it physically painful to jump in the air and land flat-footed, as Nijinsky commanded; and yet these calculated awkwardnesses seemed to possess a sort of grace of force. Indeed, it is now thought that the *Rite of Spring* riot was a response less to Stravinsky's music, which could scarcely be heard amid the uproar, than to Nijinsky's choreography, which inverted most of the conventions of ballet.

Opposed to this dragging of leaden feet in the round dance, there are, of course, many sorts of elation. Often horn calls blat out as if summoning the dancers to some bloody ritual, as in the section about the games of the rival tribes. The score is unthinkably complex, and yet it's made out of extremely simple elements: folk motives, trivial duh-DUH horn calls, and hard bits of rhythm. This agglomerating of the simple into the complicated may recall the procedures of Cubism: a few elementary shapes are put together in all sorts of intricately wrong ways. Perhaps the most Cubist (in this sense of the word) section of the score is the penultimate section of the quite incredible final dance, where a simple five-note pattern (C-Bb-Ab-C-D and similar phrase shapes) is endlessly out of sync with itself. In folk music there is a technique called heterophony, in which a melody is sung by several singers at the same time, but only approximately in the same tempo: some singers are going too fast, some too slow, some too high, and so forth. This section of the *Danse sacrale* is a sophisticated imitation of heterophony: as the dancer nears death, the musical lines go out of tune and out of rhythm in all directions at once, as if they were fuzzing out into the whole audible spectrum— the abyss. Of course, this effect is calibrated to the last hair: it's a supremely controlled loss of control.

Sometimes in the score you hear half-familiar things that tease your ear to try to place them. I hear a number of Spanish gypsy tropes in the ecstatic sections of the ballet—there may be a certain Mediterranean character to Stravinsky's sexual imagination. Consider, for example, the final section of the final dance, where, in Stravinsky's words, "When she [the Elect] is on the point of falling exhausted, the Ancestors recognize it and glide toward her like rapacious monsters in order that she may not touch the ground; they pick her up and raise her toward heaven. The annual cycle of forces which are born again, and which fall again into the bosom of nature, is accomplished in its essential rhythms."[6] This is all very highfalutin, but it looks in practice, at least in the Hodson reconstruction of the original ballet, a bit like a cheerleader calling out "Give me a V!" while doing a sort of Atlanta Braves tomahawk chop—in a strange way maybe all the more impressive for these strange orthogonals to homely late twentieth-century practices. Some of the basic material is commonplace: the descending tetrachord (for example, C-Bb-Ab-G), the basis of a great many old Italian and Spanish dances, is heard everywhere—if you listen to, say, Padre Soler's fandango (eighteenth century), you can hear Stravinsky's final dance as a mad heap of unrelated fandangos. It is disconcerting to think of fandangos in connection

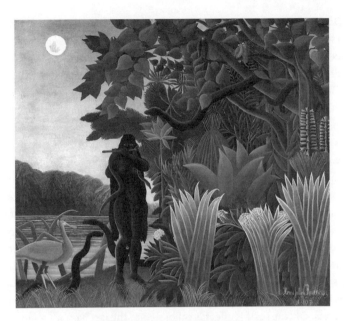

Henri Rousseau, *The Snake Charmer* (1907) Wikimedia Commons

with the pagan rites of this ballet, but the simple effective harmonic patterns of a fandango are part of the elementary stuff of music.

Perhaps I might compare Stravinsky's way of isolating and magnifying small familiar musical details to the practice of the great Primitive painter Henri Rousseau. Seduction and fatal danger are part of Rousseau's exotic landscape. But the jungle is just overgrown houseplants, as if savage wilderness consists chiefly of big philodendrons. Similarly, Stravinsky will take a commonplace gypsy riff and construct a gigantic fantasy of the prehistoric rite. It is even possible, in the *Auguries of Spring*, to hear the stamping of flamenco dancers' heels above the strumming of a guitar if you're in the right mood. Of course, other people have heard other things: in 1940 Walt Disney choreographed this section for a small troupe of erupting volcanoes. Stravinsky dismissed Disney's movie as an "unresisting imbecility,"[7] but something like geologic upheaval, the rendering asunder of worlds, seems perfectly plausible; it also rids the ballet of human subjects, who were always something of an embarrassment. Stravinsky came to prefer hearing *The Rite of Spring* in the concert hall, and it in fact lends itself well to abstraction from the theater.

I've been stressing the concrete aspects of the ballet, but it can also be understood as abstract. Much of *The Rite of Spring* consists of games, so labeled in the scenario and the score: the abduction game, the game of the rival tribes—that is, mock rape, mock war; even the final dance, where real blood is shed, is a kind of game. The ropes of dancers winding across the stage seem to me unusually faithful to the fact that *The Rite of Spring* is, at all levels, a kind of sublime hopscotch. Just as Cubist painting is a magical seizure of reality and a game of piecing blocks together, so this ballet is an image of the deepest convulsions of the body and of the disengaged play of the mind.

The critics at the early performances of *The Rite of Spring* were oddly split between those who were transported to pagan Russia and those who saw an exercise in abstract movement. One reviewer was struck by Nijinsky's "use of the human body to realize arbitrary conceptions of movement, to devise a scale of gesture just as abstract as a scale of musical notes," and compared the ballet to nonrepresentational painting;[8] another spoke of "the fallacy of Nijinsky's exacerbated 'cerebralism.' . . . What is there cerebral and intellectual in Stravinsky's superhuman force, in the athleticism of his brutal art that continually parries direct hits to the stomach and right hooks to the chin?"[9] The ballet seemed extraordinarily abstract and concrete at the same time: at once a pure play of arbitrary forms and a punch in the gut. But perhaps the wisest of all reviewers didn't hear the music until 1921, when T. S. Eliot wrote that the music seems to "transform the rhythm of the steppes into the scream of the motor-horn, the rattle of machinery, the grind of wheels, the beating of iron and steel, the roar of the underground railway, and the other barbaric noises of modern life."[10] So we see again that extremes converge: in the domain of Modernism, *The Flintstones* and *The Jetsons* are always the same show.

Imagism

Primitivism and Expressionism and Futurism tend toward an aesthetic of sensory overload: they often seek to blast and bombard the spectator into a state of excited submission. But at the same time, there were other elements in Modernism that worked toward terseness, precision, moderation: after the Great War, these elements consolidated into a major movement, Neoclassicism, but even before the war started, we find stirrings toward a sort of minimalism—especially in England.

One of the earliest statements of a new, anti-Expressionist aesthetic appeared in T. E. Hulme's 1911 essay "Romanticism and Classicism": Romanticism had shown itself to be messy, gassy, always burbling off into the infinite, Hulme says. He advocated instead a Classical art, hard and dry: "To the one party man's nature is like a well, to the other a bucket. The view which regards man as a well, a reservoir full of possibilities, I call the romantic; the one which regards him as a very finite and fixed creature, I call the classical."[1]

In the next year, 1912, three poets living in London—Ezra Pound, Richard Aldington, and H.D. (the pen name of Hilda Doolittle—she and Pound had considered marriage in 1907, when he was a graduate student at the University of Pennsylvania)—devised a program called Imagism, with (as we noted at the very beginning of this study) three tenets:

1. Direct treatment of the "thing," whether subjective or objective.
2. To use absolutely no word that does not contribute to the presentation.
3. As regarding rhythm: to compose in the sequence of the musical phrase, not in the sequence of a metronome.[2]

As the name *Imagism* suggests, this was a strongly visual form of poetry. The Imagists sought a sort of minimum pictorial residue in language, as if, by

eliminating all decorative, adjectival aspects of speech—"Use no superflu-
ous word"—one could arrive at some stark icon of the thing being written
about. Just as Picasso and Braque suppressed color in order to arrive at jag-
ged truths of form, so the Imagists tried to suppress extraneous description
in order to arrive at some hard, irreducible fact.

Just as the Cubists had to arrive at a stripped-down image that was not
the obvious limit of reduction (the most obvious would perhaps be some-
thing like a high-contrast black-and-white photo of an object, or the sort
of pictograph seen on roadside signs to mean "Children Crossing," or "No
Fishing"), so the Imagists knew that it wasn't enough to, say, write the
single word "Dog" and claim that this was the most excellent poem that
could be written about a cocker spaniel. Still, I think it's fair to say that the
Imagists, inspired by the physics of Ernest Rutherford and others, were
seeking something equivalent to an atom of poetry. What is the basic unit
of a poem, the poem-proton? The Imagist answer to this question turned
out to be surprising.

The first stage in its discovery was to eliminate the most obvious candi-
date, the symbol. If an older poet like W. B. Yeats taught that the world is "a
dictionary of symbols," Pound denied it, in a 1914 letter to his fiancée:
"There's a dictionary of symbols, but I think it immoral. I mean that I think
a superficial acquaintance with the sort of shallow, conventional, or attrib-
uted meaning of a lot of symbols *weakens*—damnably, the power of receiv-
ing an energized symbol."[3] For Yeats, a symbol acquired its symbolic value
slowly, patiently, a nacreous accretion of meaning over the history of lan-
guage; he even told Virginia Woolf that no poet today could use the word
steamroller, but after many centuries it might be all right to use that word
in a poem. For Pound, familiarity bred contempt: the purpose of art was to
defamiliarize, to create a shock of novelty; as he later wrote, poetry should
be "a scaling of the eye-balls, a castigating or purging of aural cortices; a
sharpening of verbal apperceptions."[4] He even compared the poet to a bur-
glar who scrapes the skin off the tips of his fingers so that he will be sensi-
tive enough to feel the turning tumblers of the combination lock to a safe.
A symbol, to Pound, is conducive to a sort of anesthesia, whereas an image
should create a sharp sense of the whole physical presence of the imaged
thing. It fascinates me that Pound described the new art of Imagism in ex-
actly the same terms that Braque used to describe the new art of Cubism:
just as Braque believed in tactile space, wanted to make every part of his
painting appeal to the sense of touch, Pound wanted a poem to have a

strongly tactile aspect. Here is Pound in 1912 discussing the inadequacies of Impressionist literature: "[Ford Madox Ford's] flaw is the flaw of impressionism, impressionism, that is, carried out of its due medium. Impressionism belongs in paint, it is of the eye. The cinematograph records, for instance, the 'impression' of any given action or place, far more exactly than the finest writing, it transmits the impression to its 'audience' with less work on their part. A ball of gold and a gilded ball give the same 'impression' to the painter. Poetry is in some odd way concerned with the specific gravity of things, with their nature."[5] Pound wanted symbols that, so to speak, symbolize their own physical properties, and nothing but their own physical properties; they are surrogates, not for some abstract meaning, but for the sensuous immediacy of the object to which the word refers. The Impressionist deconstructs the physical object being studied, so that the poem may fume away into a rapid succession of instantaneous sensations; but Pound gathers, clenches his symbol—what he calls the image—into a state of dense thingliness. Braque thought he could paint an Absolute object; Pound thought he could capture in writing a permanent image, in its full heft and heave.

An image, then, doesn't stand for anything outside itself, as Pound says in his 1918 commentary on his 1913 "A Few Don'ts of Imagism": "I believe that the proper and perfect symbol is the natural object, that if a man use 'symbols' he must so use them that their symbolic function does not obtrude; so that *a* sense, and the poetic quality of the passage, is not lost to those who do not understand the symbol as such, to whom, for instance, a hawk is a hawk."[6] Yeats wrote often about hawks and other raptors as symbols of solitude and self-mastery:

> The ger-eagle has chosen his part
> In the blue deep of upper air
> Where one-eyed day can meet his stare:
> He is content with his savage heart.[7]

But Pound insists that the poet limits his or her own work by demanding a single specific interpretation; the Imagistic method, on the other hand, respects the reader, leaves the poem open to the reader's experience of the world. As he says in 1914, "Imagisme is not symbolism. The symbolists dealt in 'association,' that is, in a sort of allusion, almost of allegory. They degraded the symbol. . . . One can be grossly 'symbolic,' for an example, by using the term 'cross' to mean 'trial.' The symbolist's *symbols* have a fixed

value, like numbers in arithmetic, like 1, 2, and 7. The imagiste's images have a variable significance, like the signs *a*, *b*, and *x* in algebra."[8] Again, the symbol has a narrow value, while the image has a full value: the Symbolist's hawk has a thin spectrum of arbitrarily assigned meaning; the Imagist's hawk means everything that a hawk is, a smelly bird that weighs 0.38 kilograms and possesses such keen eyesight that it can see a mouse from 200 feet in the air and swoop down at 110 feet per second. A word, for Pound, was not a mere breath of air, but a kind of placeholder for something hard and heavy: in 1916 Pound recommended to poets "a trust in the thing more than the word. Which is the solid basis, i.e. the thing is the basis."[9]

But how do you invest the poetic object with depth and volume? Obviously you can't enumerate its qualities, because enumeration is an expansive, descriptive method: the Imagist program depends on concentration, elimination, deletion. Pound disliked verbal abstractions, but he was much interested in pictorial abstractions and wanted to make a poem that approached the limit in reduction of the picture—and he alleged that avant-garde painting had shown him how to do this. An image should be a deleted picture, a stark splash of meaning:

> Three years ago in Paris I got out of a "Metro" train at La Concorde, and saw suddenly a beautiful face, and then another and another, and then a beautiful child's face, and then another beautiful woman, and I tried all that day to find words for what this had meant to me, and I could not find any. . . . And that evening, as I went home along the Rue Raynouard, I was still trying, and I found, suddenly, the expression. I do not mean that I found words, but there came an equation . . . not in speech, but in little splotches of colour. It was just that—a "pattern," or hardly a pattern, if by "pattern" you mean something with a repeat in it. . . . If I had the energy to get paints and brushes and keep at it, I might found a new school of painting, of "non-representative" painting, a painting that would speak only by arrangements of colour.
>
> And so, when I came to read Kandinsky's chapter on the language of form and colour [from *Concerning the Spiritual in Art*] . . . I found little that was new to me. . . .
>
> The "one image poem" is a form of super-position, that is to say it is one idea set on top of another. I found it useful in getting out of the impasse in which I had been left by my Metro emotion. I wrote a thirty-line poem, and destroyed it because it was what we call work "of second intensity." Six months later I made a poem half that length; a year later I made the following *hokku*-like sentence:—

"The apparition of these faces in the crowd:
 Petals, on a wet, black bough."[10]

Pound's term "non-representative" is somewhat misleading: the poem is *bi-representative*, abstract because doubly concrete. It constructs a new noun that hovers tensely between two old nouns. An image, then, is both one and two. Pound achieved this semantic hybrid, this visual minimum, by paring down a verbal description of an object until it becomes an *image* both of its original and of something else. An Imagist poem, then, is a stereoscopic presentation of two things which suggests some single Absolute form beneath them. "In a Station of the Metro"—the haiku-like poem quoted at the end of this passage—summarizes the luminous faces on the subway platform and the petals on the bough, glistening with wetness, into a single, highly contrasted, rather Orientalist linear arrangement. As we've seen, Kandinsky, especially around 1912, liked to play at the threshold state where recognizable forms tremble at the brink of becoming unrecognizable, turn into pure abstraction. And Pound is playing exactly Kandinsky's game, in that the faces in the subway are settling, hardening, into a rigid visual arrangement of circular inflorescences arranged along a line.

Pound's great hero among Modernist visual artists was the Franco-Polish sculptor Henri Gaudier-Brzeska. Gaudier's most ambitious work was perhaps *Hieratic Head of Ezra Pound* (1914), which looks in the front like a planar simplification of Ezra Pound's head, and in the back like an erect phallus—a sort of bi-representational game, a visual pun, in which Pound's head and the phallus find their common denominator in the shape of a cylinder. In order to keep a roof over his head, Pound worked for many years as an art and music critic, and much of his best art criticism concerns Gaudier, especially his statue *Red Stone Dancer*. Pound was especially intrigued by the triangle and other simple geometrical figures in this statue. He considered that Gaudier had managed to make these abstract figures constitute themselves carnally, as a kind of transcendental flesh. An abstract sculpture is not cold or forbidding or detached from life, but warm, vigorous, the appropriate idol for life-defining energies: "The triangle moves toward organism, it becomes a spherical triangle (the central life-form [in] Brzeska). . . . The 'abstract' or mathematical bareness of the triangle and circle are [*sic*] fully incarnate, made flesh, full of vitality and of energy."[11] The geometry gives a certain monumentality and purity to the dancer; the dancer gives a certain vivacity to the geometry. The bulging outward of the triangle into the spheri-

Henri Gaudier-Brzeska, *Red Stone Dancer* (ca. 1913) Tate, London / Art Resource, NY

cal triangle suggests the vivifying impulse itself. Implicit in Gaudier's sculp-
ture, to Pound, is an Imagist poem, which I make up as follows:

> The dancer thrusts her arm between her breasts:
> Three corners try to turn into a ball.

By 1914 Pound decided to replace the static term *Imagism* with the dy-
namic term *Vorticism*, partly under the influence of his colleague Wyndham
Lewis, partly because Pound wanted to emphasize the process more than
the product. Lewis may have invented the word *Vorticism* (the claim is dis-
puted), and a famous 1912 picture by Lewis, *Alcibiades*, from the *Timon of
Athens* series, shows just how active a picture in a quasi-Cubist style can
be. The painting shows a helmeted human figure echoed by other helmeted
human figures incised into a number of receding, knife-edged planes, bur-
rowing into the far depths of pictorial space—this picture derives its force
from its tilted repetitions, a whole deck of playing cards figured with chess
bishops. The extraordinary power of these images to drop deep into the
picture plane is like nothing I know by Picasso or Braque: there's a sort of
vertigo here, as if the planes at the edge are near the surface and a very

Wyndham Lewis, *Timon of Athens* (1912): *Alcibiades* Victoria and Albert Museum, London, UK/© The Wyndham Lewis Memorial Trust/Bridgeman Images

slow whirlwind is pushing the central figures inward. It is a painting in the shape of a vortex, though there is nothing messy or chaotic: all is hard and determinate.

Vorticism as a movement in the visual arts encompassed photography as well as painting: around 1915 an American photographer named Alvin Coburn invented a device that Pound called a *vortoscope*, in which the camera lens was aimed through a triangular prism created by placing three mirrors together (facing one another). The triangles tended to make abstract wedge shapes that made distinctly vortical patterns. Pound wrote the catalogue for Coburn's 1917 exhibition and considered that Coburn was in effect taking Picassos from nature; one might say that he was making explicit the kaleidoscope that always lay somewhere behind the Cubist style. To break down visual reality into a little whirlwind of spinning mirrors, to see the object

from many sides simply by normal optical trickery, this was almost giving away the joke of Cubism. Seen through a vortoscope, anything can look like a vortex, even Pound's face, as one well-known vortograph shows.

Is it possible to write a vortex-shaped poem? The account of the composition of "In a Station of the Metro" vorticizes the poem, so to speak, by providing an account of how it funneled down from something cloudy into something hard. Indeed, some Imagist poems by H.D. go far to suggest the whole process whereby objects in one domain attain some sort of formal equivalent in another domain, as we see in her poem "Oread" (1914), which Pound cited as a prime example of Vorticism:

Whirl up, sea—
Whirl your pointed pines,
Splash your great pines
On our rocks,
Hurl your green over us,
Cover us with your pools of fir.[12]

The whole field of operation transposes from ocean to mountain. An oread is a mountain nymph; and it seems that a naiad, a water nymph, has discovered herself high and dry, for the whole seascape has relocated itself on land (it may be relevant that Pound's nickname for H.D. was dryad, or tree nymph). Not only do static things like lines of faces on a subway have formal equivalents; moving things also have shape, and pines seem to eddy on a mountainside in the way that water eddies in a rock pool. Note that this poem is *about* a vortex, for a vortex is one of the most striking forms of shaped energy. A magnet can turn iron filings into a rose, as Pound would write much later in Canto 74, a most Vorticist sort of idea.

Vorticism assumes that artistic energies grow concentrated on a point, as Pound wrote in 1914: "The image is not an idea. It is a radiant node or cluster; it is what I can, and must perforce, call a VORTEX, from which, and through which, and into which, ideas are constantly rushing. In decency one can only call it a VORTEX."[13] Note that word *decency*. No wonder that Gaudier saw Pound's head as a phallus; no wonder that the Dionysiac Pound would write in 1921, "The brain itself, is, in origin and development, only a sort of great clot of genital fluid."[14] As with the Cubists, a strong erotic component exists in the discovery of the master keys of form in the universe (to use a phrase that Pound associated with the sculptor Brancusi).

However, Pound occasionally turned the vortex around and wrote cen-

trifugal instead of centripetal poems—poems that fly apart into bad forms instead of concentrating into good forms. Almost all of Pound's work as a satirist is of this sort. In his work as an art critic, Pound saw a great deal of execrable art, and he found ways of denoting wretched form. Here, for example, is a 1916 passage in which Pound contemplated a statue of Aspiration: "As for the figure 'representing' Aspiration. Does it represent 'Aspiration'? I never saw aspiration looking like that. But I have seen spaghetti piled on a plate and the *form* was decidedly similar. A great deal of 'representational' sculpture is, *in form*, not unlike plates of spaghetti."[15] The statue is superimposed on a plate of spaghetti, but instead of turning into an image, it remains a hopeless mess: no fusion between the two terms takes places, despite the congruence. In 1914 Pound described the Post-Impressionist exhibition of 1910 in what looks like a short Imagist poem:

> Green arsenic smeared on an egg-white cloth,
> Crushed strawberries! Come, let us feast our eyes.[16]

He juxtaposes two terms, one a (poisonous) pigment, the other a (not too appetizing) foodstuff—a confusion of taste in the artistic sense with taste in the gustatory sense. It is as if the feasting eye were a little mouth, profoundly disgusted by the strawberries that it saw/swallowed. Again, the superposition leads to no revelation of a single absolute form; the smear merely spreads out into two dimensions, one pertaining to the eye, the other to the tongue.

Pound was able to do much with the satirical force of flaccid, deliberately incongruous superimpositions:

> Like a skein of loose silk blown against a wall
> She walks by the railing of a path in Kensington Gardens. . . .[17]

> The mauve and greenish souls of the little Millwins
> Were seen lying along the upper seats
> Like so many unusued boas.[18]

As the critic Earl Miner has said, an image like this is a parody of Pound's own superpository technique. As a general principle, it may be said that any superimposition in which one of the terms is a plate of spaghetti will fail to yield an image in full glory. A state of squirmy shapelessness is the exact opposite of those compressed twiformities found, for example, in "In a Station of the Metro": anything comparable to a skein of loose silk, or a pile of

feather boas, dwells in a state of extreme Imagistic degradation. These spoofs correspond to images as blasphemy corresponds to prayer. "The Garden" and "Les Millwin" present images that have failed in that neither term of the superimposition seems to have a sufficiently definite shape to provide a basis for formal congruence.

At about the same time that Pound and H.D. were in London, devising Imagism, Pound's old friend from their University of Pennsylvania days, William Carlos Williams, was writing poems that had a certain affiliation with the Imagist movement.

One important aspect of Modernism, or of a certain part of Modernism, was streamlining: a poem should move like a bullet train, clean, fast, with no gewgaws that might increase wind resistance. Williams's "Portrait of a Lady" (1920—not, evidently, 1915, as Williams claimed) is a good example of a Modernist poem that seems to be throwing off superfluous ornaments as it goes along—that is, a poem in the act of modernizing itself:

Your thighs are appletrees
whose blossoms touch the sky.
Which sky? The sky
where Watteau hung a lady's
slipper. Your knees
are a southern breeze—or
a gust of snow. Agh! what
sort of man was Fragonard?
—As if that answered
anything. —Ah, yes. Below
the knees, since the tune
drops that way, it is
one of those white summer days,
the tall grass of your ankles
flickers upon the shore—
Which shore?—
the sand clings to my lips—
Which shore?
Agh, petals maybe. How
should I know?
Which shore? Which shore?

—the petals from some hidden
appletree—Which shore?
I said petals from an appletree.[19]

This poem seems closely related to a painting by Jean-Honoré Fragonard, titled *The Swing*. Her knees are indeed a southern breeze, and her thighs touch the sky; the poet has put himself in the place of the delighted fellow in the painting, who gushes out his compliments while he's getting quite an eyeful staring up the woman's skirts. Of course, it's not Watteau but Fragonard who "hung a lady's / slipper" in the sky—you can see the slipper flying off her raised foot—but this is only one of a number of mistakes that the befuddled poet makes in the course of the poem. Fragonard was the epitome of *ancien régime* erotic frivolity in the years just before the French Revolution swept away all these bland, giddy, lovesick noblemen, who seemed to have nothing better to do than play bedroom games outdoors, in parks designed to be slick artificial backdrops to pastoral sports. Williams's poem is also, in a sense, placed on the cusp of a revolution, not a bloodthirsty revolution but a revolution of taste: frilly ornate ways of writing poetry are vanishing in favor of something hard and spare; and in the case of Williams this means a conscious attack against metaphor, against rhyme, against all the old pleasures of writing poems.

In this interrupted serenade William Carlos Williams systematically disrupts the rhyme texture through false accent (*appletrees / a lady's*), through forgetting where the line ends (*knees / breeze—or*), and through preposterous macaronic (*Fragonard / that answered*); and he nullifies his metaphors, first by submitting them to a kind of overliteral interrogation to which metaphor can never know the answer (*Which sky?*), and then by suggesting that any metaphor is as good as any other metaphor, no matter what faults of logic may arise—a southern breeze, a gust of snow, who cares? Metaphor is merely prevarication, loss of verbal rigor, to a poet of Williams's sensibility. Here we have, in effect, a self-erasing poem. The elderly Yeats, trying to assess the Modernist movement, was appalled and intrigued by the general barrenness, the lack of metaphor:

> Technically we are in a state corresponding to the time of Dryden. . . . The position of the young poet to-day is not unlike that of the young Swift in the library of Sir William Temple. At that time, they were moving away from the Elizabethans and on towards Pope. To-day, we are moving away from the Victorians and

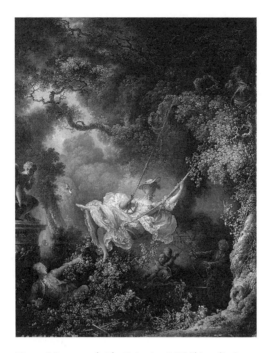

Jean-Honoré Fragonard, *The Swing* (1767) Wikimedia Commons

on towards the modern equivalent of Pope. We are developing a poetry of state-
ment as against the old metaphor. The poetry of to-morrow will be finely articu-
lated fact. T. S. Eliot fascinates us all because he is further on towards this con-
summation than any other writer.[20]

Williams's aesthetic is exactly this, an aesthetic of stripping down to finely
articulated fact; but this particular poem is not so much a stripped thing as
a meditation about the process of stripping: it is a sort of dialogue between
a Modernist and a pre-Modernist sensibility. The text dismantles the Song
of Solomon:

7:1 How beautiful are thy feet with shoes, O prince's daughter! the joints of thy
 thighs are like jewels, the work of the hands of a cunning workman.
7:2 Thy navel is like a round goblet, which wanteth not liquor: thy belly is like an
 heap of wheat set about with lilies.
7:3 Thy two breasts are like two young roes that are twins.

7:4 Thy neck is as a tower of ivory; thine eyes like the fishpools in Heshbon, by the gate of Bathrabbim: thy nose is as the tower of Lebanon which looketh toward Damascus.

7:5 Thine head upon thee is like Carmel, and the hair of thine head like purple; the king is held in the galleries.

7:6 How fair and how pleasant art thou, O love, for delights!

7:7 This thy stature is like to a palm tree, and thy breasts to clusters of grapes.

7:8 I said, I will go up to the palm tree, I will take hold of the boughs thereof: now also thy breasts shall be as clusters of the vine, and the smell of thy nose like apples;

7:9 And the roof of thy mouth like the best wine for my beloved, that goeth down sweetly, causing the lips of those that are asleep to speak.

7:10 I am my beloved's, and his desire is toward me.

By forcing you to think about what you're saying when you tell your beloved that her navel is like a cup full of some sort of fluid, Williams demonstrates the limits of figurative speech. By the standards of Solomon the poem is de-eroticized, and yet there's an erotic quality too: the woman is disrobed of the lavish metaphors that cover her up. If you say, like Shakespeare, "My mistress's eyes are nothing like the sun,"[21] you've also managed to call attention to your beloved's eyes.

Value: Self-consciously imitate, or pretend to imitate, older art.

Expressionism, always searching mind and body for every sort of ick and goo, was to some degree killed off by the Great War; with its enormous exposure of viscera, it was the Expressionist spectacle to end all Expressionist spectacles. Primitivism also became less interesting: Europe came to feel a certain revulsion against the savage. But there also was a technical reason for the creation of an art that averted its gaze from the lower depths: like all the extreme isms embraced within Modernism, Expressionism presupposed the existence of an exact contrary, just as surely as the north-seeking pole of a magnet presupposes the existence of a south-seeking pole. In music, this contrary was called Neoclassicism, and I will use this term for the plausibly anti-Expressionistic painting and literature of the era as well.

At the end of the 1910s, symptoms of a revolt against expression were everywhere: in 1919 Stravinsky composed for Diaghilev the ballet *Pulcinella*, the first Neoclassic composition (or so Stravinsky claimed)—all the material was stolen from eighteenth-century compositions by (or falsely attributed to) Pergolesi. The year before, Jean Cocteau wrote *Cock and Harlequin*, a call to a new aesthetic of the spare, the simple, the linear, the sturdy, even the ordinary—traits he found in the music of Erik Satie, with whom he had just collaborated in the ballet *Parade* (1917), also written for Diaghilev's Ballets Russes. Here are some of Cocteau's maxims (note the espousal of the sturdy, the homely, the spic and span):

Art is science in the flesh.

The musician opens the cage-door to arithmetic; the draughtsman gives geometry its freedom. . . .

With us there is a house, a lamp, a plate of soup, a fire, wine and pipes at the back of every important work of art. . . .

The nightingale sings badly. . . .

A POET ALWAYS HAS TOO MANY WORDS IN HIS VOCABULARY, A PAINTER TOO MANY COLORS ON HIS PALETTE, AND A MUSICIAN TOO MANY NOTES ON HIS KEYBOARD. . . .

SMALL WORKS. There are certain small works of art whose whole importance lies in their depth; the size of their orifice is of small account.

In music, line is melody. The return to design will necessarily involve a return to melody. . . . Wagner, Stravinsky, and even Debussy are first-rate octopuses. Whoever goes near them is sore put to it to escape from their tentacles; Satie leaves a clear road open . . .

Not music one swims in, nor music one dances on; MUSIC ON WHICH ONE WALKS. . . .

Enough of clouds, waves, aquariums, water-sprites, and nocturnal scents [i.e., enough Debussy]; what we need is a music of the earth, everyday music.

Enough of hammocks, garlands, and gondolas; I want someone to build me music I can live in, like a house. . . .

Music is not all the time a gondola, or a racehouse, or a tightrope. It is sometimes a chair as well.

A Holy Family is not necessarily a holy family; it may also consist of a pipe, a pint of beer, a pack of cards and a pouch of tobacco.[1]

This ostentatiously modest, reticent sort of art is as far from Expressionism as one can get. Satie, the anti-Schoenberg, wrote a piece entitled *Wallpaper in Forged Iron*, one of a series of pieces called furniture music (1920). He described it as follows: "You know, there's a need to create furniture music, that is to say, music that would be a part of the surrounding noises and that would take them into account. I see it as melodious, as masking the clatter of knives and forks without drowning it out completely, without imposing itself. It would fill up the awkward silences . . . it would neutralize the street noises."[2] The furniture music consisted of endlessly repeated commonplace figures from such nineteenth-century hit tunes as Camille Saint-Saëns's *Danse Macabre* and Ambroise Thomas's *Mignon*, played by a small band at the intermission of a play. Satie's only public performance turned out to be a fiasco when those within earshot insisted on listening to it instead of proceeding about their normal business, even though Satie kept shouting, "Don't listen!" The music was supposed to be an environment, not an outpouring of emotions.

Value: Consider the artwork as a physical object, not as a pseudoperson.

The Germans managed to give a name to the artistic movement proper to such a philosophy: the New Objectivity (*neue Sachlichkeit*). The German word *Sache* means "thing," and *sachlich* means "matter-of-fact." During the 1920s, an artistic movement arose that understood the artwork not as an expression, not as the mere vessel of an intimate psychic state, but as a self-standing uncontingent object, equal in dignity to other phenomena in the world. In literature, this entailed a desire to understand a poem as a verbal icon, a well-wrought urn, not connected to the poet's biography or to the political culture around it—a doctrine that followed from T. S. Eliot's "Tradition and the Individual Talent" (1919). In painting, this entailed a rejection of what Wilhelm Hausenstein called the "objectlessness of expressionism"— its preoccupation with "intestinal convolutions, nerves, and blood vessels," all that is "horribly deformed, cross-eyed, mangled"—in favor of cool colors, unstrenuous facture, and clear outlines.[3] In 1925 Franz Roh compiled a useful table of the differences between Expressionism and its successor movement:

Expressionism	*Post-Expressionism*
ecstatic objects	plain objects
many religious themes	few religious themes
the stifled object	the explanatory object . . .
dynamic	static
loud	quiet
summary	sustained
obvious	obvious and enigmatic . . .
monumental	miniature
warm	cool to cold
thick coloration	thin layer of color
roughened	smooth, dislodged
like uncut stone	like polished metal
work process preserved	work process effaced
leaving traces	pure objectification
expressive deformation of objects	harmonic cleansing of objects
rich in diagonals	rectangular to the frame
often acute-angled	parallel
working against the edges of image	fixed within edges of image
primitive	civilized[4]

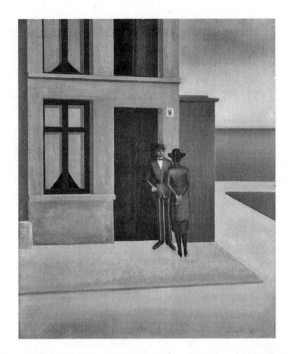

Anton Räderscheidt, *Das Haus No. 9* (1921) Pascal Raederscheidt, © 2015 Artists Rights Society (ARS), New York/VG Bild-Kunst, Bonn

An Expressionist work of art often seems unfinished because it shows on the outside the inner processes of its coming-into-being; it is less an object than a tracing of psychic activity. But a New Objective work of art tends toward a certain anonymity and arbitrariness, a canceling out of creative process. An Expressionist work of art is symbolic in the sense that it is charged with a visible burden of flagrant meaning; a New Objective work of art is symbolic in that it conceals its meaning despite leaving every surface open for inspection—as Roh says, it is "obvious and enigmatic," disturbingly impervious to interpretation. Take Anton Räderscheidt's *Das Haus No. 9* as an example. Are the man and the woman lovers, spies, a married couple, a pictorial convenience to give a sense of scale to the building? Their sheer nondescriptness makes any and all guesses possible. The painter's interest in spruce architecture reminds us that New Objectivist painting is closely related to the spare, clean-lined architecture of Walter Gropius's Bauhaus design school, exactly contemporary—such as Gropius's design for the Bau-

haus in Dessau (1925). On the other hand, much of New Objectivist paint-
ing is closer to Expressionism than it might appear. George Grosz in the
1920s was sometimes classified as a New Objectivist, and here you might go
back and look again at his oil painting *Jack the Ripper*, previously discussed
in our section on Expressionism. It is made of sharply delineated blocks
and curves, as if Grosz had cut out pieces of paper and glued them to the
canvas—Jack the Ripper's knife mutating into Grosz's virtual scissors. It's a
fairly dry work despite its gory subject matter, with little of the leaky drippy
Expressionist effect that simulates body fluids on the canvas. Many New
Objectivist works use certain techniques from Expressionism, but in a much
more apathetic fashion. Sometimes it seems that the New Objectivity cor-
responds to Expressionism as boredom corresponds to excitement.

Indeed, boredom is a crucial feature, I think, of the New Objectivity:
boredom at the rawness of flesh, boredom at the commonplaces of extreme
love and hate, boredom at revulsion itself. The New Objectivity is governed
by a dialectic of boredom and defamiliarization. The premise of all sorts of
new classicisms is (in Pound's phrase) "Make it new": restore some of the
shock that art, that experience itself, had before it became old hat. The
twentieth century is full of commands, from every side, ordering us to shake
ourselves out of familiar routine. Here is the narrator of Marcel Proust's
Swann's Way (1913) trying to sleep in an unfamiliar, oddly shaped room:

> My mind, striving for hours on end to break away from its moorings, to stretch
> upwards so as to take on the exact shape of the room and to reach to the topmost
> height of its gigantic funnel, had endured many a painful night as I lay stretched
> out in bed, my eyes staring upwards, my ears straining, my nostrils flaring, my
> heart beating; until habit had changed the colour of the curtains, silenced the
> clock, brought an expression of pity to the cruel, slanting face of the glass, dis-
> guised or even completely dispelled the scent of vetiver, and appreciably reduced
> the apparent loftiness of the ceiling. Habit! that skilful but slow-moving arranger
> who begins by letting our minds suffer for weeks on end in temporary quarters,
> but whom our minds are none the less only too happy to discover at last, for
> without it, reduced to their own devices, they would be powerless to make any
> room seem habitable.[5]

The room refuses to be appropriated by the person inside it; it resists every
attempt to subject it, subjectify it, make it warm and personal. It is at last
tamed by the force of habit, which makes everything unstrange, domestic,
after sufficient exposure; but Habit is the great villain of Proust's novel, for

Habit disenchants, diminishes, desensitizes us to our world. Proust wants to expand the ego, expand the field of reference on which the ego operates—to rescue Lost Time and to resurrect the Lost Boy who experienced it—while Habit continually works to freeze the environment, to confine the man to his body, to make life boring. Proust was in no sense a New Objectivist, but the New Objectivists were equally set against habit: they wanted to depict the ordinariness of things, and yet in such a way that this matter-of-factness seemed detached, slightly marvelous. In an early short story by the Russian writer Vladimir Nabokov, "A Guide to Berlin" (1925), the author imagines a Berlin streetcar as it will appear in a museum in the year 2120:

> Everything, every trifle, will be valuable and meaningful: the conductor's purse, the advertisement over the window, that peculiar jolting motion which our great-grandchildren will perhaps imagine—everything will be ennobled and justified by its age.
>
> I think that here lies the sense of literary creation: to portray ordinary objects as they will be reflected in the kindly mirrors of future times; to find in the objects around us the fragrant tenderness that only posterity will discern and appreciate in the far-off times when every trifle of our plain everyday life will become exquisite and festive in its own right: the times when a man who might put on the most ordinary jacket of today will be dressed up for an elegant masquerade.[6]

This is a perfect description of the aesthetics of the New Objectivity: to teach you to see how the commonplace things in your life—your UGGs, your iPad, your Google Glass (but whatever I write here will already be outdated by the time you read this)—will look when displayed in a glass case in the year 2120.

The great theorist of defamiliarization was another Russian, the critic Viktor Shklovsky. In *Theory of Prose* (1925), Shklovsky intimated that we glide through our lives without really touching anything in our vicinity; our cognitive processes reduce the world around us to a sort of wurld-whizz, the processed aerosol version of reality:

> By means of [our] algebraic method of thinking, objects are grasped spatially, in the blink of an eye. We do not see them, we merely recognize them by their primary characteristics. The object passes before us, as if it were prepackaged. We know that it exists because of its position in space, but we see only its surface. Gradually, under the influence of this generalizing perception, the object fades away. . . . So, in order to return sensation to our limbs, in order to make us

feel objects, to make a stone feel stony, man has been given the tool of art. . . .
By "enstranging" objects and complicating form, the device of art makes percep-
tion long and "laborious."[7]

T. S. Eliot thought that it was the duty of modern poetry to be difficult, and
Shklovsky here tells us why. Why paint an object as an agglomeration of
cubes, when you could just paint an instantly recognizable likeness? Why
seek out bizarre similes, such as comparing the evening to a patient ether-
ized upon a table, when you could simply say that the evening was foggy
and numbing? The answer, according to Shklovsky, is that we live in a short-
hand, abbreviated perceptual world, and it is the purpose of art to fill the
act of recognizing things with a kind of friction: to restore a sort of abrasive-
ness and grit to the objects around us. Shklovsky even defamiliarized his
theory by avoiding any ordinary word for defamiliarization, instead coining
his own term, *ostranenie*, rendered by the translator as "enstranging."

In music the great enstranger was Stravinsky. He had several strategies
for objectifying music: one was a preference for the cool sonorities of wind
instruments; another was the method of eliminating the human performer
(so likely to add expressive phrasing and emphasis) by composing for the
pianola—a player piano operated by compressed air and governed by holes
punched on paper rolls. Stravinsky's *Étude for pianola* was first performed in
1921. Other composers with a predilection for the objective also experi-
mented with similar devices—Paul Hindemith, for example, composed his
Triadic Ballet for mechanical organ in 1926. Another strategy was quotation,
either direct or indirect—this is the aesthetic of Neoclassicism. Stravinsky
invented Neoclassicism—at least according to Stravinsky, for musicologists
have made prior claims for Ferruccio Busoni (who wrote the essay "Junge
Klassizität," or "New Classicity," 1920), Sergei Prokofiev, Maurice Ravel, and
others. After Stravinsky's opulent and spectacular ballets just before the
Great War—*The Firebird* (1910), *Petrushka* (1911), *The Rite of Spring* (1913)—
he experimented with various sorts of reduction of scale, partly because,
during and after the war, no one had much money for lavish productions,
partly because Stravinsky wanted new aesthetic challenges. He was work-
ing toward an aesthetic that was not only Neoclassical but profoundly anti-
expressive; as he (or the ghostwriter of his autobiography, Walter Nouvel)
wrote in 1936,

> I consider that music is, by its very nature, essentially powerless to express any-
> thing at all, whether a feeling, an attitude of mind, a psychological mood, a phe-

nomenon of nature, etc. . . . *Expression* has never been an inherent property of
music. That is by no means the purpose of its existence. If, as is nearly always the
case, music appears to express something, this is only an illusion and not a reality.
It is simply an additional attribute which, by tacit and inveterate agreement, we
have lent it, thrust upon it, as a label, a convention—in short, an aspect uncon-
sciously or by force of habit, we have come to confuse with its essential being.[8]

In some sense he set himself the task, in *Pulcinella*, of defamiliarizing, de-
expressionizing, the fairly familiar and quite expressive music of Pergolesi.

How does Pergolesi enstranged differ from Pergolesi plain? In order to
answer that question, let me take an earlier case of deliberate reworking
of the classics. In Tchaikovsky's opera *The Queen of Spades* (1891), there is
an old-fashioned entertainment scene with a pastoral duet between a shep-
herd and a shepherdess; to provide music for this duet, Tchaikovsky, a lover
of Mozart, tried to write Mozart-like music. He found it easier to steal from
Mozart than to imitate, for the music of the divertimento is almost embar-
rassingly close to a tune from Mozart's piano concerto, K. 503, a century old
in 1891. I would say that this is not Neoclassicism, but simply anachronistic
Classicism: there's a quality of distance, but no parody, no tinge of irony;
Tchaikovsky was trying to write beautiful music in a delicate rococo style.

Stravinsky's version of Pergolesi, on the other hand, isn't so much an
evocation of the perfumes of the past as an aggressive act against the past,
an act of assimilation, theft. It doesn't try to be true to the spirit of Per-
golesi; in fact, falseness is built into the ballet in every corner. The first sig-
nificant thing about this primal Neoclassical act is the choice of Giambat-
tista Pergolesi, a most disquieting composer. It was Diaghilev's idea to make
a ballet out of the music of Pergolesi (1710-36); Stravinsky was at first re-
luctant but came to see the possibilities. Even during the eighteenth century,
Pergolesi, who died young, was the object of hoaxes: because the demand
for his music exceeded the supply, publishers published under the name
"Pergolesi" all sorts of stuff not in fact written by him, some of high quality,
some utter trash. Much of the material that Stravinsky stole for *Pulcinella* was
written by minor composers, even the famous opening movement, taken
from a trio sonata by Domenico Gallo. If you compare Gallo and Stravinsky,
you find that Stravinsky has changed almost nothing: much of the game of
Pulcinella is to investigate how far Stravinsky could Stravinskyize music
simply by means of orchestration, with little or no alteration of harmony,
melody, rhythm. *Pulcinella* isn't about Pergolesi, but about "Pergolesi" in quo-

tation marks, the way in which the present receives, hears, swallows up the past. The barrier between the real and the fake past is erased, most conspicuously in the score's best-known tune, *Se tu m'ami*, which not only isn't by Pergolesi but isn't from the eighteenth century at all: it was composed around 1885 by Alessandro Parisotti, the editor of an important anthology of old tunes, *Arie antiche*, and published as a work by Pergolesi. (Most of the other vocal numbers in *Pulcinella* are genuine Pergolesi, drawn from his operas.)

Neoclassicism tends to destroy any sense of the pastness of the past; all centuries are flattened by its irony onto a single plane; the distinction between authentic and inauthentic is rendered invalid. Even Stravinsky's account of how he wrote the ballet is full of lies: "The material I had at my disposal—numerous fragments and shreds of compositions either unfinished or merely outlined, which by good fortune had eluded filtering by academic editions—made me appreciate more and more . . . my sensory kinship with him";[9] "I relied only in part on his themes and fragments. . . . The entire musical conception . . . represents my own personal work."[10] Stravinsky did little primary research into Pergolesi, and he claimed radical originality only to get a higher royalty rate; he worked from familiar material brought to him by Diaghilev, as he says in a somewhat more truthful later account:

> I began by composing on the Pergolesi manuscripts themselves, as though I were correcting an old work of my own. I began without preconceptions or aesthetic attitudes, and I could not have predicted anything about the result. I knew that I could not produce a "forgery" of Pergolesi because my motor habits are so different; at best, I could repeat him in my own accent. That the result was to some extent a satire was probably inevitable—who could have treated that material in 1919 without satire?—but even this observation is hindsight; I did not set out to compose a satire and, of course, Diaghilev hadn't even considered the possibility of such a thing. A stylish orchestration was what Diaghilev wanted, and nothing more, and my music so shocked him that he went about for a long time with a look that suggested The Offended Eighteenth Century. In fact, however, the remarkable thing about *Pulcinella* is not how much but how little has been added or changed.[11]

You wouldn't think that instrumentation alone could achieve a whole engine transplant: remove Pergolesi's hamster-propelled motor in favor of Stravinsky's gleaming five-hundred-horsepower, overhead cam number. But it is remarkable what instrumentation can do. To my mind, the great moment in

Pulcinella is the *Vivo*, an instrumental number that is, for once, based on something Pergolesi actually wrote, a cello sonata. If you compare the catchy original with Stravinsky's version, you find something startling: Stravinsky separates Pergolesi's cello line into trombone line and double-bass line in an almost completely arbitrary fashion: where Pergolesi provides one thing, Stravinsky provides two things clashing with one another, as if a sonata could be made through contrasts not of key but of volume. Stravinsky was (justifiably) proud of his accomplishment here: "Volumes, incidentally, are all too rarely recognized as a primary musical element, and how few listeners have remarked the real joke in the *Pulcinella* duet, which is that the trombone has a very loud voice and the string bass has almost no voice at all."[12] Stravinsky evidently liked the stage curtain that Picasso designed for *Pulcinella*, a "volumetric view of balconied, Spanish-style houses."[13] Stravinsky himself was playing a volumetric game, almost a Cubist game, with Pergolesi's sonata, making the trombone line stick out at a strange angle from the rest of the composition. The trombone is an instrument that almost never appeared in an eighteenth-century orchestra, except for rare, usually funereal special effects, and certainly would not appear making a jazzy glissando under any circumstances—in fact, nobody wrote a glissando for trombone until Schoenberg did it in his early tone poem *Pelleas und Melisande*. Stravinsky gives us hip spiffy Pergolesi for the jazz age, a Pergolesi who is no dull old wig but the bee's knees.

Stravinsky did not limit his Neoclassical pastiche games to Pergolesi; in later life he played similarly with Bach (in his *Dumbarton Oaks* concerto, 1938), the sixteenth-century madrigalist Carlo Gesualdo (in *Monumentum pro Gesualdo*, 1960), and even Tchaikovsky (in *The Fairy's Kiss*, 1928). To comprehend the whole of Western music in his head at the same time was a strong ambition of Stravinsky's. Stravinsky recognized in T. S. Eliot a kindred spirit—Eliot wrote in his famous essay "Tradition and the Individual Talent" (1919) that the Individual Talent tries to find a way to incorporate into itself and then to modify the larger Tradition in which it operates: "He must be aware that the mind of Europe . . . is a mind that changes, and that this change is a development which abandons nothing en route, which does not superannuate either Shakespeare, or Homer, or the rock drawing of the Magdalenian draughtsmen."[14]

One of Eliot's most often quoted maxims is "Immature poets imitate; mature poets steal";[15] Stravinsky, a mature artist, stole Eliot's line when he said, "A good composer does not imitate, he steals."[16] You see why theft

enjoys such privilege for such Traditionalists as these: theft is a way of enforcing a likeness between your work and the works of the big mind of Europe. Stealing is not only permitted but commanded: the more you can make your art resemble a museum, the more closely your Individual Talent becomes congruent with Tradition. Eliot suggests that the poet who depersonalizes himself, separates "the man who suffers" from the "mind which creates," will be best able to contribute to the general achievement of the European mind.

This is exactly what Stravinsky believed, with his rhetoric against expressivity. In fact, Stravinsky read Eliot's "Tradition and the Individual Talent" with pleasure and approval; in a 1945 newspaper interview he confessed his debt to the poet: "I use the word 'tradition' in the sense that Eliot has given to it. To be in a tradition, one must possess a historical sense, perceive the presence of the past and the simultaneity of the entire universal intellectual inheritance."[17] The simultaneity of Gregorian chant, early secular madrigals, Bach, Tchaikovsky—this is the aesthetic of the Neoclassical Stravinsky: it's all there at once in his head, and he can make use of it at his pleasure. Neoclassical Stravinsky can seem chilly and dry after *The Rite of Spring*, but in its way it is an even stronger, more impudent assertion of genius. Stravinsky claims the whole musical mind of Europe as his own.

11 Dadaism

Value: Let nothing have value.

Value: Make ostentatious shows of the fact that nothing has value.

Dada was born in a Zurich cabaret in 1916; by the early 1920s, after a period of flamboyant research into methods of negating almost everything suggested by the word *art*, its force was almost spent. Some sense of the anti-Expressionist, antilogical, anti-everything flavor of early Dada can be seen in, for example, Francis Picabia's *Manifesto Cannibal Dada*: "Dada . . . smells of nothing, it is nothing, nothing, nothing, / It is like your hopes: nothing. / like your heaven: nothing . . . like your artists: nothing."[1] There were various ways of putting this sort of nihilism on stage: Picabia would show drawings he had made on a chalkboard and, for the audience's entertainment, erase them. Erasure games with word meanings were, from the very beginning, crucial to Dada cabaret, as we can see in Hugo Ball's description of a reading he gave at the Cabaret Voltaire, in a special costume:

> I invented a new species of verse, "verse without words," or sound poems. . . . I looked liked an obelisk . . . [and] wore a high top hat striped with white and blue. I recited the following:
>
> > gadji beri bimba
> >
> > glandridi lauli lonni cadori . . .
>
> The accents became heavier, the expression increased an intensification of the consonants. I soon noticed that my means of expression (if I wanted to remain serious, which I did at any cost), was not adequate to the pomp of my stage setting. . . .
>
> We should withdraw into the innermost alchemy of the word, and even surrender the word, in this way conserving for poetry its most sacred domain.[2]

Ball sought the basic vocables of language, sacred beyond anything spoken in modern Europe, perhaps an echo from the prehistory of the human race— "gadji beri bimba" is a stanza of Neanderthal poetry, so to speak. To recite highly alliterative nonsense syllables—all these *g*'s and *b*'s and *d*'s and *l*'s—is to compel the audience to participate in some savage rite beyond its ken. We are in a strange place, listening to man who has abandoned the shape of his body in favor of geometric form, and who has abandoned normal language in favor of primeval syllables.

Some of the Dadaists thought of themselves as Primitivists and looked to Africa for inspiration. Richard Huelsenbeck called some of his readings Negro poems, and Tristan Tzara noted that during the 9-30 April 1917 Dada exhibition the music consisted of "Negro Music and Dances" along with music by Arnold Schoenberg; in music and in poetry, the ultra-avant-garde seemed to be circling back to some dream of precivilized Africa. Behind all language, the Dadaists taught, there were phonemes, phonemes that meant more than mere words. Rousseau's tirade against exhausted abstract European languages here reaches a fever pitch.

Here the hypermeaningful (the soul's naked cry beyond language) and the unmeaningful converge. Ball, dressed up in his blue silly suit, reciting his poems, once was so overcome with emotion that he felt he was performing a sacred rite—he even had a conversion experience and was led to rejoin the Catholic Church. (From a Roman Catholic point of view, the Dada performance looks like an experiment in Pentecost, a speaking in tongues.) The nonsense syllables seem to proceed from a desire too intense for normal language, Dionysus leering from the abyss, resisting all previous formalities—a call to what Huelsenbeck named the *pandaemonium naturae ignotae* ("the pandemonium of unknown nature") inside yourself.[3] Nietzsche was indeed a strong presence here: Huelsenbeck also quoted with great approval the passage from *Beyond Good and Evil* where Nietzsche calls on us to be God's clowns:

> We are the first age as regards the study of "costumes"—I mean those of moralities, articles of faith, artistic tastes, and religions—prepared, like no age before us, for a carnival in the grand style, for spiritual *Fasching*-laughter and high spirits, for the transcendental heights of the highest nonsense and Aristophanic world-mockery. Perhaps here we shall discover the realm of our invention, that realm in which even we can still be original, for instance as parodists of world history and clowns of God—perhaps, even if nothing else today has a future, our laughter may yet have a future.[4]

The funny costumes that Ball and other Dadaists wore only call attention to the fact that all Europeans wear clown suits, though they don't know it—the clown suits of "articles of faith, artistic tastes, and religions." And Dada poetry becomes meaningful insofar as it exposes the unmeaning of normal discourse.

On the other hand, maybe Dada poetry is so disabled that it can't work as parody or as anything else; maybe Dada poetry shows not a superior laughter but complete absence of affect, frenetic listlessness, anhedonia, Andy Warhol before his time. Perhaps this morbidity of language could be better illustrated by those Dada poems that consisted of strings of words rather than strings of phonemes. Walter Serner, in his Dadaist manifesto (1919), noted that all nouns were interchangeable: "a queen is an armchair a dog is a hammock."[5] In other words, $x = y$ for all the universe's x's and y's. Raoul Hausmann saw in Dada poetry an utter devaluation of language, a loss of power of words to retain their definitions: "The DADAist poetry did not want anything, it overcame the distinctions between a mixing spoon, a cow, a rail and a saying. . . . Dada was creation from the indifference of nothingness."[6] There is, then, little reason to prefer one word over another. This attitude went so far that in 1919 John Heartfield eventually considered it a daring act against Dada orthodoxy to draw a picture of a fork and caption it, "I don't consider this to be a staircase, but a fork."[7]

Loss of affect, deliberate pleasure in the way that Capitalist society drains meaning from words, can also be seen in another kind of Dada poem, that consisting of shouting advertising slogans (in 1919, in Prague) from the stage: "Cook with gas! Wash with Cadum! Bathe at home!" If you were to spend your time saying to one another, "We make it your way at Burger King," or "Just do it," or "Things go better with Coke," then you'd be going far toward living a fully Dadaized life. But, as Picabia wrote, "in America everything is DADA."[8] Johannes Baader, one of the more clinically insane dadas, made a proposal to rebuild the Tower of Babel—and delight in the confusion of the world's languages, in babble itself, is a characteristic of the movement.

Hypermeaningful or unmeaningful, Dada poetry is caught in a whole network of convergences of extremes. Dada, by denying the value of art, would seem to deny that art can have any relation to the external world; on the other hand, Dada also claimed to be an accurate picture of the external world. The Romanian poet Tristan Tzara (who claimed that he invented the term *Dada*, a French word meaning "hobby-horse" found "by accident in the

Larousse dictionary") defended Dada as a direct imitation of nature and human cognition:

> We [Dadaists] are often told that we are incoherent, but into this word people try to put an insult that it is rather hard for me to fathom. Everything is incoherent. . . . There is no logic. . . . The acts of life have no beginning and no end. Everything happens in a completely idiotic way. That is why everything is alike. Simplicity is called Dada. Any attempt to conciliate an inexplicable momentary state with logic strikes me as a boring kind of game. . . . Like everything in life, Dada is useless. . . . Perhaps you will understand me better when I tell you that Dada is a virgin microbe that penetrates with the insistence of art into all the spaces that reason has not been able to fill with words or conventions.
>
> If I cry out:
>
> Ideal, Ideal, Ideal,
>
> Knowledge, Knowledge, Knowledge,
>
> Boomboom, Boomboom, Boomboom,
>
> I have given a pretty faithful version of progress, law, morality and all other fine qualities that various highly intelligent men have discussed in so many books.[9]

For Tzara, logic, system, science are merely illusions fostered by the foolish belief that we know something about the world around us, and art that aspires to beauty, clarity, precision is a kind of offense to reality, an act of dishonesty, insincerity.

Surrealism

Value: Let the unconscious speak.

The word *Surrealism* was coined in 1917 by the poet Guillaume Apollinaire, in a program note to Erik Satie's ballet *Parade*, in which Apollinaire approves of the antirepresentationalism of the whole spectacle—the general cognitive dissonance of Satie's music, Picasso's Cubist costumes, and Massine's dancing: "From this new alliance, for until now stage sets and costumes on one side and choreography on the other had only a sham bond between them, there has come about, in *Parade*, a kind of super-realism [*sur-réalisme*]."[1] So Surrealism begins as an attempt to make art more real than reality, super-real, by means of renouncing representation in favor of Cubist-like dissection, dislocation, what Apollinaire calls "analysis-synthesis." But Apollinaire died young, in the great Spanish flu epidemic after the war, so Surrealism as an official art movement was left in other hands, specifically the hands of the writer André Breton, who organized the movement in the early 1920s out of the ruins of Dada. Breton was a paradoxical man, in that he preached complete artistic freedom, and yet he organized Surrealism with ruthless totalitarian efficiency, expelling from the movement anyone who displeased him. Most of the Surrealists were simply the old Dadaists, like Max Ernst, most of whom enthusiastically supported the notion of a movement in which the artist listened to unconscious, preconscious, transconscious promptings from within; but some youngsters, such as Salvador Dalí, soon joined. Breton at first was enthusiastic about Dalí but quickly grew disenchanted and threw him out, though Dalí somehow managed to work under the banner of Surrealism despite Breton's condemnation. Breton never forgave him and usually referred to him by an anagram of his name, Avida Dollars.

One of the troubles that beset Dada was its love of chaos. If you hitch your art to a random number generator, it doesn't necessarily seem thrillingly impudent; it often turns out to be puzzling and, since the puzzle can't have any solution beyond the solution that it doesn't have any solution, boring. Surrealism redefined chaos not as a procedure generated by and pertinent to the outer world, but as a procedure generated by and pertinent to psychology: this guaranteed, at least in theory, that the artwork would have an occult unity, that it would reveal the last depths of human experience. Once again, we're back at Nietzsche's abyss, the abyss that stares back at you as you stare at it. Surrealism is an extraordinarily Dionysiac movement, in that it is, in its essence, a set of procedures for coaxing the abyss to speak.

Breton, a great definer of terms, published a definition of Surrealism in the *Surrealist Manifesto*:

> SURREALISM, n. Pure psychic automatism, by which one proposes to express, either verbally, or in writing, or by any other manner, the real functioning of thought. Dictation of thought in the absence of all control exercised by reason, outside of all aesthetic and moral preoccupation.[2]

The Surrealists took the notion of "dictation of thought in the absence of all control exercised by reason" quite seriously. What exactly does it mean to evade the control of reason? We all know what it means to construct an irrational sentence, in which the first part of the sentence has nothing to do with the second coming of Christ as predicted by a cicada for 29 October. But Breton had special procedures for cultivating irrational thought. One procedure was the calculated disabling of the mind's ability to make discriminations between similarities and differences. Now all original thinking is a form of saying that things that were once thought different are in fact alike, or that things that were once thought alike are in fact different. When Einstein wrote that energy *is* mass, he was simply reorganizing the field of similarity: we used to think that energy and mass were completely distinct, but this turned out to be false. Breton's "Discourse on the Paucity of Reality" (1924) is a systematic attack on the whole notion of similarity and difference: "Two leaves of the same tree are exactly alike: it's even the same leaf. I have only one word. I insist that if two drops of water resemble each other, it is because there is only one drop of water. One thread, repeating itself and crossing over itself, makes silk. The staircase up which I walk has only one step. There is only one color: white."[3] It would be equally true, and equally

unhelpful, to say that the universe is such a unity that any object is identical to any other object, or that the universe is such a diversity, such a heap of disparatenesses, that no object is similar to any other object. Nietzsche, in his essay "On Truth and Falsehood in the Extra-moral Sense," argued that each leaf was so distinct from every other leaf that the concept *leaf* was useless; Breton shrugs, makes exactly the opposite assertion—there exists only one leaf on the planet earth—but still leaves us all deprived of any useful concept of *leaf*. As another Surrealist, Georges Bataille, wrote, reality is above all else *informe*, a kind of squish: "The universe resembles noth-ing. . . . The universe is something like a spider or a gob of spit."[4]

In Surrealism's crippled universe of discourse, figures of speech can be generated simply by abutting any two nouns, without regard to whether this abutting creates what is usually called insight. As Breton explains in the "Discourse on Paucity," "What holds me back from jumbling the order of words, from trying to kill the visible manner of existence of things? Lan-guage can be and must be torn from this slavery. No more descriptions from nature . . . I don't see why people should protest when they hear me affirm that the most satisfying image of the earth I can make at this moment is that of a paper hoop. If such an ineptitude has never been proclaimed before me, it is obviously not an ineptitude."[5] Breton evaded interpretation by trying to create figures of speech in which the parts were too weakly connected to tempt the interpreter. If I compare earth to a paper hoop, I learn nothing about the nature of the earth—and this absence of rational insight is the whole point of the comparison.

Now let's look from another point of view at Breton's definition of Sur-realism as dictation of thought in the absence of all control exercised by reason. How do I go about hearing my thought's dictation, if I'm not the one doing the dictating? There's an easy answer: listen to my dreaming thoughts when I'm asleep; or, better yet, cultivate a state of trance, so that I'm just awake enough to write down where my thoughts go of their own volition. This led to many experiments with involuntary composition, such as auto-matic drawing, in which your hand moves across the page while you're not looking at it, not thinking about what you're doing, preferably not even in a waking state. Sometimes the blotches and squiggles in automatic drawings, especially those of Dalí, look a little like a schematic of the neurons in the brain, with dendrites reaching across synapses to establish electrical connec-tions. Dalí might have approved of the interpretation: the unconscious brain

moving the pen in the hand to draw an image of itself. But interpretation of any sort is, of course, venturesome in the world of Surrealism.

There was also automatic writing, in which the hand drifts compulsively across the page without the mind's directing the choice of words. An example—not exactly an example but a simulation of its texture—is found in *The Immaculate Conception* (1930) by Breton in collaboration with the poet Paul Éluard: "For seducing the weather I have shivers for adornment, and the return of my body back into itself. Ah, to take a bath, a bath of the Romans, a sand bath, an ass's milk sand bath. *To live* as one must know how to knot one's veins in a bath! To travel on the back of a jellyfish, on the surface of the water, then to sink into the depths to get the appetite of blind fish, of blind fish that have the appetite of the birds that howl at life."[6] Not only is the speaker of the text on a wild giddy ride, as the jellyfish pulls him down and further down, but the words of the text are on a wild giddy ride. The authors write the word *bath*, and the word starts to sprout bizarre predicates: "a bath, a bath of the Romans, a sand bath, an ass's milk sand bath." It is possible to follow the path of mental association here, at least for a ways, since rich Romans were reputed to take baths of milk. But it's possible to believe that the sheer will to investigate the depths of the human mind influenced the composition of the text, with the privilege it assigns to the idea of depth—"to sink into the depths."

You may have noted that Surrealism is a bit like Expressionism in its fascination with abnormal psychic states. But it differs from Expressionism in that Expressionism measures its distortions against a norm, bears witness to the power of the normal. In one of the most famous Expressionist works, Robert Wiene's movie *The Cabinet of Dr. Caligari* (1920), the camera imitates the functioning of a psychotic brain, beholding a world of false landscapes, tilted houses, and deep shadow; but at the end the movie wakes up from its somnambulist trance, and we see a perfectly ordinary madhouse. (It is true that the film's producers insisted on this return to sanity, which was not part of Wiene's original plan; but I'm not sure that the movie's psychography was damaged by the revised ending.) In some sense the message of Expressionist art is, "Be not afraid: the mind's terrors are just bad dreams, and you will soon awake." But Surrealism has no sense of the virtue of waking; it seems to aspire toward a perpetual immersion in the wonders of irrational thinking—for the mind is fundamentally irrational. The cultivation of mental disease is an explicit part of the Surrealist aesthetic. The Surrealists were fascinated

by Freud, but Freud hoped to cure his patients of neuroses and psychoses, whereas the Surrealists hoped to cure their readers of normal brain functioning. In 1928 Breton and the poet Louis Aragon wrote, in "The Fiftieth Anniversary of Hysteria,"

> We propose a fresh definition of hysteria, as follows:
>
> "Hysteria is a more or less irreducible mental condition, marked by the subversion between the subject and the moral world under whose authority he happens to be. . . . Hysteria is not a pathological condition and may in all respects be considered a supreme means of expression."[7]

Parts of *The Immaculate Conception* attempted to simulate various mental illnesses, debilities, and paralyses—Breton and Éluard write,

> If my voice can lend itself successively to the speech of the most disparate beings, to the speech of the richest and the poorest, the blind and the hallucinator, the coward and the aggressor, how then can I possibly admit that this voice, finally mine and mine alone, originates in regions that have, if only for a time, been outlawed?—regions to which I, in common with the majority of mankind, cannot hope ever to accede? . . . We would even . . . declare that, in our opinion, the "essays of simulation" of maladies virtual in each one of us could replace most advantageously the ballad, the sonnet, the epic.[8]

The notion of writing texts that imitate hysterical or psychotic thought processes may strike you as odd, but this project was taken seriously by important people. These last two passages I've quoted were translated by the very young Samuel Beckett, and a young psychoanalyst named Jacques Lacan reported this experiment in *Annales Médico-Psychologiques*. Sometimes the world of Surrealism can seem like a class of attentive students presided over by Hannibal Lecter and Dr. Alzheimer.

Salvador Dalí

Each of the Surrealists had his own specialty among the various mental diseases. Dalí's was paranoia. He advocated what he called the "paranoiac-critical" method of painting, a vague term, but Dalí provided a kind of definition:

> Paranoia: delirium of interpretative association permitting a systematic structure. Paranoiac-critical activity: spontaneous method of irrational understanding based upon the interpretative critical association of delirious phenomena.[9]

> I believe that the moment is near when by a procedure of active paranoiac thought, it will be possible . . . to systematize confusion and contribute to the total discrediting of the world of reality.[10]

Two of Dalí's favorite words were *delirium* and *paranoia*: *delirium* is actually a farming term, meaning "out of the furrow"; *paranoia* is Greek for "out of your mind." Dalí considered that the rational mind worked a narrow, well-lit rut; on either side, in the half-light, was a vast field of tantalizing, hyper-meaningful, half-formed half-things—and it was his task to bring these half-things to the attention of the waking mind.

But you will notice that such words as *spontaneous* and *delirious* are balanced by such words as *systematize* and *critical*. More than most Surrealists, Dalí was concerned with imposing arrangement and high artistic finish on the material fished up from the unconscious. This arranging is not a product of sane mental activity: it is paranoid arranging, just as a madman might come across a hopscotch grid on a sidewalk, a flat cardboard box, and a crucifix and find evidence of a conspiracy to torture him.

Dalí was an exhibitionist and determinedly publicized his odd sex life: his hateful obsession with his mother, his impotence, his fascination with masturbation. Sometimes his paintings look as if disturbing sexual thoughts had themselves deranged time and space: bad perspective and sickening angles are a feature of some of his paintings, such as *Vertigo—Tower of Pleasure* (1930), with its images of bondage and ghostly fellators. But much of the transgressive, taboo aspect of these paintings seems to spring from incestuous fantasies. Dalí's attitude toward his mother was complex. He once made a picture called *Sometimes I Spit on the Portrait of My Mother for the Fun of It* (1929), in which those words were framed by a religious silhouette— perhaps that of Christ himself, given the sacred heart and the hand uplifted to bless, as if Christ were also spitting on the Blessed Virgin; pasted nearby was a newspaper notice of Dalí's conversion to Roman Catholicism. But Dalí seems interested not only in spitting on his mother but in having sex with her. In a painting called *Oedipus Complex* (1930) there's a lump of some yellowish substance with lots of holes in it, and the words *My mother* are drawn inside the holes. In a related painting, *The Enigma of Desire: My Mother* (1929), the slice of maternal cheese is thinner, more full of holes and dents, and seems to be part of a snail. Notice the soft little terminus of what might be the snail's head: it might be a bird's head, or the head of a big-nosed man— Dalí himself had a prominent nose—with shut eyes, and with ears that look

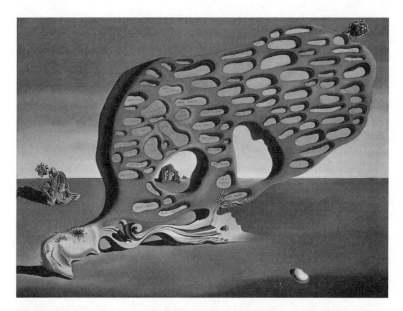

Salvador Dalí, *The Enigma of Desire: My Mother* (1929) bpk, Berlin/Pinakothek der Moderne/Art Resource, NY. © Salvador Dalí, Fundació Gala-Salvador Dalí, Artists Rights Society (ARS), New York 2015

like more shut eyes. The Dalí of *The Enigma of Desire* seems to bear his mother on his back, in his face, as if he were some hideous composite of man and mother, in danger of getting himself unborn.

This sort of figure appeared compulsively in Dalí's paintings, including the most famous painting of all, *The Persistence of Memory*. It's like a dreaming head liquefied into some flaccid shapeless organ: the fringe of hair could represent either eyelashes or the hair around a woman's labium. The softened head, the limp watches, remind us that *soft* is another favorite word of Dalí's; as he commented on this painting, "Technical objects were to become my worst enemy later on, and as for watches, they would have to be soft or not at all!"[11] Dalí's cult of sexual impotence led him to construct an impotent world where all objects sag helplessly; in many of his later paintings, crutches appear to help hold up this incompetent tissue. Dalí's *The Persistence of Memory* was evidently intended as an image of the loose bulging space-time that Einstein developed in the general theory of relativity, as Dalí commented:

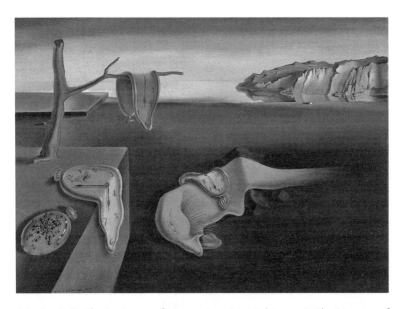

Salvador Dalí, *The Persistence of Memory* (1931) Digital Image © The Museum of Modern Art/Licensed by SCALA/Art Resource, NY. © Salvador Dalí, Fundació Gala-Salvador Dalí, Artists Rights Society (ARS), New York 2015

> If the Greeks . . . materialized their psychology and their Euclidian sentiments in their muscular, nostalgic and divine clarity of their sculpture, Salvador Dali, in 1935, is no longer content to make anthropomorphism for you out of the agonizing and colossal question which is that of Einsteinian space-time, he is no longer content to make libidinous arithmetic out of it for you, no longer content, I repeat, to make flesh of it for you, he is making you cheese of it, for be persuaded that Salvador Dali's most famous soft watches are nothing else than the tender, extravagant and solitary, paranoiac-critical camembert of time and space.[12]

A nice phrase, "camembert of time and space"; Einstein's space does indeed sag around the stars like runny cheese.

René Magritte

As I said, every Surrealist had his own specialty among modes of clinical insanity. If Dalí was attracted to paranoia, the Belgian painter René Magritte was a specialist in prosopagnosia. This word is Greek for "inability to recognize faces"—it's a neurological deficit that prevents you from matching per-

René Magritte, *Lost Worlds* (1928) Private Collection, Milan, Italy / Peter Willi / Bridgeman Images. © 2015 C. Herscovici / Artists Rights Society (ARS), New York

ceived objects with mental categories. The term was popularized by Oliver Sachs in his famous case study of "The Man Who Mistook His Wife for a Hat," concerning one Dr. P, who not only mistakes his wife for a hat but also continually chats with pieces of furniture and claps a friendly arm around mailboxes; so epistemologically damned is he that he even confuses his shoe with his foot—his own body is an alien presence to his confounded mind. Magritte's prosopagnosia is cultivated, elegant, but still destroys the semantic power of language and therefore of rational thought. In *The Key to Dreams* (1930), the painting is a set of panels with captions: an egg is labeled "*the acacia*," a woman's shoe is labeled "*the moon*," and so forth. The words are familiar, the pictures are familiar, but the wiring in the brain that connects word to picture has grown scrambled. The picture looks like a second-grade lesson in Prof. Alzheimer's School. Magritte painted many variants on this theme, including a few with English captions: one of them looks like a window divided into four panels, on which we see a horse's head labeled "*the door*," a clock labeled "*the wind*," a pitcher labeled "*the bird*," and a valise labeled "*the valise*." The choicest joke is the last panel, as if the right match of word and image were just as much a matter of lunatic indifference as the wrong ones.

Sometimes Magritte was explicit about the cognitive-failure aspect of his methods, as in *Lost Worlds*. The whole field is captioned *"country"*; within it are lobes like comic strip thought balloons, one of which says, *"Person losing his memory,"* while the other says, *"Body of a woman"*; in the lower right the word *"horse"* romps through the absent countryside.

Not only has the central figure lost his memory, but the painter seems to have lost his mind; the missing figures, the missing background, seem to suggest holes eaten away in the brain, a tangle of plaque where there ought to be neurological function. One of the foremost Surrealist journals was called *Acéphale*, that is, Headless, and the Surrealists liked to approximate a way of apprehending reality without rational thought, perhaps without a brain at all.

13 Aestheticism

Value: Nature is formless and empty; all value lies in the formalities of art.

The Symbolists of the nineteenth century were often members of the Aesthetic movement. Both Symbolism and Aestheticism generate many of their excitements from relinquishing and renouncing, from a cultivated unnaturalness. Aestheticism—the doctrine of art for art's sake, or maybe more exactly, of everything for art's sake—never produced an official manifesto, but the "Conclusion" (1868) to Walter Pater's *The Renaissance* and Oscar Wilde's essay "The Decay of Lying" (1891) come pretty close to constituting such a thing. Here is Pater:

> To burn always with this hard, gem-like flame, to maintain this ecstasy, is success in life. In a sense it might even be said that our failure is to form habits: for, after all, habit is relative to a stereotyped world, and meantime it is only the roughness of the eye that makes two persons, things, situations, seem alike. While all melts under our feet, we may well grasp at any exquisite passion, or any contribution to knowledge that seems by a lifted horizon to set the spirit free for a moment, or any stirring of the sense, strange dyes, strange colours, and curious odours, or work of the artist's hands, or the face of one's friend. Not to discriminate every moment some passionate attitude in those about us, and in the very brilliancy of their gifts some tragic dividing on their ways, is, on this short day of frost and sun, to sleep before evening.[1]

Among the main points of Oscar Wilde's essay are these:

1. Nature is shapeless, foul, boring, full of insects and uncooked birds. A sensible person stays indoors as much as possible.

2. Man in his natural state is also shapeless, foul, boring:

It is a humiliating confession, but we are all of us made out of the same stuff. In Falstaff there is something of Hamlet, in Hamlet there is not a little of Falstaff. The fat knight has his moods of melancholy, and the young prince his moments of coarse humour. Where we differ from each other is purely in accidentals: in dress, manner, tone of voice, religious opinions, personal appearance, tricks of habit and the like. The more one analyses people, the more all reasons for analysis disappear. Sooner or later one comes to that dreadful universal thing called human nature.[2]

This explains why Cecily in *The Importance of Being Earnest* can say, "It is only the superficial qualities that last. Man's deeper nature is soon found out": people are differentiated only by artificial inflections of the surface; on the deepest levels we are all the same, dully, monotonously the same.[3]

3. Human life is most satisfactory when most artificial. Insofar as we can make ourselves into a work of art, we succeed in enriching our lives. There are many avenues open to the person who wants to manufacture himself as an artifice: one can dress as a dandy (as Baudelaire recommended before Wilde); one can cultivate an elaborate system of etiquette, thereby reducing social life to ritual or game; one can surround oneself with exquisite sensory stimuli, such as incense, beautiful paintings, and chamber music. But the most significant way of artificializing one's identity is the histrionic method, that is, the conscious assumption of a theatrical role. It is of no consequence which role one chooses, but one must choose; the person who does not liberate himself by means of role-playing must instead be confined to his or her blank, stupid, natural self.

4. The priority of Art over Nature is absolute. Nature struggles in its clumsy way to conform to the models of beauty that Art has provided for it:

CYRIL. Nature follows the landscape painter, then, and takes her effects from him?
VIVIAN. Certainly. Where, if not from the Impressionists, do we get those wonderful brown fogs that come creeping down our streets, blurring the gaslamps and changing the houses into monstrous shadows? . . . [Fogs] did not exist till Art had invented them. Now, it must be admitted, fogs are carried to excess. They have become the mere mannerism of a clique, and the exaggerated realism of their method gives dull people bronchitis.[4]

In the same way, Art has dominion over human life: we are formless lumps of flesh until Art provides us with form. The histrionic method is

one example of this; but Wilde was eager to make still more extravagant claims about the priority of Art over human nature. Why are we born with our particular facial features and body shape? The usual answer today would be that these are determined by a recombination of our parents' genes. But Wilde offered a different answer: fetal development is determined by the works of art at which the mother stares: "The Greeks . . . set in the bride's chamber the statue of Hermes or of Apollo, that she might bear children as lovely as the works of art that she looked at in her rapture or her pain."[5] Wilde's vision of the world is almost wholly denatured: Nature exists only as a principle of inertia, a sluggishness impeding Art from realizing its strict delicate adorabilities. The century between Wordsworth and Wilde shows a perfect reversal in attitudes toward nature.

5. An important corollary to this loss of Nature is a loss of Truth. If there is no substrate to experience, there is nothing against which we can compare a proposition to discover whether it is true or false; a proposition cannot be judged according to its congruence to external reality if there isn't any external reality. This is why Wilde dotes on paradox: a proposition and its contrary are equally valid. This is why Wilde deplores the Decay of Lying: truths are no better than fictions—indeed truths are worse than fictions, because truths are more boring.

But in some ways the later Aestheticism of the twentieth century gives a more complete and compelling presentation of the role of art and artistic sensation in human life. I will discuss two figures, the American poet Wallace Stevens and the British novelist Virginia Woolf.

Wallace Stevens

Wallace Stevens spent much of his energy trying to elucidate the relationship between the human mind and external nature. In his poem "The Comedian as the Letter C" (1922), the protagonist, Crispin, experiments with two formulae for this relationship. The first, from the poem's opening section, called "The World without Imagination," is this:

> Nota: man is the intelligence of his soil,
> The sovereign ghost. As such, the Socrates
> Of snails, musician of pears, principium
> And lex.[6]

This is the nonaesthetic way of understanding the world: on one side there is the masterful human subject; on the other side is mindless nature, over which mankind has dominion, naming, taxonomizing, making sense of it. But later on, in the section called "The Idea of a Colony," the poet undoes this dualistic scheme:

> Nota: his soil is man's intelligence.
> That's better. That's worth crossing seas to find.
> Crispin in one laconic phrase laid bare
> His cloudy drift and planned a colony.
> Exit the mental moonlight, exit lex,
> Rex and principium, exit the whole
> Shebang. Exeunt omnes. Here was prose
> More exquisite than any tumbling verse:
> A still new continent in which to dwell.[7]

As the mind lets go of its authority, its zeal to master, we achieve a sort of interpenetration between ourselves and the physical world: as William Blake said long before, we become what we behold. We think *with* the world instead of thinking *at* the world. The imagination is the faculty that allows this melding with creation. Stevens uses metaphors of colonization, but it would be just as correct to say that the soil colonizes us as vice versa.

The evil, as Stevens sees it, arises from the attempt to separate ourselves from the external universe, to carve out a closed, hermetically sealed domain of mental and artistic (false-artistic) operation. He figures this evil in many ways:

> The greatest poverty is not to live
> In a physical world, to feel that one's desire
> Is too difficult to tell from despair. Perhaps,
> After death, the non-physical people, in paradise,
> Itself non-physical, may, by chance, observe
> The green corn gleaming and experience
> The minor of what we feel.[8]

> Home from Guatemala, back at the Waldorf.
> This arrival in the wild country of the soul,
> All approaches gone, being completely there,
>
> Where the wild poem is a substitute

> For the woman one loves or ought to love,
> One wild rhapsody a fake for another.
>
> You touch the hotel the way you touch moonlight
> Or sunlight and you hum and the orchestra
> Hums and you say "The world in a verse,
>
> A generation sealed, men remoter than mountains,
> Women invisible in music and motion and color,"
> After that alien, point-blank, green and actual Guatemala.[9]

Stevens deplores the art that muffles, the art that becomes a screen from or surrogate for actual experience. Bad art (which in "Arrival at the Waldorf" seems to be something like Glenn Miller as heard while drinking your third martini) provides an *Ersatz* universe, spectral and specular. Good art provides an immediate apprehension of the realness of reality.

Stevens considered that the Christian religion, with its cellophane fantasies of an afterlife where the harps always play in the key of C, was an especially unattractive form of bad art. In "A High-Toned Old Christian Woman" (1922), Stevens first announces that "poetry is the supreme fiction, madame," and then contrasts the Christian woman's ascetic conscience-ridden heaven with his own dreams of saints turned plump and bawdy—instead of bloodless Protestant hymns, a sort of interstellar jazz:

> Your disaffected flagellants, well-stuffed,
> Smacking their muzzy bellies in parade,
> Proud of such novelties of the sublime,
> Such tink and tank and tunk-a-tunk-tunk,
> May, merely may, madame, whip from themselves
> A jovial hullabaloo among the spheres.
> This will make widows wince. But fictive things
> Wink as they will. Wink most when widows wince.[10]

And in "Sunday Morning" (1915) Stevens applauds a woman's decision to delight in coffee and oranges and a cockatoo instead of going to church—for the atheist/hedonist, Stevens announces, "The sky will be much friendlier then . . . Not this dividing and indifferent blue."[11] The secular imagination, not the Christian imagination, provides true connection to the cosmos.

In some of Stevens's most successful poems, he contemplates a particular artwork that behaves as a kind of secular version of the Holy Ghost, ar-

resting us, enforcing a sudden crystallizing of undistinguished space into human order. In "The Idea of Order at Key West" (1934), the woman singing by the ocean's edge assimilates into her song the whole sea: she parses out the inhuman into the humanly comprehensible, makes acute and demarcated what was previously blunt and dark, unmeaning. In "Anecdote of the Jar" (1919), the artwork is less magical, but still full of amazing power:

> I placed a jar in Tennessee,
> And round it was, upon a hill.
> It made the slovenly wilderness
> Surround that hill.
>
> The wilderness rose up to it,
> And sprawled around, no longer wild.
> The jar was round upon the ground
> And tall and of a port in air.
>
> It took dominion everywhere.
> The jar was gray and bare.
> It did not give of bird or bush,
> Like nothing else in Tennessee.[12]

The homely verse (mostly tetrameter, with clompingly graceless iambs), the matter-of-fact syntax and diction, the incompetent rhymes, the hillbilly setting all contribute to a sense that there is nothing special about this jar: it isn't a Chinese vase; it's just an ordinary jug you might store beans or moonshine in. But even in its plainness it is a human artifact, and like any artifact it asserts human presence and acts as an orientation point: it unsavages nature by providing a reference frame, a coordinate geometry. It is a lighthouse.

Virginia Woolf

My other example of Modernist Aestheticism is from the artistic circle known as Bloomsbury, named after an area of London near the British Museum where the children of the philosopher, biographer, and atheist Sir Leslie Stephen (including Virginia Stephen Woolf and Vanessa Stephen Bell) took up residence after their father's death in 1904. Their house became a meeting place for a number of intellectuals, mostly associated with Cambridge University, including the economist John Maynard Keynes, the writer Lytton Strachey, the painter Duncan Grant, and the art historians Roger Fry

and Clive Bell. Anti-Victorianism was a striking feature of this community: Strachey wrote a book called *Eminent Victorians*, a deadpan but sparkling satire of Victorian grandees, and Virginia Woolf, in her novel *Orlando* (1928), presents the Victorian age as a time of mildew and monstrous gewgaws. The hero of *Orlando* is a three-hundred-year-old transsexual, and the Blooms-buryites were conspicuously anti-Victorian in their sexual practices: many of them were homosexuals or bisexuals who lived in various *ménages à* [in-sert number here], and chaste monogamy was rare.

Most of them were artists (writers, painters, ballet dancers) and often served art in other capacities too—Virgina and Leonard Woolf, for example, ran the Hogarth Press, one of the important outlets for avant-garde litera-ture. The mentor of Bloomsbury aesthetic thought was a Cambridge phi-losopher, G. E. Moore, who taught that there were only two great goods in human life: aesthetic enjoyment and personal affection. In fact, aesthetic emotion seems to be the cornerstone of his philosophy: he argues that we know that the world is real because it would be an intolerable state of affairs if our rapture at beautiful things were not grounded in the actual beauty of the physical world. Aesthetic feeling, he believes, is worthless in the ab-sence of a genuinely beautiful object to provoke that feeling:

> If we consider what value this [aesthetic] emotional element would have, *existing by itself*, we can hardly think that it has any great value, even if it has any at all. . . . We can imagine the case of a single person, enjoying through eternity the con-templation of scenery as beautiful . . . as can be imagined; while yet the whole of the objects of his cognition are absolutely unreal. I think we should definitely pronounce the existence of a universe, which consisted solely of such a person, to be *greatly* inferior in value to one in which the objects, in the existence of which he believes, did really exist just as he believes them to do.[13]

Moore deplored, perhaps even feared, the solipsist who wrapped himself in delicately nuanced hallucinations of images, sounds, smells, in the absence of a real world. (Such aesthetes *maudits* were familiar in nineteenth-century fiction, such as Joris-Karl Huysmans's *Against Nature* and Yeats's "Rosa Al-chemica.") In the novels of Virginia Woolf, we find a strong desire to ground art and artistic sensations in the real world. But Woolf suffered from schizo-phrenic episodes and often had intense sensations that had no grounding at all in reality; and for that reason, as well as others, she treats aesthetic emo-tion as salvation or damnation or some strange mixture of the two.

To the Lighthouse

Some artistic movements within Modernism react to the universal chaos of life by trying to incorporate it into the artwork. But it is also possible to take the opposite approach and try to make the artwork, as Robert Frost puts it, a momentary stay against confusion. The aesthetes of the famous Bloomsbury group usually took the latter approach, and a novel by Virginia Woolf is a good place to study it.

It's not easy to summarize the plot of *To the Lighthouse* in such a way as to make it sound fascinating. A beautiful middle-aged woman (Mrs. Ramsay, the wife of a philosopher) reads a fairy tale out loud or knits a stocking; a house guest decides to paint this heartwarming scene; a child is disappointed when a short boat ride to a lighthouse fails to take place because bad weather is expected; some years later the boat ride finally happens, but it turns out that there's nothing really to see at the lighthouse. You might not run to the bookstore to buy the book. And yet it's a disturbing book, all the more stormy and stressful in that the setting is a quiet vacation home, not the South Pole or in mid ocean. There's a fringe of horror around scenes of cozy domesticity. *To the Lighthouse* is a novel that reenacts the unintelligibility of extremely familiar things: it imitates the mind's necessary failure to come to terms with the world or with itself. Not only the interpretation of events but also the events themselves are questionable, uncertain.

It is a novel in which unanswered questions multiply everywhere. "How did one judge people, think of them?"; "How long do you think it'll last?"; "What does it mean then, what can it all mean?"[14]—these are a few of the questions that crop up amid the general giddiness, vertigo. The characters keep making tentative judgments, investing experience with tentative meanings, but they are all fiction makers, just like the novelist herself. Every answer to a question is a self-conscious fiction, with no authority behind it. For example, we may consider the question, How did Paul and Minta Rayley fall out of love? Lily Briscoe (the novel's painter-heroine) gives us an elaborate account: "There was Minta, wreathed, tinted, garish on the stairs about three o'clock in the morning. Paul came out in his pyjamas carrying a poker in case of burglars. Minta was eating a sandwich, standing half-way up by a window, in the morning light, and the carpet had a hole in it. But what did they say? Lily asked herself, as if by looking she could hear them. Minta went on eating her sandwich, annoyingly, while he spoke something violent,

abusing her, in a mutter so as not to wake the children."[15] This narrative is about as detailed and vivid as any in the novel, but Lily finally confesses that "not a word of it was true; she had made it up."[16] We can even guess how Lily managed to invent some of the details: because Minta's parents were nicknamed the Owl and the Poker,[17] her husband is given a poker to brandish in this scene. Truth drowns in the continual proliferation of fiction. Everywhere To the Lighthouse exposes the fictitious character of human "knowledge." Questions are real, answers are not—it is little wonder that the novel's mode is interrogative, an interrogation of interrogations.

It is a novel in which everyone is looking around, peeking in windows, staring intently, but no one has good eyesight. Mrs. Ramsay's myopia is only one of many different kinds of defective vision found in this book. She is often too vain to wear her glasses, and this fact becomes emblematic of the general unreality of her construction of the world: "She [Lily] had laid her head on Mrs. Ramsay's lap and laughed and laughed and laughed, laughed almost hysterically at the thought of Mrs. Ramsay presiding with immutable calm over destinies which she completely failed to understand."[18] In her passion for matchmaking, for arranging lives in an orderly fashion, Mrs. Ramsay is complicit in illusion, unwilling to face the hopeless unsteadiness of life. But all the characters inhabit fictitious worlds—only some understand it more clearly than others. Even Lily Briscoe, who retreats from all human intercourse, who aspires to be a huge detached eyeball scrutinizing people from afar, knows that her vision is inadequate: "One wanted fifty pairs of eyes to see with, she reflected. Fifty pairs of eyes were not enough to get round that one woman [Mrs. Ramsay], she thought. Among them, must be one that was stone blind to her beauty."[19] The novel multiplies perspectives at a dizzying rate—Mrs. Ramsay is shown to us not only through Lily's eyes, but through William Bankes's, Mr. Ramsay's, Charles Tansley's, and so forth—but instead of investing the woman with firmness of outline, stereoscopic solidity, the multiplying perspectives tend to dissolve her into competing images, difficult to reconcile. The Mrs. Ramsay of part III is more of an enigma than that of part I; new information only increases the puzzlingness of her being. The act of looking tends to disintegrate the object looked at.

This loss of focus, this shiftiness of subject and object, is the source of much of the reader's uneasiness. We are not accustomed to such a quicksand of a text. It is no accident that the novel is set on an island, and that water is the object of so much attention. Virginia Woolf wrote only one

novel entitled *The Waves*, but that title could be applied to almost any of her works:

> The monotonous fall of the waves on the beach, which for the most part beat a measured and soothing tattoo to her thoughts and seemed consolingly to repeat over and over again as she [Mrs. Ramsay] sat with the children the words of some old cradle song, murmured by nature, "I am guarding you—I am your support," but at other times suddenly and unexpectedly, especially when her mind raised itself slightly from the task actually in hand, had no such kindly meaning, but like a ghostly role of drums remorselessly beat the measure of life, made one think of the destruction of the island and its engulfment in the sea . . . this sound which had been obscured and concealed under the other sounds suddenly thundered hollow in her ears and made her look up with an impulse of terror.[20]

Implosion is a constant threat. No ground is so solid that it can offer a secure refuge, and drowning is possible anywhere, at any time. Everywhere in the novel Woolf counterpoints the homeliest, coziest aspects of domestic life and terror: on the opening page little James is cutting pictures of appliances out of a catalogue but has a sudden impulse to stab his father's heart; later, Mrs. Ramsay reads him a simple fairy tale, but in that fairy tale a storm rises from the sea to destroy the land. Discontinuity, unpredictability, dissolution lurk beneath the pleasing, sentimental exterior. In fact, the great banquet scene seems to take place underwater: the bowl of fruit on the table looks like "a trophy fetched from the bottom of the sea, of Neptune's banquet";[21] and when the candles are lit, the diners themselves seem suddenly transported to the bottom of the sea: "The night was now shut off by panes of glass, which, far from giving any accurate view of the outside world, rippled it so strangely that here, inside the room, seemed to be order and dry land; there, outside, a reflection in which things wavered and vanished, waterily."[22] The water cannot keep to the shore, but steadily encroaches upon the scene. In this watery matrix it is little wonder that their eyesight is distorted.

The hydrodynamics of this novel, however, are still more complicated than we have yet seen. Not only does water threaten to engulf the island, but there is also water inside the characters. Not only are the characters of the novel all swimmers, trying to keep from dissolving in their dissolving world, but also they are themselves made of water:

> She [Mrs. Ramsay] often felt she was nothing but a sponge sopped full of human emotions.[23]

What device for becoming, like waters poured into one jar, inextricably the same with the object one adored? Could the body achieve, or the mind, subtly mingling in the intricate passages of the brain? or the heart?[24]

They [Mr. Ramsay and Lily Briscoe] stood there, isolated from the rest of the world. His immense self-pity, his demand for sympathy poured and spread itself in pools at her feet, and all she did, miserable sinner that she was, was to draw her skirts a little closer round her ankles, lest she should get wet.[25]

Virginia Woolf's characters are vessels, leaky vessels indeed; and human community is a sort of interchange of fluids. This shapelessness of personality is astonishing, when we consider it in relation to the practice of nineteenth-century novelists: instead of the incised gingerbread men of Dickens or Eliot, overt, with such predictability of gesture that they are almost robots, we have characters who are sponges, bladders, exocrine glands, oozing emotion on all sides. They have skin and clothing, but their insides are more potent, more visible, than their outsides. Sometimes Woolf compares them to fish,[26] but perhaps they could be better compared to marine worms, sea cucumbers, the more amorphous species of undersea denizens.

We see, then, that water is an important theme, both the water of the "real" ocean and that of interior states of feeling. But even the dry land is basically watery in character. The trees, the house, the lawn are not firmly established; they waver and give way at many odd moments. There is a disconcerting mutability to the outer world. If Lily thinks about a kitchen table when the kitchen table isn't there, why, a kitchen table presents itself in an unusual place: "And with a painful effort of concentration, she focused her mind, not upon the silver-bossed bark of the tree, or upon its fish-shaped leaves, but upon a phantom kitchen table, one of those scrubbed board tables, grained and knotted, whose virtue seems to have been laid bare by years of muscular integrity, which stuck there, its four legs in air."[27] The landscape is fully permeable by ideas.

But in this sloshy universe there are strategies for saving oneself from drowning.

1. DISTANCE There is, then, in To the Lighthouse a double perspective. To the swimmer the waves appear to be random heaves of water, threatening to drown; but to the cliff-top gazer they are attractive and orderly. Over and over Woolf insists on this perceptual duality: up close a thing looks one way, but far away it looks quite different. The island itself, which to the is-

land dwellers is the whole world, appears to Mrs. Ramsay's daughter Cam, gazing from a boat, to be only a "leaf"; and, as she thinks idly of those who live on the island, it seems that "they have no suffering there." Distance offers not only the pleasure of an aesthetic pattern but also the bliss of anesthesia: the remote spectator sees no misery, only delight. Cam is, as far as we are told, not an artist; yet the joys of artistic consolation are available to her, indeed to anyone who finds a way of detaching from life. A boat ride is as good as genius.

2. FRAMING There are several ways of gaining the requisite distance from things. One is, as we have seen, simply by physical travel—walking away, taking a boat ride. A second method for attaining distance is by the act of framing: if the person looking can isolate the thing looked at, see it as compact and bounded, separate from the rest of reality, he or she can see it as art, as beautiful and immune from change. Framing is a common occupation in this novel, and this is why part I is called "The Window," for windows are very suitable frames for isolating and perfecting an image. Indeed, much of part I consists of the various reactions of people walking past the window where Mrs. Ramsay is reading to her son James: Lily, the scientist William Bankes, the philosopher Mr. Ramsay are all charmed by this preframed image, which seems to represent something important, stabilizing, in their lives. Mr. Ramsay's response is definitely artistic in nature, even though, like Cam, he is no artist: "He stopped to light his pipe, looked once at his wife and son in the window, and as one raises one's eyes from a page in an express train and sees a farm, a tree, a cluster of cottages as an illustration, a confirmation of something on the printed page to which one returns, fortified, and satisfied, so without his distinguishing either his son or his wife, the sight of them fortified him and satisfied him."[28] The world rushes by at dizzying speed; however, just as the train traveler's eye can look up for a second, take a mental snapshot, orient himself, and then return to his reading, so the act of framing can stock Mr. Ramsay's mind with an image that reassures, orients, remains cozily in the background of his thinking. In Woolf's fiction, memory is a kind of camera, filling the brain with snapshots; but the operation of memory is dependent to some degree on the accident of framing—in some manner the thing, if it is to be remembered, must isolate itself.

3. SYMBOLIZING So the felicity of distance can be enjoyed first by physical separation and second by framing. A third way is by symbolization. As

we have seen, framing is partly accidental—the spectator simply happens upon a ravishing image. Symbolizing is also partly accidental—suddenly a perceived object grows typical, generic, saturated with a burden of significance previously unknown to it. Lily Briscoe's eye is particularly adept at finding symbols:

> So that is marriage, Lily thought, a man and a woman looking at a girl throwing a ball. . . . And suddenly the meaning which, for no reason at all, as perhaps they are stepping out of the Tube or ringing a doorbell, descends on people, making them symbolical, making them, representative, came upon them, and made them in the dusk standing, looking the symbols of marriage, husband and wife. Then, after an instant, the symbolical outline which transcended the real figures sank down again, and they became, as they met them, Mr. and Mrs. Ramsay watching the children throwing catches.[29]

This sudden extension of the particular into the general, this strange superposition and congruence of the concrete and the abstract, is accompanied by the sensation of distance, as Woolf goes on to say: "For one moment, there was a sense of things having blown apart, of space, of irresponsibility as the ball soared high, and they followed it and lost it and saw the one star and the draped branches. In the falling light they all looked sharp-edged and ethereal and divided by great distances."[30] It is easy to see why symbol making would be associated with distance. Insofar as Mr. and Mrs. Ramsay and the children are not merely themselves, but Marriage with a capital M, they are removed from their common identities, just as the algebraic symbol x is distant from and larger than the actual integer that solves the equation. The symbolizing eye manages to fix, to hold fast the thing it looks at, by endowing it with meaning beyond itself.

4. ART Her fourth, last, and most important strategy for enforcing distance is, of course, art—that is, the actual production of a painting, poem, or novel. Physical distance, framing, symbolizing all have a certain accidental quality about them: one happens to be in a certain place, or one happens to see a particular picture in an isolated condition, or one happens to note the sudden suitability of an object as an expression of a spiritual state. But art is willed and conscious—and here Woolf differs from Marcel Proust, whom she often resembles; Proust esteemed involuntary perception, the images aroused by the random and thoughtless tasting of a madeleine soaked in a *tisane*, images that haul up from the depths of the mind the felt actuality of

the past, whereas Woolf preferred the voluntary effort to hold the beloved object by means of art. In this sense Woolf is heroic in a way impossible to Proust; whereas Proust's narrator simply wanders about idly, hoping to blunder by chance upon the magic keys to lost paradises—to search in a connected, determinate fashion would mean that he would never find them—Woolf's major characters must press every resource they own into the fight to seize and recapture those things that they love, to impress upon a sensuous medium an image of what they value.

The main artist in *To the Lighthouse* is, of course, Lily Briscoe, and she is one of the most puzzling characters in literature. It has been recognized, since the novel appeared in 1927, that it was autobiographical in tendency. The Ramsays are quite clearly modeled on Woolf's parents: Sir Leslie Stephen, the great Victorian agnostic, the author of summaries of eighteenth- and nineteenth-century British thought still used by students today, the author of much of the sixty-three volume *Dictionary of National Biography*; and his second wife Julia Duckworth Stephen, a celebrated beauty much younger than her husband, who should have been the comfort of his old age but who instead died young, when Virginia was thirteen years old. Virginia Woolf's sister Vanessa was among the first readers to congratulate her on the psychological accuracy of her portrayals. And yet, when we compare *To the Lighthouse* with one of the many autobiographical novels about the childhood of the Great Writer, such as James Joyce's *A Portrait of the Artist as a Young Man*, we immediately see a great difference: Joyce is primarily interested in representing himself, while Woolf disguises herself, makes the artist-heroine as unlike herself as possible. Virginia Stephen Woolf was a beautiful woman, famous for her vivacity and sharp wit, one of the central figures in the intellectual life of her time. But Lily Briscoe is a withered spinster with little squinty eyes, ineffectual and retiring in many social situations. Why would Virginia Woolf write an autobiographical novel in which she demoted her artist-heroine to such a seemingly low state?

The answer, I believe, lies in the necessity for distance. Distance is our only hope for not perishing in the welter of experience, and Woolf grants herself a kind of extreme distance from her family by regarding them through the eyes of Lily—who is not even a family member but an outsider in the Ramsay household. She is simply a detached eye outfitted in a hat and skirt— an eye detached from the Ramsay family, detached from her own family (of whom we hear next to nothing), detached from sexual life (though Paul Rayley's sexual magnetism can inspire a few faint flushes in her), detached

from everything. She has no function except to observe; she is just a film, an achromatic medium on which the experiences of Virginia Woolf's childhood may grow vivid, luminous. In fact, it is almost as if Virginia Woolf suppressed her own personality in order to record the experiences that formed her personality as accurately as possible.

Value for postwar Modernism: Reinterpret, consolidate, challenge prewar Modernism.

Lily Briscoe and Vanessa Bell

To understand Lily's art, it is necessary to understand the background of *To the Lighthouse* in the prewar world of the visual arts, when the Bloomsbury painters were doing much of their liveliest and most original work. *To the Lighthouse* is quite an up-to-date novel, but it is a novel that is still trying to come to terms with the artistic breakthroughs that occurred some fifteen years before its publication. Woolf had to digest the meal that she and her friends ate a good while ago.

Lily Briscoe's pedigree as an artist is complicated. Mr. Pauncefort, who started a local vogue for soft greens and pinks and lemons and grays in paintings of the beach, is an Impressionist, recasting the visible world into striking color combinations;[31] and Lily is also a kind of Impressionist, interested in breaking up the settled, "photographic" scene before her into hasty brushstrokes, streaks and masses of paint, in order to investigate optical verities beyond the camera's power. But Lily is also a kind of proto-Abstractionist, searching for hidden geometries underneath the surfaces of things, painting forms so cryptic and unintelligible that the spectator could scarcely guess what was being represented. Indeed, there may be something anachronistic in Lily's method—even a very well informed British amateur painter was not likely to know much about this style of painting in the pre–World War I era of part I of this novel. The Cubism of Picasso and Braque and the Abstractionism of Kandinsky were little known. Virginia Woolf's close friend Roger Fry organized the first London exhibition of the French Post-Impressionists (principally Gauguin, Van Gogh, and Cézanne) in 1910—Fry also was the first to use the term *Post-Impressionism*—and it was not wholly well received. The critic Wilfred Scawen Blunt, viewing Fry's exhibition, didn't much like it:

> The exhibition is either an extremely bad joke or a swindle. I am inclined to think the latter, for there is no trace of humour in it. Still less is there a trace of sense

of skill or taste, good or bad, or art or cleverness. Nothing but the gross puerility which scrawls indecencies on the walls of a privy. The drawing is on the level of that of an untaught child of seven or eight years old, the sense of colour that of a tea-tray painter, the method that of a schoolboy who wipes his fingers on a slate after spitting on them.[32]

There was a good deal of public resistance in England to the avant-garde. As a painter, Lily isn't wholly credible, for she seems to be a not especially well educated provincial pondering the creative act in the most advanced Bloomsburyian vocabulary. Though the novel presents her as a loner, a marginal presence in a remote philosopher's household, she seems well acquainted with the up-to-date painting methods and ideas of Duncan Grant, Roger Fry, and Woolf's sister, the painter Vanessa Bell. It may help to see Lily's imaginary paintings through the real works of Vanessa Bell, though I don't mean to suggest that Woolf is using her sister as a model—I'm only suggesting that Woolf considered visual creativity through the most readily available visual creator at hand.

One of Vanessa Bell's lovers was Roger Fry, but she was married to another art historian, Clive Bell. Bell's catchphrase was *significant form*: in his 1914 book *Art* he argues that aesthetic emotion has nothing to do with the emotions of day-to-day life, such as the emotion you feel at the sight of Jennifer Lopez or Brad Pitt, or the sight of a dead raccoon on the road. (In this Bell follows Kant, who in the *Critique of Judgment* defined aesthetic emotion as an emotion you feel without a prior desire—you want a beefsteak because you're hungry, but there's no physical desire that makes you hunger to see the *Mona Lisa*.) Aesthetic emotion, according to Bell, is aroused by significant form—accuracy of representation means nothing. Bell doesn't give many examples of exactly how one form manages to be more significant than another, but when Lily's painting seems to disengage Mrs. Ramsay, isolate her, extratemporalize her, it seems that the novel is being orthodox Clive Bell.

There are a number of Vanessa Bell's paintings that seem congruent with the themes of *To the Lighthouse*. For one thing, Bell (from now on when I write Bell I mean Vanessa Bell, not Clive) liked windows, as in *View of the Pond of Charleston*. The framing device in this painting works as in the narrative: to set off experience, to render it manageable. The jar in the foreground works to aestheticize the landscape behind it, as if the plane of the real trees and the plane of the reflected trees were somehow wrapped around the jar, the central axis around which the composition poises.

Vanessa Bell, *View of the Pond of Charleston* (1919) Sheffield Galleries and Museums
Trust, UK/Photo © Museums Sheffield/Bridgeman Images

In some of her paintings, such as *Studland Beach*, Bell veers away from
the friendly themes of domestic life into something more eerie. Perhaps the
woman is just stepping into a cabana, but she seems to be stepping into a
door frame cut into the ocean itself—the painting has a mysterious chill
calm, as if she were saying goodbye to the earth. If we were told that this
was meant to be the ghost of the artist's mother, we might be only a little
surprised.

Bell sometimes moved far into abstraction, not only in her craft designs
(such as for wallpaper) but, on a few occasions, in her canvases as well: she
made at least four purely abstract paintings. They may be full of significant
forms, but it's hard to know what they signify. So we see in Bell's work the
whole range of possibilities that Lily toys with, from stylized portraiture to
sheer abstraction. But there's one work of Bell's, *Virginia Woolf at Asheham*,
that haunts me in the same way that the imaginary portrait of Mrs. Ramsay
in *To the Lighthouse* might be haunting. I don't know if Woolf here is knitting
a reddish brown stocking exactly like Mrs. Ramsay's, but it's not far from it;
and the picture suggests the same sense of domestic centrality, long inti-

Vanessa Bell, *Studland Beach* (1912) Tate, London / Art Resource, NY

macy, with which Lily tries to imbue her painting of Mrs. Ramsay. But note the face: it's blurry, half-erased-looking, as if Woolf were starting to lose human feature, to become monumental and indistinct. I wonder if Woolf meditated on this picture of herself when writing the novel: in the book William Bankes notes that Lily's painting reduces Mrs. Ramsay and her son— Madonna and Child—to a purple shadow without irreverence; in the paint- ing Woolf herself is reduced to a bland, almost uninflected mask without irreverence.

Bell provides a still more faceless version of Woolf in *Virginia Woolf in a Deckchair*. Woolf's husband, Leonard, admired this picture enormously and told Richard Shone that "it's more like Virginia in its way than anything else of her."[33] A famous author has been reduced to something like a clothes mannequin without irreverence.

A fascination with the blank is everywhere in Lily's meditations on her art. When Lily thinks of her art, she uses two distinct vocabularies, which reflect her two distinct artistic purposes. The first is the vocabulary of mo- tion: "The brush descended. It flickered brown over the white canvas; it left a running mark. A second time she did it—a third time. And so pausing and so flickering she attained a dancing rhythmical movement . . . she scored

Vanessa Bell, *Virginia Woolf at Asheham* (1912) © National Portrait Gallery, London

her canvas with brown running nervous lines which had no sooner settled there than they enclosed (she felt it looming out at her) a space."[34] Flickering, running, dancing, nervous—these words suggest Lily's attempt to render the dynamism of the scene before her, to imitate the perceptual intensity latent in the quiet domestic scape. This is the vocabulary of Impressionism. But notice that all these quick, running brushstrokes serve to enclose, to define an empty space on the canvas; Lily is passing from a consciousness of motion to a consciousness of stasis. At the center of all this busy movement there is just a blank. A somewhat similar blank, but a painted blank, not empty canvas, bemused William Bankes in the first version of Lily's painting, back in part I of the novel:

> What did she wish to indicate by the triangular purple shape, "just there"? he asked.
>
> It was Mrs. Ramsay reading to James, she said. She knew his objection—that no one could tell it for a human shape. But she had made no attempt at a likeness,

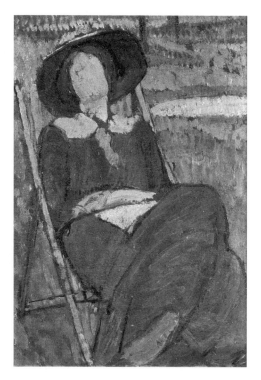

Vanessa Bell, *Virginia Woolf in a Deckchair* (1912) © Sotheby's / akg-images. © Estate
of Vanessa Bell, Courtesy Henrietta Garnett

she said. For what reason had she introduced them then? he asked. Why in-
deed?—except that if there, in that corner, it was bright, here, in this, she felt the
need of darkness. Simple, obvious, commonplace, as it was, Mr. Bankes was in-
terested. Mother and child then—objects of universal veneration, and in this case
the mother was famous for her beauty—might be reduced, he pondered, to a
purple shadow without irreverence.[35]

Here we have not the vocabulary of Impressionism or Post-Impressionism
but the vocabulary of Abstractionism. A nineteenth-century painter like
Édouard Manet might be called a mass Impressionist, balancing rather flat
masses of paint, but this stark reduction of Madonna and Child to a purple
triangle is closer to the twentieth-century world of Kandinsky. Kandinsky,
in his book *Concerning the Spiritual in Art*, spoke of the superior spirituality

of abstract forms—forms whose beauty was untainted by representation, contact with the lower world. Lily does not use this high-flown sort of defense of her art, but it is telling that she depicts Mrs. Ramsay, whom she loves and venerates, perhaps more than anyone on earth, as a blank geometrical abstraction.

There is, then, a tension between the dynamic and static elements of Lily's art, the Impressionist and the Abstractionist. On one hand, Lily wants to present the delicate, vibrant surfaces of things; on the other hand, she wants to dig beneath the surface to some region of pure essences, naked forms. Lily expresses this division in her goals in the following way: "Beautiful and bright it [her picture] should be on the surface, feathery and evanescent, one colour melting into another like the colours on a butterfly's wing; but beneath the fabric must be clamped together with bolts of iron. It was to be a thing you could ruffle with your breath; and a thing you could not dislodge with a team of horses."[36] Virginia Woolf, as it happened, spoke of her own art in very similar terms. She entitled a collection of her essays *Granite and Rainbow*, and that phrase appears often in her writings. She thought that art should be faithful to the granite of things, the inviolable understructure of form perceived at the bottom of reality, and to the rainbow, the sensuous enchantment of the surface.

I said earlier that *To the Lighthouse* was a novel of double perspective; its two perspectives correspond exactly to granite and rainbow. Up close, you see the rainbow, the shimmering play of light on surfaces, but far away, you discern the granite. All of the methods for gaining distance help you to attain a vision of deep form, the icy abstractions that underlie the world of melting appearances, the world of water. The purple triangle *is* Mrs. Ramsay. It is a glimpse of her being, beneath all the stocking knitting and dinner organizing, beneath her pottering about the garden and her investigations into the purity of milk, beneath all the casual, daily acts of her life. There are two Mrs. Ramsays: there is the extensive Mrs. Ramsay, who unfolds and diffuses into the whole household; who is like a fruit tree that gives succor to her family;[37] who is, as Woolf said of her own mother, less like a human being than like an atmosphere.[38] This is Mrs. Ramsay as rainbow. But there is also the intensive Mrs. Ramsay, the granite Mrs. Ramsay, expressed in Lily's painting as a purple triangle. One of the spookiest aspects of *To the Lighthouse* is the coincidence of Lily's purple triangle with Mrs. Ramsay's own deepest image of her identity, as she knits a reddish-brown stocking:

To be silent; to be alone. All the being and the doing, expansive, glittering, vocal, evaporated; and one shrunk, with a sense of solemnity, to being oneself, a wedge-shaped core of darkness, something invisible to others. Although she continued to knit, and sat upright, it was thus that she felt herself; and this self having shed its attachments was free for the strangest adventures. When life sank down for a moment, the range of experience seemed limitless. . . . There were all the places she had not seen; the Indian plains; she felt herself pushing aside the thick leather curtain of a church in Rome. This core of darkness could go anywhere, for no one saw it. . . . There was freedom, there was peace, there was, most welcome of all, a summoning together, a resting on a platform of stability. Not as oneself did one find rest ever, in her experience (she accomplished here something dexterous with her needles) but as a wedge of darkness. Losing personality, one lost the fret, the hurry, the stir.[39]

From the purple triangle of Lily's painting to this dark wedge there is only a short step; the two images of the depersonalized Mrs. Ramsay are uncannily congruent. The deep, intrinsic Mrs. Ramsay is capable of strange, imaginative transformations; she can hover over the Indian plains, or enter a church in Rome; the usual limitations of time and space no longer impede her. We saw earlier that distance was bliss, safety, anesthesia; and here we see that distance from one's commonplace self brings eerie delights. To abstract oneself, to be an abstraction, is a species of joy.

There is, however, something slightly morbid about this delirium. We should not forget that on one level Virginia Woolf is writing about her long-dead mother, and in this famous passage Mrs. Ramsay has a kind of prevision of her own death. The Roman poet Lucretius wrote a passage, much quoted in nineteenth-century British literature, about how the gods, immune from snow and rain and hail, looked down with amusement at the spectacle of human suffering. And it is almost as if Mrs. Ramsay carries inside her a vision of her dead, impersonal self as a Lucretian god, strangely detached from her children, her husband, all human concerns, and invested with godlike power of movement. The dark wedge is a flying carpet. There is something morbid, too, in Lily's image of the purple triangle—it seems slightly sinister that no eye, not even that of William Bankes, can recognize Mrs. Ramsay in Lily's picture. Too much of Mrs. Ramsay's ordinary self has been sacrificed by Lily's unintelligible hieroglyphic.

It is a little frightening, too, that we cannot easily find any relation between the two Mrs. Ramsays, the beautiful mother and the purple triangle,

the appearance and the essence. It is, in a sense, a defect of Lily's painting, this inability to connect the original and the formal representation. And it is, in a sense, a defect of Virginia Woolf's fiction writing as well. Lily's inability reflects Woolf's own difficulties in translating her mother from a real woman into a satisfying artistic image. To study further the limitations of art, we should look for a moment at one of Woolf's most important essays, "Mr. Bennett and Mrs. Brown" (1924).

Mr. Bennett and Mrs. Brown

This essay, written not long before Woolf began *To the Lighthouse*, is a meditation on the difficulty of characterization. Woolf here tells a somewhat playful story about the origin of novels—novels come into being because the novelist continually chases after characters without quite being able to catch them:

> A little figure rose before me—the figure of a man, or of a woman, who said, "My name is Brown. Catch me if you can."
>
> Most novelists have the same experience. Some Brown, Smith, or Jones comes before them and says in the most seductive and charming way in the world, "Come and catch me if you can." And so, led on by this will-o'-the-wisp, they flounder through volume after volume, spending the best years of their lives in the pursuit, and receiving for the most part very little cash in exchange. Few catch the phantom; most have to be content with a scrap of her dress or a wisp of her hair.[40]

Woolf goes on to tell an anecdote about a fellow passenger in a train compartment, an elderly woman who was a total stranger to her, but who—with her air of dignified shabbiness and suppressed misery—somehow stimulated Woolf to fiction making. This elderly woman, whom Woolf calls "Mrs. Brown," is the germ of a novel trying to get itself written. Woolf pretends that any novelist would find her an irresistible subject; if the popular realistic novelist Arnold Bennett had seen her, he would have described how the thumb of her left glove had been carefully mended, along with a thousand other precisely seen realistic details. But, Woolf says, the essence of the woman would be smothered, would vanish, under this pile of particulars:

> I asked them [novelists like Arnold Bennett]—they are my elders and betters— How shall I begin to describe this woman's character? And they said: "Begin by saying that her father kept a shop in Harrogate. Ascertain the rent. Ascertain the

wages of shop assistants in the year 1878. Discover what her mother died of. De-
scribe cancer. Describe calico. Describe—" But I cried: "Stop! Stop!" And I regret
to say that I threw that ugly, that clumsy tool out of the window, for I knew that
if I began describing the cancer and the calico, my Mrs. Brown, the vision to
which I cling though I know no way of imparting it to you, would have been
dulled and tarnished and vanished for ever.[41]

Woolf calls, instead, for a deeper, more poetic art than the art of the con-
ventional realist, an art that can see aspects of Mrs. Brown that utterly elude
the shallow 20/20 vision of novelists like Bennett: "You should insist that
she [Mrs. Brown] is an old lady of unlimited capacity and infinite variety;
capable of appearing in any place; wearing any dress; saying anything and
doing heaven knows what. But the things she says and the things she does
and her eyes and her nose and her speech and her silence have an over-
whelming fascination, for she is, of course, the spirit we live by, life itself."[42]
Far from being a heap of particulars, Mrs. Brown has generalized into the
human race. She is not a specific woman but a kind of Muse of our species.

In *To the Lighthouse*, Woolf tried to put into practice some of the ideas of
this essay. It would have been easy for her to write an Arnold Bennett-like
(or Dickens-like) novel about her parents, as the following description of
Sir Leslie Stephen, taken from the autobiographical essay "A Sketch of the
Past," shows:

Over the whole week . . . brooded the horror of Wednesday. On that day the
books were shown him. If they were over eleven pounds, that lunch was a tor-
ture. The books were presented. Silence. He was putting down his glasses. He
had read the figures. Down came his fist on the account book. There was a roar.
His vein filled. His face flushed. Then he shouted "I am ruined." Then he beat his
breast. He went through an extraordinary dramatization of self-pity, anger and
despair. He was ruined—dying . . . tortured by the wanton extravagance of Van-
essa and Sophie. "And you stand there like a block of stone. Don't you pity me?
Haven't you a word to say to me?" and so on. Vanessa stood by his side absolutely
dumb. He flung at her all the phrases—about shooting Niagara and so on—that
came handy. She remained static. Another attitude was adopted. With a deep
groan he picked up his pen and with ostentatiously trembling fingers wrote out
the cheque. This was wearily tossed to Vanessa. Slowly and with many groans the
pen, the account book were put away. Then he sank into his chair and sat with
his head on his breast. And then at last, after glancing at a book, he would look
up and say half plaintively, "And what are you doing this afternoon, Ginny?"

Never have I felt such rage and such frustration. For not a word of my feeling could be expressed.[43]

Here is old-fashioned characterization at its best. Behind this vivid scene stand a thousand misers and elderly self-dramatizing killjoys from the Commedia dell'Arte and other old shows, but the coloring of detail is straight out of the realistic novel. When we compare this scene to any scene in which Mr. Ramsay appears, we see how Woolf has altered the depth of field of her camera, made the surface yield to what is beneath. Instead of the rainbow of habitual observed behavior, she shows us the granite of various deep symbolic equivalents: Mr. Ramsay as he appears to himself, a doomed arctic explorer;[44] Mr. Ramsay as he appears to others, a scimitar or a beak of brass;[45] or a channel marker indicating the safe path for navigation.[46]

Woolf's treatment of Mrs. Ramsay is still more strikingly influenced by the artistic doctrines of "Mr. Bennett and Mrs. Brown"—indeed, the Mrs. Brown of the essay has many interesting common features with the Mrs. Ramsay of To the Lighthouse. Each has a superficial aspect and a deep aspect. Mrs. Ramsay, like Mrs. Brown, is a locus of story making. No one knows much about her, but the other characters speculate endlessly about her. Did a young man commit suicide out of despairing love for her?[47] No one knows the facts of her past, but inventions proliferate to fill the vacuum. Lily even makes up a little scene in which Mrs. Ramsay accepts her marriage proposal while stepping out of a boat.[48] To the Lighthouse is crammed full of vivid superficial detail worthy of Arnold Bennett—even the twisted finger of Mrs. Ramsay's glove seems to echo the mended glove that the imaginary Bennett notices on Mrs. Brown's hand.[49] But To the Lighthouse greatly differs from a conventional realistic novel in its author's lack of confidence in the importance and the trustworthiness of the little anecdotes, the glittering particulars. Woolf gives her readers the rainbow, the attractive surface, she provides her characters with clothes, with personal histories, but she calls attention to the unreliability and uselessness of this information at the same time.

When we turn to the deep Mrs. Ramsay, we see the same generalizing tendency ascribed to Mrs. Brown. As a dark wedge Mrs. Ramsay identifies herself with human life in its broadest aspects—she is everybody, she is nobody, she is "of unlimited capacity and infinite variety," like Mrs. Brown or Shakespeare's Cleopatra. We see, then, that To the Lighthouse practices, to some extent, the novel that the essay "Mr. Bennett and Mrs. Brown" preaches, a sort of novel that moves downward and inward from conven-

tional realism to the depths of man. But it is much less triumphant than the essay seems to predict, as if Woolf, once she found the depths, found them less wonderful than she thought she would.

If the novel ended at the end of part I, we would think that it conformed pretty exactly to the theory of "Mr. Bennett and Mrs. Brown." We have seen that the sensuous world is in constant flux, but that underneath the flux something remains: Lily's painting, for example, which cherishes and defends the Ramsays' domestic bliss from disintegration. But Lily is not the only artist of part I: Mrs. Ramsay herself is a kind of life artist, arranging stray young folks into husbands and wives, creating from the scattered stuff of life something permanent. Near the end of the banquet scene, Mrs. Ramsay serves an especially tender chunk of *boeuf en daube* to William Bankes and thinks to herself, "There is a coherence in things, a stability; something, she meant, is immune from change, and shines out (she glanced at the window with its ripple of reflected lights) in the face of the flowing, the fleeting, the spectral, like a ruby."[50] Mrs. Ramsay says that she has done (and we have no reason to doubt her) something akin to what Shakespeare did in his sonnet: to suck the essence out of life and to present it as a rounded whole, a jewel.[51]

But after part I comes part II, and part II casts into doubt many of the certainties of part I. Part II is called "Time Passes," but it might just as well have been given the Wallace Stevens-like title "The World without Imagination." What is frightening about part II is not just that the deaths of so many beloved people are demoted to casual parentheses, but that all the means we possess for holding on to the cherished images of the dead are destroyed:

> The sea tosses itself and breaks itself, and should any sleeper fancying that he might find on the beach an answer to his doubts, a sharer of his solitude, throw off his bedclothes and go down by himself to walk on the sand, no image with semblance of serving and divine promptitude comes readily to hand bringing the night to order and making the world reflect the compass of the soul. . . .
> [Mr Ramsay, stumbling along a passage one dark morning, stretched his arms out, but Mrs Ramsay having died rather suddenly the night before, his arms, though stretched out, remained empty.] . . .
> Once the looking-glass had held a face; had held a world hollowed out in which a figure turned, a hand flashed, the door opened, in came children rushing and tumbling; and went out again. Now, day after day, light turned, like a flower reflected in water, its sharp image on the wall opposite.[52]

Part II is an attack on representation, on art: no wonder that its dominant image is an empty mirror, because the human mind's every attempt to apprehend and remember its world is rendered futile. The mode of this section is iconoclastic: all the jewels so lovingly fabricated in part I are smashed. Part I suggested that, at the bottom of reality, there was an eerie stability, where a woman transfigured into a dark wedge made love to a man transfigured into a lighthouse. But part II suggests that, at the bottom of reality, there is this:

> Listening (had there been any one to listen) from the upper rooms of the empty house only gigantic chaos streaked with lightning and tossing, as the winds and waves disported themselves like the amorphous bulks of leviathans whose brows are pierced by no light of reason, and mounted one on top of another, and lunged and plunged in the darkness or the daylight (for night and day, month and year ran shapelessly together) in idiot games, until it seemed as if the universe were battling and tumbling, in brute confusion and wanton lust aimlessly by itself.
>
> In spring the garden urns, casually filled with wind-blown plants, were gay as ever. Violets came and daffodils. But the stillness and the brightness of the day were as strange as the chaos and tumult of night, with the trees standing there, looking before them, looking up, yet beholding nothing, eyeless, and so terrible.[53]

Note especially the word *eyeless* here. In the universe of part I, man and nature lived in a state of extreme interresponsiveness, equally fluid and adaptable. Nature was the mirror of the human consciousness. Here is what the urns looked like in part I: "the urns with the trailing red geraniums which had so often decorated processes of thought, and bore, written up among their leaves, as if they were scraps of paper on which one scribbles notes in the rush of reading."[54] Nature was a writing table, or itself notation. But in part II all this legibility, this conformity to the mind, breaks apart into unreason and chaos. Nature excludes man, is blind to him; indeed, by the middle of part II few vestiges of human presence remain beyond a hypothetical narrator, who narrates in the absence of a narrator, who sees without eyes, who listens even as she reminds us that there is no one there to listen. The depths of life contain not purified, geometrical images of man but a swarm of leviathans who wish to exterminate every human trace. If there is a spirit of human nature—to quote from "Mr. Bennett and Mrs. Brown"—it is not Mrs. Brown or Mrs. Ramsay but the crackpot cleaning lady, Mrs. McNab, who does not seem to embody the best of mankind. Man and his works have been effaced in a general outbreak of nature's insanity; and when they return, in part III, it is with a greatly diminished sense of

confidence. And yet, in part III the long-suspended—eleven-year-long-suspended—actions of part I are in fact accomplished: the voyage to the lighthouse arrives at its destination, and Lily's painting is painted.

Part III revises the whole model of surface and depth that Woolf presented in part I, or in "Mr. Bennett and Mrs. Brown." In the earlier works, the surface tends to be trivial, and the depths seem all-important; but now, after the bathysphere of part II has investigated the depths more carefully, the surface has a new value. Homely anecdotes—how the nearsighted Mrs. Ramsay tried to write a letter at the beach—begin to have a heightened intensity. Little memories, little fictions start to outweigh the profundities of the general.

The separation of surface from depth, carefully maintained through part I, is almost abolished in part III. In part I, the lighthouse was strictly symbolic and aesthetic, operating as a kind of Greenwich Observatory to provide an axis to the universe's coordinate geometry; but in part III the lighthouse is a real place, with washing spread on the rocks to dry.[55] It still retains a symbolic character—it represents to James the starkness and loneliness of his and his father's masculine nature—but it is now symbolic and ordinary at the same time.[56] Part II called into question the possibility of symbols, the possibility of any meaning whatsoever, but in part III we see that tentative, experimental, nonuniversal symbols still can operate, as long as no one makes any great claims about their efficacy.

Similarly, Lily's art, her vision of Mrs. Ramsay, is better informed by the superficies of things. The abstracting power of art is far less vigorous than in part I; Lily's eye beholds a far fuller, fleshlier image, even though Mrs. Ramsay is now dead:

> Suddenly the window at which she was looking was whitened by some light stuff behind it. At last then somebody had come into the drawing-room; somebody was sitting in the chair. For Heaven's sake, she prayed, let them sit still there and not come floundering out to talk to her. Mercifully, whoever it was stayed still inside; had settled by some stroke of luck so as to throw an odd-shaped triangular shadow over the step. It altered the composition of the picture a little. It was interesting. . . . One wanted, she thought, dipping her brush deliberately, to be on a level, with ordinary experience, to feel simply that's a chair, that's a table, and yet at the same time, It's a miracle, it's an ecstasy. . . . "Mrs. Ramsay! Mrs. Ramsay!" she cried, feeling the old horror come back—to want and not to have. Could she inflict that still? And then, quietly, as if she refrained, that too became

part of ordinary experience, was on a level with the chair, with the table. Mrs. Ramsay—it was part of her perfect goodness—sat there quite simply, in the chair, flicked her needles to and fro, knitted her reddish-brown stocking, cast her shadow on the step. There she sat.[57]

This is the climax of the novel. This apparition of the dead woman is not a ghost, is not a sign of Mrs. Ramsay's literal persistence beyond the grave; it is instead a proof that fiction inventing and image making, while remaining nothing more than fiction inventing and image making, can nevertheless give us the revelation we want. If we do not ask too much, if we do not expect a guarantee that the vision will last for a long time, or will be significant to everyone, we can get it. The two perspectives of part I converge in this vision: Mrs. Ramsay is simultaneously a purple wedge (an "odd-shaped triangular shadow") and the replete, motherly, arrestingly beautiful woman of her surface identity. Surface and depth, meaning and sensuous gesture, are wholly fused. A chair is both an ordinary chair and a miracle; the butterfly's wing turns out to be made of steel. Lily's vision of Mrs. Ramsay cannot be embodied in paint very well, nor can it be transmitted, except by a kind of telepathy to Mr. Carmichael; and yet, when Lily says on the novel's last page, "I have had my vision," there is triumph, though a triumph mingled with many sorts of regret and self-excoriation.

In part III, art is more effective because more conscious of its limitations and incompetences; the art of part III is intimate with the chaos of part II and does not seek to do more than it can. We have already seen that, after Lily begins the second version of her painting, she sees a terrifying blank space enclosed by her running lines; this blank space is analogous to the emptiness and destruction at the heart of reality in part II. A paintbrush is a kind of weapon against chaos, but it cannot hope to conquer it.

One of the strangest features of *To the Lighthouse* is Woolf's decision to make Lily Briscoe a mediocre artist, whose painting will be rolled up and stuck under a sofa or hung in someone's attic, if it lasts at all.[58] It would have been very easy to make her an obscure genius like Joyce's Stephen Dedalus, ready to burst on the world in glory. But Woolf's conception of art made it more fitting to present Lily as a humble amateur.

All triumphs of art, Woolf felt, are local and provisional. If Lily were Phidias or Michelangelo, she could not hope to do much more than she has done: to make an image of something significant to her. All writing is done on sand, all painting painted on water.

Corporealism

The Modernist thrust toward nonrepresentational art and other forms of abstraction is strong. But, as we've seen, every thrust presupposes a counterthrust, and one form of the revolt against Abstractionism is a tendency we might call Corporealism.

Value: All delight and all sanity and all meaning come from the body.

D. H. Lawrence

In philosophy, the term *Corporealism* is old and well established, as a synonym for materialism. But in the twentieth century the American composer Harry Partch redefined it as the name of a body-intensive artistic movement, and he took the British novelist D. H. Lawrence as its great hero. Lawrence himself did not use this term, but it seems appropriate to describe his vision, since he understood his protagonists not in terms of quirks of speech or character or cognitive processes, but in terms of deep nerve centers in their bodies—plexuses and ganglia. His last full-length novel, *Lady Chatterley's Lover* (1927), is perhaps his most Corporealist work, and we will take it as our example of literary Corporealism. The plot is simple. A paralyzed aristocrat's bored wife, Connie Chatterley, has two affairs, one with an Irish playwright named Michaelis, the other with a gamekeeper, Oliver Mellors; the wife falls in love with the gamekeeper, becomes pregnant, and seeks a divorce, which the husband refuses. But this straightforward story contains some of the most profound meditations ever written on the carnality of being human.

Lawrence and Nietzsche

When Lawrence was sixteen, he and a slightly older girl would pass idyllic summer days reading Nietzsche together. And some of his novels are

structured according to Nietzschean dialectic: not Apollo versus Dionysus so much as Socrates versus Dionysus, some exemplar of mind's cunning competing against some exemplar of the body's potency and sanity. The Socrates figure is usually wealthy, of high social standing, outwardly strong but inwardly crippled—Clifford Chatterley is slightly against type in that his crippledness is so conspicuous. The satyr or silenus is usually from the margins of society—a gypsy, an American Indian, a Nottinghamshire game-keeper—because some pretext has to be found for immunizing him from the virus of civilization. Lawrence always had trouble imagining just how Dionysus might fit into, might arise from, the modern world—in fact, the composition history of *Lady Chatterley's Lover* shows his extraordinary dif-ficulties in specifying the character of the gamekeeper with whom the no-blewoman falls in love. In the first draft, the gamekeeper is rather illiterate and ignorant, and it takes a real leap of imagination for Connie Chatterley to see his decency and innate nobility. By the third and final draft, Mellors has become Proteus, able to speak every dialect from the coarsest to the King's English, able to adjust his manners instinctively to please a duchess or a serving maid—Lieutenant Mellors, an army officer, who reads "books about bolshevist Russia, books of travel, a volume about the atom and the elec-tron, another about the composition of the earth's core, and the causes of earthquakes."[1] He is not a credible character in the tradition of the realistic novel, but quite a credible character in the tradition of Nietzsche's Diony-sus, a man who is Everybody and Nobody. The whole repertoire of human identity seems latent within him; this is a not-too-scary way of being a human abyss. Lawrence once said that no man is as much a man as a leopard is a leopard.[2] Mellors is an attempt to imagine a man who is as much a man as a leopard is a leopard.

Lawrence's Objections to the Novel, Both Old and New

Lawrence waged a long polemic against many things—he was a man of pronounced dislikes. He disliked certain aspects of nineteenth-century real-istic fiction and was consciously engaged in the process of dismantling it. In the older novel, the objective universe—the world of homely familiar things, pebbles, trees, chairs, clothes—is rendered comfortable to man, adequate to his need for emotional expression. The pebbles make a road for man's feet, the trees shade him or wave violently in the wind to express man's misery, the furniture betrays man's social status and authority, the clothes

make the man. But in modern fiction there is no longer any secure relation between outside and inside, no more privilege to be given to mere things. Lawrence wasn't interested in furniture or clothes, any more than the other well-known Modernists were. But Lawrence had no use for Modernist stream-of-consciousness fiction, any more than for Victorian doting on externals:

> So there you have the "serious" novel, dying in a very long-drawn-out fourteen-volume death agony, and absorbedly, childishly interested in the phenomenon. "Did I feel a twinge in my little toe, or didn't I?" asks every character of Mr. Joyce or of Miss Richardson or M. Proust. Is my aura a blend of frankincense and orange pekoe and boot-blacking, or is it myrrh and bacon-fat and Shetland tweed? . . . It is self-consciousness picked into such fine bits that the bits are most of them invisible, and you have to go by the smell. Through thousands and thousands of pages Mr. Joyce and Miss Richardson tear themselves to pieces, strip their smallest emotions to the finest threads, till you feel you are sewed inside a wool mattress that is being slowly shaken up, and you are turning to wool along with the rest of the wooliness.[3]

There is a passage in *Lady Chatterley's Lover* that uses exactly the same metaphor for the depravity of modern fiction: "Clifford was really clever at that slightly humorous analysis of people and motives which leaves everything in bits at the end. But it was rather like puppies tearing the sofa cushions to bits; except that it was not young and playful, but curiously old, and rather obstinately conceited. It was weird and it was nothing. This was the feeling that echoed and re-echoed at the bottom of Connie's soul: it was all nothing, a wonderful display of nothingness."[4] So, if you were wondering what sort of writer Clifford Chatterley was, now you know: he's a Modernist from the school of Joyce, and Dorothy Richardson, and Virginia Woolf, pulling apart the cotton wool of commonplace life. Lawrence was fond of quoting a motto by D'Annunzio, "Anatomy presupposes a corpse"; and he found the modern novel a kind of autopsy of man, an act of assault committed by the mind against the body. Lawrence thought that almost every modern novelist was tainted by an excessive preoccupation with mental processes, with a bad sort of depth psychology that imagined the inside of a human head as a kind of sewer. He hoped to reverse that trend in his own work. He aspired to depict not the mind's *operations* but the body's, and he indeed became the great realist of the body.

The Body *Is* the Unconscious

Lawrence's body-realism is not quite like any other sort of realism. A novelist like Émile Zola is preoccupied with the body, but no novelist is less like Zola than Lawrence: Lawrence did not want (as Zola wanted) to display the disgusting aspects of the body, its boils and suppurations, its susceptibility to disease and decay; instead, he wished to show the sanctity of the body, the wonder of it. Lawrence dreamed of a future in which the human body would be bold, ferocious, beautiful, a thing of glory. In his novels he tried to suggest ways in which the corrupt men of the present might restore their bodily sanity.

Corresponding to Lawrence's esteem of the body is his hatred of the mind. He was widely read in German and British philosophy and letters; in his spare time he wrote a complete history of Europe, and he could talk ideas with Bertrand Russell in ways that Russell found stimulating, indeed alarming. And yet, the only philosophy that mattered to him was the Romantic philosophy that declared that the mind was the source of all corruption. Friedrich Schelling wrote that the true fall of man occurred when he ate the fruit of the Tree of *Knowledge*: "[This is] a truly Platonic fall of man, the condition in which man believes that the dead, the absolutely manifold and separated world which he conceives, is in fact the true and actual world."[5] According to this important tradition, every separation between man and nature, every movement toward the objective and the abstract, increases our damnation. Schelling's writings were studied by Coleridge and thereby entered English Romanticism. By 1850 Matthew Arnold had written a poem, "Empedocles on Etna," in which the Greek philosopher tries to decide whether to jump into the volcano: he thinks that his breath could become part of the air, his blood could become part of the ocean, but his mind could never find a home in nature—the mind forever alienates man, sets him apart from the rest of the cosmos. As the aphorist E. M. Cioran put it, Consciousness is itself an exile.

In all his novels, Lawrence stated in one form or another a myth of the fall of man similar to Schelling's, a myth of the predatory human intelligence that continually interposes its killing abstractions between us and reality. Lawrence also wrote theoretical works in which he stated his opinions about the relation between mind and body: *Psychoanalysis and the Unconscious* (1921) and *Fantasia of the Unconscious* (1922); let me summarize his argument.

He wrote to contradict the writings of Freud. Lawrence lived in Germany during the early 1910s, and he was the first important English novelist to acquaint himself with Freud's ideas. Freud's notion of the id especially annoyed him. Lawrence believed that the unconscious was not a kind of cesspool or sewer in which all the foulness of human desire lay repressed, struggling to express itself; Lawrence believed instead that the unconscious was essentially pure and wholesome and prompted only good behavior. He mocked William James's idea of the stream of consciousness—this is part of his polemic against Joyce and Woolf, as well as his polemic against Freud:

> Freud . . . was seeking for the unknown sources of the mysterious stream of consciousness. Immortal phrase of the immortal James! Oh stream of hell which undermined my adolescence! The stream of consciousness! I felt it streaming through my brain, in at one ear and out at the other. And again I was sure it went round in my cranium, like Homer's Ocean, encircling my established mind. . . . Horrid stream! Whence did it come, and whither was it bound? . . .
>
> [Freud discovered] the vast darkness of a cavern's mouth, the cavern of anterior darkness whence issues the stream of consciousness. . . . What was there in the cave? Alas that we ever looked! Nothing but a huge slimy serpent of sex, and heaps of excrement, and a myriad repulsive little horrors spawned between sex and excrement.[6]

He further argued that Freud's analysis of incest was completely incorrect: whereas Freud thought that all men by nature desire to marry their mothers, Lawrence believed that incestuous desires originated not in the body but in the upper consciousness, as mental perversions. If Freud were right, said Lawrence, "you must admit incest as you now admit sexual marriage, as a duty even," since we must avoid repression at all costs.[7] Incest, therefore, must be not an instinct but an *idea*. Lawrence believed that the mind had taken over all the proper functions of the body and continually tampered with man's sexual nature, substituting false, unreal surrogate affections for man's healthy sexual responses to his environment.

In *Fantasia of the Unconscious*, Lawrence equates the unconscious with the body. The body has its own urges, its own powers of recognition, acknowledgment, forward thrust, recoil; but the mind obscures and weakens these urges as best it can. Lawrence imagined the unfolding of the human body from the moment of conception. In Lawrence's version of my development, I had a will long before I was born, indeed even when I was but a single cell: I spun myself out deliberately, as a spider spins for itself a web.

By the time I was born, I had accreted for myself two great nerve centers: one, located in the solar plexus, near the umbilical cord, was the source of all desire for union, for incorporation of my being in some other being (what Lawrence called the *sympathetic* will); the other, located in the lumbar ganglion, at the base of the spine, was the source of all desire for separation, for individuality, for cutting myself free from other beings (what Lawrence called the *volitional* will). At birth I cried out for my mother, tried to clasp her, because of sympathetic impulses from my navel; but I also felt volitional impulses in my spine, which urged me to kick her away with my little legs when she tried to hug me. Lawrence felt that both these impulses were necessary and good, and that a healthy life keeps these wills properly balanced against each other. If sympathetic nerve centers grow strong at the expense of the volitional, the child becomes weak, stoop shouldered, mother dominated, "spineless." If the volitional nerve centers grow strong at the expense of the sympathetic, the child becomes cold, loveless, aggressive. All deformity of body and of character is the result of defects of equilibrium in the inner body.

Furthermore, there are important upper nerve centers: the cardiac plexus and the thoracic ganglion. The cardiac plexus is the site of devoted, spiritual, objective love—love that doesn't seek total fusion with its object, as the solar plexus does, but love that distinguishes, discriminates. The thoracic ganglion controls the shoulders and is the site of cooperative effort toward a goal—Lawrence's great example is the Panama Canal, in which thousands of men got their thoracic ganglia together to dig a magnificent project. Once you have these keys, you can understand human character through physical appearance.

Clifford's broad shoulders and stiff pose denote hypertrophy of the thoracic ganglion: curiosity and objective control, though not in his case benevolent control—the control of the miners, the curiosity to find new ways of squeezing more coal out of the depleting seams, for example, by buying "a new [German] locomotive engine with a self feeder, that did not need a fireman."[8] Of course, the snapping of his spine manifests the utter loss of relation with his lower, more potent centers: they simply aren't there any more, thereby precluding any possibility of salvation. If little remains of Clifford beyond his thoracic ganglion, Mrs. Bolton, a bosomy sort of creature, is all cardiac plexus: she offers Clifford her breasts but retains the faculty of objective judgment over him, as the remarkable scene of Clifford's collapse shows:

When she sponged his great blond body, he would say . . . "Do kiss me!" and she would lightly kiss his body, anywhere, half in mockery.

And he lay with a queer, blank face like a child, with a bit of the wonderment of a child. And he would gaze on her with wide, childish eyes, in a relaxation of Madonna-worship. It was sheer relaxation on his part, letting go all his manhood, and sinking back to a childish position that was really perverse. And then he would put his hand into her bosom and feel her breasts, and kiss them in exultation, the exultation of perversity, of being a child when he was a man.

Mrs Bolton was both thrilled and ashamed, she both loved and hated it.[9]

Here the weak props and struts that sustain Clifford's inner life give way, and he reverts to a condition of fetal dependency, as if he were trying to reenter his mother's womb. All the articulation of his deep nerve centers fails—inside he turns into a puddle, though his outer husk is unimpaired. Many of the metaphors that Clifford uses are crustacean in character: he writes at one point, "We are weird, scaly-clad submarine fauna, feeding ourselves on offal like shrimps."[10] Elsewhere he writes, "So you see, we are deep-sea monsters, and when the lobster walks on mud, he stirs it up for everybody."[11] But the exoskeletal quality that Clifford attributes to everybody is, in fact, chiefly true of Clifford himself, as the narrator notes: "Clifford was drifting off to this other weirdness of industrial activity, becoming almost a *creature*, with a hard, efficient shell of an exterior and a pulpy interior, one of the amazing crabs and lobsters of the modern, industrial and financial world, invertebrates of the crustacean order, with shells of steel, like machines, and inner bodies of soft pulp."[12] To be all outside and no inside is a hellish condition in Lawrence: according to one of his aphorisms, a vulture was once an eagle until it developed a fixed form.[13]

If Clifford is a hard blond skull plunked on top of a broken dummy body, Connie is just the opposite. When she looks into the mirror, she doesn't see her face at all, and she notices little about her upper torso: she is all lower torso, all solar plexus and lumbar ganglion. Her most excellent place is the small of her back, the lumbar region: "She thought the most beautiful part of her was the long-sloping fall of the haunches from the socket of the back, and the slumberous, round stillness of the buttocks. Like hillocks of sand, the Arabs say, soft and downward-slipping with a long slope. Here the life still lingered hoping. But here too she was thinner, and going unripe, astringent."[14] Her basically solitary life leaves her volitional, independence-seeking lower spine undamaged, as beautiful as ever; but her thwarted need for deep

love withers and slackens the area around her solar plexus: "Her belly had lost the fresh, round gleam it had had when she was young, in the days of her German boy, who really loved her physically. Then it was young and expectant, with a real look of its own. Now it was going slack, and a little flat, thinner, but with a slack thinness. Her thighs, too, they used to look so quick and glimpsy in their female roundness, somehow they too were going flat, slack, meaningless. Her body was going meaningless, going dull and opaque."[15] When Mellors comes into her life, her whole body starts to regain tautness and presence, for our bodies are direct, legible expressions of the nerve centers of our body. If I want to know you, according to Lawrence, the bulges of your face and body tell me everything—a phrenology not of the skull but of the whole self.

The Art of the Insides: Moving from Exterior Description to Description of the Body's Innards

In Lawrence's autobiographical novel, *Sons and Lovers* (1913), the hero is a young painter, who tells his girlfriend that he never paints the dead outer shapes of things; instead, he paints the protoplasm inside: "It [the painting]'s [true to life] because—it's because there is scarcely any shadow in it; it's more shimmery, as if I'd painted the shimmering protoplasm in the leaves and everywhere, and not the stiffness of the shape. That seems dead to me. Only this shimmeriness is the real living. The shape is a dead crust. The shimmer is inside really."[16] Lawrence's fiction is, in several senses of the word, shapeless; its forms are tentative, provisional, for the best, the freest energies are those that are not confined by a material shape.

And yet the dead surfaces of objects do have a function to play in Lawrence's art. No one can write a novel about protoplasm; it is impossible to describe the internal functions of nerve centers, except in terms of the scientific abstractions that Lawrence hated. Lawrence had to begin with depictions of the outer world, of objective reality, before he could move downward and inward into the energies that constituted his true theme. In all of his work there is a double perspective, according to which the physical eye competes with the eye of imagination. William Blake, the fierce Romantic poet whom Lawrence resembled in many ways, once wrote that when a miser looked at the sun, he saw a guinea, but that when he, Blake, looked at the sun, he saw ten thousand angels singing hosanna. One might say that Lawrence's novels provide both the miser's perspective and the poet's perspective: Lawrence depended on the tension between sun-as-gold-coin and

sun-as-angelic-chorus, on the tension between the ordinary and the vision-
ary, to make his fiction exciting. Lawrence, then, half accepted and half re-
jected the canons of the realistic novel as it evolved in the nineteenth cen-
tury: he offered an abundance of the same acutely observed physical detail
that George Eliot offered, and yet he presented this objective reality chiefly
in order to mock it, to get beneath it.

 Lady Chatterley's Lover is a novel in which very little happens. Most of
Lawrence's other novels of the 1920s were travelogues: *Kangaroo* to Austra-
lia, *The Plumed Serpent* to Mexico, *St. Mawr* to New Mexico, *The Man who
Died* to ancient Judea, and so forth; *Lady Chatterley's Lover*, by contrast, is
a novel that mostly sticks close to Lawrence's birthplace. You could make
a play out of it with two sets, Wragby Hall and Mellors's cottage—that is,
Mindland and Bodystan. But although the horizon of event is fairly con-
stricted, the horizon of interpretation stretches far: it's a novel about sex,
but what counts isn't orgasm—what counts is what orgasm *means*. As for
the physiological fact, even Michaelis can provide Connie with an orgasm,
though he's surly about it; even her talky young German lover could provide
her with an orgasm, in the form of "a row of asterisks that can be put to
show the end of a paragraph, and a break in the theme." But Lawrence wants
Connie to have an orgasm not as a form of discourse, but as a form of trans-
figuration. *Lady Chatterley's Lover* was Lawrence's last full-length novel, but
Lawrence's very last book was *Apocalypse*, a study of the Biblical book of
Revelation. The novel is also about apocalypse, not just a genital apocalypse
but an apocalypse of the whole body. The novel concerns readjustment of
hermeneutics, readjustment of vision, learning to see with the eyes of plexus
and ganglion rather than the literal eyes in your skull.

 Lawrence's strategy for making the deep body speak turned out to be the
nearly Surrealist method of devising landscapes of nerves and organs: "She
was like a forest, like the dark interlacing of the oakwood, humming inaudi-
bly with myriad unfolding buds. Meanwhile the birds of desire were asleep
in the vast interlaced intricacy of her body."[17] But often, especially during
the sex scenes, Lawrence deals not in landscapes but in oceanscapes:

 She felt his naked flesh against her as he came into her. For a moment he was still
 inside her, turgid there and quivering. Then as he began to move, in the sudden
 helpless orgasm, there awoke in her new strange thrills rippling inside her. Rip-
 pling, rippling, rippling, like a flapping overlapping of soft flames, soft as feathers,
 running to points of brilliance, exquisite, exquisite and melting her all molten in-

side. It was like bells rippling up and up to a culmination. She lay unconscious of
the wild little cries she uttered at the last. But it was over too soon, too soon!

And she could no longer force her own conclusion with her own activity. This
was different, different. She could do nothing. She could no longer harden and
grip for her own satisfaction upon him. She could only wait, wait and moan in
spirit as she felt him withdrawing, withdrawing and contracting, coming to the
terrible moment when he would slip out of her and be gone. Whilst all her womb
was open and soft and softly clamouring, like a sea-anemone under the tide,
clamouring for him to come in again and make a fulfilment for her.[18]

The notion of the uterus as a sea anemone is again reminiscent of the Sur-
realists, who liked to find equivalents for human body parts in various sorts
of invertebrate life-forms—but Lawrence isn't trying to make a shocking
juxtaposition, only trying to discover a rhetoric appropriate to the convul-
sions of the preconscious, prehistoric, prehuman body. The unconscious, to
Lawrence, is a kind of poem—rippling rippling flapping overlapping, it's a
domain of rhymes.

And yet, there are unintended ironies in this sort of rhetoric. Previously
I quoted Lawrence's satirical description of the stream of consciousness,
sloshing about inside Lawrence's skull; this passage about orgasm is oddly
similar, and equally vulnerable to parody, partly because it evolved into a
style favored by soft-porn writers, partly because of its own excesses of
rhythm and florid language. Still more ironic is the fact that Lawrence, who
hated theorizing of every sort, is here dependent on an extremely dubious
theory, Freud's notion of evil clitoral orgasms versus good vaginal orgasms.
Mellors's first wife, Bertha Coutts, was little except a huge clitoris:

She sort of got harder and harder to bring off, and she'd sort of tear at me down
there, as if it was a beak tearing at me. By God, you think a woman's soft down
there, like a fig. But I tell you the old rampers have beaks between their legs, and
they tear at you with it till you're sick. Self! self! self! all self! tearing and shout-
ing! . . . She got no feeling off it, from my working. She had to work the thing
herself, grind her own coffee. And it came back on her like a raving necessity, she
had to let herself go, and tear, tear, tear, as if she had no sensation in her except
in the top of her beak, the very outside top tip, that rubbed and tore. That's how
old whores used to be, so men used to say.[19]

It's remarkable how the female characters in the novel sort themselves by
erogenous zone: Bertha, clitoris; Mrs. Bolton, breast; Connie, buttocks and
perineum.

Not all of the sex scenes are quite so interiorized as the rippling rippling flapping overlapping scene. In one famous passage Lawrence devised a ritual wedding of the genital organs:

> He fastened fluffy young oak-sprays round her breasts, sticking in tufts of bluebells and campion: and in her navel he poised a pink campion flower, and in her maidenhair were forget-me-nots and woodruff.
>
> "That's you in all your glory!" he said. "Lady Jane, at her wedding with John Thomas."
>
> And he stuck flowers in the hair of his own body, and wound a bit of creeping-jenny round his penis, and stuck a single bell of a hyacinth in his navel. She watched him with amusement, his odd intentness. And she pushed a campion flower in his moustache, where it stuck, dangling under his nose.
>
> "This is John Thomas marryin' Lady Jane," he said. "An' we mun let Constance an' Oliver go their ways."[20]

It isn't just that Mellors wants to abolish the social selves of Constance and Oliver, the discrepancy of rank that makes their relation so difficult to make public; it's that Mellors wants to abolish their whole personal identities.

Lawrence and Futurism

Lawrence understood his mission as a novelist as a displaying of those deep layers of the human where everyone is absolutely alike, as he said in the greatest of all his letters (5 June 1914 to Edward Garnett):

> Somehow—that which is physic—non-human, in humanity, is more interesting to me than the old-fashioned human element—which causes one to make a character in a certain moral scheme and make him consistent. . . . When Marinetti writes: ". . . The heat of a piece of wood or iron is in fact more passionate, for us, than the laughter or tears of a woman"—then I know what he means. . . . Because what is interesting in the laugh of the woman is the same as the binding of the molecules of steel or their action in heat: it is the inhuman will, call it . . . physiology of matter, that fascinates me. . . . You mustn't look in my novel for the old stable ego of the character. There is another ego, according to whose action the individual is unrecognizable, and passes through, as it were, allotropic states which it needs a deeper sense than any other we've been used to exercise, to discover are states of the same single element of carbon. (Like as diamond and coal are the same pure single element of carbon. The ordinary novel would trace the history of diamond—but I say, "Diamond, what! This is carbon." And my diamond might be coal or soot, and my theme is carbon.)[21]

Just as Eliot's notion of impersonality developed around a metaphor from chemistry, the shred of platinum (as we'll see in a later chapter), so Lawrence's notion of impersonality developed around a metaphor from physics, the allotrope. As egos, as quirky finite personality, Connie and Mellors are just as boring as everyone else: it's only by finding the carbon beneath, the organic substrate, that they attain a kind of glory. Sexual arousal, insofar as it resists conscious control, seemed to Lawrence to be a form of speech from the deep body. As Connie and Mellors grow faint and indeterminate, as social egos, so John Thomas and Lady Jane evolve into sacred personages of their own: "John Thomas. Art boss? of me? Eh well, tha're more cocky than me, an' tha says less. John Thomas! Dost want *her*? Dost want my lady Jane? Tha's dipped me in again, tha hast. Ay, an' tha comes up smilin'.—Ax 'er then! lady Jane! Say: Lift up your heads, O ye gates, that the king of glory may come in. Ay, th' cheek on thee! Cunt, that's what tha're after. Tell lady Jane tha wants cunt. John Thomas, an' th' cunt o' lady Jane!"[22] This would be blasphemous, except that Lawrence makes a serious religion out of the venereal; the address to the genitals has a tender, intimate, strangely prayerful quality. The word *cunt* confuses Connie, a refined woman, so Mellors defines it: "Cunt! It's thee down theer."[23] In the novel's hermeneutic, Connie must learn to redefine herself as the inside of her own body, and as the body's major orifices, not just her vagina, but her urethra and anus as well:

> His finger-tips touched the two secret openings to her body, time after time, with a soft little brush of fire.
> "An' if tha shits an' if tha pisses, I'm glad. I don't want a woman as couldna shit nor piss."[24]

These are perhaps the oddest terms of endearment in the entire history of the European novel, and yet Lawrence, I think, manages to make them work.

If Lawrence has to invent a rhetoric appropriate to Connie's deep body, he also has to invent a rhetoric appropriate to Clifford's deep body. Of course, in Clifford's case there are no interior landscapes—there's nothing healthy, fertile, productive inside him; instead, Lawrence uses a rhetoric of surrogacy, in which various inorganic things encroach on Clifford's body and soul. Here we have Marinetti's Futurism, not as a dream of something ideally impersonal beneath social identity, but as a nightmare. Instead of a lower body, a deep body, he has a wheelchair:

"Sir Clifford on his foaming steed!"

"Snorting, at least!" she laughed.

". . . I ride upon the achievements of the mind of man, and that beats a horse."

"I suppose it does. And the souls in Plato riding up to heaven in a two-horse chariot would go in a Ford car now," she said.

"Or a Rolls-Royce: Plato was an aristocrat!"

"Quite! No more black horse to thrash and maltreat. Plato never thought we'd go one better than his black steed and his white steed, and have no steeds at all, only an engine!"[25]

Instead of a body, Clifford has a motorized chair, as he slowly metamorphoses into the inorganic; instead of a soul, he has a radio:

He was queer. He preferred the radio, which he had installed at some expense, with a good deal of success at last. He could sometimes get Madrid or Frankfurt, even there in the uneasy Midlands.

And he would sit alone for hours listening to the loudspeaker bellowing forth. It amazed and stunned Connie. But there he would sit, with a blank entranced expression on his face, like a person losing his mind, and listen, or seem to listen, to the unspeakable thing.

Was he really listening? Or was it a sort of soporific he took, whilst something else worked on underneath in him?[26]

All the work of thinking, feeling, waking, dreaming can be done by machines: Clifford is lost in what the movies call "the Matrix." Increasingly, Lawrence reconstructs Clifford as a Surrealist analogue of a human being, with a loudspeaker instead of a head.

The intellectual world of Clifford's set represents, from Lawrence's point of view, a concentrated attack on human values. They're all just loudspeakers reproducing ideas from the culture's general radio. There's Lady Bennerley, who thinks that the release of morphine gas into the planet's air would promote happiness. There's Olive Strangeways, who looks forward to the invention of contraceptive injections to "immunize" women against pregnancy, so that "a woman can lead her own life"; Clifford is so moved by this idea that he speculates, "All the love business for example, it might just as well go. I suppose it would if we could breed babies in bottles." Olive objects violently (she likes sex; she just doesn't want children), but the company keeps toying with the idea of a human race promoted out of organic bodies altogether—even Connie idly says, "Imagine if we floated like tobacco

smoke."[27] Later in the novel, Clifford reads to Connie from a book about the universe's gradual evolution from matter to spirit: "the physical world, as we at present know it, will be represented by a ripple barely to be distinguished from nonentity"; Clifford further comments, "Believe me, whatever God there is is slowly eliminating the guts and alimentary system from the human being, to evolve a higher, more spiritual being."[28] While Clifford prattles on, his wife thinks of how she can signal to Mellors from her window for a tryst. Not only is Clifford's deep life a nullity; he dreams of a general annihilation of the carnal aspects of the human race. Nonentity is his state, his career, his aspiration.

When Clifford spoke of breeding babies in bottles, I imagine that many readers thought of Huxley's *Brave New World*—but that novel wasn't published until 1932, two years after Lawrence's death. Lawrence knew Huxley, and they may have discussed such ideas together, but it is also possible that Lawrence was thinking of H. G. Wells, who advocated family planning in his 1923 Utopian novel *Men like Gods*, and who, as early as 1901, in *First Men in the Moon*, described a lunar society of intelligent insects who bred their children in bottles, but in a special way, so that one favored organ hypertrophies and the rest of the body atrophies: "If, for example, a Selenite is destined to be a mathematician, his teachers and trainers set out at once to that end. They check any incipient disposition to other pursuits, they encourage his mathematical bias with a perfect psychological skill. . . . His brain grows continually larger. . . . His limbs shrivel, his heart and digestive organs diminish, his insect face is hidden under its bulging contours. His voice becomes a mere squeak for the stating of formulae."[29] I suspect that Lawrence paid close attention to this passage, because he seems to echo it in a poem written not long after *Lady Chatterley's Lover* called "Wellsian Futures":

When men are made in bottles
and emerge as squeaky globules with no bodies to speak of,
and therefore nothing to have feelings with,

they will still squeak intensely about their feelings
and be prepared to kill you if you say they've got none.[30]

Lawrence was obsessed with modern civilization's assault against the body: the Great War, the war that crippled Clifford, was one of the chief forces in that assault, but Lawrence found many others as well. He devoted his novels to ways of shocking us insect-people out of our chiton, our mind-shells; his

novels disturbed his contemporaries—and still disturb us today—because of their ferocity, their will to shatter. Lawrence was above all an iconoclast, a breaker of idols, because he felt that he had to break through the mind's rigid formalisms, its abstractions of reality, and free the body's physical reality.

Lawrence felt that insidious mental constructions had everywhere usurped the body's authority, had attacked the body's physical integrity. In another poem he described how the mind had mangled the body, had substituted a hard ugly shape in place of the flexible, sinuous physical presence:

> Oh the handsome bluey-brown bodies, they might just as well
> > be gutta-percha,
> and the reddened limbs red india-rubber tubing, inflated,
> and the half-hidden private part just a little brass tap,
> > robinetto,
> turned on for different purposes.
>
> They call it health; it looks like nullity.
>
> Only here and there a pair of eyes, haunted, stares out as
> > if asking:
> Where then is life?[31]

When Lawrence looked around him, he beheld a mankind degenerating into a dead parody of itself, the inorganic semblance of a human race—as far as he was concerned, Western civilization was populated by robots and Stepford wives. Lawrence's heroes and heroines are always trying to restore their own physicality, sometimes by violent political revolution (as in *Kangaroo* and *The Plumed Serpent*, which concern Fascist cadres trying to overthrow the government in order to establish a state worshiping the gods that rule inside the body), sometimes (as in Connie Chatterley's case) simply by private subversion of mechanical models of human behavior. It may be worth mentioning that in 1901, at the age of sixteen, Lawrence was briefly employed as a clerk in a firm that made artificial arms and legs—the hatred of prostheses, of bodies made of rubber and steel instead of flesh, was impressed on him early in his life.

Lawrence and Painting

Lawrence was keenly interested in Picasso and the other Modernists; there is a passage in *Lady Chatterley's Lover* that even looks back to the early

Cubist world of *Les demoiselles d'Avignon*: "Sometimes he [Michaelis] was handsome: sometimes as he looked sideways, downwards, and the light fell on him, he had the silent, enduring beauty of a carved ivory Negro mask, with his rather full eyes, and the strong queerly-arched brows, the immobile, compressed mouth; that momentary but revealed immobility, an immobility, a timelessness which the Buddha aims at, and which Negroes express sometimes without ever aiming at it; something old, old, and acquiescent in the race! Aeons of acquiescence in race destiny, instead of our individual resistance. And then a swimming through, like rats in a dark river."[32] In his novels Lawrence sometimes places African masks over the faces of his characters, to suggest a kind of abandonment to passive sensationalism. By having an affair with Michaelis, Connie is, in effect, sleeping with modern art, in all its thematic foulness and somewhat life-denying formal purity: "On the far side of his supreme prostitution to the bitch-goddess he seemed pure, pure as an African ivory mask that dreams impurity into purity, in its ivory curves and planes."[33]

Connie encounters Modernist art much later in the person of Duncan Forbes: "Duncan was a rather short, broad, dark-skinned, taciturn Hamlet of a fellow with straight black hair and a weird Celtic conceit of himself. His art was all tubes and valves and spirals and strange colours, ultra-modern, yet with a certain power, even a certain purity of form and tone: only Mellors thought it cruel and repellent."[34] Duncan Forbes is a parody of Duncan Grant, the Bloomsburyan who worked closely with Virginia Woolf's sister Vanessa Bell at the Omega Workshop—so closely that he became the father of some of her children. Lawrence was fascinated by Grant's experiments in abstraction, though deeply suspicious of them—in fact, he gave Grant some advice on how to rectify his art, make it more humane.

It is useful to compare the suspect painting methods of Grant with Lawrence's own paintings, full of every sort of Mellorsian virtue. Lawrence had learned painting as a young man, carefully copying black-and-white reproductions of Giotto and coloring them as his fancy pleased; but at the end of his short life (he died of tuberculosis in 1930) he spent a great deal of time and effort trying to master the discipline—indeed, the spirit of *Lady Chatterley's Lover* is perhaps easier to find in his paintings than in the somewhat abrupt, schematic, and congested fiction of his last three years. He looked principally to Gauguin and Cézanne for models, in the hope that wild colors and distortions of body shape could approximate the child's perception of the inner body's secret forces, the secret forces in the landscape. Sometimes

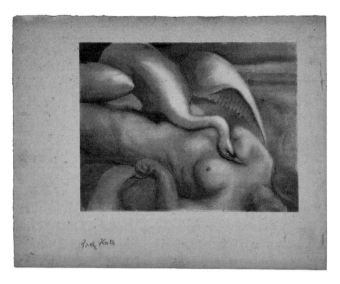

D. H. Lawrence, *Leda* (1928) Harry Ransom Center, The University of Texas at Austin

(as in *Red Willow Trees*, 1927) his human figures have negligible heads, just blank knobs on top of big thick bodies, with buttocks and thighs looming out at us. This is what human beings look like when seen by the eyes of the unconscious, eyes sensitive to the forces within. If Paul Morel in Lawrence's early novel tries to paint the protoplasm inside the leaf, Lawrence himself has gone a step further, by painting the fire inside the leaf: the red willows are painted as if they were blowtorches in full combustion. The pink human bodies beneath seem to catch some of their orange flare.

Some of Lawrence's paintings follow from *Lady Chatterley's Lover* in that they attempt to represent orgies, such as *Rape of the Sabine Women* (1928), a writhe of torsos, or *Dance Sketch* (1928), in which a naked man and a naked woman cavort with a goat standing on its hind legs. This might be compared with the marriage of John Thomas and Lady Jane—if the man and woman here do not decorate their genitals with hyacinths and creeping jennies, the participation of the goat in their capers gives a sacral, prehistoric aspect to the scene, as if we were still in Eden and were one with all creation. A similar sense of a voyage back into myth can be felt in perhaps the sexiest of all of Lawrence's paintings, *Leda*.

In some of his poems, Lawrence tries to topple our scientific view of real-

ity by reinstating the Greek gods: he even speaks of "the swan within the vast chaos, within the electron"; he prays for gods to sweep away the

> Mists
> where the electron behaves and misbehaves as it will,
> where the forces tie themselves up into knots of atoms
> and come untied.[35]

Just as Zeus took the form of a swan in order to rape Leda, so Lawrence hoped that our whole abstract-scientific-industrial reality would undergo a general dismantling by some god, who would restore some sense of holiness to the burnt-out landscape. The sexual grossness of the painting was designed to shock us out of complacency: you see Leda's hand curled in ecstasy, and the swan's neck seems a second phallus looking for some larger thing to enter into. In his poems Lawrence imagined the swan that

> furrows our featherless women
> with unknown shocks
> and stamps his black marsh-feet on their white and marshy flesh.[36]

He further imagined the offspring of swan and woman, half human and half cygnet:

> Won't it be strange, when the nurse brings the new-born infant
> to the proud father, and shows its little, webbed greenish feet
> made to smite the waters behind it?[37]

Lawrence's ferocity of rejection of the human race as he knew it here reaches a fever pitch.

Lawrence's paintings are generally wishful in character—fantasies of a more potent landscape where human life finds better scope for fulfillment. Lawrence's vision is essentially post-historical, since he looks forward to a recovery of Eden. I know only one Lawrence painting that actually shows industrial scenery, of the sort presented in such repulsive detail in his novels. This is an allegorical tease; as Lawrence glossed it in a letter to a friend, "I'm just finishing a nice big canvas, Eve dodging back into Paradise, between Adam and the Angel at the Gate, who are having a fight about it—and leaving the world in flames in the far corner behind her."[38] Adam is the blond; the Archangel Michael is the huffy bearded guy barring the way. Lawrence's Eve is a rounded, sensual woman struggling with all her might to detach herself from the electric wires of a generating plant—the plant is

less painted than drawn with compass and ruler, in a deliberately childish schematic, as if the whole industrial world were insubstantial geometry, a blueprint of itself. The power plant is all triangles and ovals and cylinders and rough zigzags—the left quarter of the painting is a parody of a semi-abstract painting.

As an allegory of Modernism, this painting will do pretty well: all you have to do is remember that sometimes you flee back to Eden, while at other times you flee away from Eden to the joys of the dynamo.

Harry Partch

Lady Chatterley's Lover itself contains industrial-strength parodies of the artistic degradations that correlate perfectly to the degradations of modern civilization—it seems that Modernism is managing to terminate history itself. There is an evil short-story writer, Clifford; an evil playwright, Michaelis; a somewhat evil painter, Duncan Forbes. Music plays little role in this novel—but if a composer had joined Lawrence in his critique of a mechanized civilization, what would he look like?

One candidate might be a California hobo, who, like Lawrence, rose from humble beginnings to confront high Modernism. In 1930 Harry Partch (1901-74), a largely self-taught composer who had survived the Depression through migrant labor, picking grapes and plums, looked at the whole history of Western music and decided to discard it—he thought he could do better. He thought that the human body, especially as expressed in the speaking voice, was the ultimate source of authority and virtue in music: all music that abstracted itself from the body, by engrossing itself in artificial procedures of counterpoint, development, and other formalities, was insipid and useless.

Partch's first mature compositions struggle to re-center the art of music on the speaking voice: "The origin of music in speech intonation among the early peoples to whom we ascribe civilizations—the Greeks and the Chinese particularly—seems pretty well established."[39] But he felt that neither the twelve-note scale of Western music nor the instruments of the Western orchestra were viable tools for achieving a genuinely concrete music, a music attentive to the nuances of speech. A speaking sort of music needs to imitate intervals far smaller than the semitones to which most woodwind, brass, and keyboard instruments are confined. So Partch devised his own 43-tone scale, which begins by achieving the major second (defined by a pitch ratio of 9/8) as the termination of a widening series of near-unison pitch ratios

(1/1, 81/80, 33/32, 21/20, 16/15, 12/11, 11/10, 10/9, and at last 9/8), and he devised his own instrumentarium in order to be able to play these pitches. The earliest novelties were stringed instruments such as the Adapted Viola (a viola with a huge neck grafted on), used to accompany the precisely no-tated intoning voice in *17 Lyrics by Li Po* (1931). Later, Partch used all sorts of technological junk, including artillery casings, lightbulb tops, airplane fuel tanks, and hubcaps, to create an enormous variety of instruments, to which he gave whimsical names, such as Diamond Marimba, Spoils of War, Zymo-Xyl, Boo, Harmonic Canon, Gourd Tree, and Cloud Chamber Bowls.

Partch's first major ambition was to re-create Yeats's translation of Sophocles's *King Oedipus* as an opera of speech: "It is in no sense opera. The drama is paramount always—there is no attempt to reconcile it with musical form. It is drama heightened throughout, and finally purged, by music."[40] In 1934 a Carnegie grant enabled Partch to visit Dublin, meet Yeats, hear a performance of the play at Yeats's Abbey Theatre, and notate the pitches and rhythms of the actors' voices. Yeats was excited by Partch's method of speaking, often without melody, over musical instruments that employ "very minute intervals"; he wrote to Partch that "so far as I can understand your method [it has] my complete sympathy."[41] It was not until 1952, after Yeats's death, that the finished opera was performed at Mills College, but Partch's *King Oedipus* remains one of the twentieth century's most compel-ling resurrections of the speech-oriented aesthetic of the earliest operas, those written around 1600 by Jacopo Peri and Claudio Monteverdi.

Partch's later works continue his exploration of reviving Greek drama—what might be called the Partchian Renaissance—most notably in *Revelation in the Courthouse Square* (1962), loosely based on Euripides's *The Bacchae*; here Dionysus is reimagined as a rock singer. Partch was attracted to classi-cal Greece for many reasons, not least because of the intimacy then preva-lent between music and the speaking voice—he quoted Plato's complaint that "'harmony' had no 'meaning' without words."[42] Indeed, he defined Cor-poreal music as "the essentially vocal and verbal music of the individual . . . a music that is vital to a time and place, a here and now. . . . Corporeal music is emotionally 'tactile.' "[43] This is not to say that all of Partch's music presents easily understood words: in *Water! Water!* (1962), a satire about dam build-ing in California, the text is gibberish; and in such long instrumental com-positions as *And on the Seventh Day Petals Fell in Petaluma* (1963-66), he allowed the "sound-magic," the timbre collage of his strange instruments, to evoke the image of the dryness of wood, the heft of rock, the physical pres-

ence of the earth as it impinges on the human body. Few composers have achieved such an intense witness of the reifying power of music, its textures of scrape and hit and pluck, its mouth-feel.

Partch preferred folk and pop singers to refined, operatic voices, because the untrained voices offer immediate emotional connection between singer and listener:

> Frequently they break a word off short of its notated time and let it fall or rise in a gliding inflection regardless of the notation. Frequently they personify a directness of word appeal, characteristic of this age and this land, and characterized by suggestions of actual times, actual localities, actual identities, and actual human situations, all of which is the very antithesis of the Abstract concept.
>
> By mere control of the lips, mouth, tongue, palate, glottis, and diaphragm under emotional stimulus, the human voice is ready to express all the feelings and attitudes which the cumulative centuries have symbolized in words and poured into the dictionary—from joyful spite to tragic ecstasy, from ecstatic melancholy to hedonic fatuity, from furtive beatitude to boisterous grotesquerie, from portentous lechery to obdurate athanasia—prescience, felicity, urbanity, hauteur, surfeit, magniloquence, enravishment, execration, abnegation, anguish, riot, debauch, hope, joy, death, grief, effluent life, and a lot more.[44]

I don't know which phrase I like better: "obdurate athanasia," or the simple ending of "and a lot more." When I read this, I think of Roland Barthes's essay "Rasch," in which he described what he called *somathemes*: "In Schumann's *Kreisleriana* (Opus 16; 1838), I actually hear no note, no theme, no contour, no grammar, no meaning, nothing which would permit me to reconstruct an intelligible structure of the work. No, what I hear are blows: I hear what beats in the body, what beats the body, or better: I hear this body that beats."[45] But it could be argued that *Kreisleriana* is full of themes, grammar, meaning—Barthes's words better apply to the extremely somathematic music of Partch.

Remarkably, much of Partch's theory of concrete music was derived from D. H. Lawrence, who had (except in his early novel *The Trespasser*) little of interest to say about music. As Partch himself said,

> Contemporary visual art, and attitudes toward it, which arouse explosive resentment in D. H. Lawrence, in many ways parallel this situation in "serious" music. In viewing paintings, he maintains, we "are only undergoing cerebral excitation. . . . The deeper responses, down in the intuitive and instinctive body, are

not touched. They cannot be, because they are dead. A dead intuitive body stands there and gazes at the corpse of beauty: and usually it is completely and honestly bored."

And intuition died, declares Lawrence, because "Man came to have his own body in horror." We are afraid of the "procreative body" and its "warm flow of intuitional awareness," and fear is "poison to the human psyche." "We don't live in the flesh. Our instincts and intuitions are dead, we live wound round with the winding sheet of abstraction." . . .

Finally [Lawrence writes]: "The history of our era is the nauseating and repulsive history of the crucifixion of the procreative body for the glorification of the spirit, the mental consciousness. Plato was an arch-priest of this crucifixion. . . . in the eighteenth century it became a corpse, a corpse with an abnormally active mind: and today it stinketh." . . .

I am trying to hope that we are not entering an era where the only men of significance in music will be those facile at quoting Bach and Beethoven, Brahms and Tschaikowsky. . . . If we are entering such an age it is already dead.[46]

Like Lawrence, Partch hoped to resurrect a dead age by jolting our failing nerves and muscles with art's electricity.

Totalizing Art

Value: If you speak, say everything.

Here I am avoiding the appropriate ism word *totalitarianism* because I don't mean art that seeks to further the aims of totalitarian governments (for example, Hitler's or Stalin's); I mean art that seeks to encompass the entire curriculum of human thought and feeling—totalizing art. Throughout the history of the West, we find artworks that strive for maximum inclusiveness: Dante's *Commedia*, in which all virtue and all vice find embodiment in a fable; Milton's *Paradise Lost*, a poem that wishes to be not the local epic of a particular culture but the epic of the whole human race; Goethe's *Faust*, especially the second part, which carefully synthesizes the classical and the modern, the Mediterranean culture and the Northern European. But some of the Modernists regarded these works as still too limited, too bound to a Christian or a European worldview: might there not be works of art that comprised science as well as myth, Asian philosophy as well as Thomas Aquinas?

The ambitions of the Modernists were almost limitless. Gustav Mahler told his fellow composer Jean Sibelius that the symphony must be like the world—it must embrace everything. And a certain encyclopedic, universe-comprehending desire can be seen in literature too. We will look now at three writers—T. S. Eliot, Ezra Pound, and James Joyce—and, briefly, at one composer, Alban Berg. The first two were somewhat totalitarian in the political sense, in that they were drawn to Fascism: Pound was tried for treason after making radio broadcasts from Mussolini's Italy, urging American soldiers to defect; Eliot advocated the founding of a neo-medieval agrarian Christian civilization, with a distinct hierarchy of lower and higher classes. But all of them tried to draw a line around the whole horizon and make art of it.

Of course, totalizing ambition can be found in many other artists as well, including some unexpected ones. The American novelist William Faulkner, for example, includes in *The Sound and the Fury* (1929) a section narrated by an idiot, a section narrated by a suicidal Harvard student, and a section narrated by an omniscient narrator concerned with an earth-mother-like black servant. Faulkner compares their divergent forms of poetry:

> Caddy got the box and set it on the floor and opened it. It was full of stars. When I was still, they were still. When I moved, they glinted and sparkled. I hushed.

> Father said clocks slay time. He said time is dead as long as it is being clicked off by little wheels; only when the clock stops does time come to life. The hands were extended, slightly off the horizontal at a faint angle, like a gull tilting into the wind.

> "I've seed de first en de last," Dilsey said. "Never you mind me."
> "First en last whut?" Frony said.
> "Never you mind," Dilsey said. "I seed de beginnin, en now I sees de endin."[1]

Faulkner tries to feel his way into every kind of human intelligence—in a later novel, *As I Lay Dying* (1930), he includes a section narrated by a corpse, as if not even death were enough to stop his powerfully empathic imagination.

T. S. Eliot

One of the most famous essays in English letters is T. S. Eliot's "Tradition and the Individual Talent" (1919), which sets the artist the breathtaking task of confronting the great brain that thought up all Western culture—the Individual Talent tries to find a way to incorporate into itself and then to modify the larger Tradition in which it operates: "He must be aware that the mind of Europe . . . is a mind that changes, and that this change is a development which abandons nothing en route, which does not superannuate either Shakespeare, or Homer, or the rock drawing of the Magdalenian draughtsmen."[2] The mind of Europe—it is a stunning ambition, this wish to identify yourself as completely as possible with the mind that wrote the whole British Museum and painted the whole Louvre.

How do you achieve this union of the individual with the All? The simplest answer is by theft: "Immature poets imitate; mature poets steal."[3] By stealing, you can enforce a likeness between your work and the works of the big mind of Europe. The more you can make your art resemble a museum, the more closely your Individual Talent becomes congruent with Tradition.

Eliot was oddly fascinated with descriptions of verbal creativity derived from science: the poet's mind (he says) is the shred of platinum that catalyzes feelings and thoughts into poem, just as an actual shred of platinum cata- lyzes oxygen and sulfur dioxide into sulfurous acid—the catalyst makes the reaction possible but takes no part in it. This laboratory-like impersonality is closely related to Eliot's sense that the poet isn't working solo, but is in- stead a sort of vehicle through which the impersonal mind of Europe is find- ing expression. Eliot doesn't go as far as Yeats, who speculated that the "Ode to a Nightingale" preexisted in the mass subconscious of the human race long before Keats was born—Keats was just the scribe who wrote it down. But Eliot does seem to suggest that the poet who depersonalizes himself, separates "the man who suffers" from the "mind which creates," will be best able to contribute to the general achievement of the European mind. You just add your bit of platinum to the huge chemical reaction that keeps bringing European poems into being.

Eliot's creative personality was an odd mixture of arrogance and submis- siveness. On one hand, he is a reverse Jonah who has succeeded in swallow- ing the whole whale; on the other hand, he is a sort of nobody, a ghost haunting the margins of the potent languages of the past.

"Gerontion"

"Gerontion," written in the same year as "Tradition and the Individual Talent," is a fine example of what it feels like to be the mind of Europe in full senescence. Eliot wrote it when he was thirty-one years old, but it seems that the burden of mind-meld with the mind that wrote the works of Shake- speare and Dante and painted the Cro-Magnon cave paintings has left the poet prematurely senile, detached and drifting, losing his way as he tries to follow cobwebby threads of speculation:

> Here I am, an old man in a dry month,
> Being read to by a boy, waiting for rain.
> I was neither at the hot gates
> Nor fought in the warm rain
> Nor knee deep in the salt marsh, heaving a cutlass,
> Bitten by flies, fought.
> My house is a decayed house,
> And the Jew squats on the window sill, the owner,
> Spawned in some estaminet of Antwerp,

Blistered in Brussels, patched and peeled in London.
The goat coughs at night in the field overhead;
Rocks, moss, stonecrop, iron, merds.
The woman keeps the kitchen, makes tea,
Sneezes at evening, poking the peevish gutter.
 I am an old man,
A dull head among windy spaces.[4]

Throughout the poem Eliot seeks ways of identifying Gerontion with European history. If he lives in a world that looks like a tuberculosis ward (coughing goats, sneezing housekeepers), it is because Europe is itself sick; if the Jew squats at his windowsill, it is because the usury of bankers has ruined civilization (Eliot's anti-Semitism will always trouble readers of his poetry, and for some readers it will vitiate his whole creative enterprise). Furthermore, he seems to have vivid memories of history-defining battles that happened hundreds or thousands of years ago: "hot gates" translated into Greek is Thermopylae, and there seem to be allusions to Cannae and Waterloo as well. Of course, Gerontion is a sort of negative inversion of a human being and defines himself through absence, not presence: he was *not* at the battles that are so sharply evoked in the text. The mind of Europe seems to suffer from some sort of Alzheimer's disease, as great empty spaces start to interfere with his cognitive processes—he's a "dull head among windy spaces":

Signs are taken for wonders. 'We would see a sign':
The word within a word, unable to speak a word,
Swaddled with darkness. In the juvescence of the year
Came Christ the tiger

In depraved May, dogwood and chestnut, flowering judas,
To be eaten, to be divided, to be drunk
Among whispers; by Mr. Silvero
With caressing hands, at Limoges
Who walked all night in the next room;
By Hakagawa, bowing among the Titians;
By Madame de Tornquist, in the dark room
Shifting the candles; Fräulein von Kulp
Who turned in the hall, one hand on the door. Vacant shuttles
Weave the wind. I have no ghosts,

An old man in a draughty house
Under a windy knob.[5]

Gerontion's head seems stuffed with wispy tags from the whole literature of
Europe: when he speaks of "Christ the tiger," he seems to remember Blake's
famous "The Tyger":

Tyger tyger burning bright
In the forest of the night
What immortal hand or eye
Dare frame thy fearful symmetry

But Blake's sense of God's terror has diminished into a helpless, prissy, bum-
bling, myopic waving of hands to avert some catastrophe Gerontion can't
articulate even to himself. Like any good Pharisee, Gerontion cries out, "We
would see a sign!" but his universe is fully designified, a blank billboard with
a telephone number saying "Put your message here."

As the poem continues, it becomes clear that in modern Europe religion
has dwindled, deviated into perversion: the perversion of worshiping art
(Hakagawa among the Titians), the perversion of occult spiritualism (Ma-
dame de Tornquist, shifting her candles, seems to be a medium), and various
sexual perversions (in the context of "depraved May," Mr. Silvero's "caress-
ing hands" seem sinister). History is as useless as religion in trying to make
sense of things: history is a labyrinth of "cunning passages, contrived cor-
ridors," down which you keep meeting a dead end. The history of Europe
appears to be wholly nonlinear, a jumble of things that Gerontion can't
quite place. Consider, for example, the remarkable prayer:

I that was near your heart was removed therefrom
To lose beauty in terror, terror in inquisition.[6]

"Inquisition" is a very historical sort of word—you hear it and you think of
Torquemada's antiheretical purges. But Gerontion deflects the term from its
normal historical context to refer to some horrid sort of mental decay: the
process by which all feeling, positive or negative, gets eaten away by empty
cerebration. Gerontion feels that he's turning into some H. G. Wells night-
mare of a brain floating in a bottle, as his sense organs progressively lose
function:

I have lost my sight, smell, hearing, taste and touch:
How should I use them for your closer contact?[7]

This is impotence in the largest sense of the word. Eliot was the only major Western poet who was fully trained in academic philosophy—indeed, if he'd been able to cross the Atlantic Ocean in 1916 to defend his PhD dissertation on the philosopher F. H. Bradley (the Great War prevented transit), he might well have wound up as a professor of philosophy at Harvard— he was both attracted to and repelled by academic life. As a philosopher, Eliot espoused a complicated form of Idealism, strongly insistent on the complete oneness of body and mind: as Eliot put it in a 1916 article on Leibniz's monadism, "Soul is to body as cutting is to the axe."[8] As Gerontion loses his body, he must necessarily lose his mind as well; superlatively educated though it may be, Gerontion's cognitive faculty is thinning and dispersing, and the poem ends in images of disintegration, all atoms and stray feathers:

> These with a thousand small deliberations
> Protract the profit of their chilled delirium,
> Excite the membrane, when the sense has cooled,
> With pungent sauces, multiply variety
> In a wilderness of mirrors. What will the spider do,
> Suspend its operations, will the weevil
> Delay? De Bailhache, Fresca, Mrs. Cammel, whirled
> Beyond the circuit of the shuddering Bear
> In fractured atoms. Gull against the wind, in the windy straits
> Of Belle Isle, or running on the Horn,
> White feathers in the snow, the Gulf claims,
> And an old man driven by the Trades
> To a sleepy corner.
>
> Tenants of the house,
> Thoughts of a dry brain in a dry season.[9]

A mind that loses itself in vast intellectual constructs from the past may lose everything. If you can swallow the whale, well and good; but there's always a danger that you may bite off more than you can chew.

The Waste Land

Eliot considered using the whole text of "Gerontion" as an introduction to his 1922 epic *The Waste Land*, a freeze-dried encyclopedia of cultural futility and anarchy; instead, he chose to begin *The Waste Land* with a Latin

passage describing the Cumaean Sibyl withering away in a hanging cage: when someone asks the sibyl what she wants, she says, "I want to die." The idea that the mind of Europe was at once immortal and senile, continually imploding, haunted Eliot. For certain other Modernists, such as D. H. Lawrence, the cure to Europe's senile dementia was clear: resurrect the body. Eliot might have liked to achieve this too: he advises the poet to look not only into his heart but also into his "nervous system, and the digestive tracts."[10] But it seems that Eliot, in "Gerontion," didn't see a real way to revive the lost senses of sight, smell, hearing, taste, and touch, even with the most pungent sauces. In *The Waste Land* the body's failure is in some ways still more devastating: Eliot describes various states of carnal decrepitude and perversion and investigates possibilities for the body's resurrection— possibilities that seem to founder on the fact that resurrection requires mythological potencies unavailable in modern Europe. Myth collapses into mock myth.

The Waste Land and James Joyce's *Ulysses* were published in the same year, but Eliot was already familiar with Joyce's work, since Joyce had been publishing excerpts from it since 1918. Eliot wrote that

> in using the myth, in manipulating a continuous parallel between contemporaneity and antiquity, Mr. Joyce is pursuing a method which others must pursue after him. . . . They will not be imitators, any more than the scientist who uses the discoveries of an Einstein in pursuing his own, independent, further investigations. It is simply a way of controlling, of ordering, of giving a shape and a significance to the immense panorama of futility and anarchy which is contemporary history. . . . Instead of narrative method, we may now use the mythical method. It is, I seriously believe, a step toward making the modern world possible in art.[11]

In representing modern life, Eliot wished for a kind of undergirding of a familiar, smoothly contoured, intelligible old story: the myth, tensely counterpointed with the shattered contemporary world, would not only provide a measure by which the reader could judge the quality and degree of recent depravity, disorder, but also provide a covert recipe for putting the world back together again, even if it was only a matter of propping up a ruin by shoring sturdy old fragments against it.

The mythic substrate of *The Waste Land* is not derived from Homer (as Joyce's was), nor from Africa (as Picasso's was, in *Les demoiselles d'Avignon*), nor from prehistoric Russia (as Stravinsky's was, in *The Rite of Spring*); it is derived, instead, from two books: the first is *The Golden Bough* (1890), by Sir

James Frazer, a comparative anthropologist; the second is *From Ritual to Romance* (1920), written by a student of medieval literature, Jessie L. Weston. *The Golden Bough* is one of the most ambitious projects of the late nineteenth century: an attempt to reconstruct from the thousands of myths of primitive tribes a single governing supermyth, a giant myth that would contain and explain all particular mythologies. Frazer decided that behind all primitive mythologies there lay a story about a god who represented the fertility of earth—a god named Osiris in Egypt, or Adonis in Greece, or Tammuz in Babylonia, but all merely names for the same thing. In winter the earth is sterile and cold, because the god of the land is dismembered, dead; but in spring he will stir, rouse himself, if mankind can align itself properly with the forces of regeneration. Of course, the resurrection of Christ from the dead is, from Frazer's perspective, only another example of a fertility cult—though Christianity first attempted to suppress, and finally forgot, its origins in nature worship.

Jessie Weston, thirty years later, tried to demonstrate that Frazer was correct through a study of medieval romances of Galahad, Percival, and Gawain, stories that, she believed, contained secret allusions to fertility rites persisting even up until the eleventh and twelfth centuries—she thought that official Christianity had never quite succeeded in exterminating the old nature cults. She regarded the romances as slick literary concoctions that more or less botched the story of the nature-god; but, she thought, if one read between the lines, one could see the outlines of the archetypal myth.

Let's look at her analysis of the romance of Percival, or (as he was called on the Continent) Parsifal or Perceval, as told by Chrétien de Troyes and other medieval poets. In most versions, the young knight Parsifal is sent on a quest for the Grail, the cup that caught the drops of blood that fell from Christ's body on the cross. He must bring the Grail to the Fisher King (sometimes named Amfortas), who has been terribly wounded in his side or groin; and the whole countryside around the Fisher King's castle has withered, become a wasteland. We have, then, a sick king who reigns over a sick land. It is Parsifal's mission to heal the Fisher King and restore fertility to the land.

In this story Jessie Weston saw still another version of the legend of Osiris or Adonis or Tammuz: she thought that the Fisher King was the nature-god, who had suffered castration and thereby brought winter to the earth; and she saw Parsifal as the agent of the Fisher King's resurrection, a cure that would make the earth bloom again. Indeed, she found in the medieval romance an allusion to an ancient ritual, in which the outgoing nature-god was

dramatized as an old feeble man lying in a coffin, while the incoming, resurrected nature-god was dramatized as a healthy young man who was surreptitiously substituted for the old man, so that he could spring out of the coffin ruddy-cheeked and glowing (the popular images of the New Year as a bannered baby and the Old Year as a withered bearded fellow with scythe and hourglass are clearly related to this antique drama).

There are at least two reasons that Eliot would have found Weston more poetically suggestive than Frazer. The first reason is that Weston's focus was on literature: she presented the old Grail romances as corrupt texts, written by authors who didn't quite understand the magical implications of their own stories; and Eliot wanted to write a poem that was not an exposition of truth but only dimly suggestive of a possible resurrection of culture not available to his, or maybe to anyone's, understanding. In a sense *The Waste Land* is a deliberate imitation of medieval Grail romance, in which the author's ignorance, the botched quality, is deliberately heightened. To Jessie Weston, Chrétien's *Perceval* is a distorted, ungainly tale that doesn't understand how far removed it is from the truth; *The Waste Land*, of course, is famously difficult and obscure, for centuries have past since Chrétien's time, and the archetypal nature myth can be alluded to only by means of still more arcane and fragmentary suggestions.

Human history abstracts us ever further from the great drama of the regeneration of the land, and with each century it requires a fiercer effort to recover it. Wherever Eliot looked in modern Europe, he saw people unconsciously conforming to certain archetypes; and the method of *The Waste Land* is to splice together stories in such a manner that the reader sees their common pregnancy-with-fertility legend. Few of Eliot's anecdotes, taken in isolation, would much resemble the Grail story; but when skillfully combined, they manifest something of the First Myth, the great myth of the human race, next to which all religions are partial and derivative.

The second reason that Weston was more appealing than Frazer is that Frazer was a good nineteenth-century man who scoffed at primitive superstitions: to him magic was only defective science—men have sex with their wives in the cornfield, engage in ceremonies to ensure the fertility of the land, only because they don't know how to take sensible measures, such as digging irrigation ditches and damming up streams. Jessie Weston, on the other hand, said explicitly that: "Visits to the Otherworld are not *always* derivations from Celtic Fairy-lore. Unless I am mistaken the root of this theme is far more deeply imbedded than in the shifting sand of Folk and Fairy tale.

I believe it to be essentially a Mystery tradition; the Otherworld is not a
myth, but a reality, and in all ages there have been souls who have been
willing to brave the great adventure, and to risk all for the chance of bring-
ing back some assurance of the future life."[12] In other words, the Grail ro-
mances aren't just pretty tales, but sober records of men who have found
salvation, real news of the afterlife. Jessie Weston believed that Adonis,
Osiris, Tammuz were real gods, or different names of the one real god. Eliot
in 1920 was a man with a considerable appetite for religion—he was eventu-
ally to become an orthodox Christian, but for a while he studied Buddhism
and other Eastern religions, and it may have seemed possible to him that the
nature religion of Jessie Weston was as tenable as any. To Frazer, the savage
is an infant and the modern a muscular, brawny, mature man; to Weston,
the savage is mature and healthy, while the modern is senile, withered, dry,
incompetent. Eliot, like Weston, wanted to reconnect modern man with his
lost springs of energy.

 The Waste Land is not an easy poem to understand. It is extremely eclec-
tic, in the collage style of some Modernist paintings—a poem of sudden
leaps, not graduated transitions. It collects an astonishing variety of little
stories, anecdotes from the lives of archdukes and maids, sailors and secre-
taries. Most storytellers summarize or offer commentary or at least give a
moral to one story before moving on to the next; but Eliot refuses to medi-
ate, refuses to cushion us. His stories are raw, not cooked and digested by
narrative art. The edges of his stories are jagged, not carefully filed down.

 But there is a method in Eliot's madness: the rapid splices, the instanta-
neous transitions, require the reader to superimpose one story on top of the
previous one, a process that allows him to discover for himself the essential
congruence of the anecdotes. Beneath the apparent diversity of Eliot's little
stories there is a kind of monotony: they all turn out to be different versions
of the same tale, different expressions of the same sterility, the same lack of
Grail. To Eliot there exists only one story, the archetypal myth of Frazer and
Weston, and in this way there is a governing simplicity beneath Eliot's dif-
ficulty of texture.

 We have seen that Eliot thought of the poet's mind as a catalyst, a shred
of platinum that united different feelings. *The Waste Land* is a profoundly
catalytic poem, although it catalyzes not feelings but anecdotes, little narra-
tives; the poet's mind is a medium for the combination of tiny wisps of plot
into a grand design.

The original title of this poem was not *The Waste Land* but *He Do the Police in Different Voices*—that phrase comes from Dickens's novel *Our Mutual Friend*, where it is used to describe a half-wit boy who likes to read the newspaper aloud with various vocal characterizations. *The Waste Land* is best understood, I think, as a continuous act of impersonation—when you read it, you should think of a single voice pretending to be the Countess Marie Larisch, and the prophet Ezekiel, and a man going to a fortune-teller, and all the other characters in the poem:

April is the cruellest month, breeding
Lilacs out of the dead land, mixing
Memory and desire, stirring
Dull roots with spring rain.
Winter kept us warm, covering
Earth in forgetful snow, feeding
A little life with dried tubers.
Summer surprised us, coming over the Starnbergersee
With a shower of rain; we stopped in the colonnade,
And went on in sunlight, into the Hofgarten,
And drank coffee, and talked for an hour.
Bin gar keine Russin, stamm' aus Litauen, echt deutsch.
And when we were children, staying at the archduke's,
My cousin's, he took me out on a sled,
And I was frightened. He said, Marie,
Marie, hold on tight. And down we went.
In the mountains, there you feel free.
I read, much of the night, and go south in the winter.

What are the roots that clutch, what branches grow
Out of this stony rubbish? Son of man,
You cannot say, or guess, for you know only
A heap of broken images, where the sun beats,
And the dead tree gives no shelter, the cricket no relief,
And the dry stone no sound of water. Only
There is shadow under this red rock,
(Come in under the shadow of this red rock),
And I will show you something different from either
Your shadow at morning striding behind you

Or your shadow at evening rising to meet you;
I will show you fear in a handful of dust.

> *Frisch weht der Wind*
>
> *Der Heimat zu*
>
> *Mein Irisch Kind*
>
> *Wo weilest du?*

"You gave me hyacinths first a year ago;
They called me the hyacinth girl."
—Yet when we came back, late, from the Hyacinth garden,
Your arms full, and your hair wet, I could not
Speak, and my eyes failed, I was neither
Living nor dead, and I knew nothing,
Looking into the heart of light, the silence.
Oed' und leer das Meer.

Madame Sosostris, famous clairvoyante,
Had a bad cold, nevertheless
Is known to be the wisest woman in Europe,
With a wicked pack of cards. Here, said she,
Is your card, the drowned Phoenician Sailor,
(Those are pearls that were his eyes. Look!)[13]

In the Idealist philosophy that Eliot is just beginning to outgrow, a single person mutates so much from instant to instant that he or she is best thought of as a series of wholly different people; *The Waste Land* is a demonstration of a single voice continuously mutating through the whole range of the human race.

Poetry, said Eliot, is not an expression of personality but an escape from personality, and so we see the narrator of *The Waste Land* reeling backward from personality to personality, as if each were an escape, a relief from the last. Each personality is an experiment in vocal timbre, as if the narrator hoped to find the Real Right Voice, capable of making the authentic expression, the declaration of love, the announcement of joy, the uttering of the magic words that would bring healing water to the waste Europe; and if the narrator never finds this ideal voice, it is not from lack of trying.

The opening lines are a parody of the first lines of Chaucer's General Prologue to *The Canterbury Tales*, the story of a pilgrimage that begins in the wet season, when April with his showers soote the draught of March hath

perced to the roote, and bathed every vein in such liquor, of which virtue engendered is the flower. *The Canterbury Tales* are also a set of narratives giving thanks for the sacred restoration of the land, for the rain that engenders new growth—as if Eliot wished to begin with Chaucerian authority, confidence. And yet the opening is more likely to disturb us than to make us confident: Eliot's characters, far from setting off on a pilgrimage in honor of spring, Easter, the resurrection, are huddled in their holes, hoping that spring will fail to awaken them; far from thirsting for regeneration, they are in love with winter. We have from the beginning Eliot's chief indictment of modern life: that we want a comfortable lifelessness, without memory or desire or selfhood; that we are afraid of rebirth.

The first anecdote concerns a noblewoman's sled ride when she was a girl, a moment of terror and exhilaration, the exact opposite of the studious oblivion of the Chaucerian pastiche. Eliot implies that in childhood modern folk can experience prehistoric sensations—each of us can appeal to some deep substrate of our being, some giddy recollection of freedom and vitality, real feeling, which tends to derange our habitual anesthesia. (Despite Eliot's avowed hatred of Romanticism and love of Classicism, he also is a grandchild of Jean-Jacques Rousseau, the eighteenth-century philosopher who held up the noble savage as a reproach to modern civilization: Eliot too seeks the authentic in the domain of the primitive.) Ontogeny recapitulates phylogeny—the development of each man comprehends the whole evolution of the race: we were once savages, and *felt*. But our lives stiffen into habit, a kind of rigor mortis: we start to govern ourselves by schedules, reading at night, going south in the winter, and thereby lose spontaneous vivacity of feeling.

The same structure of intercutting can be found in the second verse paragraph: a description of a wasteland is followed by glimmers, glimpses, hints of the good life that existed before the devastation of the land. Instead of winter, we have summer heat: the desert with its heap of broken images— the whole poem is a heap of broken images investigating the possibility of coherence; but in neither season will the earth support a human presence. The heat is interrupted by flashes of significant experiences: fear of death, reminiscences of the ecstasy of young love.[14]

The German lines are sung (unaccompanied) by a young sailor, directly after the Prelude to Wagner's opera *Tristan und Isolde* (1865): he announces his ache of yearning for his sweetheart, as his ship leaves Ireland for Cornwall:

Homeward we sail,
The wind blows stronger;
My Irish child,
Where do you linger?[15]

Then the narrator remembers a dazzling vision of the hyacinth girl—the hyacinth is an emblem of the fertility god. But these moments of tenderness and beauty are interrupted by the cry of the shepherd, telling the dying Tristan that Isolde is not going to come to heal his wound: *"Oed' und leer das Meer"* ("Waste and empty the sea"). These Wagnerian references are important, for by switching from Wagner's *Parsifal* (1882)—the greatest modern treatment of the Grail legend—to Wagner's *Tristan und Isolde*, Eliot seems to be sexualizing the Grail story to a much greater extent than the original romances. Tristan is wounded because of his adulterous, world-consuming passion for Isolde—it's as if Eliot thought that the Fisher King suffered his wintering wound because of some sexual transgression. (Indeed, in his early sketches for *Tristan und Isolde*, Wagner intended that the Grail knight Parsifal visit the sick Tristan while he raved by the seashore.) It seems that some intimate error in human coitus has devastated the land; as we see in part III, we must learn to rectify our sexual conduct if we are to be saved. In many places in the poem it's possible to imagine that the narrator of *The Waste Land* is himself the wounded Fisher King, the nature-god, delirious from his suffering, reliving in memory his moments of strength and glory, the sexual climaxes that seem partly to save him and partly to destroy him.

As the poem continues, Eliot's cast of characters keeps expanding dangerously: a man who buries a corpse in his backyard in the hopes that it will sprout; an upper-class literary couple trapped in a marriage that seems to annihilate them; a gabby lower-class woman who talks casually about abortion. But despite this multiplicity of narratives, there are in fact very few plots, only various forms of being-in-love-with-death, either through a willful wasting away or through rape—rape is the main crime against generation, treated again and again throughout the text.

We see rape for the first time in part II of *The Waste Land* in a sort of literary aside—this is a carnivorous poem capable of swallowing any previous poem whole. Part I began with a parody of Chaucer; part II begins with a parody of Shakespeare, Enobarbus's description of Cleopatra's throne:

The Chair she sat in, like a burnished throne,
Glowed on the marble, where the glass

Held up by standards wrought with fruited vines
From which a golden Cupidon peeped out
(Another hid his eyes behind his wing)
Doubled the flames of sevenbranched candelabra
Reflecting light upon the table as
The glitter of her jewels rose to meet it,
From satin cases poured in rich profusion;
In vials of ivory and coloured glass
Unstoppered, lurked her strange synthetic perfumes,
Unguent, powdered, or liquid—troubled, confused
And drowned the sense in odours; stirred by the air
That freshened from the window, these ascended
In fattening the prolonged candle-flames,
Flung their smoke into the laquearia,
Stirring the pattern on the coffered ceiling.
Huge sea-wood fed with copper
Burned green and orange, framed by the coloured stone,
In which sad light a carvèd dolphin swam.
Above the antique mantel was displayed
As though a window gave upon the sylvan scene
The change of Philomel, by the barbarous king
So rudely forced; yet there the nightingale
Filled all the desert with inviolable voice
And still she cried, and still the world pursues,
"Jug Jug" to dirty ears. . . .
"My nerves are bad to-night. Yes, bad. Stay with me.
Speak to me. Why do you never speak. Speak."[16]

Note that the perfumes are synthetic, and the whole scene is a stifling arti-
fice: one of London's unreal aspects is that it's a city made out of coal tar;
the very air has been replaced by a thick, sweet substance, drowning, con-
founding the senses. This is the extreme of unnature, the farthest remove
from whatever force will make the spring return.

The story of Philomela, painted above the mantel, is an important clue
about the relation of modern times to the more vital past. The tale of Tere-
us's rape of his sister-in-law, his cutting out of her tongue, is one of the most
brutal of Greek legends; but it seems that in archaic times violence could
metamorphose into beauty—the injured Philomela could change into a night-

ingale, whereas nowadays extreme suffering remains untransformed: nothing happens. Instead of metamorphosis, we have self-evasion: people don't feel their own emotions intensely enough to change themselves. Amid the anesthesia, the drugs, the lotus eating of modern Londoners, feeling can never attain the requisite urgency, and so the relief of metamorphosis is no longer possible. We are each of us stuck in our present sad shape. This theme is significant to the nature myth too, for unless the dying god can metamorphose into his youthful spring identity, winter will last forever—and it indeed seems possible that the seasons have become stuck, that spring will never come.

Rape becomes an explicit theme in the middle of part III, the very center of *The Waste Land*, as we hear the story of the typist and the young man carbuncular:

> At the violet hour, when the eyes and back
> Turn upward from the desk, when the human engine waits
> Like a taxi throbbing waiting,
> I Tiresias, though blind, throbbing between two lives,
> Old man with wrinkled female breasts, can see
> At the violet hour, the evening hour that strives
> Homeward, and brings the sailor home from sea,
> The typist home at teatime, clears her breakfast, lights
> Her stove, and lays out food in tins.
> Out of the window perilously spread
> Her drying combinations touched by the sun's last rays,
> On the divan are piled (at night her bed)
> Stockings, slippers, camisoles, and stays.
> I Tiresias, old man with wrinkled dugs
> Perceived the scene, and foretold the rest—
> I too awaited the expected guest.
> He, the young man carbuncular, arrives,
> A small house agent's clerk, with one bold stare,
> One of the low on whom assurance sits
> As a silk hat on a Bradford millionaire.
> The time is now propitious, as he guesses,
> The meal is ended, she is bored and tired,
> Endeavours to engage her in caresses
> Which still are unreproved, if undesired.

> Flushed and decided, he assaults at once;
> Exploring hands encounter no defence;
> His vanity requires no response,
> And makes a welcome of indifference.
> (And I Tiresias have foresuffered all
> Enacted on this same divan or bed;
> I who have sat by Thebes below the wall
> And walked among the lowest of the dead.)
> Bestows one final patronising kiss,
> And gropes his way, finding the stairs unlit . . .[17]

The narrator of the poem, doing the police in different voices, has always been an amazingly gifted vocal impersonator, a sort of Robin Williams: now the narrator appears in the flesh as the withered hermaphrodite Tiresias, an amazingly gifted physical impersonator, a kind of Proteus capable of taking every shape, feeling every feeling, whether male or female. (As Eliot explains in a note, quoting Ovid in Latin, Tiresias once saw two snakes mating, struck them with his staff, and was miraculously changed into a woman; some years later he again struck a pair of snakes and was changed back into a man; when Juno and Jupiter called him in to settle their dispute—whether man or woman found the greater pleasure in sex—Tiresias said, Woman, a response that so angered Juno that she blinded him, but Jupiter in compensation gave him the gift of prophecy.) As the note to line 218 suggests, Tiresias is the single character of the poem, outfitted in dozens of costumes: "Tiresias, although a mere spectator and not indeed a 'character,' is yet the most important personage in the poem, uniting all the rest. Just as the one-eyed merchant, seller of currants, melts into the Phoenician Sailor, and the latter is not wholly distinct from Ferdinand Prince of Naples, so all the women are one woman, and the two sexes meet in Tiresias. What Tiresias *sees*, in fact, is the substance of the poem."[18] What Tiresias *is* is the substance of the poem.

Tiresias is infinitely metamorphosable; indeed, he is just the principle of metamorphosis given a proper name. He is also an avatar of the dying nature-god, Osiris or Adonis, desperately in need of a new god to take his place—after thousands of years of dying, the nature-god has shriveled into this blind incompetent thing, crippled by his inability to die. Tiresias is a spectator of the dead, an empathizer with the dead, infected with death, and it doesn't seem likely that a great upwelling of new energy is going to rejuve-

nate him and the land. Tiresias is too decayed, oversophisticated, slack; he has lost the elasticity necessary to renew himself—he's just a puddle of shapelessness instead of the overwhelming force that civilization needs.

The typist is a second Philomela, the young man carbuncular a second Tereus—but instead of a drama of intolerable suffering, we have a mock rape in which nobody is much troubled by the assault:

> She turns and looks a moment in the glass,
> Hardly aware of her departed lover;
> Her brain allows one half-formed thought to pass:
> "Well now that's done: and I'm glad it's over."
> When lovely woman stoops to folly and
> Paces about her room again, alone,
> She smoothes her hair with automatic hand,
> And puts a record on the gramophone.[19]

In a passage deleted from part III, Eliot compared modern Londoners to pavement toys tracing cryptograms, and here we have sexual intercourse as enacted by wind-up dolls. Yeats once castigated Eliot for the mechanical rhythm of these lines[20]—but of course the whole point is that the typist is as much a machine as her gramophone, a robot or pavement toy for whom sex is, like every other activity, just a yawn. Tiresias seeks to connect this scene with its ancient roots, its archetype—but, in fact, modern life is only a parody of reality. Coitus ought to be a sacred act, conducive to world re-generation, tending to heal the damage done to nature; instead, modern sex tends to damage nature all the more, tends to inflict further wounds on the god—this is why Eliot is so fascinated by rape, by sex in its mutilating forms. The sexual intercourse of the typist and the young man carbuncular dimly alludes to resurrection, new health, but is in fact further evidence of their estrangement from vitality, further evidence of their damnation.

After part III, the poem spirals outward further and further, until, in part V, it embraces all the various Sodoms and Gomorrahs—the cities of the plain—that make up the modern world:

> Who are those hooded hordes swarming
> Over endless plains, stumbling in cracked earth
> Ringed by the flat horizon only
> What is the city over the mountains

Cracks and reforms and bursts in the violet air
Jerusalem Athens Alexandria
Vienna London
Unreal

A woman drew her long black hair out tight
And fiddled whisper music on those strings
And bats with baby faces in the violet light
Whistled, and beat their wings
And crawled head downward down a blackened wall
And upside down in air were towers
Tolling reminiscent bells, that kept the hours
And voices singing out of empty cisterns and exhausted wells.[21]

As the focus widens, the poet's grasp on reality seems to weaken further, and we enter a Surrealist world of hellish images, a mad babbling world of untranslated Latin and French and Italian and Sanskrit—whereas the previous parts catalyzed disparate stories into a few archetypal narrative poems, we now seem to be in a pathless, storiless desert. The poet does what he can to bring healing rain to the Waste Land: he makes the thunder speak the ancient Indo-European root DA (related to, for example, the Latin imperative *Give*, but also dangerously close to half a dada); he even tries to conjure water through magical onomatopoeia:

If there were water
And no rock
If there were rock
And also water
And water
A spring
A pool among the rock
If there were the sound of water only
Not the cicada
And dry grass singing
But sound of water over a rock
Where the hermit-thrush sings in the pine trees
Drip drop drip drop drop drop drop
But there is no water[22]

(Eliot, incidentally, thought that the lines just quoted were the finest lines in the poem.) But it is far from certain that the act of saying "drip drop" is sufficient to quench Europe's thirst.

The poem ends with some celebrated gibberish:

> *Poi s'ascose nel foco che gli affina*
> *Quando fiam uti chelidon*—O swallow swallow
> *Le Prince d'Aquitaine à la tour abolie*
> These fragments I have shored against my ruins
> Why then Ile fit you. Hieronymo's mad againe.
> Datta. Dayadhvam. Damyata.
> Shantih shantih shantih[23]

These fragments remain undigested quotations, as if the poet, previously so adept at wearing masks, has lost his ability to sustain a persona even for a brief time. The narrator seems at last unable to speak, only to point to a few lines from Dante's *Commedia* and the *Pervigilium Veneris* ("When shall I be like the swallow") and a sonnet by Gérard de Nerval ("The Prince of Aquitaine at the ruined tower") and a play by Thomas Kyd and a Sanskrit amen, lines that dramatize his predicament—lines about yearning and burning and savage madness. The poem finally looks like a ruin, despairing of final closure, any achievement of structure—for Eliot cannot believe that his efforts will result in valid magic, in redemption of the land.

And yet maybe we shouldn't find the ending too black. It is true that Eliot takes a hammer to the major languages of Europe—but perhaps he shatters them only in order to reduce them to their primal Indo-European vocables, like DA. This is as close to a magic syllable as anything Eliot can find; he seems to hope that the antidote to catastrophe somehow inheres in the catastrophe itself, that in the ruin of language some more archaic, forceful language can be found. And the line from Dante, about the refining fire ("Then he hid in the fire that refines them"), also conceals a hopeful sign: for if the fire is an agent not of annihilation but of refinement, we may be permitted to hope that modern Europe, modern America, which look like hell, may actually be only purgatory.

Ezra Pound

The Waste Land was originally about twice as long as the text we know: Eliot's friend Ezra Pound edited it into shape—Eliot was the first of many readers who was startled to read his poem. Pound paid little attention to

thematic development or coherence—not that coherence was ever a real option for any editor to choose; he closely attended to the poetic excellence, the tensile strength, of individual lines and passages. In some ways, then, *The Waste Land* is one of Pound's Cantos, the text of which happened to be written by Eliot, since Pound's almost lifelong attempt at writing an epic, called *Cantos*, was governed by compositional procedures similar to those of *The Waste Land*: severe deletion of all matter except the most crucial— though the crucial matter might be advice from Confucius on a well-ordered state, or a dirty joke about homosexuals, or a Renaissance document about paying Titian to paint, as well as an arrestingly beautiful image. *The Waste Land* follows the model of several of the Cantos written around 1919-23: ragged textual surfaces imprinted with voices ("My nerves are bad to-night"; "Well now that's done: and I'm glad it's over") often juxtaposed abruptly, and interspersed with spangles hinting at a kind of remote aesthetic relief ("Those are pearls that were his eyes"; "Inexplicable splendour of Ionian white and gold"). Not only did Pound influence *The Waste Land*, but *The Waste Land* influenced Pound—Canto 8 begins with a smiling allusion to Eliot: "These fragments you have shelved (shored): / 'Slut!' 'Bitch!'"[24]

Nietzsche called Wagner, a composer famous for extremely long operas, the greatest miniaturist in music. In a similar paradox, Ezra Pound, one of the great miniaturists among poets, decided that he needed to write an epic, not just the epic of a single tribe or culture, but the global epic, the epic of the whole human race, from Italy to China to Africa to Australia.

There are many obstacles to reading this poem—maybe the greatest obstacle stems from the fact that it was the work of a poet too ambitious, too afraid of being cramped, to work according to a plan. Instead of a plan, Pound devised new Cantos out of his schemes to make sense of his old Cantos, so that the story of the Cantos comprises two intertwined stories, one concerning Pound's writing of the poem, the other concerning Pound's interpretations of what he had already written.

This twin story begins in 1915, when Pound was thirty years old and felt that it was time to write a grand poem worthy of Homer and Dante. As early as 1909, Pound told his mother that he intended to write an epic, but he was not immediately certain how to proceed. In 1915 he wrote a long poem, ultimately published in 1917 in *Poetry* magazine as *Three Cantos*—a poem quite different from any of the Cantos as we know them today. It is characteristic of Pound that he had to erase the beginning of the Cantos, since his whole career is a structure of reinterpretation, often of repudiation, of his

earlier work. The sequence of Pound's Cantos feels like a live thing, inter-
rogating itself, casting off outworn versions of itself.

In 1915, Pound could already present himself as the most versatile and
accomplished translator in English: even today, translations of Old English
tend to echo (or play off) the abrupt, overstressed voice that Pound estab-
lished in 1911 in "The Seafarer" ("Known on my keel many a care's hold, /
And dire sea-surge, and there I oft spent / Narrow nightwatch nigh the ship's
head"); and the Chinese translations of his 1915 volume *Cathay* seemed to
display a delicacy of diction new to our language. But Pound's original work
was less prepossessing. He had written some fine passages in a somewhat
nervously archaic idiom, as well as many of the small, tense, sometimes sa-
tirical poems, not at all archaic, that were to be collected in the volume
Lustra (1916), such as "In a Station of the Metro" (1913)—these short poems
were written as examples of Imagism, a movement we've already discussed.

Almost as soon as the Imagist movement began, Pound sought for ways
of extending the poetic image without losing its concentration. As we've
seen, the Vorticist movement of 1914 sought ways of embodying in a poem
not just the image itself but the *process* through which the image was con-
ceived and transmitted: "The image . . . is a radiant node or cluster; it is what
I can, and must perforce, call a VORTEX, from which, and through which,
and into which, ideas are constantly rushing. In decency one can only call it
a VORTEX."[25] The notion of a whirl of ideas fining themselves down, focus-
ing on some central point, seems more useful to an epic poet than the no-
tion of an interminable gallery of terse and disconnected images—pattern
units in the absence of a pattern. But how was Pound to write an epic in the
form of a tornado?

Three Cantos (1917)

In a sense, the Pound of 1915 did not want to ask himself such questions;
he simply wanted to write, and to write without any particular sense of a
model. His very choice of the word *canto* to describe his poem is intriguing.
Canto is simply an Italian word for song, but in English it suggests a chunk
of a single long poem, such as Homer's *Odyssey* or Dante's *Divine Comedy*.
But Pound used the word ambiguously: the English sense is not quite right,
for the theme of the whole, the form of the whole, the destination of the
whole—none of these were determined when he began; the whole was to
be a construct of the parts, and so each Canto had to claim a certain inde-

pendence, a certain authority in solitude. And the Italian sense is not quite right either, for the songlike passages are intermixed with material extremely hard to sing, such as excerpts from the letters of Thomas Jefferson. The word *canto* is an impudence: an allegation of a comprehensiveness of design that was never likely to be evident—though Pound hoped that someday, somehow, it would be achieved; and an allegation of music that indeed can be heard, but only fitfully, as if the whole poem were a transcript of a radio broadcast that kept losing the proper channel, dissolving into static, or into the blare of the aggressive wrong stations occupying a bandwidth close to the faint right station.

The choice of the word *canto* arouses certain expectations in the reader, perhaps most of all the expectation that the poem is a *Divine Comedy* for the Modernist age. Pound sometimes invited and sometimes resisted this. In 1915 Pound wrote, "I am working on a long poem which will resemble the Divina Commedia in length but in no other manner . . . it will prevent my making any money for the next forty years, perhaps"; but in 1917, when Harriet Monroe was printing (contrary to his wishes) *Three Cantos* in installments, Pound wrote, "Have at last had a letter from Harriet, consenting to print the Divina Commedia, in three sections."[26] The premise of Dante's poem, of course, is a series of interviews between a character named Dante, a tourist in the afterlife during the year 1300, and various dead souls, whose torture or beatitude takes the form of a certain expressive urgency: they boast, they exhort, they weep, they sing. There are a few passages in Pound's Cantos that closely follow Dante's premise:

Exuded the great usurer Geryon, prototype
of Churchill's bankers. And there came singing
Filippo Tomaso in rough dialect, with h for c,
all right, I am dead, but do not want to go to heaven,
 I want to go on fighting
& I want your body to go on with the struggle.
And I answered: "my body is already old,
I need it, where wd. I go?
But I will give you a place in a Canto . . .
& leave the talking to me.
And let me explain,
 sing of the eternal war
 between light and mud.[27]

But this eerie encounter between Pound and the Futurist Marinetti occurs in a late Canto, from 1944, originally written in Italian, as if Pound could become Dante only by abandoning the English language. In the early Cantos, we behold glimpses of the torsions of hell and the opalescences of heaven, as Dante conceived them, but Pound's structural technique owes little to Dante.

Pound was reluctant to shape his poem according to classical or medieval European models, and he was also reluctant to shape his poem according to extremely up-to-date Modernist models. The appearance of Marinetti in Canto 72 suggests not only an alternate, unwritten version of the Cantos in the style of Dante, but another possible version that Pound might have considered and rejected: Cantos in the style of Marinetti. By 1915, when Pound was beginning the project, Europe was full of experiments in making language look like pictures: in 1914 Apollinaire had begun his *Calligrammes* (originally called *idéogrammes lyriques*), and Marinetti published his *Zum Tumb Tuum*. Apollinaire's early calligram *Lettre-océan* shows sentences radiating across the page from a center, like radio transmissions from the Eiffel tower; and a page of Marinetti's book takes the words *PALLONE FRENATO TURCO* (Turkish captive balloon) and prints them in a circle, from which dangle vertical lines of print, representing the ropes that tie the balloon down. In the 1910s Pound tended to be contemptuous of Marinetti and suspicious of the French experiments with poetic ideograms; on the other hand, he regarded Chinese as a language blessed by its pictorial specificity of meaning, and he noted with awe that the sculptor Gaudier-Brzeska was so sensitive to design that, though he had studied almost no Chinese, he could read its ideograms, through sheer power to destylize the signs into pictures.[28] The Modernist hope of shaping language into typographic forms through which the eye can *see* the meaning of the text informs some passages in the Cantos:

> For the procession of Corpus
> come now banners
> comes flute tone
> ο☐ χθόνιον [hoi chthonion, the earth-born]
> to new forest,
> thick smoke, purple, rising
> bright flame now on the altar
> the crystal funnel of air

out of Erebus, the delivered,

 Tyro, Alcmene, free now, ascending

e i cavalieri

 ascending,

no shades more,

 lights among them, enkindled . . .[29]

Here is a passage arranged in the shape of a vortex, through which and into which ideas constantly rush: the syntax, the spatial arrangement of the words, seems to shape a funnel on the page, as the participles at the line breaks push the verbal flow back to the left-hand margin. But this is from a very late Canto, published in 1955—in many of the late Cantos, Pound seems to be experimenting with compositional procedures unused in the bulk of the poem. For the most part, neither Dante nor Marinetti, neither the old nor the modish, gave Pound what he needed for his great project.

Despite Pound's unwillingness to limit his field of poetic operation by planning, *Three Cantos* (1917) did make use of a model—a model that no other poet on earth would have chosen as the basis of a long Modernist poem: *Sordello* (1840), an overwhelmingly ambitious poem by the very young Robert Browning, published at his father's expense. *Sordello* soon became a byword for gnarled and willful obscurity; Tennyson noted that he could understand only two of the poem's approximately six thousand lines, the very first ("Who will, may hear Sordello's story told") and the very last ("Who would has heard Sordello's story told")—unfortunately, he felt, both lines were lies.[30] Still, the first words given to the world from Pound's Cantos consisted of a tribute to *Sordello*:

Hang it all, there can be but one *Sordello*!

But say I want to, say I take your whole bag of tricks,

Let in your quirks and tweeks, and say the thing's an art-form

Your *Sordello*, and that the modern world

Needs such a rag-bag to stuff all its thought in;

Say that I dump my catch, shiny and silvery

As fresh sardines flapping and slipping on the marginal cobbles?

(I stand before the booth, the speech; but the truth

Is inside this discourse—this booth is full of the marrow of wisdom).

Give up th' intaglio method.[31]

The ejaculative, impertinent tone of this passage is itself borrowed from Browning—but Browning's persona was only one of several features that attracted Pound to *Sordello*. Pound liked Browning's way of resurrecting the past—the historical Sordello was a thirteenth-century troubadour who eloped with Cunizza da Romana, a nobleman's wife—by means of a modern intermediary, who dramatizes himself in the act of dramatizing long-extinct characters. Indeed, Browning introduces himself to the reader as a sort of professor dressed like a clown:

> Motley on back and pointing-pole in hand . . .
> So, for once I face ye, friends . . .
> Confess now, poets know the dragnet's trick,
> Catching the dead, if fate denies the quick . . .
> What heart
> Have I to play my puppets . . . ?[32]

Throughout the *Three Cantos*, Pound, following the Browningesque model of puppet master, plays the genial but erratic impresario, making his pretty merchandise dance for public admiration—glances at the pomp of Italian and Spanish parades, snatches from Catullus and the story of el Cid, memories of his 1908 trip to Venice, all shot through with visions of old gods taking shape in the air. It is a self-conscious, theatrical sort of poetizing, which at last terminates in the third of the *Three Cantos*, when the poet opens an old book, Andreas Divus's Latin translation (1538) of the *Odyssey*, and gently complains about the hard work of translating, whether from Latin or Provençal:

> I've strained my ear for *-ensa*, *-ombra*, and *-ensa*
> And cracked my wit on delicate canzoni—
> Here's but rough meaning:
> "And then went down to the ship, set keel to breakers,
> Forth on the godly sea;
> We set up mast and sail on the swarthy ship . . .[33]

The section in quotation marks turned out to be a draft of Canto 1, as it would appear in *A Draft of XVI Cantos* (1925), and as it appears today. During the eight years between the composition of *Three Cantos* and the recasting of Canto 1 in 1923, a tremendous reorientation had occurred in Pound's poetics; his idea of what a Canto was had shifted so greatly that he found himself simply emancipating the translation of Odysseus's descent to Hades

from all the masses of prefatory material. Pound took a flensing knife to *Three Cantos*; but in order to do so, he needed to devise a clear principle for distinguishing meat from blubber.

Three Cantos is a work with a deep focal field. In the foreground is the poet, the showman with his sardines; in the middle ground are exhilarating landscapes, like those Tuscan climes where "the senses at first seem to project for a few yards beyond the body"[34]; in the background is a tissue of reminiscence of art and literature, from Botticelli to Egyptian inscription. In 1915 Pound conceived an epic as a careful mediation of a central consciousness surrounding, animating, swirling into, receding from, the brief stories and the descriptions of the text—as Joyce put it in *A Portrait of the Artist as a Young Man*, to be published the following year, in the epic "the personality of the artist passes into the narration itself, flowing round and round the persons and the actions like a vital sea."[35] Pound regarded his work as something far choppier, more discontinuous, than the old epics—as he expostulated to Browning in *Three Cantos* I,

> You had one whole man?
> And I have many fragments, less worth? . . .
> Ah, had you quite my age, quite such a
> beastly and cantankerous age?
> You had some basis, had some set belief.[36]

But Pound may have felt that the very fragmentariness of the modern age required the emollience of a clearly present core sensibility, absorbing all the fragments into a single matrix, preventing their rough edges from cutting the reader. Pound compared the *Three Cantos* to a "rag-bag"; one might also think of chunks of fruit suspended in the Jell-O of the poet's mind.

But there were certain obvious dangers in entrusting the great project of one's life to a model of fragments stuck in a rag-bag. Any fragment, any bright pebble that catches the eye, is as good as any other, unless some method can be found for discriminating the Luminous Detail from the general muck.[37] And just as the contents of the Cantos were looking ominously random, so the coordinating sensibility, the mind of Pound, also seemed incoherent. Poggio, in Pound's dialogue "Aux Etuves de Wiesbaden" (1918), notes, "They ruin the shape of life for a dogmatic exterior. . . . I myself am a rag-bag, a mass of sights and citations, but I will not beat down life for the sake of a model."[38] This makes a noble affirmation of a shapeless self and codeless conduct—but it seems to lead to the opposite of art, insofar as art

represents selection, intensification, beauty. In 1920 Pound reviewed the list of personae in his poetry and noted that while Propertius, the Seafarer, and Mauberley "are all 'me' in one sense; my personality is certainly a great slag heap of stuff which has to be excluded from each of th[ese] crystalizations."[39] At that time Pound was trying to decide how to proceed with the Cantos, and it is easy to see why he was uncertain: no single persona was inclusive enough to be the Sordello of the Modernist age; but to present the whole "slag heap" was simply to present something bulging and ugly, the detritus of self instead of the informing force. The road of the *Three Cantos* leads to self-insistence, gigantism, Wagnerian opera, and general uffishness and whiffling—not the goals that Pound sought. Instead of giving up the intaglio method—carefully chiseled art—Pound needed to find a way of integrating epic aspirations with incisive design.

Schemes for Canto Design

THE NOH PLAY The Cantos got on the right path (from Pound's point of view) in 1919, when he wrote Canto 4—the first Canto that he regarded as capable of standing in the finished sequence, although it too was revised to some degree. Canto 4 has an entirely different texture from the *Three Cantos* of 1917.

Instead of the carefully modeled perspective drawing of the *Three Cantos*, where the reader is oriented in psychological space, we now have a flat field. The poet, the events, the literary allusions—they all coexist on the same plane:

And she went toward the window and cast her down,
 "All the while, the while, swallows crying:
Ityn!
 "It is Cabestan's heart in the dish."
 "It is Cabestan's heart in this dish?
 "No other taste shall change this."
And she went toward the window,
 the slim white stone bar
Making a double arch . . .
 and the wind out of Rhodez
Caught in the full of her sleeve.
 . . . the swallows crying:
'Tis. 'Tis. Ytis! . . .

Then Actæon: Vidal,
Vidal. It is old Vidal speaking,
 stumbling along in the wood . . .
The pine at Takasago
 grows with the pine of Isé!
The water whirls up the bright pale sand in the spring's mouth
"Behold the Tree of the Visages!" . . .
 The Centaur's heel plants in the earth loam.
And we sit here . . .
 there in the arena . . .[40]

This is only a condensation of Canto 4, but it is faithful to the hard edges of
Pound's transitions: the slabs of texts abut one another without much sense
of a professor, or clown, or master of ceremonies creating a steady context
for the evolution of the pictures and stories. The last two lines did not ap-
pear in the text until 1925—originally the poet scarcely had any presence in
the poem. But even this final allusion to the premise of *Three Cantos* I—the
showman-poet sitting in "the old theatre at Arles" and conjuring visions [41]—
does not succeed in producing a graduated field with the poet's intelligence
on one plane and the stories and pictures on another. Instead, the snapshot
of poet in arena is just another pictorial element of the collage.

Pound has cast off "Bob Browning" in favor of a different structural
model. The key to the method of Canto 4 lies in the section about the pines
of Takasago and Isé: Pound has turned to the Orient to reorient his poem.
In an undated letter, Pound told Harriet Monroe that the theme of the Can-
tos is "roughly the theme of 'Takasago,' which story I hope to incorporate
more explicitly in a later part of the poem."[42] This may suggest that even
during the composition of *Three Cantos*, Pound considered the Japanese Noh
play, and specifically the Noh play *Takasago*, as crucial to the whole project.
In *Three Cantos* Pound made some picturesque allusions to the Noh theater,
but Canto 4 suggests that the Cantos could aspire not simply to include
pretty elements of Japanese theater, but to *be* a kind of Noh play.

Pound spent his winters at Stone Cottage in Sussex from 1913 to 1916,
working with Yeats on (among other things) the possibilities for finding a
Western equivalent to the classic Noh theater of Japan. The Noh is, by West-
ern standards, a theater without drama. There is rarely anything that could
be called a story; the action, which is minimal, is usually accomplished dur-
ing, and by means of, the climactic dance. In the simplest plays a traveling

priest (called the *waki*), often a folklorist or a connoisseur of landscape, meets a humble old man or old woman; after a series of interrogations it dawns on the priest that what appears to be a vagrant, a beggar, or a leech gatherer is actually a spirit (called the *shite*)—perhaps the ghost of a great man triumphantly remembering the scene of a mighty deed, or a genius loci, taking pleasure in the presence of his or her locus. A metamorphosis is accomplished by means of a costume change and a change of mask; there is no scenery, nothing but bridges and potted pines and the painted pine tree that is the backdrop of all Noh plays. The dramatic action, then, is only a movement toward enlightenment: what is surrounded by material illusion at last reveals itself in its true supernatural glory, a glory that reaches its perfection in the characteristic dance of the spirit. It is not the sort of dramatic action that we are accustomed to, but in certain films we find something similar to it. For example, Steven Spielberg's *Close Encounters of the Third Kind* (1977) is Noh-like in that it has neither heroes nor villains, no action except the tantalizing unveiling of a remarkable and nearly incomprehensible spectacle. Since we rarely like, these days, to speak of spirits, Spielberg substitutes an extraterrestrial being, which is all that is acceptable of the otherworldly; where a Noh play would have a climactic dance, Spielberg substitutes an increasing visual magnificence of unearthly forms. Spielberg was probably not influenced by Noh drama, but this film and the Noh share a common aesthetic goal, an attempt to provoke a delirium of wonder.

Pound discovered in the Noh an answer to a question that had puzzled him: "I am often asked whether there can be a long imagiste . . . poem. The Japanese, who evolved the *hokku*, evolved also the Noh plays. In the best 'Noh' the whole play may consist of one image. I mean it is gathered about one image. Its unity consists in one image, enforced by movement and music."[43] A Noh play is unitary; it is incisive; it is an extended writing, but antidiscursive—a text with the instantaneity and direct grasp of a painting, or an ideogram. These are the very qualities to which the Cantos aspire. Motokiyo's *Takasago* takes for its "one image" the embrace of two pine trees:

> PRIEST. . . . Why do they call all the pines in Takasago and in Suminoye "Ai-oi?"
> the two places are very far distant, and the word means "growing together."
> OLD MAN. Yes, I know anyone can read in the preface of Kokin that "It seems the
> pine trees of Takasago and Suminoye grow together" but I am a man of Sum-
> iyoshi . . . you had better ask the old woman, she's of this place.

PRIEST. What, I see the old pair here together and yet he says they live apart, he
 says he is of Sumiyoshi!
TSURE. That's a stupid thing you are saying. Though the mountain and river lie
 between us we are near in the ways of love. . . .
PRIEST. Yes, but what is the story that you are half telling? . . .
TSURE. Takasago mean the old age of the emperor Manyoshu.
OLD MAN. Sumiyoshi mean our own time . . .
CHORUS. Though grass and trees have no mind
 They have their time of blossoming and of bearing their fruit . . .
OLD MAN. And the look of this pine is eternal.
 Its needles and cones have one season.[44]

The play is an affront to time and space. The two pines are geographically
apart, separated by mountain and river, and yet they clasp; the pine of Ta-
kasago symbolizes a past age, and the pine of Sumiyoshi symbolizes the
present age, and yet they coexist. Pound considered *Takasago* a nearly per-
fect play, and it demonstrates how the Noh theater dismantles clock time
and yardstick space in order to gesture at some evergreen eternal present,
where two pine trees can incarnate themselves as an old man and an old
woman, a panpsychic field at the end of all metamorphoses.

Pound tried his hand at writing original Noh plays. His most interesting
attempt was *Tristan* (1916), evidently inspired by a performance of Wagner's
Tristan und Isolde conducted by Beecham. It opens with a Prologue, in which
the audience is asked to imagine a shore and a ruined castle; a Sculptor (the
waki) enters, looking for a certain quince tree, a botanical wonder that blos-
soms in Cornwall (owing to the Gulf Stream, he thinks) before any other
quince tree. This premise is derived from an episode from the life of the
sculptor Gaudier-Brzeska: "Gaudier had been through Wales. He had made
a particular pilgrimage to a certain tree, that blooms on a set day in the year
because of the warmth of the Gulf-stream. (This might be out of a Japanese
'Noh' play, but it isn't.)"[45] In the play, the Sculptor finds an enigmatic woman
(the *shite*), who tries to shoo him away and then vanishes herself; soon he
finds himself witnessing a spectacle in which the *shite*, now dressed as Yseult
in brilliant medieval costume, performs a series of slow passes and re-passes
with a man, Tristan. Their costumes are gray on one side, so that when they
turn round they become invisible against the gray background; thus, from
the Sculptor's and the audience's point of view, they seem spectral pres-
ences, dissolving and reforming in a slow stately dance. "They flash and fade

through each other," the Sculptor says.[46] Pound's play is a theatrical presen-
tation of life inside Wagner's *Tristan* chord, a chord that demands harmonic
resolution yet remains suspended, incapable of resolving, incapable of con-
struing itself, at once creeping upward and diminishing ever further into its
own private hypospace—an endless frustration. Because the whole spec-
tacle is one image, the whole action is only the arbitrary spinning out of a
multidimensional stasis into a metamorphosis.

 Canto 4 ends with the poet sitting in an old arena because the poem is
itself a kind of theater—a composite Noh play, made up of several dissected
and reassembled fragments of shape-change stories. There is the Baucis
and Philemon story from *Takasago*—the pious old couple metamorphosed
into trees. There is Actaeon, the Peeping Tom who spied Artemis naked in
her bath and then was transformed into a stag and torn apart by Artemis's
hounds. There is the lycanthrope troubadour Peire Vidal, who outfitted him-
self with a wolfskin out of love for a woman named Loba (she-wolf). There
is Philomela, changed into a singing bird after her brother-in-law Tereus
raped her and cut out her tongue—as revenge, her sister Procne killed Tere-
us's (and her own) son Itys, cooked him, and served the hideous meal to
Tereus. There is the troubadour Cabestanh, murdered by his lord after Ca-
bestanh slept with the lord's wife Seremonda—the lord commanded Cabes-
tanh's heart to be served to her in a dish, and she leaped out a window to
her death. Pound cunningly arrests and arranges these bright shards of nar-
ratives in such a way that they seem all part of a single incurved action:
Seremonda is a second Tereus in that she eats human flesh without knowing
it, but a second Philomela in that she takes to the air, swings herself out
the window like a bird; Actaeon the stag and Vidal the wolf seem part of a
single action, a sexual urgency that either flees or attacks, depending on the
quality of desire. The Noh theater provided Pound with a model for mani-
festing the approach through time and space of some whole beyond time
and space. The pine of Takasago and the pine of Isé are, in some occult
sense, intertwined at the root, and so are Philomela and Seremonda and
Tereus and Vidal.

 Pound was never particularly concerned with Nietzsche, though Yeats
considered that Pound and Nietzsche had the identical personality type.
But I think of the ferocious Dionysus of *The Birth of Tragedy*—the world
shatterer, the enemy of all individuation, the convulsive shape changer—as
being one of the hidden heroes of Pound's whole creative project.

FUGUE In the Cantos written after Canto 4, Pound discovered that he kept alighting on a few main motives: first, a Descent into Hell (this is the theme of Canto 1, an English translation of a Latin translation of the episode in the Odyssey where Odysseus visits the underworld (quarried from the end of *Three Cantos* III), and second, a Metamorphosis (this is the theme of Canto 2, based on the Homeric Hymn in which slave traders kidnap Dionysus, not understanding that he is a god—the god enchants their boat and turns them into fish). So in the later 1920s Pound started thinking of his project as a fugue in which these two motives were prominent: a resurrection of the dead and a buckling of our normal world into a domain of divine energies. In 1927 he wrote to his father:

> Afraid the whole damn poem is rather obscure. . . . Have I ever given you outline of main scheme ::: or whatever it is?
>
> 1. Rather like, or unlike subject and response and counter subject in fugue.
>
> A. A. Live man goes down into world of Dead
>
> C. B. The "repeat in history"
>
> B. C. The "magic moment" of moment of metamorphosis, bust thru from quotidien into "divine or permanent world." Gods, etc.[47]

As for the third element, the "repeat in history," it is certainly the chief constructive principle of the Cantos: the achronological superposition of stories with common formal elements, such as married women abducted by handsome young lovers. Later in this letter Pound explicated Canto 20 and used the phrase "subject-rhyme"—a fascinating term, implying that Pound has displaced the principle of rhyme from the level of phonics to the level of theme: history itself displays a structure of echoes, a sort of stanza form. An example of the repeat in history (using the term *history* loosely) can be found in Sordello's running off with Cunizza: a thirteenth-century recapitulation of Paris's abduction of Helen of Troy. Pound enjoyed finding events thick-fringed with reverberations of previous events.

In some sense the Cantos, as Pound conceived them in 1927, are to history what a chart of landscape contours is to geography: a mapping of recurrence in time, *heard* as a subtle chiming, as if history were an endless troubadour song, a huge *canto*. The tripartite design of descent into "world of Dead" (hell), "bust thru from quotidien" (heaven), and "repeat in history" (our world—or purgatory) suggests that there is a whole divine comedy in every Canto, all mixed up together. If the whole project constitutes a fugue,

it seems that Pound wanted to hear the voices in the Cantos not as taking regular turns, but as *sounding all at once*, in an overlapping vocal polyphony. While the metamorphosis begins, the descent to the underworld continues; Pound strains his ear to grasp history ahistorically, as a chorus of voices all of which are copresent, contemporaneous.

But if Pound hoped that a fugal model of the Cantos would impart a satisfying form to the whole project, he was mistaken. As the musicologist Donald Tovey has noted, a fugue is not a form but a texture: "The first thing to realize about fugue is that it is a medium, like blank verse, not a thing, like a rondo."[48] It requires extraordinary art to make a satisfactory fugue, but the art is a local art, an art of arranging overlaps in a pleasing manner, not a global art. It is the sort of art that a poet gifted at writing lyrical miniatures, like Pound, could employ to produce one of the longest poems in the language. Pound may have been aware, however, that the hope that the Cantos would become a rounded, polished, formally satisfying whole was a forlorn hope: the year after he described the tripartite scheme to his father, he wrote, "I am not going to say: 'form' is a non-literary component shoved on to literature by Aristotle. . . . But it can do us no harm . . . to consider the number of very important chunks of world-literature in which form, major form, is remarkable mainly for its absence."[49]

IDEOGRAM By 1934 Pound had devised a new, or partly new, scheme for conceiving the Cantos: the ideogram:

> But when the Chinaman wanted to make a picture of . . . a general idea, how did he go about it?
>> He is to define red. How can he do it in a picture that isn't painted in red paint?
>> He puts . . . together the abbreviated pictures of
>> ROSE CHERRY
>> IRON RUST FLAMINGO
>> That, you see, is very much the kind of thing a biologist does . . . when he gets together a few hundred or thousand slides, and picks out what is necessary for his general statement. Something that fits the case, that applies in all of the cases.[50]

Pound had discovered this scheme for the ideogram in the notes of the sinologist Ernest Fenollosa—notes that Pound had used for his translations from Chinese and Japanese during 1914-16, and which he had edited and published as *The Chinese Written Character as a Medium for Poetry*. (It may

be worth noting that the actual Chinese character for *red* has nothing to do with rose, cherry, rust, or flamingo.) But in the 1930s Pound took new inspiration from these notes and recommended them as an *Ars Poetica* and an instruction in thinking.[51] This model of the ideal poetic act—a signifying whole extrapolated from a heap of concrete particulars—helped Pound to explain what he had done, and it also provided a dominant model for the Cantos to come. There is a moment in Canto 38 which provides an example of ideogrammic thinking at work. In a passage that ponders African and Arab languages, Pound noted,

> Bruhl found some languages full of detail
> Words that half mimic action; but
> generalization is beyond them, a white dog is
> not, let us say, a dog like a black dog.
> Do not happen, Romeo and Juliet . . .[52]

For some folks, a rose by any other name would not smell as sweet, because there is no such thing as a rose, only particular roses. Pound was starting to dream of an English like the language described here: a language with tremendous powers of evoking concrete action, but without generalization, except insofar as the reader's mind draws unmistakable inferences from minute particulars. In his "Vorticism" article of 1914, Pound spoke of certain generalizations as "'lords' over fact"—just as $(x - a)^2 + (y - b)^2 = r^2$ is not a particular circle, but the general form of all circles.[53] But in many of the Cantos, Pound pursued the ideogrammic method so remorselessly that he, essentially, asked facts to find ways of becoming lords over themselves.

He hoped that he could present rose, cherry, rust, and flamingo, and that he could then body forth the idea *red* with a devastating clarity. There are occasions in the later Cantos when he did. But there are other occasions when the reader is more likely to discover not *red* but a thorny flamingo leg terminating in a curlicue of scrap iron—a futile mishmash. The ideogrammic method—like the rag-bag method, the Noh play method, and the fugal method—did not solve all of Pound's problems. Instead, it created problems; but Pound's strength as a poet lay in his extraordinary capacity for creating problems, without necessarily solving them.

Pound's Cantos are in many ways exasperating and unsatisfactory—in his old age he himself referred to the work as a botch. But the project constitutes the closest thing to a world-poem ever written. (If we think of Joyce's *Finnegans Wake* as a poem, it might be one of the few competitors for this

title.) Pound embraces not only Chinese and Japanese culture, both themati-
cally and formally, but much of the rest of the world's too—for example, he
makes use of a native-Australian myth about the creator Wanjina who made
objects by saying their names: "whose mouth was removed by his father /
because he made too many *things*."[54] An unkind critic might wish that
Pound's mouth had been removed before he wrote quite so many words,
but there is no sequence in the Cantos that does not afford some delight.

The music alone is worth the price of admission: Pound's lines often sing
out brilliantly, or brilliantly give the experience of hearing music:

> Form, forms and renewal, gods held in the air,
> Forms seen, and then clearness,
> Bright void, without image, Napishtim, [Babylonian sage]
> Casting his gods back into the νοῦς. [*nous*, Greek for "mind"]
>
> "as the sculptor sees the form in the air . . .
> "as glass seen under water . . .
> and saw the waves taking form as crystal,
> notes as facets of air,
> and the mind there, before them, moving,
> so that notes needed not move.[55]

The music seems to freeze before the poet's eyes into visible sine waves,
vitreous, glistening, a string of swells and tapers like a necklace of translu-
cent cowrie shells. Pound was a composer—in fact, around 1921, during a
respite from his labor on the Cantos, he wrote an opera to texts by the
medieval poet François Villon. And Canto 75 is itself a musical score, a
transcription for violin of a chanson by the Renaissance composer Clément
Janequin, a concert of birdsong.

Those interested in further exploration of the Cantos might begin by
reading the first four Cantos, Cantos 14 and 15 (descriptions of hell as a bad
bank and a bad printing press), Canto 16 (a description of the purgatory of
the Great War), Canto 20 (concerning the lotus eaters, the only Canto for
which Pound left an explanation), Canto 36 (an intent and moving trans-
lation of Cavalcanti's canzone *Donna mi prega*), Canto 45 (the great chant
against usury), Canto 47 (a delicate evocation of Chinese art), and Canto 81
(the great chant against vanity); in fact, the whole Pisan sequence (Cantos
74-84), written while Pound was in a detention camp awaiting his trial for
treason, is one of the major treasures of Western literature.

James Joyce, "The Oxen of the Sun"
The Tower of Babel

Pound edited parts of Joyce's *Ulysses* for magazine publication and cen-
sored certain passages about defecation—indeed, Pound hinted to Joyce
that the difference between poetry and prose was the difference between
sex and excrement. Pound and Joyce were near opposites as personalities:
Pound was a loudmouth and an instigator, going to remarkable lengths to
propagandize Modernist works he admired, whereas Joyce was reticent,
aloof, in his later days nearly blind. But *Ulysses* is one of the few artistic
projects of the twentieth century that competes with Pound's Cantos in its
scope.

Every so often we find a work of art that attempts to incorporate into
itself the history of its own artistic medium. I think that the appearance of
such an artwork is the measure of a certain maturity of the art: by creating
such a thing, the artist is trying to tell a story about his or her relation to a
larger tradition—it's a measure of the self-awareness of the artist as taking
some part, however small, in some historical evolution. Eliot spoke of the
ways in which the artist's mind can try to identify itself with the mind of
Europe, and this has been a goal of artists for a long time—as Chaucer puts
it at the end of his *Troilus and Criseyde*:

> Go, litel book, go litel myn tragedie,
> Ther god thy maker yet, er that he dye,
> So sende might to make in som comedie!
> But litel book, no making thou nenvye,
> But subgit be to alle poesye;
> And kis the steppes, wher-as thou seest pace
> Virgile, Ovyde, Omer, Lucan, and Stace.[56]

Chaucer saw himself as following in the footsteps, indeed kissing the foot-
prints, of his illustrious predecessors, such as Virgil, Ovid, and Homer.

But this sort of homage is a little different from actually incorporating a
sense of historical progression into the text of your work. To write a work
that actually embodies a chronological span of styles is an extremely ambi-
tious thing, because it makes a sort of implicit claim that history culminates
in *you*—you aren't following in anybody's footsteps; instead, your predeces-
sors are struggling to approximate that perfection that is achieved in your
work. I'm discussing all this with "Oxen of the Sun" (the fourteenth chapter

of Joyce's *Ulysses*) in mind, but before I discuss Joyce, I'd like to mention another work that plays games similar to its game: an anonymous sixteenth-century Flemish painting of the Tower of Babel, possibly painted in response to the great Tower of Babel paintings of Peter Brueghel the Elder. It depicts not only a ramp in space but a ramp in time: near the bottom of the tower, we see medieval castles and other old-fashioned quaint things, all made of brick; but as we ascend, we start to see elements of Renaissance art, such as smooth stone niches filled with images of human figures—stone, as a building material, was Italian, modern, in a sense newfangled. We might expect that near the top of the tower we would find architecture that was, by the standards of sixteenth-century Europe, contemporary (the little town in which the tower sits is an ordinary sixteenth-century town), maybe even futuristic—but instead, the tower trails off into fog, because the Tower of Babel could never be finished:

1 And the whole earth was of one language, and of one speech.

2 And it came to pass, as they journeyed from the east, that they found a plain in the land of Shinar; and they dwelt there.

3 And they said one to another, Go to, let us make brick, and burn them thoroughly. And they had brick for stone, and slime had they for mortar.

4 And they said, Go to, let us build us a city, and a tower, whose top *may reach* unto heaven; and let us make us a name, lest we be scattered abroad upon the face of the whole earth.

5 And the LORD came down to see the city and the tower, which the children of men builded.

6 And the LORD said, Behold, the people *is* one, and they have all one language; and this they begin to do: and now nothing will be restrained from them, which they have imagined to do.

7 Go to, let us go down, and there confound their language, that they may not understand one another's speech.

8 So the LORD scattered them abroad from thence upon the face of all the earth: and they left off to build the city.

9 Therefore is the name of it called Babel; because the LORD did there confound the language of all the earth: and from thence did the LORD scatter them abroad upon the face of all the earth.[57]

The Bible doesn't say that God destroyed the Tower of Babel, but Christian tradition imagines a lightning bolt or earthquake leveling the tower as a further punishment for human presumption.

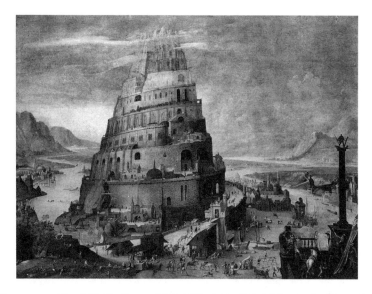

Anonymous (Flemish), *The Tower of Babel* Alfredo Dagli Orti / The Art Archive at Art Resource, NY

The whole episode in Genesis 11 resonates unmistakably with the creation story in Genesis 1-3. There Adam named all the living things in Eden ("And out of the ground the LORD God formed every beast of the field, and every fowl of the air; and brought *them* unto Adam to see what he would call them: and whatsoever Adam called every living creature, that *was* the name thereof. And Adam gave names to all cattle, and to the fowl of the air, and to every beast of the field"[58]); here God undoes all those divine names, leaves us all in the predicament of having to invent new, wrong names, names that only some of us can understand. There, during the creation story, Satan tempted Eve by saying "ye shall be as gods";[59] here men try to become gods in the most literal way imaginable, by climbing into heaven and maybe ousting Jehovah. If the spiral ramp is the track of European history from, say, the days of the Crusaders to the present, that is, the sixteenth century, it's also a ruined history, leaving off in midair. The painter may have felt, as many pious Christians have felt in all ages, that the Last Judgment was near, that time was itself about to end.

Joyce's Program for "Oxen of the Sun"

"Oxen of the Sun" is itself a Tower of Babel, a spiral ramp extending through the whole history of English literature. It is a beast with many tongues. In the single day that occupies the whole of Joyce's huge novel, stretching from 16 to 17 June 1904, it occupies the time slot from 10:00 to 11:00 p.m. Among a crowd of friends waiting in a maternity hospital for the birth of the umpteenth child of Mina Purefoy, the wife of an accountant, are the novel's two main characters, Leopold Bloom, an amiable, tolerant, cautious middle-aged man who sells advertising copy for a newspaper, identified with both the Wandering Jew and with Ulysses himself, and Stephen Dedalus, the novel's Telemachus, that is, Ulysses's son, a gifted, disillusioned, smart-ass scholar. Earlier in the day we saw these two characters going about their separate, not particularly compelling businesses: Stephen shaving, then dawdling along the beach; Bloom eating breakfast, defecating, visiting his newspaper office, drinking in a bar. Everywhere Joyce's style has reflected some aspect of the content of his fable, or the content of the Homeric parallel: for instance, in "Aeolus" (the newspaper chapter) Joyce writes as if he were composing newspaper copy, even providing the reader with headlines; in "Sirens" (the sirens are the two barmaids at the Ormond Hotel) Joyce plays so many games with onomatopoeia and verbal polyphony that the chapter is one long cantabile tintinnabulation. Now, in "Oxen of the Sun," the theme is fetal development, and the development of the English language is the stylistic premise. (After "Oxen of the Sun," the drunken Stephen finds himself at a brothel, and, after much tumult and delirium, Stephen and Bloom urinate together in Bloom's backyard—the final reconciliation of Ulysses with his long-lost son.)

In a letter to a friend, written in 1920, Joyce summarizes his method for composing this chapter:

> Am working hard at *Oxen of the Sun*, the idea being the crime committed against fecundity by sterilizing the act of coition. Scene, lying-in hospital. Technique: a nineparted episode without divisions introduced by a Sallustian-Tacitean prelude (the unfertilized ovum), then by way of earliest English alliterative and monosyllabic and Anglo-Saxon ("Before born the babe had bliss. Within the womb he won worship." "Bloom dull dreamy heard: in held hat stony staring") then by way of Mandeville ("there came forth a scholar of medicine that men clepen etc") then Malory's *Morte d'Arthur* ("but that franklin Lenehan was prompt ever to pour

them so that at the least way mirth should not lack"), then the Elizabethan chron-
icle style ("about that present time young Stephen filled all cups"), then a passage
solemn, as of Milton, Taylor, Hooker, followed by a choppy Latin-gossipy bit,
style of Burton-Browne, then a passage Bunyanesque ("the reason was that in the
way he fell in with a certain whore whose name she said is Bird in the hand") after
a diarystyle bit Pepys-Evelyn ("Bloom sitting snug with a party of wags, among
them Dixon jun., Ja. Lynch, Doc. Madden and Stephen D. for a languor he had
before and was now better, he having dreamed tonight a strange fancy and Mis-
tress Purefoy there to be delivered, poor body, two days past her time and the
midwives hard put to it, God send her quick issue") and so on through Defoe-
Swift and Steele-Addison-Sterne and Landor-Pater-Newman until it ends in a
frightful jumble of Pidgin English, nigger English, Cockney, Irish, Bowery slang
and broken doggerel. This progression is also linked back at each part subtly with
some foregoing episode of the day and, besides this, with the natural stages of
development in the embryo and the periods of faunal evolution in general. The
double-thudding Anglo-Saxon motive recurs from time to time ("Loth to move
from Horne's house") to give the sense of the hoofs of oxen. Bloom is the sper-
matozoon, the hospital the womb, the nurse the ovum, Stephen the embryo. . . .
How's that for high?[60]

There are three points that I should make about this remarkable description
of method.

1. First is that the main theme of the chapter is *fecundity versus sterility*.
 (The same could be said of *The Waste Land*—one of many connections
 between the two great works of 1922.) There are some references to
 sterile sexual activities such as masturbation (during the preceding chap-
 ter of *Ulysses*, Bloom masturbated while watching a girl on the beach),
 and lots of references to condoms: "for that foul plague Allpox and the
 monsters they cared not for them for Preservative had given them a
 stout shield of oxengut and, third, that they might take no hurt neither
 from Offspring that was that wicked devil by virtue of this same shield
 which was named Killchild."[61] This is also, late in the chapter, a curious
 passage ("Any brollies or gumboots in the fambly?"[62]) that might mean
 (as critics have pointed out) that Bannon is asking Bloom for a condom—
 Bannon intends to use it to have sex with Bloom's own daughter Milly.
 But the fecundity we find in this chapter goes far beyond sexual propaga-
 tion. The most fertile thing in the whole chapter isn't Mrs. Purefoy, but
 Joyce's own verbal imagination: the English language, under his touch,

keeps sprouting in all sorts of wild directions, displaying a great many of its possibilities for growth. Old disused tendrils and limbs and tentacles of language keep reaching out of the text, until the end, where Joyce invents a future tongue in an act of linguistic science fiction.

2. A second point about the letter to Budgen is that Joyce's review of styles is particularly rich in parodies of historical and religious texts—historians such as Tacitus and Holinshed, and gossips such as Pepys, Evelyn, Addison, and Steele, and ecclesiastical writers such as Hooker and Cardinal Newman appear prominently. History concerns the profane, and religion concerns the sacred—and the chapter is constructed around not only the theme of fecundity versus sterility but also the related theme of the *sacred versus the desecrated*. There is a great deal of horseplay and clowning in this chapter, both on the part of the drunken students and on the part of Joyce himself, but at the center there is something that seems worth celebrating and maybe venerating, the birth of a child. To some extent, the Homeric story behind the chapter is less a parallel to the action than a sort of counterplot to it: Mina Purefoy successfully gives birth, but Odysseus fails to prevent his sailors from slaughtering the Oxen of the Sun-god Helios—sacred oxen whose death will cause terrible consequences for the crew, since the angry Zeus destroys Odysseus's ship with a lightning bolt as soon as they leave the island. But in the magical world of the *Odyssey*, the boundaries between the sacred and the desecrated, between life and death, keep shifting eerily: when the evil sailors roast the Oxen of the Sun, strange things happen, as Odysseus recounts: "As soon as I got down to my ship and to the sea shore I rebuked each one of the men separately, but we could see no way out of it, for the cows were dead already. And indeed the gods began at once to show signs and wonders among us, for the hides of the cattle crawled about, and the joints upon the spits began to low like cows, and the meat, whether cooked or raw, kept on making a noise just as cows do."[63] There are certain structural parallels (as Joyce himself noted) between the "Oxen of the Sun" chapter and the "Hades" chapter, in which Bloom attends a funeral: in the midst of life there is death; in the midst of death there is life. The "Oxen of the Sun" chapter is itself a kind of roaring of dead cows—I mean a roaring of the dead authors resurrected by means of parody. The end of the chapter is especially full of roaring: the revels of the drunken students represent a kind of drowning in alcohol, and yet there's a sort of fertility in their very degradation. Joyce roasts the English language,

cuts it up into little pieces, and yet it roars. Nothing in this chapter seems so sterile or so desecrated or so dead that it can't keep starting into violent motion. Energy is everywhere.

3. The third point is that Joyce intends to represent the stages of what he calls "*faunal evolution*," that is, the animal evolution of the fetus in the womb. Darwin is never far from Joyce's mind in this chapter: at one point we hear of "that missing link of creation's chain desiderated by the late ingenious Mr Darwin"[64]; and later we hear of "the survival of the fittest."[65] There's another catchphrase from biology relevant to this chapter, "ontogeny recapitulates phylogeny"—this is the so-called law of biogenesis, invented by nineteenth-century biologist Ernst Haeckel. Haeckel was an ardent admirer of Charles Darwin (Darwin admired him, too), and he sought to remedy a defect in Darwin's theory of evolution. Darwin feared that we would never have much real information about the innumerable links by which man evolved from lower creatures, but Haeckel considered that we have a rich quarry of information about vertebrate evolution in the uterus of every pregnant woman, because ontogeny recapitulates phylogeny—that is, the fetal development of an individual animal goes through the same stages as the evolution of the whole species. There is a time when a human embryo has creases in its neck like the gills of a fish; and according to Haeckel, every one of us evolves from amoeba to fish to reptile to monkey in the course of our fetal development. In his 1868 book on embryology, Haeckel supported his argument with fake drawings of fetal anatomy: for example, he used the same drawing to represent the embryo of a chicken, a turtle, and a dog, to show that at a certain stage in development all embryos are exactly alike. His work has generally been discredited, but anyone who talks of the reptilian nature of the limbic brain is using a Haeckelian model of mankind, and some recent biologists have thought that Haeckel's ideas, with modifications, might have some merit.

The Forty Weeks of Gestation

OLD ENGLISH I think that the "Oxen of the Sun" chapter is constructed along perfectly Haeckelian lines. The mature language that Joyce writes contains within itself the whole history of English, and he uses the pretext of a baby's birth to tease out from his own immensely subtle, potent, and sophisticated language the earlier prose forms that evolved into it, often naïve or clunky. But it may be that the naïve or clunky has a power in it beyond

the power of highly evolved literary modes: Friedrich Schiller, in his famous old essay on naïve and sentimental poetry, paid homage to the nakedly creative, world-constructive power of such naïve poets as Homer, as opposed to the artificial and derivative aspects of recent "sentimental" authors. Joyce isn't simply mocking old writers; he's borrowing energy from them.

At the beginning we see the English language starting to take shape, as Joyce writes in a parody of Old English four-stress alliterative verse: "Before born babe bliss had. Within womb won he worship. Whatever in that one case done commodiously done was."[66] We have not completely abandoned Latinate vocabulary, as the adverb "commodiously" shows. But Latin is a highly hypotactic language (that is, full of subordinate clauses); here, however, the style is, in the Germanic/Old English way, paratactic (that is, there is abutment of phrases without subordination). In its way it's still hard to read, since the words abut against one another so abruptly, and the verbs are in odd positions, and it all feels clipped, elliptical, choppy. Little bones seem to be developing in the English language, even in the first days of its existence. There's a striking sense of forward motion—as Joyce says, hoofbeats.

MANDEVILLE When we come to the week-nine paragraph, we enter the world of exciting fantasies of remote geography, Sir John Mandeville's *Travels* (ca. 1366):

> And whiles they spake the door of the castle was opened and there nighed them a mickle noise as of many that sat there at meat. And there came against the place as they stood a young learning knight yclept Dixon. And the traveller Leopold was couth to him sithen it had happed that they had had ado each with other in the house of misericord where this learning knight lay by cause the traveller Leopold came there to be healed for he was sore wounded in his breast by a spear wherewith a horrible and dreadful dragon was smitten him for which he did do make a salve of volatile salt and chrism as much as he might suffice. . . . And the traveller Leopold went into the castle for to rest him for a space being sore of limb after many marches environing in divers lands and sometimes venery.
>
> And in the castle was set a board that was of the birchwood of Finlandy and it was upheld by four dwarfmen of that country but they durst not move for enchantment. And on this board were frightful swords and knives that are made in a great cavern by swinking demons out of white flames that they fix in the horns of buffalos and stags that there abound marvellously. And there were vessels that are wrought by magic of Mahound out of seasand and the air by a warlock with

his breath that he blares into them like to bubbles. And full fair cheer and rich
was on the board that no wight could devise a fuller ne richer. And there was a
vat of silver that was moved by craft to open in the which lay strange fishes with-
outen heads though misbelieving men nie that this be possible thing without
they see it natheless they are so. And these fishes lie in an oily water brought
there from Portugal land because of the fatness that therein is like to the juices
of the olive press.[67]

Mandeville was (or pretended to be) a traveler in space; but Joyce's version
of Mandeville is a traveler in time. An ordinary day in Dublin in 1904 is, from
the point of view of a man writing in 1366, pure science fiction: a drinking
glass must have been created by heathen magic, hand blown from molten
sand; a tin of sardines is an inconceivable wonder. One of Joyce's purposes
in writing *Ulysses* was a purpose common in twentieth-century art, defamil-
iarization: the desire to restore the sense of the miraculous in commonplace
life. Joyce makes strange the sardine tin by describing it from the point of
view of a man who can understand it only as a miracle.

The episode in which traveler Leopold "came there to be healed for he
was sore wounded in his breast by a spear wherewith a horrible and dreadful
dragon was smitten him" refers to a day a few weeks earlier, when the medi-
cal student Dixon tended to Bloom after he was stung by a bee. That is, the
"Oxen of the Sun" chapter is deliberately falsifying the account of Bloom's
injury given in the "Hades" chapter: "Nice young student that was dressed
that bite the bee gave me. He's gone over to the lying-in hospital they told
me."[68] The "Oxen of the Sun" chapter contains all manner of exaggerations,
evasions, deflections, riddles, dark speech, outright lies. I think that these
false or devious forms of representation might be connected to Haeckel's
embryology: we must pass through fish, reptile, and other grotesque forms
before we attain full humanity. We are, so to speak, at the sardine or dragon
stage of the embryo's development, here in the Mandeville section.

Mandeville himself is a specialist in monsters: in chapter 22 of his *Travels*
he speaks of an island where "dwell folk of foul stature and of cursed kind
that have no heads. And their eyen be in their shoulders"—Shakespeare's
Othello would later meet these odd men in the course of *his* travels. "And in
another isle be folk of foul fashion and shape that have the lip above the
mouth so great, that when they sleep in the sun they cover all the face with
that lip"—Mandeville is especially interested in distortions of the mouth, it
seems. In chapter 6, he visits Babylon:

And understandeth, that that Babylon that I have spoken of, where that the sultan dwelleth, is not that great Babylon where the diversity of languages was first made for vengeance by the miracle of God, when the great Tower of Babel was begun to be made; of the which the walls were sixty-four furlongs of height; that is in the great desert of Arabia, upon the way as men go toward the kingdom of Chaldea. But it is full long since that any man durst nigh to the tower; for it is all desert and full of dragons and great serpents, and full of diverse venomous beasts all about. That tower, with the city, was of twenty-five mile in circuit of the walls, as they of the country say, and as men may deem by estimation, after that men tell of the country.[69]

The Tower of Babel is a taboo, dragon-infested area, off-limits even to Mandeville, who visits China and India and Ethiopia without any qualms. The atrociously deformed men whom Mandeville encounters, the mongrels of beasts and human beings—"folk that have horses' feet . . . folk that be both man and woman"[70]—can be understood as babblings, for Mandeville speaks a fallen, deformed language, a language full of lies, a post-Babel tongue. Joyce, it seems, must both relish and exorcise these uses and abuses of language in order to become the novelist he wants to be. The "Oxen of the Sun" chapter is full of monsters—babblings of the genetic code—as the students in the waiting room ponder all that can go wrong with pregnancy: "miscarriages and infanticides, simulated and dissimulated, acardiac *foetus in foetu* and aprosopia due to a congestion, the agnatia of certain chinless Chinamen (cited by Mr Candidate Mulligan) in consequence of defective reunion of the maxillary knobs along the medial line so that (as he said) one ear could hear what the other spoke . . . the recorded instances of multigeminal, twikindled and monstrous births conceived during the catamenic period or of consanguineous parents."[71] As baby Purefoy gropes toward shape, Joyce rehearses all the possibilities for misshapenness, both in human development and in the development of language.

SWIFT AND ALLEGORY Another kind of dark speech is allegory, and in a later section of "Oxen of the Sun" (week 24) we see the figure of the ox getting displaced from Homer to an extended conceit for the Roman Catholic Church:

An Irish bull in an English chinashop. I conceive you, says Mr Dixon. It is that same bull that was sent to our island by farmer Nicholas, the bravest cattle breeder of them all, with an emerald ring in his nose. True for you, says Mr Vincent cross the table, and a bullseye into the bargain, says he, and a plumper and a portlier

bull, says he, never shit on shamrock. He had horns galore, a coat of gold and a sweet smoky breath coming out of his nostrils so that the women of our island, leaving doughballs and rollingpins, followed after him hanging his bulliness in daisychains. What for that, says Mr Dixon, but before he came over farmer Nicholas that was a eunuch had him properly gelded by a college of doctors, who were no better off than himself. So be off now, says he, and do all my cousin german the Lord Harry tells you and take a farmer's blessing, and with that he slapped his posteriors very soundly. But the slap and the blessing stood him friend, says Mr Vincent, for to make up he taught him a trick worth two of the other so that maid, wife, abbess and widow to this day affirm that they would rather any time of the month whisper in his ear in the dark of a cowhouse or get a lick on the nape from his long holy tongue then lie with the finest strapping young ravisher in the four fields of all Ireland. Another then put in his word: And they dressed him, says he, in a point shift and petticoat with a tippet and girdle and ruffles on his wrists and clipped his forelock and rubbed him all over with spermaceti oil and built stables for him at every turn of the road with a gold manger in each full of the best hay in the market so that he could doss and dung to his heart's content. By this time the father of the faithful (for so they called him) was grown so heavy that he could scarce walk to pasture. To remedy which our cozening dames and damsels brought him his fodder in their apronlaps and as soon as his belly was full he would rear up on his hind quarters to show their ladyships a mystery and roar and bellow out of him in bull's language and they all after him.[72]

Joyce is remembering that an Irish bull is a name for an especially pointless sort of anecdote, and that papal edicts are known as bulls. In fact, Farmer Nicholas is Nicholas Breakspear, Pope Adrian IV, the only British pope, who granted sovereignty over Ireland to King Henry II of England in AD 1155 (but the Lord Harry of this paragraph refers to several different King Henrys of England). The author whom Joyce is imitating here is Swift, who published in 1704 a book called A Tale of a Tub, a satire against organized religion. The passage that Joyce is remembering concerns Lord Peter, who represents the evils of Roman Catholicism—the Roman Catholic Church traces its mission from the apostle Peter, called the first pope:

> But of all Peter's rarities, he most valued a certain set of bulls, whose race was by great fortune preserved in a lineal descent from those that guarded the golden-fleece [that is, the golden fleece that Jason sought with his Argonauts]. Though some who pretended to observe them curiously doubted the breed had not been kept entirely chaste, because they had degenerated from their ancestors in some

qualities, and had acquired others very extraordinary, but a foreign mixture. The bulls of Colchis are recorded to have brazen feet; but . . . Lord Peter's bulls were extremely vitiated by the rust of time in the metal of their feet, which was now sunk into common lead. However, the terrible roaring peculiar to their lineage was preserved, as likewise that faculty of breathing out fire from their nostrils; which notwithstanding many of their detractors took to be a feat of art, and to be nothing so terrible as it appeared, proceeding only from their usual course of diet, which was of squibs and crackers. . . . Peter put these bulls upon several employs. Sometimes he would set them a roaring to fright naughty boys and make them quiet. Sometimes he would send them out upon errands of great importance, where it is wonderful to recount, and perhaps the cautious reader may think much to believe it; an *appetitus sensibilis* deriving itself through the whole family from their noble ancestors, guardians of the Golden Fleece, they continued so extremely fond of gold, that if Peter sent them abroad, though it were only upon a compliment, they would roar, and spit, and belch, and snivel out fire, and keep a perpetual coil till you flung them a bit of gold; but then *pulveris exigui jactu* ["these passions of their souls, these conflicts so fierce, will cease, and be repressed by the casting of a little dust"—Virgil, *Georgics* 4], they would grow calm and quiet as lambs. In short, whether by secret connivance or encouragement from their master, or out of their own liquorish affection to gold, or both, it is certain they were no better than a sort of sturdy, swaggering beggars; and where they could not prevail to get an alms, would make women miscarry and children fall into fits; who to this very day usually call sprites and hobgoblins by the name of bull-beggars. They grew at last so very troublesome to the neighbourhood, that some gentlemen of the North-West got a parcel of right English bull-dogs, and baited them so terribly, that they felt it ever after.[73]

Swift's allegory is morally serious, as allegories usually are, but also satirical; and so is Joyce's—grotesque, burlesque, deliberately overextended, an exercise in swollen language to match the ridiculousness of the thing being parodied. Here, in the parable of gelded bull lovingly caressed by the whole female populace of Ireland, Joyce's indictment of sterility reaches its climax: the celibate priesthood can father no children. The half-formed fetus now seems in danger of a kind of miscarriage.

DE QUINCEY In some sense every retrograde element of style is read as deviant against some imagined norm from elsewhere in the novel—though even before the "Oxen of the Sun" chapter begins, Joyce has used so many

different styles that it's hard to specify just what the *Ulysses* style might be said to be. And because the theme of the chapter is sterility versus fecundity, we tend to read the deviant styles as either sterile (plain, sober, oversimple) or hypertrophied, too fertile (as when some stylistic tic, such as prolific metaphors, becomes an obvious mannerism).

The moment of maximum stylistic inflation occurs in the paragraphs representing weeks 35 and 36—as we enter the ninth month of pregnancy, the English language seems to be getting uncomfortably swollen, incoherently grand:

> The voices blend and fuse in clouded silence: silence that is the infinite of space: and swiftly, silently the soul is wafted over regions of cycles of generations that have lived. A region where grey twilight ever descends, never falls on wide sage-green pasturefields, shedding her dusk, scattering a perennial dew of stars. She follows her mother with ungainly steps, a mare leading her fillyfoal. Twilight phantoms are they, yet moulded in prophetic grace of structure, slim shapely haunches, a supple tendonous neck, the meek apprehensive skull. They fade, sad phantoms: all is gone. . . . And on the highway of the clouds they come, muttering thunder of rebellion, the ghosts of beasts. Huuh! Hark! Huuh! Parallax stalks behind and goads them, the lancinating lightnings of whose brow are scorpions. Elk and yak, the bulls of Bashan and of Babylon, mammoth and mastodon, they come trooping to the sunken sea, *Lacus Mortis.* Ominous, revengeful zodiacal host! They moan, passing upon the clouds, horned and capricorned, the trumpeted with the tusked, the lionmaned, the giantantlered, snouter and crawler, rodent, ruminant and pachyderm, all their moving moaning multitude, murderers of the sun.
>
> Onward to the dead sea they tramp to drink, unslaked and with horrible gulpings, the salt somnolent inexhaustible flood. And the equine portent grows again, magnified in the deserted heavens, nay to heaven's own magnitude, till it looms, vast, over the house of Virgo. And lo, wonder of metempsychosis, it is she, the everlasting bride, harbinger of the daystar, the bride, ever virgin. It is she, Martha, thou lost one, Millicent, the young, the dear, the radiant. How serene does she now arise, a queen among the Pleiades, in the penultimate antelucan hour, shod in sandals of bright gold, coifed with a veil of what do you call it gossamer. It floats, it flows about her starborn flesh and loose it streams, emerald, sapphire, mauve and heliotrope, sustained on currents of cold interstellar wind, winding, coiling, simply swirling, writhing in the skies a mysterious writing till, after a myriad metamorphoses of symbol, it blazes, Alpha, a ruby and triangled sign upon the forehead of Taurus.[74]

The author whom Joyce is here imitating is the Romantic essayist Thomas De Quincey, whose most famous work is *Confessions of an English Opium-Eater* (1821)—Joyce seems to have abandoned the notion of writing a novel, seems to be lost in dreams, as if the English language itself has taken a dose of opium and is simply unfurling highfalutin words in a wonderful profusion. The prose has lost its referential characters and billowed off into the clouds, like a helium balloon that has severed any connection with the earth. But it is possible to find a few relations between this passage and the novel as we know it.

For one thing, the Homeric Oxen of the Sun, so often submerged in the text, approached only obliquely and allusively, here seem to stagger into the foreground, ghostly as they are—the Homeric parallels are, in a sense, the text's dreams, and in this dreamy section they can manifest themselves. Also, the ontogeny-recapitulates-phylogeny theme is suddenly overt, for we're presented with the whole chain of mammalian evolution, from rodent to elephant.

For another thing, the symbolic Alpha, "a ruby and triangle sign," will shortly be interpreted as an image on the label of a beer bottle, at which Bloom is staring: "During the past four minutes or thereabouts he had been staring hard at a certain amount of number one Bass bottled by Messrs Bass and Co at Burton-on-Trent which happened to be situated amongst a lot of others right opposite to where he was and which was certainly calculated to attract anyone's remark on account of its scarlet appearance."[75] So Bloom, gazing at the beer bottle, is lost in cloudy reverie; eventually his thoughts turn to women, to his secret pen pal Martha and to his daughter Milly, who float through the sky of his thoughts as symbols of unearthly glory. Style has drifted so far away from substance that the story seems in danger of vanishing into the Romantic sublime; but Joyce will bring us thump back to earth by providing the occasional coarse detail, such as the beer bottle, or the little stammer of "what do you call it gossamer," in which Bloom is feeling his way along a train of thought recorded in the previous chapter, "Nausicaa," in which he was thinking of how delicate things cling to his wife's body: "It's like a fine veil or web they have all over the skin, fine like what do you call it gossamer."[76] The odd name Parallax for the demon or god that goads the cloud-beasts is also a kind of joke, in that the whole chapter is an exercise in parallax—I mean, in the perceptual errors that arise from shifts in point of view.

DICKENS What brings us most firmly back to solid ground is the birth of the baby. If the sterility theme reaches its climax in week 24, the Defoe-

Swift paragraph, the fertility theme reaches its climax, naturally enough, when baby Purefoy is born, in the paragraph just after paragraph-week 40:

> Meanwhile the skill and patience of the physician had brought about a happy accouchement. It had been a weary weary while both for patient and doctor. All that surgical skill could do was done and the brave woman had manfully helped. She had. She had fought the good fight and now she was very very happy. Those who have passed on, who have gone before, are happy too as they gaze down and smile upon the touching scene. Reverently look at her as she reclines there with the motherlight in her eyes, that longing hunger for baby fingers (a pretty sight it is to see), in the first bloom of her new motherhood, breathing a silent prayer of thanksgiving to One above, the Universal Husband. And as her loving eyes behold her babe she wishes only one blessing more, to have her dear Doady there with her to share her joy, to lay in his arms that mite of God's clay, the fruit of their lawful embraces. He is older now (you and I may whisper it) and a trifle stooped in the shoulders yet in the whirligig of years a grave dignity has come to the conscientious second accountant of the Ulster bank, College Green branch. O Doady, loved one of old, faithful lifemate now, it may never be again, that faroff time of the roses! With the old shake of her pretty head she recalls those days. God, how beautiful now across the mist of years! But their children are grouped in her imagination about the bedside, hers and his, Charley, Mary Alice, Frederick Albert (if he had lived), Mamy, Budgy (Victoria Frances), Tom, Violet Constance Louisa, darling little Bobsy (called after our famous hero of the South African war, lord Bobs of Waterford and Candahar) and now this last pledge of their union, a Purefoy if ever there was one, with the true Purefoy nose. Young hopeful will be christened Mortimer Edward after the influential third cousin of Mr Purefoy in the Treasury Remembrancer's office, Dublin Castle. And so time wags on: but father Cronion has dealt lightly here. No, let no sigh break from that bosom, dear gentle Mina. And Doady, knock the ashes from your pipe, the seasoned briar you still fancy when the curfew rings for you (may it be the distant day!) and dout the light whereby you read in the Sacred Book for the oil too has run low and so with a tranquil heart to bed, to rest. He knows and will call in His own good time. You too have fought the good fight and played loyally your man's part. Sir, to you my hand. Well done, thou good and faithful servant![77]

This is modeled on the fiction of Charles Dickens—it's bluff, good-hearted, in-your-face novel writing, in which the author exclaims directly at the reader ("Reverently look at her as she reclines") and talks to his own characters as if they were real acquaintances ("Doady, knock the ashes from

your pipe"). He's an intrusive, fussy, commanding sort of narrator, who uses a lot of verbs in the imperative mood. He's also pious and sentimental, as he imagines dead ancestors gazing down at the new addition to the Pure-foy clan.

FUTURE ENGLISH At the end of the "Oxen of the Sun" chapter, it seems that the curse of Babel is realized before our eyes, because the English language dissolves into a squirmy squash of subdialects, slangy substandard stuff: "Golly, whatten tunket's yon guy in the mackintosh? Dusty Rhodes. Peep at his wearables. By mighty! What's he got? Jubilee mutton. Bovril, by James."[78] Dusty Rhodes was a comic strip character; "jubilee mutton" is slang for a small portion of meat (Queen Victoria's jubilee gift of 1901 proved stingy); Bovril is a brand of beef bouillon concentrate. We are in an enigmatic world of random snippets of speech, advertising displays, pop culture, Cockney rhyming slang, black American idioms, and other abrasive stubbles of language, word-grit. It is Baudelaire's dream of city modernity, except that there's no attempt to squeeze out any precious essence: the detritus itself seems to have a certain preciousness. Sometimes a sort of communication seems to be achieved, as when Bannon or somebody begs a condom from Bloom; often the revelers seem to be blathering without bothering to see if anyone is listening. They may be too drunk to care. It may be that if English is headed in this direction, our language is doomed; or it may be that this sheer degradation, this yucky placenta of expelled speech, is itself fertile—maybe a viable future language will get itself born out of this seething mass.

Finnegans Wake

Joyce tried hard to ensure that *Ulysses* would be published on 2 February 1922, his fortieth birthday. For the rest of his life he worked on a project eventually known as *Finnegans Wake*, designed to be to the mind of night what *Ulysses* was to the mind of day: that is, not the stream of waking consciousness, but the stream of the unconscious, the dreams of dreaming language.

The end of "Oxen of the Sun" is as close as Joyce comes in *Ulysses* to the rifted, vagrant, elusive, endlessly punning texture of *Finnegans Wake*. In *Finnegans Wake* we are at the heart of Babel, for Joyce synthesizes a language out of every European language from Gaelic to Albanian, and some languages well outside the Indo-European orbit, as if he were trying to

gather up the scattered limbs of language and jolt them back into life. On
the first page Joyce represents a thunderclap by means of a single great
thunder-word:

bababadalgharaghtakamminarronnkonnbronntonnerronntuonnthunn
 trovarrhounawnskawntoohoohoordenenthurnuk

This word is put together out of primary vocables, ba ba da, like infant's
babbling, or like the word *Babel* itself, and also out of words meaning "thun-
der" in lots of different languages, including Japanese (*kaminari*), Hindu
(*karak*), Greek (*brontaō*), French (*tonnerre*), Italian (*tuono*), Swedish (*åska*),
Irish (*tórnach*), Portuguese (*trovão*), Old Romanian (*tun*), and Danish (*tor-
denen*). On one hand, this is pure nonsense; on the other hand, it is so hyper-
meaningful that you should be able to understand it as thunder no matter
what your native language is—and if you can't exactly understand it, you
should be able to hear it as a thundering, a huge crash of sound.

Parts of *Finnegans Wake* came out under the title *Work in Progress* as
Joyce worked slowly through the 1920s and then the 1930s, isolated, nearly
blind, lost in the reverberations of words in his brain. The young Samuel
Beckett contributed an essay to a 1928 collection of essays called *Our Exag-
mination Round His Factification for Incamination of Work in Progress.* This
essay, "Dante...Bruno.Vico..Joyce," makes remarkable claims for Joyce's new
work. Beckett goes so far as to say that Joyce has attained a magical seizure
of reality:

> Here form *is* content, content *is* form. You complain that this stuff is not written
> in English. It is not written at all. It is not to be read—or rather it is not only to be
> read. It is to be looked at and listened to. His writing is not *about* something; *it
> is that something itself*. . . . When the sense is dancing, the words dance. Take this
> passage at the end of Shaun's pastoral: "To stir up love's young fizz I tilt with this
> bridle's cup champagne, dimming douce from her peepair of hide-seeks tight
> squeezed on my snowybreasted and while my pearlies in their sparkling wisdom
> are nippling her bubblets I swear (and let you swear) by the bumper round of my
> poor old snaggletooth's solidbowel I ne'er will prove I'm untrue to (theare!) you
> liking so long as my hole looks. Down." The language is drunk. The very words
> are tilted and effervescent.[79]

Socrates, in the *Cratylus*, speculated on whether a word could actually be
identical to a physical object—could represent an extension of the physical
object onto a different plane of being. Beckett is almost answering, Yes—

and Joyce managed to do this, managed to promote a collection of words into a status equal in ontological dignity to the thing it represented—or, not represented, but incarnated.

Finnegans Wake can seem a quite abstract and cerebral sort of prose, but Beckett claims that, far from being abstract, *Finnegans Wake* is concrete, carnal, the speech of the deep body. In the passage that Beckett quotes, we see a sort of lamination or superimposition of two distinct planes of meaning, one concerning the nuzzling of lovers and the other concerning drunkenness: *nippling* contains *nipping* and *nipple*; *bubblets* contains *bubbles* (from the champagne) and *bubby* (a dialect word for a woman's breast, preserved in our modern *boob*); and from the little thicket of hair teased out in *peepair of hide-seeks* there peeks a bottle of Piper-Heidsieck, a brand of champagne.

As Beckett explains, Joyce based the overall structure of his book on Vico's cyclical theory of history, how it begins in barbarism and goes through feudalism and democracy, only to end in anarchy once again. Beckett sees the language of *Finnegans Wake* as desophisticated, vitally metaphorical, full of primitive power. And it's true that Joyce's continual play with roots restores certain energies lost in modern English: *in twosome twiminds* does indeed emphasize the concept of *two* so obvious in the German word *Zweifel* (the German word for "two" is *zwei*) and so absent (except in an etymological dictionary) in the English word *doubt*. The language of *Finnegans Wake* is a dream of cleansed English, ostentatious in its root potencies, unthinkably open to influences from every other language under the sun.

Beckett notes that Joyce's purgatory is circular and therefore interminable. Dante's purgatory, by contrast, is a spiral, like the Tower of Babel itself, in many representations. Dante regarded the building of the tower as a sort of second fall of man, a catastrophe, and he placed Nimrod, its builder, near the very bottom of hell, a giant buried to his navel in the ground:

> His face appeared to me as long and large
> > As is at Rome the pine-cone of Saint Peter's,
> And in proportion were the other bones;
> > So that the margin, which an apron was
> > > Down from the middle, showed so much of him
> Above it, that to reach up to his hair
> > Three Frieslanders in vain had vaunted them;
> > > For I beheld thirty great palms of him

Down from the place where man his mantle buckles.
　　"Raphael mai amech izabi almi,"
　　　　Began to clamour the ferocious mouth,
To which were not befitting sweeter psalms.
　　And unto him my Guide: "Soul idiotic,
　　　　Keep to thy horn, and vent thyself with that,
When wrath or other passion touches thee.
　　Search round thy neck, and thou wilt find the belt
　　　　Which keeps it fastened, O bewildered soul,
And see it, where it bars thy mighty breast."
　　Then said to me: "He doth himself accuse;
　　　　This one is Nimrod, by whose evil thought
One language in the world is not still used.
　　Here let us leave him and not speak in vain;
　　　　For even such to him is every language
As his to others, which to none is known."[80]

Having caused human language to be confounded, Nimrod himself can utter only gibberish. There are parts of *Finnegans Wake* not much more intelligible than Nimrod's "Raphael mai amech izabi almi"—and maybe the attempt to reform the English language as a still suppler, more flagrantly intense medium of expression is doomed to yield only gibberish. But things that are drifting into interesting meanings often begin as something like gibberish:

Ra Ra-ah-ah-ah
Roma Roma-ma
GaGa
Oh la-la
Want your bad romance

I want your ugly
I want your disease
I want your everything
As long as it's free

I don't know that Lady Gaga's refrain will become part of the English language, but I think that the word *gaga* has already shifted its meaning a bit under her influence, and something of that shift may get retained. The English language is at every moment peering into its future, whenever we open

288 Isms

our mouths, and Modernist literature may help sensitize us to the not-yet-born language that our descendents may speak.

Alban Berg

The closest thing to *Ulysses* in the world of Modernist music is an opera by Alban Berg, a pupil of Schoenberg's: *Lulu*, left unfinished at Berg's death in 1935. Based on two turn-of-the-century plays by Frank Wedekind, notorious in Germany for explorations of taboo sexual themes, the opera concerns a femme fatale of obscure origin who goes by many names, including Lulu and Eva—and she is indeed a kind of Eve, the world's original sexual being. She is a girl born into poverty who used her body to rise into high society, first the wife of an elderly professor of medicine (who dies of a heart attack on discovering her affair with a painter); then the wife of the painter (who commits suicide after Dr. Schön, a newspaper magnate, tells the painter the details of her sordid life, including her affair with Schön himself, possibly begun when she was twelve); then the wife of Dr. Schön (whom she murders after he gives her a pistol and urges her to commit suicide); and at last the consort of Dr. Schön's son Alwa, with whom she lives in squalor in London—in the opera's final scene she works as a prostitute, picking up customers who abuse her or reject her, including, finally, Jack the Ripper, who stabs her to death.

The settings comprise a large tranche of modern society, from a painter's studio to a theater to a mansion to a tenement, and the huge cast of characters includes (in addition to the unhappy husbands mentioned above) a lesbian countess, an African prince, a schoolboy, an acrobat, all of whom are helpless before Lulu's convulsive erotic pull. The opera is a sort of magazine of contemporary life: we even watch, in the third act, the Great Depression in action, as stock shares become worthless and panic reigns among the rich. On the other hand, Lulu is not at all bound by time, but an Eternal Woman, a universal object of desire: in the Prologue a carnival barker displays some of the acts in his circus, and finally his Star Turn, Lulu, whom he describes as a snake—for she is Eve and the serpent in one. She exults in her sexual power: as Alwa declares his mad love for her, rapt before the slink of her body, she remarks, as if absently, "Isn't this the sofa on which your father bled to death?" Elsewhere, she wishes she could be a man, to experience the pleasure that she could give. She seems such a pure incarnation of the venereal that she might say, like another great fin de siècle femme fatale,

Sara in Villiers de l'Isle-Adam's play *Axël*, "I think I remember having made the angels fall."

Berg's music, like the text, is also about omniform desire. During her marriage to Dr. Schön, Lulu works as a dancer, and Berg provides seductive 1920s-pop-style dance tunes; when Alwa Schön declares his love, Berg has him sing a hymn to her, one of the most ravishing melodies in the whole operatic repertory; after her fall from grace (a high-class pimp blackmails her and destroys her when he discovers that she is the escaped murderer of Dr. Schön), Berg provides music fit for gutter lust—the interlude after the first scene of the third act is a set of variations on a prostitute's song. The "Circe" chapter of *Ulysses* takes place in a brothel, but *Lulu*, far more than *Ulysses*, constitutes an encyclopedia of erotic sensation, from sadomasochism to ultrarefined courtship.

There is another way in which *Lulu* is more totalizing than *Ulysses*: *Lulu* is meta-opera, so its artistic universe comprises (among many other things) itself. Alwa Schön is a composer, and we see him in the act of composing an opera about Lulu that seems to be identical to Berg's own *Lulu*. During the scene on the fatal sofa, Alwa keeps comparing Lulu's body parts to passages in his as-yet-unwritten opera: her ankles are a *grazioso*, her calves a *cantabile*, her knees a *misterioso*. Alwa's—and Berg's—opera becomes a kind of dilation upon a woman's flesh. In *Ulysses*, Stephen Dedalus is a gifted writer whose childhood is more or less identical to Joyce's; and yet, when we see him on 16 June 1904, he seems far too curdled and throttled a person to write a novel of the scope, detachment, and empathic virtuosity of Joyce's own.

The most impressive connection between *Lulu* and *Ulysses* lies in the relation of the "Oxen of the Sun" chapter to the opera's structural plan. Just as Joyce retraces the history of English literature from Old English alliterative verse through allegory and dream-vision and sentimental novel and so forth, Berg made old forms of instrumental music the hidden template of certain parts of his very up-to-date opera: buried beneath the operatic expostulations the music obeys the old conventions—in the first act a sonata, in the second a rondo, in the third a chorale theme with variations. I'll take as an example the sonata scene. The instrumental form known as the sonata, or sonata-allegro, consists of three parts: (1) the exposition, which presents two musical themes, the first in the tonic key, the second (typically) in the dominant key, a fifth up from the tonic; (2) the development, in which

one theme or both undergo a kind of imaginative disassembly, become taste-
fully jiggled apart or otherwise worked about; and (3) the recapitulation,
which presents the two themes more or less as they appeared in the exposi-
tion, but this time both are in the tonic key.

The sonata form, then, is an icon of conflict: at first the two themes
stand apart from each other, in two different music spaces (the tonic and the
dominant); but after entering the greenworld of the development, after en-
during various trials and confusions, they emerge reconciled, in the same
music space. In *Lulu*, Berg embodies the conflict between Dr. Schön and
Lulu as a sonata: during the exposition (act 1, scene 2), Dr. Schön tells Lulu
that he wishes to break off their affair so he can marry an honest woman—
the first theme is a *Leitmotiv* of Dr. Schön's; the second, an old-fashioned
dance called a gavotte, is associated (as Douglas Jarman has pointed out in
his handbook *Lulu*[81]) with Dr. Schön's old-fashioned desire for a respectable
love match. During the development and recapitulation (act 1, scene 3, back-
stage in Lulu's dressing room), Dr. Schön insists more urgently that their
affair must end—but when Lulu taunts him about a prince who intends to
take her away to Africa, Dr. Schön collapses, realizes that he can't live with-
out Lulu; then Lulu dictates to him a letter in which Dr. Schön announces
to his fiancée that their engagement is over ("Now comes my execution," he
announces melodramatically, as the act ends). The conflict resolves, and the
sonata, a pure abstract of conflict resolution, reinforces the textual theme.
In this way Berg makes his opera a conspectus of many old musical forms,
as if the opera aspired to be Music itself in all its endless varieties—just as
Ulysses aspired to be not just *a* novel but *the* novel.

Communism, Fascism,
and Later Modernism

After the Great Depression of 1929, the character of Modernism changed. In its great flowering in the 1910s and 1920s, Modernism had often exulted in technical investigations of artistic processes—in seeing how far toward the extremities of the aesthetic phenomenon that art could go. These experiments didn't stop, but in an anxious, more or less bankrupt world they became somewhat marginalized: the great thrust in the new art of 1930s was political. (The earlier avant-garde was political, too, but usually the political aspect was not understood as opposed to the aesthetic-experimental aspect.) The teeming of new artistic isms decreased dramatically: we still remember Abstract Expressionism from the 1950s, but for the most part Communism and Fascism were sufficient isms to occupy artists' attention. Communism and Fascism are, like all terms supercharged with emotional value, hard to define, but for artistic purposes we might attempt these definitions:

1. Fascism (a fasces is a bundle of sticks tied together, a Roman emblem for the superior strength of the group to the individual) appeals to the essentialist notion that virtue is inborn and tribal: my tribe (race, nation) is better than your tribe because we have inherited strength, courage, eloquence, craft from our ancestors. Our folk melodies, the old decorative motives of our weaving, the tales of our heroes, possess a beauty, conviction, and emotive force beyond those of any other tribe. A prime example of Fascist artistic thought can be found in Richard Wagner's belief that the music of Felix Mendelssohn (a Christian of Jewish ancestry) was worthless because music is founded on speech, and no Jew, not even a superlatively educated Jew like Mendelssohn, could really speak proper German; German art is a function of German blood.

2. Communism is the internationalist belief that whatever segregates peo-
ple into separate tribes or classes is inherently evil and probably the re-
sult of a conspiracy to oppress certain groups. Leo Tolstoy is a prime
example of artistic Communism: he even went so far as to argue that
harmony in music is pernicious because it assigned a distinct national or
tribal style to music, and only unaccompanied melody is truly universal,
prized by all human beings. A striking feature of the art of Communist
states, such as the Soviet Union, is its emphasis on the glory of labor,
following from Karl Marx's belief that the alienation of the worker from
the worked-on commodity was the source of much of the wretchedness
of Capitalism. Indeed, the Communists hoped to make labor itself into
a kind of art: in 1920 there was a concern of factory whistles in the
early Soviet Union, and even Russian ballets tried to incorporate factory
labor—Alexander Mosolov's *Iron Foundry* (1926-28) and Sergei Proko-
fiev's *Pas d'Acier* (1927) showed dancers operating gigantic machines as
they danced.

Perhaps the artists of the Left best equipped to confront the sober des-
titution of the age were the playwright Bertolt Brecht and the composer
Kurt Weill—partly because Germany had already spent the 1920s in a state
of poverty, the result (to some degree) of the burden of reparations after the
Great War. Weill was well trained in the atonal arts of musical Modernism
and had to unlearn much in order to write the popular tunes found in *The
Threepenny Opera* (1928), one of the greatest hits of the age. Brecht, on the
other hand, had spent part of his youth as an impoverished itinerant per-
former and was sensitive to the possibilities of an intelligent and beautifully
wrought lowbrow (or all-brow) theater, a theater that could transform
society.

In an early play, *Mann ist Mann* (1926), Brecht described how individuals
mean little in themselves, indeed *are* little in themselves: we are shapeless
things, and we take whatever shape that our ecological niche forces on us.
The play concerns a harmless stupid fellow, Galy Gay, who finds himself in
the company of three scheming soldiers who need to make him occupy the
role of their missing comrade, Jeraiah Jip:

POLLY. What will he say if we transform him into the soldier Jeraiah Jip?
URIA. So someone is transformed into an essentially different person. If you fling
 him in a pool, in two days' time webs will grow between his fingers. That's
 because he has nothing to lose.[1]

By the end of the play, Galy Gay is so successfully metamorphosed into a soldier that he single-handedly takes down a fort in Tibet.

In his later plays Brecht erects on stage various society-machines and shows how the characters form or deform themselves to accommodate them. In *The Rise and Fall of the City of Mahagonny* (1930), the society-machine is anarchic Capitalism: the motto of Mahagonny, a new city in Florida founded by thieves, is "Here you can do anything you want"—a domain of prostitution, gluttony, and fixed boxing matches. But, of course, the subtext of the motto is "As long as you can pay for it"; and the opera's hero, Jimmy Mahoney, is put to death after he is unable to pay his bar tab. He desperately pleads with his friends and his lover (the prostitute Jenny) to lend him the money; they refuse, and the opera's master of ceremony addresses the audience members and speculates that they, too, would probably not like to pay for Jimmy's drink. Indeed, the opera is filled with placards, slogans, asides to the audience, texts of all kinds, for the whole theatrical experience is disintegrating into a heap of competing messages. Brecht called this the epic theater:

> The modern theater is the epic theater. The following table shows certain changes of emphasis as between the dramatic and the epic theater:

DRAMATIC THEATRE	EPIC THEATRE
plot	narrative
implicates the spectator in a stage situation	turns the spectator into an observer, but
wears down his capacity for action	arouses his capacity for action
provides him with sensations	forces him to take decisions
experience	picture of the world
the spectator is involved in something	he is made to face something
suggestion	argument
instinctive feelings are preserved	brought to the point of recognition
the spectator is in the thick of it, shares	the spectator stands outside, studies the experience
the human being is taken for granted	the human being is the object of the inquiry
he is unalterable	he is alterable and able to alter
eyes on the finish	eyes on the course
one scene makes another	each scene for itself
growth	montage

linear development	in curves
evolutionary determinism	jumps
man as a fixed point	man as a process
thought determines being	social being determines thought
feeling	reason

The invasion of the methods of epic theatre into the opera first leads to a radical *division of the elements*. The great fight for primacy among words, music and pro-duction . . . can simply be laid aside by radically dividing the elements. As long as the term "total art work" implies that the totality is a smear, as long as the arts are to be "fused" together, the separate elements will all be degraded in equal mea-sure, and each can be for the others only a supplier of cues. . . . Such magic is naturally to be fought against. Everything that attempts to hypnotize will pro-duce unworthy intoxications, will make fog, and must be given up.

Music, text, and setting must each learn better how to stand by itself. . . . For music, the following shifts in weight are submitted:

DRAMATIC OPERA	EPIC OPERA
The music is deferential	The music enables
music heightening the text	music explaining the text
music affirming the text	music accepting the text for what it is
music illustrating	music taking a position
music depicting the psychic situation	music giving the demeanor[2]

We see that Brecht conceived the function of music in the old Dramatic Opera according to metaphors derived from painting; in the new Epic Opera, according to metaphors derived from pantomime or sign making. Music is liberated: it can comment on, even contradict, the text. A famous example is in *The Threepenny Opera*, the Pimp's Ballad, in which an unsentimental text, in which Mac the Knife remembers fondly how he used to crawl under the bed when his prostitute girlfriend Jenny entertained a customer, is sung to a swoony romantical tune. Wagner referred to his artistic ideal as a *Gesamt-kunstwerk*, a total artwork; Brecht, by contrast, wants a sort of civil war waged within the spectacle itself.

By making the theater a place of dissonant and competing interpretations, Brecht hoped to breed a race of canny spectators, who wouldn't become emotionally involved in the drama but would exert their critical faculties. This is why Brecht so prized alienation, what he called *Verfremdung*: the spectator must be compelled to stand apart from the events on stage, must

be compelled to think about the political and social implications of the events enacted. We saw earlier how defamiliarization, "enstrangement," was an important part of the Modernist program; Brecht turns this alienation into a didactic instrument. There's a scene in *Mann ist Mann* where Galy Gay is facing a death sentence for impersonating a soldier: Brecht told his Galy Gay, Peter Lorre, to speak his plea for his life as if he were reading from a script not necessarily relevant to his own fate. The actor, like the playwright, participates in a teaching exercise.

During the late 1920s, Brecht's political attitudes were quickly hardening. *The Threepenny Opera* doesn't have a particularly clear political message, but in the following year, 1929, Brecht and Weill wrote a sort of sequel to it, *Happy End*, in which the political message is quite clear: in fact, excerpts from *The Communist Manifesto* were read onstage. Near the end a chorus sings *Hosanna Rockefeller Hosanna Henry Ford*, and sarcasm against a Capitalist mock theocracy is strong. (Similarly, in Aldous Huxley's 1932 novel *Brave New World* the Christian cross has been replaced by the T of the Model T Ford automobile, and dates are computed Annum Ford.) Brecht even revised his earlier work with an eye toward improving its leftist orthodoxy: for a 1931 performance of *The Threepenny Opera* he transferred a speech from *Happy End* into the prison scene, so that Mack the Knife explicitly says that the crime of robbing a bank is nothing compared to the crime of founding a bank.

The career of Brecht illustrates two (very rough) generalities about the artists who emerged or whose work came to fruition in the 1930s (I speak of those artists whom we still attend to): (1) they were leftists, as opposed to their rightist precursors; and (2) the notion of epic art was changing quickly.

As to the first point, we may note that the earlier Modernists often found themselves distinctly attracted to Fascism (though it is easy to find exceptions, such as André Gide). T. S. Eliot published in *Criterion* magazine a review skeptical of the idea that the Nazis were herding Jews into concentration camps. Ezra Pound was arrested for treason in 1946 after making radio broadcasts in support of the Mussolini government, urging American soldiers to defect. And racial essentialism was a powerful factor in the imagination of William Butler Yeats, who considered that he wrote his poems to glorify Ireland and Celtic racial stock; as he wrote in 1938, a few months before his death,

Irish poets, learn your trade,
Sing whatever is well made,

Scorn the sort now growing up
All out of shape from toe to top,
Their unremembering hearts and heads
Base-born products of base beds.
Sing the peasantry, and then
Hard-riding country gentlemen,
The holiness of monks, and after
Porter-drinkers' randy laughter;
Sing the lords and ladies gay
That were beaten into the clay
Through seven heroic centuries;
Cast your mind on other days
That we in coming days may be
Still the indomitable Irishry.[3]

In a tract on eugenics, *On the Boiler*, also written in 1938, Yeats hoped that the coming war would purge Europe of fools and sluggards; indeed, he imagined that the new war would be a scientific complement to the Trojan War—warriors fighting with a cavalry of machines instead of horses.

Yeats did not himself live in an entirely fantastical world: he was in some ways a keen and canny politician, and he served as a senator of the Irish Free State. But in his poems he usually describes war in terms of deep symbolic equivalents, as in "The Second Coming," written in 1919, just after the Great War, where he looks forward, not without unease, to the year 2000, when a still more catastrophic war will abolish two thousand years of hateful Christian hegemony and reestablish the pagan, aristocratic, heroic, Homeric culture that Christianity had driven out. He imagines the inaugurator of this culture as a sphinx-Antichrist:

The Second Coming! Hardly are those words out
When a vast image out of *Spiritus Mundi*
Troubles my sight: somewhere in sands of the desert
A shape with lion body and the head of a man,
A gaze blank and pitiless as the sun,
Is moving its slow thighs, while all about it
Reel shadows of the indignant desert birds.
The darkness drops again; but now I know
That twenty centuries of stony sleep
Were vexed to nightmare by a rocking cradle,

And what rough beast, its hour come round at last,
Slouches towards Bethlehem to be born?[4]

Yeats had studied Nietzsche carefully, and he fully accepted Nietzsche's argument that Christianity is a slave religion that teaches passive obedience instead of passionate exercise of all faculties of body and mind.

The younger artists of the 1930s were, for the most part, less enthusiastic about war, less inclined to mythologize it, and more willing to serve in it and, whether they served or not, to advocate leftist positions (though it is easy to find exceptions here too, such as the passionately Fascist Louis-Ferdinand Céline). Ernest Hemingway drove an ambulance in the Great War—and the protagonists of several of his novels are warriors struggling to come to terms with the ways in which war has maimed them. W. H. Auden and George Orwell both went to Spain to aid in the fight against Franco's Fascists during the Spanish Civil War; the poet Federico García Lorca was probably murdered by the Fascists for his outspoken liberal views. Orwell's *Homage to Catalonia* records his struggle to behave decently in a situation where decency seemed of little use or meaning; Auden's whole notion of the poet's relation to his society was slowly transformed in part as a result of his (very brief) taste of war. In 1937, at the age of thirty, he wrote flamboyantly rhetorical propaganda poems—or (perhaps better to say) poems that urged poetry to step aside for a while, in order to give propaganda some space to be heard:

What's your proposal? To build the just city? I will.
I agree. Or is it the suicide pact, the romantic
 Death? Very well, I accept, for
I am your choice, your decision: yes, I am Spain.[5]

Even as World War II was beginning, Auden still was imagining himself in heroic postures of resistance; in "September 1, 1939," he denounces the "psychopathic god" of the Nazis and points to his own chest as he shows "an affirming flame":

All I have is a voice
To undo the folded lie,
The romantic lie in the brain
Of the sensual man-in-the-street
And the lie of Authority
Whose buildings grope the sky:

> There is no such thing as the State
> And no one exists alone;
> Hunger allows no choice
> To the citizen or the police;
> We must love one another or die.[6]

But Auden expunged both these poems from his published canon, on the grounds that they were grandiose: we all die whether we love one another or not. In a stanza added to his Yeats elegy, Auden states the new motto: "Poetry makes nothing happen."[7] I think that the younger Auden was se-duced by the extreme self-aggrandizement of the earlier Modernists such as Pound, who felt that he could offer a complete conspectus and critique of Western (and maybe Eastern) culture; and it is a distinguishing characteris-tic of several of the later Modernists, not just Auden, that they take a more modest view of the power of art and the power of the artist. Auden identi-fied himself with Shakespeare's Prospero, casting off the cloak of magic—the incantatory power of words—to tell the plain truth of things. As he wrote to Stephen Spender,

> In so much "serious" poetry I find an element of "theatre", of exaggerated gesture and fuss, of indifference to naked truth, which as I get older, increasingly revolts me. This element is mercifully absent from what is conventionally called good prose. In reading the latter, one is only conscious of the truth of what is being said, and it is this consciousness which I would like what I write to arouse in a reader *first*. Before he is aware of any other qualities it may have, I want his reac-tion to be: "That's true." . . . To secure this effect I am prepared to sacrifice a great many poetic pleasures and excitements.[8]

This led Auden, in later life, to write some very mundane poems, for ex-ample, about the fixtures in his bathroom; but Auden was saved from dull-ness by his belief in strenuous exactness of expression. It is telling, I think, that the ambitious Eliot thought that poetry is about the horror, boredom, and glory at the bottom of life, whereas the humbler Auden defined art as "De-narcissus-ized en-/During excrement."[9]

Probably the most celebrated political painters of the 1930s were Diego Rivera and Pablo Picasso, though they were a generation older than Auden or Orwell. Although a Communist, Rivera, an ornery fellow, did not always toe the party line: he was forced to leave the Soviet Union abruptly in 1928 after spending a year painting murals, and he was subsequently expelled

from the Mexican Communist Party. In 1933 he was commissioned to deco-
rate the new Rockefeller Center in New York City, but, after the press noted
that the face of Lenin was clearly visible, his work was either covered up or
destroyed. The next year, in Mexico City, he repainted the mural. Also in
1933, Otto Dix painted *The Seven Deadly Sins*, in which Envy bears the face
of Adolf Hitler. But a German artist needed to be circumspect during the
1930s, and Dix did not paint the telltale toothbrush mustache on Hitler's
face until after the war.

Picasso painted his unforgettable *Guernica* (1937) in response to the an-
nihilation of a Basque village in northern Spain, after Franco asked Germany
and Italy to send airplanes to bomb it. In this painting Picasso has eliminated
almost everything that is not terror. The chopped-up people in the Cubist
works that Picasso had developed about thirty years before this painting
always had a certain potential for terror: as Wyndham Lewis (himself a fine
Cubist painter) put it in *Tarr* (1918), "How would you like your face to be as
flat as a pancake, your nostrils like a squashed strawberry, one of your eyes
cocked up by the side of your ear? Would not you be very unhappy to look
like that?"[10] Some of the dissections and amputations in the middle third
of *Guernica* simply liberate certain expressive potentials usually suppressed
in the old Cubism; even the overstrung sinews in the arm in the lower left
corner look like Cubist paper-fold simulations. And yet, most of the heads
are not Cubist at all, but cartoony simplifications of shrieks. These heads,
like the lumpy fingers and toes and knees, have a disturbingly comical as-
pect; in the television series *The Simpsons*, when Homer Simpson chokes his
son, the animators use a visual vocabulary similar to that of *Guernica*. But
expressions of terror and other extreme emotions always have a certain
potential for collapsing into farce, and by incorporating *Guernica*'s own pos-
sibilities for burlesque into the painting itself, Picasso made the impact of
the work all the stronger, purer. When the woman holding the lamp flies
down like the ghost of a comic book thought balloon, she becomes an aveng-
ing fury in caricature, maybe the kind of avenging fury that the age finds
most potent of all.

The political situation among composers differed sharply from that of
writers and painters, because, outside of quoting politically charged tunes,
such as the *Internationale* or *Deutschland über alles*, it is not easy to assign
political meaning to a set of notes. A number of composers would have liked
to identify the forward march toward a more egalitarian society with the
avant-garde harmony promoted by Schoenberg—and some, especially Hanns

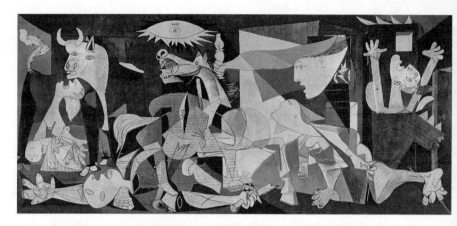

Pablo Picasso, *Guernica* (1937) Erich Lessing/Art Resource, NY. © 2015 Estate of Pablo Picasso/Artists Rights Society (ARS), New York

Eisler, skillfully combined the progressive in both areas. But Eisler, like all the rest, knew that factory laborers don't bustle into taverns at the end of the day to sing atonal canons, no matter how cheering. This led to a certain tension between the two different notions of progress.

In the Soviet Union, this tension became institutionalized. Receptive in its early days to the experimental music of Nicolay Roslavets and others, the Soviet Union under Stalin attempted to denounce (under such names as Formalism and Obscurantism) and exterminate every sort of music that would trouble an unlearned ear. Therefore, the composers who felt frustrated by restrictions were forced to cultivate irony as a technique for obeying the letter but subverting the spirit of state control: the triumphalist gestures in certain works of Dmitri Shostakovich, for example, seem puffed up, calculated to sneer (hand hiding mouth) at the authorities that command them. In Germany of the 1920s, on the other hand, such left-wing composers as Weill cultivated similar forms of irony to mock the bourgeois, leading to the odd result that antibourgeois music and anti-Soviet music have the same sort of in-quotation-marks, somebody-else-is-saying-this-not-me flavor— though Weill's irony is more conspicuous, since his game (until Hitler took power) was less dangerous.

In the Germany of the 1930s, there were few composers well known today who were committed Nazis, though Hans Pfitzner did what he could to court the favor of Joseph Goebbels, Hitler's minister of propaganda. Most

of the Jewish composers either fled (like Weill and Schoenberg) or were executed (like Viktor Ullmann); the non-Jewish composers either fled (like Paul Hindemith—rather reluctantly) or found some form of accommodation with the government. A senior composer like Richard Strauss, who knew that his cultural prestige was immense, could probe the limits of his freedom in various ways: Strauss tried to have a clear public acknowledgment of the role of his Jewish librettist Stefan Zweig, a loud opponent of Hitler, at the première of *Die schweigsame Frau* in 1935; on the other hand, in 1933 Strauss had dedicated to Joseph Goebbels his song *Das Bächlein*, Op. 88/1 (the otherwise-harmless text contains a reference to "mein Führer"), to celebrate Strauss's appointment as president of the *Reichsmusikkammer*. Less monumental composers tended to acquiescence to the regime, either grudgingly or not: Carl Orff worked in Germany, and Anton Webern in Nazi Austria, without much difficulty.

But it is venturesome to say that there is a Nazi or an anti-Nazi musical style, or a Soviet or an anti-Soviet style. The Nazi exhibitions of *entartete Kunst* (degenerate art) pretended to have some stylistic basis for the category, but, in fact, any sort of music composed by a degenerate composer (that is, Jewish or otherwise unsatisfactory from the Nazi point of view) would be discovered, on careful examination, to be degenerate. Music officially approved by totalitarian governments certainly tended to be simple, or simplistic, on the level of harmony and structure. But it is rarely easy to say whether the accessible style of Carl Orff or the later (Soviet) Sergei Prokofiev is the result of conformity to political demands or the result of engagement with one of many aesthetic movements that exalt the ritualistic and the communal over individual expression. Furthermore, it is impossible to make clear stylistic distinctions between the political rightists and leftists. The rightist Anton Webern (enthusiastic for the Nazi Party) and the leftist Eisler were both pupils of Schoenberg (a monarchist Jew) and continually stressed their admiration of him. Compositional technique is indifferent to the politics it serves—which is not to say that politics is indifferent to the technique that serves it.

Epic

As I said earlier, the newer Modernists also revised the concept of epic, and Auden and Hemingway will again prove useful as examples. Brecht uses the word *epic* not with reference to any particular ancient text, but with reference to a theatricality opposed to the Aristotelean model: a Brechtian

epic drama does not comprise a single action, does not necessarily take place in one day or in one decade, resolutely refuses any cathartic sense of conclusion, since it wants to keep all issues open for further debate; the stage action is often mediated by a master of ceremonies or some other form of narrator—just as a classical epic was chanted by a rhapsode. But the older Modernists used epic themes as well as epic structures: both Pound and Joyce modeled the great projects of their career on the *Odyssey*, and in *The Waste Land* Eliot created a curious sort of dehydrated epic, though his "plot" was based on Grail romances, not on Homer. When we read Auden and Hemingway, however, we find ourselves not in the sunny world of Mediterranean epic, filled with bright gods, but in the cold mists of northern epic.

From early childhood on, Auden was fascinated by Norse legends, as his schoolmate, lover, and collaborator Christopher Isherwood explained: "The saga-world is a schoolboy world, with its feuds, its practical jokes, its dark threats conveyed in pun and riddles and understatements; 'I think this day will end unluckily for some; but chiefly for those who least expect harm.'"[11] To re-create this saga-world in the modern age was a strong part of Auden's mission as a poet, in such works as his first play *Paid on Both Sides*, his poem "The Wanderer" (written in imitation Old Germanic alliterative verse: "Doom is dark and deeper than any sea-dingle"), his travelogue *Letters from Iceland*, and his translation of the Elder Edda:

> It is best for a man to be middle-wise,
> Not over cunning and clever:
> The learned man whose lore is deep
> Is seldom happy at heart. . . .
>
> A man should know how many logs
> And strips of bark from the birch
> To stock in autumn, that he may have enough
> Wood for his winter fires.[12]

The giver of this advice is the chief of the gods, Odin. And, of all Modernist authors, the one who follows such advice most scrupulously is Hemingway.

Hemingway's characters are full of practical knowledge ("With the ax he slit off a bright slab of pine from one of the stumps and split it into pegs for the tent"[13]) and try hard to be middle-wise, that is, not to know deep things. Here are Bill and Jake from *The Sun also Rises* (1926); Bill is asking Jake—an

ex-soldier who suffered a castrating wound during the Great War—whether he ever loved Lady Brett, the great love of his life:

"Say," Bill said, "what about this Brett business?"

"What about it?

"Were you ever in love with her?

"Sure."

"For how long?"

"Off and on for a hell of a long time."

"Oh, hell!" Bill said. "I'm sorry, fella."

"It's all right," I said. "I don't give a damn any more."

"Really?"

"Really. Only I'd a hell of a lot rather not talk about it."

"You aren't sore I asked you?

"Why the hell would I be?"

"I'm going to sleep," Bill said. He put a newspaper over his face.

"Listen, Jake," he said, "are you really a Catholic?"

"Technically."

"What does that mean?"

"I don't know."[14]

Vagueness, evasion, refusal, and profession of ignorance are the typical Hemingway responses to important questions. Mutilated, living in a mutilated world, the protagonist tries hard not to think about things, to hew close to surfaces. This is one reason for the extreme detail and precision about technical procedures: the more Hemingway talks about chopping a pine stump with an axe or threading a worm on a fishing hook, the more firmly he can discriminate the speakable from that which must not be spoken of. His world is bleak, riddling, undermined; even the landscape, like the scarred and charred countryside through which Nick wanders in "Big Two-Hearted River," sometimes testifies to the general ruin. In the Elder Edda, the universe is supported by Yggdrasil, the World Ash Tree, but monsters are gnawing at its roots.

Control and Chaos

During the 1930s and 1940s, this sense of nothingness or chaos underlying the cosmos was promoted into a philosophy (Existentialism), and there arose a number of artistic strategies for resistance or creative surrender to the real disorder at the core of things. We've seen how some of the old

Dadaists from 1919-22, like Tristan Tzara, took a jokey sort of delight in making art as random and meaningless as the universe itself; but the later artists often approached the heart of darkness more seriously, with varying emotions, including grim solemnity, quiet satisfaction, overflowing joy, or (to use a word that became the title of Jean-Paul Sartre's 1938 novel) nausea.

The later Modernists went far beyond the Dadaists in their explorations of chaos. Tzara allowed chance operations to determine a poem by cutting up newsprint into individual words and scrambling them. This procedure allowed the reader to confront a disordered set of words, but (as you can prove yourself by chopping up an article on, say, oil shale in Alberta, or on strategies for ridding your rose bed of Japanese beetles) the chaoticized article still has a great deal of lexical coherence, despite its syntactic incoherence; it's not as if Tzara fed the whole dictionary into a random word generator. Similarly, Duchamp's scheme for mixing up the notes from two octaves of the chromatic scale and listening to them one by one allows for contemplation of unusual intervallic leaps, but it doesn't force you to confront a universe of white noise refracting into odd colors.

Samuel Beckett looked for richer expressions of chaos. Sometimes he composed texts by permutational processes, that is, by taking a set of elements and doggedly transcribing every possible arrangement: "For one day Mr Knott would be tall, fat, pale and dark, and the next thin, small, flushed and fair, and the next sturdy, middlesized, yellow and ginger, and the next small, fat, pale and fair, and the next middlesized, flushed, thin and ginger, and the next tall, yellow, dark and sturdy, and the next fat, middlesized, ginger and pale, and the next tall, thin, dark and flushed, and the next small, fair, sturdy and yellow, and the next tall, ginger, pale and fat."[15] And the paragraph keeps going on in this fashion, for a long time. Mr. Knott (that is, Mr. Not) is a human chaos, in that each day he appears in a different assortment of four of the twelve descriptors with which Beckett is playing. If you imagine a similar paragraph written with, say, five hundred descriptors, Mr. Knott would transshift across the whole human race: he would be every character in every novel ever written. Not only do you have a chaotic text, but you are introduced to a personification of chaos.

When Beckett thinks of chaos, he conceives it arithmetically, as the full array of permutations among a finite set of objects. Consider the ordered sequence 1, 2, 3, 4, 5. The number of different reorderings is 5! (that is, 5 × 4 × 3 × 2 × 1), or 120 ways. So a tabulation of these 120 orders constitutes

a full statement of chaos—that is, of the chaos available in a universe that has only five objects in it. By keeping chaos restricted to a limited number of objects, Beckett allows us to savor it intently. As he wrote in his first published novel, *Murphy* (1938),

> He took the biscuits carefully out of the packet and laid them face upward on the grass, in order as he felt of edibility. They were the same as always, a Ginger, an Osborne, a Digestive, a Petit Beurre and one anonymous. He always ate the first-named last, because he liked it the best, and the anonymous first, because he thought it very likely the least palatable. The order in which he ate the remaining three was indifferent to him and varied irregularly from day to day. On his knees now before the five it struck him for the first time that this reduced to a paltry six the number of ways in which he could make his meal. But this was to violate the very essence of the assortment. . . . Even if he conquered his prejudice against the anonymous, still there would be only twenty-four ways in which the biscuits could be eaten. But were he to take the final step and overcome his infatuation with the ginger, then the assortment would spring to life before him, dancing the radiant measure of its total permutability, edible in a hundred and twenty ways![16]

In his fiction and drama, Beckett often presents shrunken universes with few possibilities, but he will generally exhaust all the possibilities, because respect for chaos demands it. In the Beckett cosmos, as in the cosmos that physics describes, whatever is not forbidden is compulsory.

In 1961 Beckett told an interviewer, "To find a form that accommodates the mess, that is the task of the artist now."[17] The other great expert in chaos among the later Modernists, John Cage, often tried to allow chaos to generate its own forms, without the artist's imposing some preconceived form upon it. Cage studied with Arnold Schoenberg—after fleeing Hitler's Germany, Schoenberg took refuge in Los Angeles; Schoenberg later said that Cage was not a composer but an inventor of genius. He invented strategies for letting sound happen with as little intervention of human will as possible.

Cage had a delicate ear and was not particularly fond of loud noise; silence intrigued him, partly because as you make your world quieter and quieter, the universe's default background noises, the underpinning of things, make themselves audible: "In fact, try as we may to make a silence, we cannot. . . . I entered [an anechoic chamber] at Harvard University several years ago and heard two sounds, one high and one low. When I described them

to the engineer in charge, he informed me that the high one was my nervous system in operation, the low one my blood in circulation. Until I die there will be sounds. And they will continue following my death. One need not fear about the future of music."[18] In 1952, Cage composed his famous 4'33", in which the player, usually a pianist, sits with an instrument and makes no sound; the music, then, is the rustling of program notes and candy wrappers, the hum of the heating system, whatever is going on while the pianist does nothing. In 1951 Cage saw an exhibit of all-white paintings by Robert Rauschenberg and found them not empty but supercharged with a kind of sacred joy: "I have come to the conclusion that there is nothing in these paintings that could not be changed, that they can be seen in any light and are not destroyed by the action of shadows. Hallelujah! the blind can see again; the water's fine."[19] Rauschenberg was not the first painter to exhibit white canvases: long ago, in 1918, Kazimir Malevich, the Russian Suprematist, had painted his *White on White*—not quite a white canvas, since a large tilted rectangle of darker white is imposed on a lighter white background. Malevich believed that he had achieved something like the ultimate end of the whole art of painting, as if *White on White* were a rocket ship that had escaped earth's gravitational field: "Our century is a huge boulder aimed with all its weight into space. From this follows the collapse of all the foundations in Art, as our consciousness is transferred onto completely different ground. The field of color must be annihilated, that is, it must transform itself into white . . . the development of white . . . points to my transformation in time. My imagining of color stops being colorful, it merges into one color—white. . . . Geometrical forms constitute a portal to the perfectly objectless, which no longer has any point of reference to external reality."[20] So, for Malevich, an all-white painting means an *absence of representation*, an adventure in purity beyond the physical world. But when Rauschenberg, at the beginning of his distinguished career as a Postmodernist in 1951, painted a series of white canvases, the war against representation was yesterday's news; now an all-white canvas was exciting because it meant an *absence of signs*. Cage, similarly, had no interest in sound or silence that referred to anything outside itself: "I'd never been interested in symbolism; that I preferred just taking things as themselves, not as standing for other things."[21]

Furthermore, he had no interest in sound that referred to himself, either. During the year of his breakthrough, 1951, he decided to abolish the element of his own will by allowing chance procedures to govern his music—

specifically, he used the sixty-four hexagons of the old Chinese book of changes, the *I Ching*, to generate random orderings among various elements of his composition. In his first experiment, *Music of Changes*, he wrote out a number of tiny music segments—sometimes just chords, even bits of silence—and then let the *I Ching* determine the sequence and overlay of these events, as well as their duration and loudness. Further inquiry produced random note durations and random dynamics. In later compositions Cage used star charts or the imperfections on sheets of music paper to create music—the former was a new twist on the old idea of the Music of the Spheres, as if the zodiac could be enticed to a make a music not of cosmic order but of calm celestial chaos.

Cage's other method he called indeterminacy. This referred not to compositional procedure but to performance procedure: in an indeterminate piece the performer was asked to play ad libitum, although usually under some constraint or other that Cage imposed. I think that in both his chance-derived and his indeterminate compositions, Cage enjoyed the sense that he was covertly conspiring with external reality to make music—as if Chaos and Old Night were his friends and valued collaborators. Cage had a cheerful creative disposition and tended to speak of chaos in glowing terms:

> And what is the purpose of writing music? One is, of course, not dealing with purposes but dealing with sounds. Or the answer must take the form of a paradox: a purposeful purposelessness or a purposeless play. This play, however, is an affirmation of life—not an attempt to bring order out of chaos nor to suggest improvements in creation, but simply a way of waking up to the very life we're living, which is so excellent when one gets one's mind and one's desires out of its way and lets it act of its own accord.
>
> Well, the grand thing about the human mind is that it can turn its own tables and see meaninglessness as the ultimate meaning. . . . Let us say Yes to our presence together in Chaos.[22]

Among the Modernists, then, there were several (in Wallace Stevens's phrase) connoisseurs of chaos. On the other side, there were those who erected extraordinarily rigid and comprehensive artistic systems.

Probably the first great systematizer was one of the older Modernists, Piet Mondrian. In his youth Mondrian painted reasonably representational canvases, but during the 1910s he desired to purify his art by reducing all visual phenomena to a kind of lyrical grid. He thought that he had attained,

or nearly attained, the ultimate goal of art, as he explains to the educable philistine called A. in his "Dialogue on the New Plastic" (1919):

A. . . . art will be much impoverished if the natural is eliminated.

B. How can its expression be impoverished if it conveys more clearly what is important and essential to the work of art?

A. But the *straight* line can say so little.

B. The straight line tells the truth. . . . I see reality as a *unity*; what is manifested in all its appearances is *one and the same*: the *immutable*. We try to express this plastically as purely as possible.

A. It seems reasonable to take the immutable as the basis: the *changeable* provides nothing solid. But what do you call *immutable*?

B. *The plastic expression of immutable relationship: the relationship of two straight lines perpendicular to each other. . . .*

A. So the New Plastic is the end of painting?

B. Insofar as there can be no purer plastic expression of equilibrated relationships . . .[23]

The pre-Socratic philosopher Parmenides held that reality was a changeless sphere, and that all change—growth, decay, the whirling of the planets—was illusory, the result of a defect in our sensory apparatus. Mondrian might be called a neo-Parmenidean. In *Pier and Ocean* (1914), he looks out at the waves and contemplates a sea of plus signs—one of the least fluid oceans to be found in art history: Mondrian has discovered the ocean's skeleton. Mondrian's pictures of trees from this period look rather similar, though they retain a few of the diagonals that he would soon find weak and hateful. As Mondrian grew older, he experimented with still more extreme reduction, until there wasn't much left (e.g., *Composition with Yellow Patch*, 1930) except a big vertical and a big horizontal line slightly enriched by a subdivision or two, and a startling big yellow square of pigment that seems to be discreetly sidling out of the picture. For Mondrian, such paintings showed the inner truth of nature—nature as it would look purged of all contingency, stripped to the absolute. It is at once a schematic diagram of reality as God sees it—all universal and no universe—and a statement of how things might be related, positioned with respect to one another, if a thing or two ever happened to appear in one of the white fields. It's a Cartesian x-axis and a y-axis erected in a world of ratios without visible numbers.

In music, the great systematizer was Schoenberg. Around 1923 Schoenberg told some friends that he had made a discovery that would ensure the

supremacy of German music for the next hundred years. This discovery was the twelve-tone method. This was a procedure that removed from music all possibility of a tonic note, of a key, by a legislative act: the basis of a musical composition would no longer be a scale but a *tone row*. A tone row is an ordered set of the twelve notes of the chromatic scale; this set is the quarry from which all melody and harmony are drawn. This method gives an absolute equality to each of the twelve notes, since you can't give any priority to one note—you can't interrupt the tone row to insert a second E♭ once you've heard the first E♭, that is, not until all other eleven notes have been heard. There are ways around this rule, since you can group notes from the row into chords at pleasure and thus make some notes stand out while others are suppressed, but the twelve-tone method is nonetheless intended as a decisive defeat of the principle of tonality, while nevertheless preserving something of the orderliness, the rigor, of the tonal system. This method could be used for many purposes, even comic opera, but was especially well adapted to Neoclassical procedures. In Schoenberg's earliest twelve-tone works, he often named the movements after eighteenth-century dance forms: for example, in the *Piano Suite* (1921-23), there is a gavotte that sounds nothing like the earlier free-atonal Schoenberg of *Erwartung*—it's a sort of music box for mechanical grasshoppers. Schoenberg himself did not announce that tonal music was henceforth dead, but some of his pupils, such as Anton Webern, were quite willing to make that leap.

Later composers experimented with serializing all elements of music, not just pitch. Pierre Boulez, when composing *Structures 1* for two pianos (1952), made serial charts of twelve dynamic levels, twelve durations for the notes, and ten modes of attack—as if no element of the music could be left to whim and every note, every mark in the score, needed to be justified as necessary and inevitable.

It sounds as if the connoisseurs of chaos and the systematizers are exactly opposed, but in fact, as often happens in art, these extremes converge. It is remarkable how similar Boulez's *Structures 1* and some of Cage's chance-derived piano music sound. Cage wrote his *Music of Changes*, as well as many other works, by means of a system—blind chance can be every bit as harsh a taskmaster as a twelve-tone row, if followed slavishly. And, in Boulez's serial charts, the particular sequence of pitches (or durations, and so forth) was determined by Boulez's taste, not by God or the decimal expansion of pi or some other commanding universal. I've treated Beckett as a connoisseur of chaos, but his dogged exhausting of permutations makes him just as

easy to treat as a systematizer—in fact, in his novel *Molloy* (1951) there's a scene in which Molloy devises a system to suck each of his sixteen sucking stones in order, so that no stone is sucked more often than any of the others; I regard this stone-row method as a deliberate parody of Schoenberg's tone-row method. In art, chaos and cosmos are remarkably intimate.

Epilogue:
The End of Modernism?

When does Modernism end? Many different termini have been proposed, including the end of either world war; or 1951, on the grounds that Cage's experiments with the *I Ching* presented something other than Modernism, especially if Modernism is understood as a strong assertion of the author's authority; or maybe there was a gradual transition to what is called Postmodernism, marked by these features:

1. *Bricolage*: the jury-rigging of art, the assembling of the art object from the odds and ends of older art, in a denatured and desecrated fashion, in order to expose the purely arbitrary character of the signs that all artists, past and present, employ. In this sense the modality of Postmodernist art is a collage of ironic quotations. Art history is wholly flattened, de-narratized: the passage of centuries shows no progress, development, or flowering of art, only a steady accumulation of shiny familiar junk, such as Botticelli's *Birth of Venus* (a print of which appears in Robert Rauschenberg's 1955 *Rebus*), the first four notes of Beethoven's Fifth Symphony, or Hamlet's speech *To be or not to be*. As the philosopher Jacques Derrida has written, "Every sign, linguistic or non-linguistic, spoken or written . . . in a small or large unit, can be *cited*, put between quotation marks; in so doing it can break with every context, engendering an infinity of new contexts in a manner which is absolutely illimitable."[1]

2. *Polystylism*: this is *bricolage* on the level of technique instead of content. The polystylistic artist may combine academically shaded images with car-toony outline drawings, as in Saul Steinberg's 1953 *Techniques at a Party*; a polystylistic composer may combine Gregorian chant, tuneful tonality, and obnoxious dissonances into a single composition, in order to create incongruities that deny the propriety or the tenability of any single style.

3. *Randomness*: a technique for depersonalizing the artist, for demonstrating the transcendental anonymity of the work of art. If artistic decisions are governed by the rolling of dice, then the artwork is liberated from human responsibility. Roland Barthes's influential essay "The Death of the Author" (1968) has helped bring into being a sort of art in which the maker dramatizes the absence of authority within the made object.

On the other hand, it may be that there is no such thing as Postmodernism, since all these tendencies were vividly alive even in early Modernism; as for Polystylism, it may be that the greatest Polystylistic opera ever written is Mozart's *The Magic Flute* (1791), in which simple tunes in pop style abut against virtuoso coloratura display pieces and even a pseudo-Bachian chorale prelude.

We may live, as we've always lived, in a world that is at once premodern, modern, and postmodern.

Notes

Introduction. Modernist Transvaluation

1. Ezra Pound, *Literary Essays* (New York: New Directions, 1968), 3.

2. Jonathan Swift, *Gulliver's Travels and Other Writings*, ed. Louis A. Landa (Cambridge, MA: Riverside, 1980), 219.

3. Ibid., 238.

4. Matthew Arnold, "The Study of Poetry," in *Poetry and Criticism of Matthew Arnold*, ed. A. Dwight Culler (Boston: Riverside, 1961), 313.

Chapter 1. Baudelaire

1. Author's translation from www.uni-due.de/lyriktheorie/texte/1863_baudelaire .html.

2. Author's translation from fleursdumal.org/poem/103.

3. Author's translation from www.uni-due.de/lyriktheorie/texte/1886_moreas .html.

4. Ursula Bridge, ed., *W. B. Yeats and T. Sturge Moore: Their Correspondence, 1901–37* (New York: Oxford University Press, 1953), 38.

5. William Butler Yeats, *Essays and Introductions* (New York: Collier Books, 1961), 190, 192-93.

6. John Ruskin, *The Stones of Venice*, vol. 3 (Boston: Dana Estes, n.d.), 176-78.

7. Yeats, *Essays and Introductions*, 148-49.

8. W. B. Yeats, "The Secret Rose," in *The Poems*, ed. Daniel Albright (London: Everyman, 1994), 87.

9. W. B. Yeats, *Mythologies* (New York: Macmillan, 1959), 111.

10. Yeats, "To the Rose upon the Rood of Time," in *Poems*, 52-53.

11. Yeats, "Her Courage," in *Poems*, 209.

Chapter 2. Nietzsche

1. Friedrich Nietzsche, *Beyond Good and Evil*, in *Werke in Drei Bänden* (Munich: Carl Hanser Verlag, 1966), 2:567.

2. Nietzsche, *Beyond Good and Evil* 146, in *Werke in Drei Bänden*, 2:636.

3. Nietzsche, *Die Geburt der Tragödie*, in *Werke in Drei Bänden*, 1:57.

4. Thomas Mann, *Schopenhauer* (Stockholm: Bermann-Fischer Verlag, 1938), 26.

5. Richard Wagner, *Wagner on Music and Drama*, ed. Albert Goldman and Evert Sprinchorn, trans. H. Aston Ellis (New York: Da Capo, 1964), 271.

6. Nietzsche, *Werke in Drei Bänden*, 1:42.

7. Ibid., 1:55.

8. Ibid., 1:64.

9. Victor Hugo, *La préface de Cromwell: introduction, texte, et notes*, ed. Maurice Souriau (Paris: Boivin, n.d.), 22-23.

10. Nietzsche, *Werke in Drei Bänden*, 1:131-33.

11. Ibid.

12. Ibid., 2:711.

13. Ibid., 1:16.

14. Ibid., 1:15.

15. Ibid., 1:176.

16. Author's translation from http://raptusassociation.org/wagbeet1870g.html.

17. Nietzsche, *Werke in Drei Bänden*, 1:115-17.

18. Ibid., 2:127-28.

19. Ibid., 3:913.

20. Ibid., 3:918.

21. Ibid., 3:924-25.

22. Ibid., 3:930.

23. Euripides, *The Bacchae*, in *Euripides III*, ed. David Grene and Richmond Lattimore, trans. William Arrowsmith (New York: Modern Library, 1959), 359-60, lines 13-17, 19-20.

24. Author's translation from www.gutenberg.org/cache/epub/12108/pg12108.html. I translated all quotations from the novel from this site.

25. Thomas Mann, *The Letters of Thomas Mann, 1889-1955*, trans. Richard and Clara Winston (Berkeley: University of California Press, 1975), 101.

26. Alma Mahler, *Gustav Mahler: Memories and Letters*, ed. Donald Mitchell, trans. Basil Creighton (Seattle: University of Washington Press, 1975), 116.

Chapter 3. Impressionism

1. Gerard Manley Hopkins, "Pied Beauty," 1877.

2. Bernard Denvir, *The Impressionists at First Hand* (London: Thames & Hudson, 1987), 36.

3. Phoebe Poole, *Impressionism* (London: Thames & Hudson, 1991), 228.

4. Ibid., 224.

5. Denvir, *Impressionists at First Hand*, 146-47.

6. Friedrich Nietzsche, *Werke in Drei Bänden* (Munich: Carl Hanser Verlag, 1966), 3:313.

7. Lionel Abel, *Camille Pissarro: Letters to His Son Lucien* (New York: Pantheon, 1943), 64.

8. Denvir, *Impressionists at First Hand*, 180.

9. John Rewald, *The History of Impressionism* (New York: Museum of Modern Art, 1973), 318.

10. Jules-Antoine Castagnary, *Le Siecle*, 29 Apr. 1874, www.artchive.com/galleries/1874/74critic.htm.

11. Louis Leroy, *Le Charivari*, 25 Apr. 1874, www.artchive.com/galleries/1874/74leroy.htm.

12. Walter Pater, *The Renaissance*, ed. Donald L. Hill (Berkeley: University of California Press, 1980), xix.

13. Ibid., 51-52, 176.

14. Ibid., 178.

15. Ibid., 50, 171.

16. Ibid., 185.

17. Ibid., 186-87.

18. All quotations are from http://archive.org/stream/poetrydrama02monruoft/poetrydrama02monruoft_djvu.txt.

19. *In Memoriam*, 95.

20. Joseph Conrad, *The Collected Letters of Joseph Conrad*, ed. Frederick Karl and Laurence Davies (Cambridge: Cambridge University Press, 1986), 94-95.

21. Joseph Conrad, *Heart of Darkness and The Congo Diary*, ed. Owen Knowles (London: Penguin Classics, 2007), 3.

22. Ibid., 55.

23. Ibid., 71.

24. Arthur Schopenhauer, *The World as Will and Idea*, trans. R. B. Haldane and J. Kemp (New York: Charles Scribner's Sons, 1950), 1:341.

25. Ernest Fenollosa, *The Chinese Written Character as a Medium for Poetry*, ed. Ezra Pound (San Francisco: City Lights, 1969), 10-11.

26. Claude Debussy, "Monsieur Croche the Dilettante Hater," in *Three Classics in the Aesthetic of Music* (New York: Dover, 1962), 3-4.

27. Léon Vallas, *Claude Debussy: His Life and Works*, trans. Maire and Grace O'Brien (New York: Dover, 1973), 118.

28. Ibid., 112.

29. Ibid., 117.

30. Ibid., 112.

31. Claude Debussy, *Claude Debussy Lettres, 1884-1918*, ed. François Lesure (Paris: Hermann, 1980), 109.

32. Vallas, *Claude Debussy*, 117, 116.

33. Ibid., 117.

34. Debussy, *Claude Debussy Lettres, 1884-1918*, 90.

Chapter 4. Expressionism

1. Donald E. Gordon, *Expressionism: Art and Ideas* (New Haven, CT: Yale University Press, 1987), 175.

2. Friedrich Nietzsche, *Werke in Drei Bänden* (Munich: Carl Hanser Verlag, 1966), 2:281.

3. Wolf-Dieter Dube, *The Expressionists* (London: Thames & Hudson, 1990), 37, 40.

4. Nietzsche, *Beyond Good and Evil* 146, in *Werke in Drei Bänden*, 2:636.

5. Dube, *Expressionists*, 181.

6. *Abstraction and Empathy*, 1908, cited in Gordon, *Expressionism*, 51.

7. See www-history.mcs.st-and.ac.uk/HistTopics/General_relativity.html.

8. See www.schoenberg.at/index.php?option=com_content&view=article&id=179&Itemid=354&lang=en.

9. Theodor Adorno, *Philosophie der neuen Musik* (Frankfurt: Europäische Verlagsanstalt, 1966), 43. The "very first publication" is *Arnold Schönberg*, ed. Alban Berg et al.; Kandinsky's essay is reproduced in *Arnold Schoenberg/Wassily Kandinsky/Letters, Pictures, and Documents*, ed. Jelena Hahl-Koch, trans. John C. Crawford (London: Faber & Faber, 1984), 125-28. Kandinsky there remarks that Schoenberg paints "in order to give expressions to those motions of the spirit [*Gehirnakte*] that are not couched in musical form."

10. Sigmund Freud, "Five Lectures on Psychoanalysis," in *The Freud Reader*, ed. Peter Gay (New York: W. W. Norton, 1995), 75.

11. Arnold Schoenberg, *Style and Idea*, ed. Leonard Stein, trans. Leo Black (Berkeley: University of California Press, 1984), 105.

12. See http://raptusassociation.org/wagbeet1870g.html.

13. Arnold Schoenberg, *Arnold Schoenberg Letters*, ed. Erwin Stein, trans. Eithne Wilkins and Ernst Kaiser (Berkeley: University of California Press, 1987), 139-41.

14. Otto Weininger, *Geschlecht und Charakter: eine prinzipielle Untersuchung* (Vienna: W. Braunmüller, 1903), 333-34.

15. Ibid., 388-89.

16. Franz Kafka, *Aphorismen* 54, 86, 57, 26, 39, and 97, in *Beim Bau der chinesischen Mauer* (Frankfurt: Fischer Taschenbuch, 1994), 228-48.

17. See www.gutenberg.org/files/25791/25791-h/25791-h.htm, 28-29.

18. Franz Kafka, *Dearest Father*, trans. Ernst Kaiser and Eithne Wilkins (New York: Schocken, 1954), 80.

19. Kafka, *Aphorismen* 108.

20. See http://gutenberg.spiegel.de/buch/169/7.

21. Gustav Janouch, *Conversations with Kafka*, trans. Goronwy Rees (New York: New Directions, 1968), 66.

Chapter 5. Futurism

1. Filippo Tommaso Marinetti, *Selected Writings*, ed. R. W. Flint (New York: Farrar, Straus and Giroux, 1972), 43.

2. Ibid., 39-40.

3. Ibid., 84-85.

4. Ibid., 84.

5. Ibid., 87.

6. Daniel Albright, *Modernism and Music: An Anthology of Sources* (Chicago: University of Chicago Press, 2004), 180.

7. Marinetti, *Selected Writings*, 95.

8. Ibid., 96.

9. Mary Ann Caws, *Manifesto: A Century of Isms* (Lincoln: University of Nebraska Press, 2000), 219.

10. Ibid., 179.

11. Ibid., 179-80.

12. Albright, *Modernism and Music*, 178.

13. Marinetti, *Selected Writings*, 112.

14. Filippo Tommaso Marinetti and Pino Masnata, "La radia," trans. Stephen Sartarelli, in *Wireless Imagination*, ed. Douglas Kahn and Gregory Whitehead (Cambridge, MA: MIT Press, 1992), 267.

15. Margaret Fisher, *Ezra Pound's Radio Operas* (Cambridge, MA: MIT Press, 2002), 80.

Chapter 6. Cubism

1. John Golding, *Cubism* (Cambridge, MA: Harvard University Press, 1988), 5.

2. Ibid., 51.

3. Ibid., 34.

4. Douglas Cooper, *The Cubist Epoch* (London: Phaidon, 1970), 27-28.

5. Ibid., 33.

6. Ibid., 59.

7. John Golding, *Braque: The Late Works* (London: Royal Academy of the Arts, 1997), 4.

8. John Golding, *Visions of the Modern* (Berkeley: University of California Press, 1994), 107.

9. Golding, *Cubism*, 116.

10. Ibid., 117-18.

11. Gertrude Stein, *Lectures in America* (New York: Vintage Books, 1975), 81-82.

12. Gertrude Stein, *Selected Writings of Gertrude Stein*, ed. Carl van Vechten (New York: Vintage Books, 1990), 436-37.

Chapter 7. Abstractionism

1. Wassily Kandinsky, *Concerning the Spiritual in Art*, trans. M. T. H. Sadler (New York: Dover, 1977), 32.

2. Ibid., 47.

3. Wassily Kandinsky, *Reminiscences*, 1913, quoted in *Kandinsky: Complete Writings on Art*, ed. Kenneth C. Lindsay and Peter Vergo (Boston: Da Capo, 1994), 373.

4. Kandinsky, *Complete Writings*, 142.

5. Kandinsky, *Concerning the Spiritual in Art*, 29, 44.

6. Kandinsky, *Complete Writings*, 275-76.

7. Ibid., 257.

8. Kandinsky, *Concerning the Spiritual in Art*, 51.

9. Ibid., 25.

10. Kandinsky, *Reminiscences*, quoted in *Complete Writings*, 363-64.

Chapter 8. Primitivism

1. D. H. Lawrence, *Women in Love* (London: Penguin Books, 1995), 253.

2. See www.hyperion-records.co.uk/dw.asp?dc=W8525_66863&vw=dc.

3. Richard Taruskin, *Stravinsky and the Russian Traditions* (Berkeley: University of California Press, 1995), 1:882.

4. Igor Stravinsky and Robert Craft, *Memories and Commentaries* (Berkeley: University of California Press, 1981), 30.

5. Johann Gottfried Herder, *On the Origin of Language*, trans. John Moran (New York: Frederick Ungar, 1966), 133.

6. Vera Stravinsky and Robert Craft, *Stravinsky in Pictures and Documents* (New York: Simon & Schuster, 1978), 526.

7. Igor Stravinsky and Robert Craft, *Expositions and Developments* (Berkeley: University of California Press, 1981), 146.

8. Jann Pasler, ed., *Confronting Stravinsky* (Berkeley: University of California Press, 1988), 80.

9. Minna Lederman, ed., *Stravinsky in the Theatre* (New York: Pellegrini & Cudahy, 1949), 21.

10. T. S. Eliot, "London Letter," *Dial*, Sept. 1921.

Chapter 9. Imagism

1. T. E. Hulme, "Romanticism and Classicism," in *Modernism: An Anthology of Sources and Documents*, ed. Vassiliki Kolocotroni, Jane Goldman, and Olga Taxidou (Chicago: University of Chicago Press, 1999), 179-80.

2. Ezra Pound, *Literary Essays* (New York: New Directions, 1968), 3.

3. Omar Pound and A. Walton Litz, eds., *Ezra Pound and Dorothy Shakespear: Their Letters: 1909-1914* (New York: New Directions, 1984), 302.

4. R. Murray Schafer, ed., *Ezra Pound and Music* (New York: New Directions, 1977), 256-57.

5. Brita Lindberg-Seyested, ed., *Pound/Ford: The Story of a Literary Friendship* (New York: New Directions, 1982), 10.

6. Pound, *Literary Essays*, 9.

7. W. B. Yeats, *The Variorum Edition of the Plays of W. B. Yeats*, ed. Russell K. Alspach (New York: Macmillan, 1966), 787.

8. Ezra Pound, *Ezra Pound and the Visual Arts*, ed. Harriet Zinnes (New York: New Directions, 1980), 201.

9. Ezra Pound, *The Selected Letters of Ezra Pound, 1907-1941*, ed. D. D. Paige (New York: New Directions, 1971), 89.

10. Pound, *Ezra Pound and the Visual Arts*, 203-5.

11. Ibid., 251.

12. Ibid., 152.

13. Ibid., 207.

14. Ezra Pound, *Pavannes and Divagations* (New York: New Directions, 1958), 203.

15. Pound, *Ezra Pound and the Visual Arts*, 221.

16. Ezra Pound, *Personae* (New York: New Directions, 1926), 113.

17. Ibid., 83.

18. Ibid., 93.

19. William Carlos Williams, *The Collected Poems of William Carlos Williams*, vol. 1, *1909-39* (New York: New Directions, 1991), 129, 492.

20. E. H. Mikhail, *W. B. Yeats: Interviews and Recollections* (New York: Barnes & Noble Books, 1977), 2:200.

21. William Shakespeare, Sonnet 130.

Chapter 10. Neoclassicism

1. Margaret Crosland, ed., *Cocteau's World: An Anthology of Writings by Jean Cocteau* (New York: Dodd, Mead, 1972), 304-14 passim.

2. Alan M. Gillmor, *Erik Satie* (New York: W. W. Norton, 1988), 232.

3. Anton Kaes, Martin Jay, and Edward Dimendberg, eds., *The Weimar Republic Sourcebook* (Berkeley: University of California Press, 1994), 481.

4. Ibid., 91.

5. Marcel Proust, *Remembrance of Things Past*, trans. C. K. Scott Moncrieff and Terence Kilmartin (New York: Vintage, 1982), 1:8-9.

6. Vladimir Nabokov, *Details of a Sunset and Other Stories* (New York: McGraw-Hill, 1976), 94.

7. Viktor Shklovsky, *Theory of Prose*, trans. Benjamin Sher (Elmwood Park, IL: Dalkey Archive Press, 1991), 5-6.

8. Igor Stravinsky, *An Autobiography* (New York: W. W. Norton, 1962), 53-54.

9. Ibid., 82-83.

10. Letter cited in London CD 425614, 1990.

11. Igor Stravinsky and Robert Craft, *Expositions and Developments* (Berkeley: University of California Press, 1981), 112-13.

12. Igor Stravinsky and Robert Craft, *Dialogues* (Berkeley: University of California Press, 1982), 34.

13. Stravinsky and Craft, *Expositions and Developments*, 114.

14. T. S. Eliot, *Selected Essays* (New York: Harcourt, Brace & World, 1960), 6.

15. Ibid., 182.

16. Peter Yates, *Twentieth Century Music* (Westport, CT: Greenwood, 1967), 41.

17. Vera Stravinsky and Robert Craft, *Stravinsky in Pictures and Documents* (New York: Simon & Schuster, 1978), 537.

Chapter 11. Dadaism

1. Richard Huelsenbeck, ed., *The Dada Almanac: Berlin 1920*, trans. Malcolm Green et al. (London: Atlas, 1983), 56.

2. Robert Motherwell, ed., *The Dada Painters and Poets: An Anthology* (Cambridge, MA: Belknap, 1981), xxv.

3. Richard Huelsenbeck, *Memoirs of a Dada Drummer* (Berkeley: University of California Press, 1991), xxxv.

4. Friedrich Nietzsche, *Werke in Drei Bänden* (Munich: Carl Hanser Verlag, 1966), 2:686.

5. Huelsenbeck, *Dada Almanac*, 25.

6. Ibid., x.

7. Ibid., 140.

8. Ibid., 106.

9. Motherwell, *Dada Painters and Poets*, 250, 79.

Chapter 12. Surrealism

1. Guillaume Apollinaire, *Oeuvres en prose complètes*, ed. Pierre Caizergues and Michel Décaudin (Paris: Éditions Gallimard, 1991), 2:865-66.

2. André Breton, *Oeuvres complètes*, ed. Marguerite Bonnet (Paris: Éditions Gallimard, 1988), 1:328.

3. Ibid., 2:273.

4. Sidra Stich, *Anxious Visions: Surrealist Art* (New York: Abbeville Press, 1990), 31.

5. Breton, *Oeuvres complètes*, 2:276-77.

6. André Breton, *What Is Surrealism? Selected Writings*, ed. Franklin Rosemont (New York: Pathfinder, 1978), 2:50. This passage was translated by John Ashbery.

7. Ibid., 2:321.

8. Ibid., 2:51.

9. Patrick Waldberg, *Surrealism* (London: Thames & Hudson, 1997), 91.

10. William S. Rubin, *Dada, Surrealism, and Their Heritage* (New York: Museum of Modern Art, 1977), 109.

11. Victoria Charles, *Dali* (London: Sirrocco, 2004), 16.

12. Salvador Dalí and Haim Finkelstein, *The Collected Writings of Salvador Dalí* (Cambridge: Cambridge University Press, 1998), 272.

Chapter 13. Aestheticism

1. Walter Pater, *The Renaissance*, ed. Donald L. Hill (Berkeley: University of California Press, 1980), 190.

2. Oscar Wilde, *Complete Works*, ed. Vyvyan Holland (London: Collins, 1973), 975.

3. Ibid., 356.

4. Ibid., 986.

5. Ibid., 982-83.

6. Wallace Stevens, *The Collected Poems of Wallace Stevens* (New York: Random House, 1965), 27.

7. Ibid., 36-37.

8. "Esthétique du Mal" (1944), in ibid., 325.

9. "Arrival at the Waldorf" (1940), in ibid., 240-41.

10. Ibid., 59.

11. Ibid., 68.

12. "Anecdote of the Jar" (1919), in ibid., 76.

13. G. E. Moore, *Principia Ethica* (Cambridge: Cambridge University Press, 1959), 190, 197.

14. Virginia Woolf, *To the Lighthouse* (New York: Harvest, 1955), 40, 161, 217.

15. Ibid., 257.

16. Ibid., 258.

17. Ibid., 87.

18. Ibid., 78.

19. Ibid., 294.

20. Ibid., 27-28.

21. Ibid., 146.

22. Ibid., 146-47.

23. Ibid., 51.

24. Ibid., 79.

25. Ibid., 228.

26. Ibid., 160.

27. Ibid., 38.

28. Ibid., 52-53.

29. Ibid., 110-11.

30. Ibid., 111.

31. Ibid., 23.

32. Wilfred Scawen Blunt, *My Diaries, 1900-14: The Coalition against Germany* (New York: Alfred A. Knopf, 1922), 329.

33. Michael Benton, *Literary Biography: An Introduction* (Chicester: Wiley-Blackwell, 2009), 109.

34. Woolf, *To the Lighthouse*, 235-36.

35. Ibid., 81.

36. Ibid., 255.

37. Ibid., 60.

38. Virginia Woolf, *Moments of Being*, ed. Jeanne Schulkind (New York: Harcourt Brace Jovanovich, 1976), 83.

39. Woolf, *To the Lighthouse*, 95-96.

40. Virginia Woolf, *Collected Essays* (New York: Harcourt, Brace & World, 1967), 1:319.

41. Ibid., 1:332.

42. Ibid., 1:336-37.

43. Woolf, *Moments of Being*, 124-25.

44. Woolf, *To the Lighthouse*, 56.

45. Ibid., 58.

46. Ibid., 69.

47. Ibid., 46.

48. Ibid., 295.

49. Ibid., 76.

50. Ibid., 158.

51. Ibid., 181.

52. Ibid., 193-94.

53. Ibid., 202-3.

54. Ibid., 66.

55. Ibid., 277.

56. Ibid., 302.

57. Ibid., 299-300.

58. Ibid., 237, 309.

Chapter 14. Corporealism

1. D. H. Lawrence, *Lady Chatterley's Lover* (Cambridge: Cambridge University Press, 2002), 212.

2. D. H. Lawrence, *St. Mawr and The Man Who Died* (New York: Vintage, 1953), 50.

3. D. H. Lawrence, "Surgery for the Novel-or a Bomb," 1923, in *Phoenix: The Posthumous Papers of D. H. Lawrence*, ed. Edward D. McDonald (New York: Viking, 1968), 517-18.

4. Lawrence, *Lady Chatterley's Lover*, 50.

5. Cited in *Romanticism*, ed. Michael O'Neill and Mark Sandy (Abington: Routledge, 2006), 212.

6. D. H. Lawrence, *Psychoanalysis and the Unconscious and Fantasia of the Unconscious* (New York: Viking, 1971), 5.

7. Ibid., 7.

8. Lawrence, *Lady Chatterley's Lover*, 108.

9. Ibid., 291.

10. Ibid., 266.

11. Ibid., 266, 269.

12. Ibid., 110.

13. D. H. Lawrence, *Phoenix II* (New York: Viking, 1968), 405.

14. Lawrence, *Lady Chatterley's Lover*, 71.

15. Ibid.

16. D. H. Lawrence, *Sons and Lovers, Part I* (Cambridge: Cambridge University Press, 2007), 183.

17. Lawrence, *Lady Chatterley's Lover*, 138.

18. Ibid., 133.

19. Ibid., 202.

20. Ibid., 228.

21. D. H. Lawrence, *The Letters of D. H. Lawrence*, ed. George J. Zytaruk and James T. Boulton, vol. 2, *1913-16* (Cambridge: Cambridge University Press, 1981), 183-84.

22. Lawrence, *Lady Chatterley's Lover*, 210.

23. Ibid., 178.

24. Ibid., 223.

25. Ibid., 179.

26. Ibid., 110.

27. Ibid., 74-75.

28. Ibid., 233, 235.

29. H. G. Wells, *The First Men in the Moon, and Some More Human Stories* (London: T. Fisher Unwin, 1925), 236-37.

30. D. H. Lawrence, *The Complete Poems of D. H. Lawrence*, ed. Vivian de Sola Pinto and F. Warren Roberts (New York: Viking, 1971), 510.

31. "Sea-Bathers," in ibid., 625.

32. Lawrence, *Lady Chatterley's Lover*, 23.

33. Ibid., 51.

34. Ibid., 286.

35. "Give us Gods," in Lawrence, *Complete Poems*, 437.

36. "Swan," in ibid., 436.

37. "Won't It Be Strange—?," in ibid., 438.

38. D. H. Lawrence, 9 Feb. 1927, in *The Letters of D. H. Lawrence*, ed. James T. Boulton and Lindeth Vasey, vol. 5, *1924-27* (Cambridge: Cambridge University Press, 1989), 639.

39. Harry Partch, *Genesis of a Music* (New York: Da Capo, 1979), 8.

40. From Partch's project report to the Carnegie Foundation, in Philip Blackburn's *Enclosure 3: Harry Partch* (St. Paul: American Composer's Forum, 1997).

41. Ibid., 28.

42. Partch, *Genesis of a Music*, 15.

43. Ibid., 8.

44. Ibid., 53.

45. Roland Barthes, *The Responsibility of Forms: Critical Essays on Music, Arts, and Representation*, trans. Richard Howard (New York: Hill & Wang, 1985), 299.

46. Partch, *Genesis of a Music*, 54-55; the quotations from Lawrence are from *Phoenix*, 552, 554, 556, 569, 570, 584.

Chapter 15. Totalizing Art

1. William Faulkner, *The Sound and the Fury: The Corrected Text with Faulkner's Appendix* (New York: Modern Library, 1992), 40, 82, 287.

2. T. S. Eliot, *Selected Essays* (Harcourt, Brace & World, 1960), 6.

3. Ibid., 182.

4. T. S. Eliot, *Collected Poems, 1909-1962* (New York: Harcourt, Brace & World, 1963), 29.

5. Ibid., 29-30.

6. Ibid., 31.

7. Ibid., 31.

8. T. S. Eliot, *Knowledge and Experience in the Philosophy of F. H. Bradley* (New York: Farrar, Straus, 1964), 195.

9. Eliot, *Collected Poems*, 31.

10. Eliot, *Selected Essays*, 250.

11. T. S. Eliot, "*Ulysses*, Order and Myth," from http://people.virginia.edu/~jdk3t/eliotulysses.htm.

12. Jessie L. Weston, *From Ritual to Romance* (New York: Doubleday, 1957), 186.

13. Eliot, *Collected Poems*, 53-54, lines 1-48.

14. Ibid.; "fear in a handful of dust," line 30.

15. Ibid., lines 31-34, translated.

16. Ibid., 56-57, lines 77-103, 111-12.

17. Ibid., 61-62, lines 215-48.

18. Ibid., 72.

19. Ibid., 62, lines 249-56.

20. W. B. Yeats, ed., *The Oxford Book of Modern Verse, 1892-1935* (Oxford: Clarendon, 1936), xxi.

21. Eliot, *Collected Poems*, 67-68, lines 369-85.

22. Ibid., 66-67, lines 346-59.

23. Ibid., 69, lines 428-34.

24. Ezra Pound, *The Cantos of Ezra Pound* (New York: New Directions, 1995), 8/28. All subsequent citations from *The Cantos* will be in the form of Canto number/page number.

25. Ezra Pound, *Ezra Pound and the Visual Arts*, ed. Harriet Zinnes (New York: New Directions, 1980), 207.

26. Ezra Pound, *The Letters of Ezra Pound to Alice Corbin Henderson*, ed. Ira P. Nadel (Austin: University of Texas Press, 1993), 120, 223.

27. Pound, *Cantos*, 72/432.

28. Ernest Fenollosa, *The Chinese Written Character as a Medium for Poetry*, ed. Ezra Pound (San Francisco: City Lights, 1969), 31.

29. Pound, *Cantos*, 90/628-29.

30. Robert Martin, *Tennyson: The Unquiet Heart* (Oxford: Clarendon, 1980), 302.

31. Ronald Bush, *The Genesis of Ezra Pound's Cantos* (Princeton, NJ: Princeton University Press, 1989), 53.

32. Robert Browning, *Sordello*, 1:30, 31, 35-36, 71-72.

33. Bush, *Genesis*, 69-70.

34. Ezra Pound, *Literary Essays* (New York: New Directions, 1968), 152.

35. James Joyce, *A Portrait of the Artist as a Young Man* (New York: Compass, 1963), 214.

36. Bush, *Genesis*, 54.

37. Ezra Pound, *Selected Prose, 1909-1965*, ed. William Cookson (New York: New Directions, 1973), 22.

38. Ezra Pound, *Pavannes and Divagations* (New York: New Directions, 1958), 102.

39. Ezra Pound, *Pound/Ford: The Story of a Literary Friendship*, ed. Brita Lindberg-Seyested (New York: New Directions, 1982), 42.

40. Pound, *Cantos*, 4/13-16.

41. Bush, *Genesis*, 57.

42. Pound, *Letters of Ezra Pound to Alice Corbin Henderson*, xxii.

43. Pound, *Ezra Pound and the Visual Arts*, 209.

44. Trans. Pound, in *Letters of Ezra Pound to Alice Corbin Henderson*, 112-15.

45. Ezra Pound, *Gaudier-Brzeska: A Memoir* (New York: New Directions, 1970), 76.

46. Ezra Pound, *Plays Modelled on the Noh (1916)*, ed. Donald C. Gallup (Toledo: Friends of the University of Toledo Libraries, 1987), 36.

47. Ezra Pound, *The Selected Letters of Ezra Pound, 1907-1941*, ed. D. D. Paige (New York: New Directions, 1971), 210.

48. Donald Francis Tovey, *Symphonies and Other Orchestral Works* (New York: Oxford University Press, 1989), 17.

49. Pound, *Literary Essays*, 394.

50. Ezra Pound, *ABC of Reading* (New York: New Directions, 1960), 21-22.

51. Pound, *Selected Letters*, 322; Ezra Pound, *Jefferson and/or Mussolini* (New York: Liveright, 1970), 22.

52. Pound, *Cantos*, 38/189.

53. Pound, *Ezra Pound and the Visual Arts*, 207.

54. Pound, *Cantos*, 74/447.

55. Ibid., 25/119.

56. 5.1786-92.

57. Genesis 11, King James version.

58. Genesis 2:19-20.

59. Genesis 3:5.

60. James Joyce to Frank Budgen, 20 Mar. 1920, in *Selected Joyce Letters*, ed. Richard Ellmann (New York: Viking, 1975), 251-52.

61. James Joyce, *Ulysses: A Critical and Synoptic Edition*, ed. Hans Gabler et al. (New York: Garland, 1986), 2:853.

62. Ibid., 2:915.

63. Book 12, trans. Samuel Butler.

64. Week 29, Burke; Joyce, *Ulysses*, 2:877.

65. Herbert Spencer's social-Darwinist catchphrase—week 40, Huxley; ibid., 2:905.

66. Ibid., 2:827.

67. Ibid., 2:831-33.

68. Ibid., 1:199.

69. See www.romanization.com/books/mandeville/chap06.html.

70. Sir John Mandeville, *Travels*, chap. 22.

71. Week 32, Gibbon; Joyce, *Ulysses*, 2:883-85.

72. Ibid., 2:861-63.

73. Jonathan Swift, *Gulliver's Travels and Other Writings*, ed. Louis A. Landa (Boston: Riverside, 1960), 300-301.

74. Joyce, *Ulysses*, 2:891-93.

75. Week 38, Macaulay; ibid., 2:897-99.

76. Ibid., 2:805.

77. Ibid., 2:907.

78. Ibid., 2:921.

79. Samuel Beckett, *Disjecta*, ed. Ruby Cohn (New York: Grove, 1984), 27. Beckett quotes James Joyce, *Finnegans Wake* (New York: Viking, 1966), 462.

80. Dante, *Inferno*, Canto 31, trans. Henry Wadsworth Longfellow.

81. Douglas Jarman, *Alan Berg: Lulu* (Cambridge: Cambridge University Press, 1991), 60.

Chapter 16. Communism, Fascism, and Later Modernism

1. Bertolt Brecht, *Die Stücke von Bertolt Brecht* (Frankfurt: Suhrkamp, 1992), 144.

2. Daniel Albright, *Modernism and Music: An Anthology of Sources* (Chicago: University of Chicago Press, 2004), 344-45.

3. W. B. Yeats, "Under Ben Bulben," in *The Poems*, ed. Daniel Albright (London: Everyman, 1994), 375.

4. Yeats, *Poems*, 235.

5. W. H. Auden, "Spain 1937," in *The English Auden*, ed. Edward Mendelson (New York: Random House, 1977), 211.

6. Auden, "September 1, 1939," in ibid., 246.

7. W. H. Auden, *Collected Poems*, ed. Edward Mendelson (New York: Random House, 1976), 197.

8. Humphrey Carpenter, *W. H. Auden: A Biography* (Boston: Houghton Mifflin, 1981), 418-19.

9. Auden, "The Geography of the House," in *Collected Poems*, 527.

10. Wyndham Lewis, *Tarr* (New York: Alfred A Knopf, 1918), 97.

11. Stephen Spender, ed., *W. H. Auden: A Tribute* (New York: Macmillan, 1974), 75.

12. "The Song of the High One," stanzas 56, 60, in *The Elder Edda*, trans. Paul B. Taylor and W. H. Auden (New York: Random House, 1970), 42-43.

13. Ernest Hemingway, *In Our Time* (New York: Charles Scribner's Sons, 1958), 185.

14. Ernest Hemingway, *The Sun Also Rises* (New York: Charles Scribner's Sons, 1954), 123-24.

15. Samuel Beckett, *Watt* (New York: Grove, 1953), 208 (written 1941-44).

16. Samuel Beckett, *Murphy* (New York: Grove, 1957), 96-97.

17. Dougald McMillan and Martha Fehsenfeld, eds., *Beckett in the Theatre* (London: John Calder, 1988), 14.

18. John Cage, *Silence* (Hanover, NH: Wesleyan University Press, 1973), 8.

19. Statement printed in Emily Genauer's column in the *New York Herald Tribune*, 27 Dec. 1953, sec. 4, p. 6.

20. Kazimir Malevich, *The Artist, Infinity, Suprematism—Unpublished Writings, 1913-1933*, ed. Troels Andersen (Copenhagen: Borgen, 1978), 34-35.

21. Cage, *Silence*, 85.

22. Ibid., 12, 195.

23. Piet Mondrian, *The New Art—the New Life*, ed. Harry Holtzman and Martin S. James (Boston: G. K. Hall, 1986), 78-79.

Epilogue. The End of Modernism?

1. Jacques Derrida, "Signature Event Context," *Glyph* 1 (1977): 185.